THE LOST MUSEUM

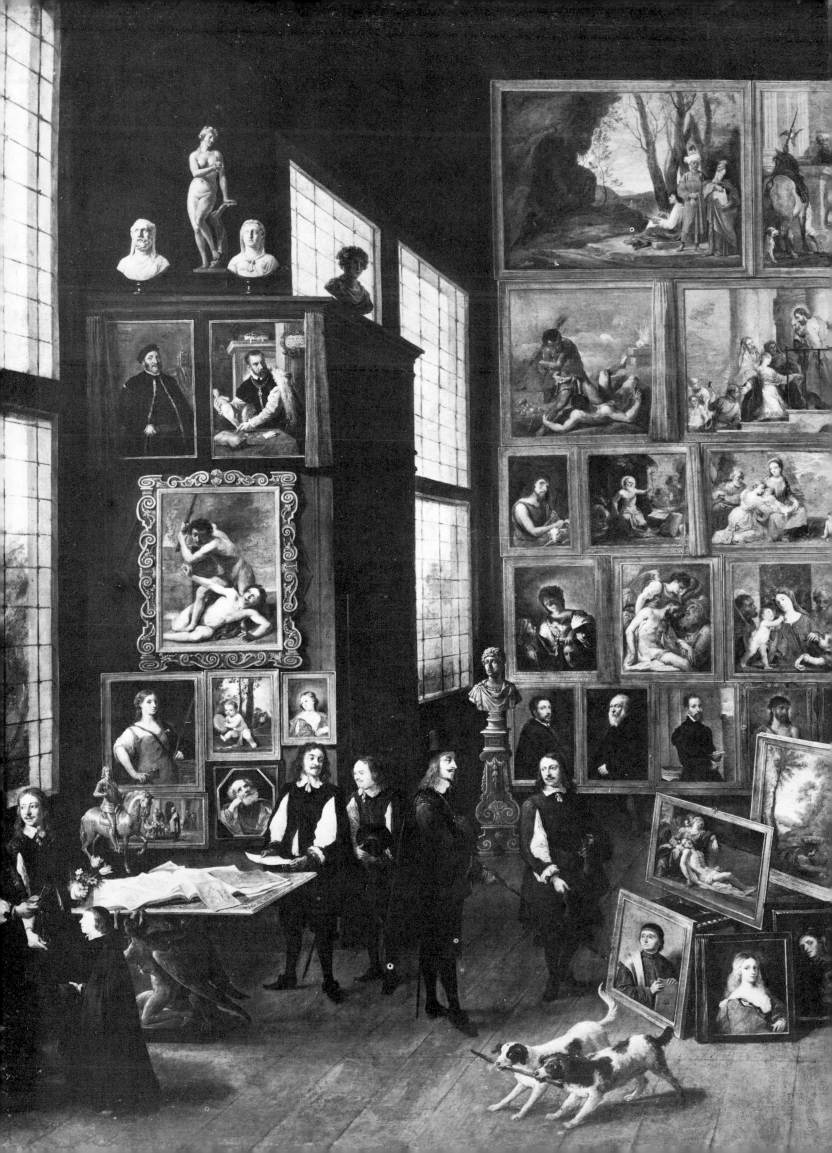

THE LOST MUSEUM

Glimpses of Vanished Originals

by
Robert Adams

A STUDIO BOOK

The Viking Press~New York

Copyright © Robert M. Adams, 1980
All rights reserved
First published in 1980 by The Viking Press
625 Madison Avenue, New York, N.Y. 10022
Published simultaneously in Canada by
Penguin Books Canada Limited

Library of Congress Cataloging in Publication Data
Adams, Robert Martin, 1915–
 The lost museum.
 (A Studio book)
 Includes index.
 1. Art—Mutilation, defacement, etc.
 2. Art thefts.
 3. Art and war. I. Title.
N8557.A32 702'.8 79-20360
ISBN 0-670-44107-4

Printed in the United States of America
by the Murray Printing Company,
Westford, Massachusetts

Set in Times Roman

Index prepared by Jacob Meyerowitz

CONTENTS

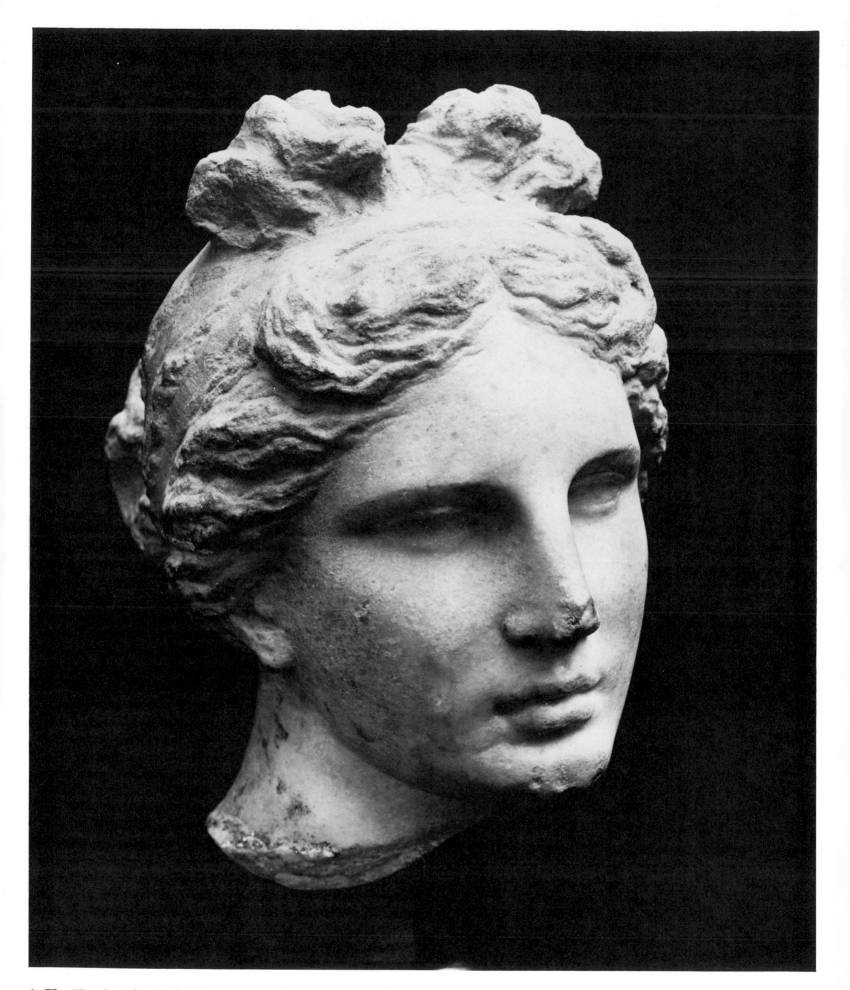

1 *The "Bartlett" head of Aphrodite in the Boston Museum of Fine Arts is certainly a Greek original, and has even been claimed for Praxiteles. A Praxiteles original would be very nice to have, but the qualities of this head are even more striking if it is by a run-of-the-mill, anonymous Greek craftsman. Roman* *copies obviously lost some of the quality of the original they were imitating, and the more Greek originals we recover (a few still turn up from time to time), the more vast appears the gap between the work of the Hellenes and that of their Italian imitators.*

ACKNOWLEDGMENTS

He who wanders the world as a snapper-up of considered trifles never makes an acquisition without also assuming a debt. In assembling this book I have levied an informal but peremptory tax on my friends, colleagues, family, casual acquaintances, and any library within my reach. Nicholas Adams contributed largely to widen the scope of the book; I wish more of it could have been his. Gerald Goldberg and Blake Nevius were particularly helpful and enthusiastic at the other side of the Continent. For years on end, the staff of the Dickson Art Library at UCLA put up with the presence of a ruminant outsider who seemed to have no focus at all for his exotic interests. Librarians, museum curators, and archivists around the world responded kindly, sometimes even promptly, to queries and requests for photographs. A generous grant from the Faculty Research Council at UCLA enormously facilitated the search for illustrations; and Jeanette Gilkison did for my sorry mess of pasteups, overlays, and interlineations her usual impeccable job of typing. To all, I am deeply grateful.

Ne sutor ultra crepidam is an old motto and a good one: never trust a cobbler away from his last. But if it were followed implicitly, some useful items of footwear might never get made. No man is or should be a professional student of lost works of art; but it is useful for everyone who thinks of the plastic arts at all to be reminded, if only in passing, how much the record of the past has been blocked, constricted, distorted, mutilated, and improved almost out of existence, in the process of reaching us. By sticking to our lasts, we may become experts in this painter's middle period or that one's early phase, without ever pausing to think how the whole context in which we place particular artists has been shaped within our minds by the accident of what survived or failed to survive from their period. "Out of sight, out of mind" is not a good motto for anybody, not even for a curious, unprofessional stroller of the galleries. By knowing something of what did not survive, we put new accents and contours on our vision of what did. This book, as the work of a cobbler so aberrant that he hardly recognizes what last he properly belongs at, aims to demonstrate very little, but hopes to suggest much.

—Robert M. Adams

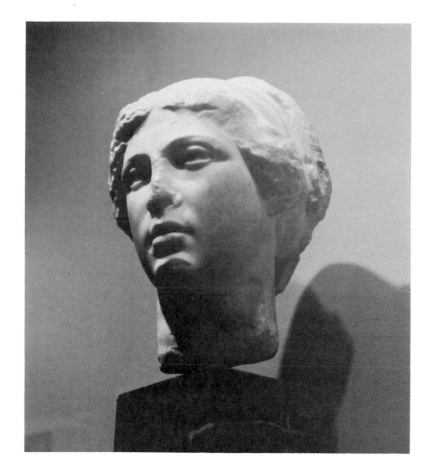

2 *This is a Roman copy of the age of Trajan (roughly the second century* A.D.*) after a Greek original estimated to have been of the fourth century* B.C. *Discounting the wear and tear of the centuries, it still appears a far less inward and poetic representation of a divinity than the Bartlett head, which is from Greece itself. That the original of the Roman copy may have represented an Athena Lemnia in the style of Phidias is only a speculation, but it renders all the more notable the spiritless look of this copy.*

The shape of our culture, as of so much else in the world around us, is determined in good part by our wonderful, instinctive capacity for forgetting; every so often books come along devoted essentially to repeating that single, soft, final word of King Charles I: "Remember!" This is one of them.

There are particular reasons why works of art, once the original is destroyed or lost, should generally be obliterated from the memory of men. Verbal descriptions of lost paintings, sculptures, and buildings are notoriously inadequate; three men, sketching from a single verbal description, will produce three extravagantly different images of the original. Even physical facsimiles of a specific work of art, made by skilled artists working in the very presence of the original, will vary significantly. Much art destruction is performed by men who think the art they destroy valueless or positively evil; they do their best to obliterate all traces of it, including copies, and they have no interest in describing what they have destroyed. Even art historians are not very friendly to the work of art which is not around to be inspected, tested, authenticated. Copies are tainted evidence when their accuracy cannot be checked, and it's an important part of the historian's work to ensure that the canon of authentic work is not diluted by unverified attributions. Thus the lost works fall readily among the doubtful and difficult cases, and often enough they fall out of sight entirely. Steadily and imperceptibly, year after year, they drop out of sight and out of mind—until it takes a deliberate effort of the historical imagination to realize how little remains, compared with how much is gone.

Indeed, more of the past (or, to put it properly, more material from more different pasts) is now available to us than to any generation that ever lived, along with a keener awareness of its historical distance. We have deciphered the Rosetta stone, uncovered Homer's Troy, dug out Machu Picchu, and scoured the Mediterranean for long-drowned statues. In many ways, we know the past better than the past ever knew itself. A medieval burgher might have worshiped every day of his life in the cathedral church of Milan, or for that matter in Notre Dame de Paris, without ever seeing the capitals that crown the piers of the nave or most of the wall decorations.* They are much too high and the churches are too dark to make them accessible to the unaided eye. A modern photographic crew arrives with a truck-borne generator, piles of steel scaffolding, floodlights beyond number, and a dozen expensive color cameras. They climb high and move in close, they adjust the lighting, they take a hundred pictures of each decorative detail from every conceivable angle, and select the best for reproduction in a book which any purchaser may have at chairside

* Even today, an addict of the paintings of Parma is frustrated, for example, by the church of San Giovanni Battista in that city, where after his pilgrimage he can make some meager light for Parmigianino's frescoes in the first and second vaults of the nave, if he is lucky enough to find the dark little box in which to deposit his hundred lire. But the fourth arch is irredeemably dark, and the Correggios of the cupola are not only obscure but covered with apparently permanent scaffolding. Another light-problem is posed by museums, like the Pitti in Florence, with floor-to-ceiling paintings; once they are stuck thirty feet off the floor, where they cannot possibly be seen, the paintings are never moved. To my personal knowledge, there is a portrait by Andrea del Sarto in the Pitti which has hung exactly where it is now for the last fifty years, semi-visible but tantalizing. The lack of a policy of rotation suggests a darkness in the minds of the staff more depressing than the darkness of the halls.

while he listens to a stereo recording of Gregorian chants—or the music of Karlheinz Stockhausen, if he's that way inclined. The contents of Scythian grave mounds are mounted in traveling exhibitions and shown to millions; for an encore, the cultural circus produces the treasures of Tutankhamen's tomb.

From prehistoric cave paintings on down, the cultural stream flowing to us out of the past is enriched by a thousand tributaries till, as it reaches us, it appears full and various, some might even say choked. A deliberate effort of the will is needed to realize how radically the stream has been diminished by its passage through history. In fact, those artifacts often come to us in best shape which have had least contact with humankind over the intervening years. The prehistoric cave paintings at Lascaux would be blurred and dim beyond recognition if they had been discovered a hundred years ago; the only way they can be preserved now, under constant air-conditioning, is by denying access to the avid lines of culture-hungry tourists who in filing past would contaminate them with destructive molds and vapors. The treasures of Scythian grave mounds, concealed from the looters, collectors, and curators of twenty-five centuries, are therefore as fresh as if created yesterday because, historically speaking, they were found only yesterday. Time all by itself is not the major destroyer of what comes down from the past; contamination, corruption, wear and tear, and that combination of violence, greed, and suspicion of the unfamiliar that is the peculiar prerogative of man—these do most of the damage.

The further back we reach into the past, the heavier the tax that has been levied by human beings on the works of human culture. That we possess the two great poems of Homer is a miracle of survival, performed through the agency of the tyrant Pisistratus, for which we have scarcely any counterpart in the arts of painting and sculpture. We know, for example, the names of several famous painters of Greek antiquity—Zeuxis, Apelles, Polygnotus, Protogenes, Aristides of Thebes. We know the names of their paintings, and some of the reasons for which they were highly regarded. We have some quite elaborate verbal descriptions of their creations. But though much painting of earlier ages in other cultures survives, not a scrap of classical Greek painting do we have, not even in the form of a known copy. When the famous Hermes of Praxiteles was discovered in 1877, it represented the first major original work by a known Greek sculptor of the classic age to be positively identified—apart from the Parthenon friezes, where the part played by Phidias is very uncertain. Practically everything else is copies, Hellenistic or Roman, and we have come perilously close to destroying most of those.

Of the seven ancient wonders of the world, only the pyramids of Egypt endure; the mausoleum at Halicarnassus, the Hanging Gardens of Babylon, the temple of Artemis at Ephesus, the statue of Zeus by Phidias at Olympia, the Colossus of Rhodes, and the lighthouse at Alexandria, all are gone. Ancient coins preserve for us more or less schematic representations of the temple (the fifth, not the famous fourth burnt by Herostratus), the statue of Zeus, and the Colossus, but the things themselves, and any qualities they had that would make them the wonders of the world, are no more. (When, in the Renaissance, Antonio Tempestá engraved a series on the theme of the seven wonders, it was his imagination that had to father them all.) Not a single building of ancient

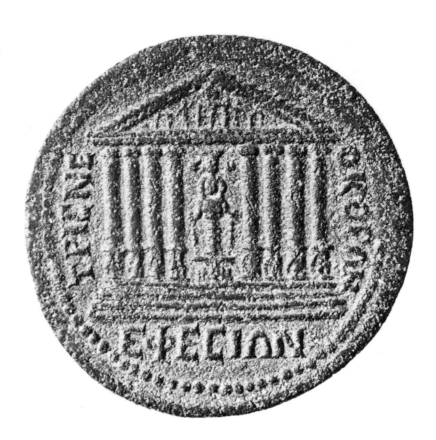

3 *Coin of the Age of Maximus (235–238* A.D.*) showing the Temple of Diana at Ephesus as it was rebuilt after being destroyed by Herostratus. Essentially what the coin portrays is the temple as known to Saint Paul. Among the curious features are several windows in the pediment, through which the deity or some representation of the deity evidently appeared on occasion; we also get a sense of what the inner statue was like, and can guess that some figure—perhaps a Gorgon or Medusa's head—was placed at the center of the pediment. On the smaller coin, which is of the age of Caracalla (*A.D. 211–217*), exigencies of space dictated to the die-maker that the temple be shown with four rather than eight pillars.*

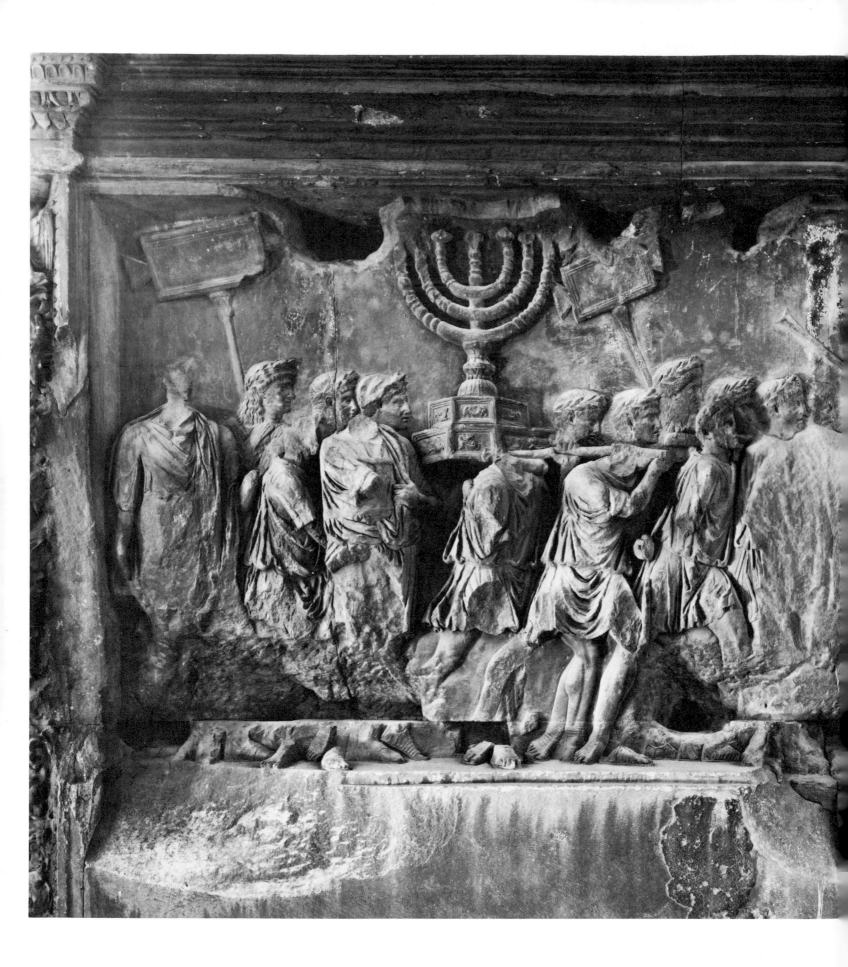

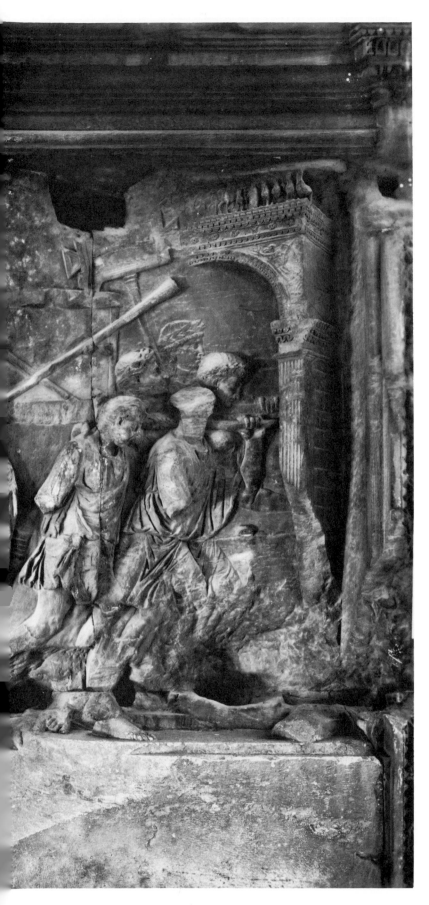

4 *After overcoming long and desperate resistance, the soldiers of the Emperor Titus stormed Jerusalem in 70 A.D. and demolished the temple constructed by Solomon. Of that temple only the piece of foundation known as the wailing wall remains in Jerusalem itself. But when the soldiers of Titus returned in triumph to Rome, they brought with them booty recognizably from the temple, and their procession was engraved on a bas-relief inside the Arch of Titus. Thus we have, in outline form, a representation of objects from the holiest and most ancient sanctum of the Jewish people.*

Greece survives, except as a ruin; not many survive at all. Apart from the odd arch, aqueduct, sewer, column, or amphitheater, only a couple of major Roman temples remain unruined, and only the Pantheon in Rome still possesses its original roof. Even more recent works of art, or works which had survived until recently, are disappearing at an appalling rate, through war, theft, looting, traffic, construction, "restoration," sabotage, and the ancient, silent, pervasive enemy of art, public indifference to its preservation. The Colosseum totters in Rome and the cathedral quakes in Milan under the vibrations of modern traffic, while the entire city of Venice subsides slowly into the oily acids of its putrefying lagoon; and the still more recent American past is battered down to make way for new Woolworth outlets or their all-important adjuncts, parking lots.

My interest in this book is in works of art that have succumbed to the tooth of time, the rage of men, the fury of historical change—but which have left a record behind, in the form of a copy or image that conveys some impression of what they were like. Ruins, on the whole, I've not been much interested in: there are too many of them, and they are, after a fashion, survivals. I'm interested in the work of art that is no longer around to speak even stutteringly for itself, but which speaks nonetheless through a secondary veil or mirror in a way that appeals to the eye or imagination. Art students are mostly concerned with the authentic; the present concern is with a particular range of the secondary, that range which lies closest to the real. I've tended to exclude both imaginary reconstructions of works long gone, and projects for works never carried out. And of course, as I've never ceased to be aware, over the horizon of this book is the boundless reach of objects, once palpable and present but now disappeared without a trace, sunk forever in the ocean of time. What was Nineveh like in its prime? All we know is what imagination and ingenuity can devise on the basis of excavations over the past century or so; of contemporary representations there are none. Trophies taken from the ancient Temple of Jerusalem are depicted on the Arch of Titus in Rome; but as to what the temple itself was like, we have to guess, and guesses are largely outside the province of this book. If I could get a copy of the de Kooning drawing that Robert Rauschenberg erased to create his celebrated "Erased de Kooning by Rauschenberg," that would exactly fulfill my theme.

Close by that theme lies a topic which, though I've had to touch on it, is really peripheral to my main interest. Theft is now, and since time immemorial has been, a way in which works of art get distributed; it is also a way in which they disappear. I am interested in lost art, not in morally or immorally acquired art. Half the contents of the Louvre are Napoleonic loot, with no better title to be there than was provided in the early nineteenth century by a regiment of dragoons. The New York Metropolitan has been known to indulge in hankypanky with dealers in art works of dubious origins—often with no better excuse than that of the man who runs a whorehouse down the avenue: "If I didn't do it, someone else would." Morally, if one wanted to take a moral stance, I don't see that there's much to choose between the peon who loots a tomb, the dealer who buys the loot, the collector who submits to the dealer's markup, and the museum director who puts the stolen object in his collection without asking where it came from—

or, for that matter, the archaeologist who to preserve his find for science ships it openly or surreptitiously out of the country of origin and hides it on the shelves of an academic laboratory.

But theft is "destruction" of an art object only when it involves dismemberment or obliteration of its character. The man who in 1934 stole the panel of "The Just Judges" out of the great van Eyck altarpiece at Ghent may or may not have destroyed his loot, and perhaps he did not destroy the picture, for a copy of the panel was promptly painted, and it may have been better than the "original" panel, which itself had been repainted many times, and by hands less trained and minds less disciplined—but within his limits, he did what he could to destroy the altarpiece for its viewers. When Hitler stole the entire altarpiece and hid it deep in an Austrian salt mine at Alt Aussee, his intentions may not have been quite as bad, for what he envisaged was a splendid European museum in which all the masterpieces of the Continent could be seen, by the Master Race at least; but he subjected the entire van Eyck masterpiece to much greater risks of complete destruction than any common burglar could have encompassed.

Indeed, a work of art may be effectually destroyed by being dismembered, even though all the individual parts survive somewhere or other. Classical structures were mined in Christian Rome to provide parts for churches, and the Septizonium of Severus survives, after a fashion, in the cupola of Saint Peter's and the loggia of Sixtus V (by Domenico Fontana) in the Lateran. Dismemberment, whether carried out under legal auspices or not, is a form of destruction more or less complete, depending on circumstances. Because they have individual identities, the separate parts of a disintegrated altarpiece are not really destroyed, even when they are separated as widely as the pieces of Signorelli's Bichi Chapel altarpiece from San Agostino in Siena. At the moment, eight elements of that once-harmonious collection are to be found, two in Toledo, Ohio, two in Berlin, one in Ireland, one in Scotland, one in the Louvre, and one in Williamstown, Massachusetts. The effect of the ensemble can, in part, be recovered by assembling photographs of the assorted pieces: but imagine if that were the only way we had to appreciate the symphonic amplitude of Matthias Grünewald's multi-paneled retable of Isenheim at Colmar. To a lesser extent the "Maestá" of Duccio has been similarly disintegrated: more than half the predella is at various places in America, instead of where it should be, with the main altarpiece in the cathedral at Siena, for which it was made.

Some paintings have been so badly and so thoroughly repainted that we may dispute whether or not they have been totally destroyed—or, if they should be properly restored now, whether they would represent an old painting rescued or a new one recreated. In the late seventeenth century, the nine large panels of Andrea Mantegna's "Triumph of Caesar," which from their home in Mantua had been brought to England by Charles I, were entrusted to an executioner almost as fell as the one who truncated that unfortunate monarch. Louis Laguerre fell upon Mantegna's work, which had been done with tempera on fine linen, and covered it with a thick layer of oil paint. He also changed the style of the painting, seeing his function as "mimicking" the original while appealing to the baroque tastes of his own time. For many years all that remained of the original severe and lucid celebration of Roman

5 Even a partial history of the great van Eyck altarpiece in Ghent would fill a volume. There is doubt about the authorship, and doubt about the proper arrangement of the two dozen panels making up the complex. The frame in which they were first disposed was destroyed by iconoclasts in 1566 and 1578, and over the centuries, the paintings have frequently been dispersed. The French stole some of them in 1794, the Germans grabbed them from the French, and they returned to Belgium only as a consequence of the Versailles Treaty. Before Hitler could steal the whole ensemble again in 1940, some private-enterprise thief stole the single panel of "The Just Judges" (they are riding with the Soldiers of the Lord to take part in the Mystic Wedding of the Lamb), and it has never turned up since. The crime is particularly pointless since the panel makes little sense outside the context of the ensemble.

6 The Septizonium raised by Septimius Severus was not finally razed to the ground till that strong-minded, stiff-necked pope, Sixtus V, decided its stones would be useful in the reconstruction of Rome. He tore it down in order to place a cupola atop Saint Peter's and to refurbish the Lateran Palace; the Roman populace, which liked its ruins and also its liberties, showed its relief at being rid of this heavy-handed master by rioting at his death and tearing down his statue. But these turbulent events were more than fifty years in the future when Maarten van Heemskerck, visiting Rome from his native Netherlands during 1532-1535, made these sketches of the remaining ruins.

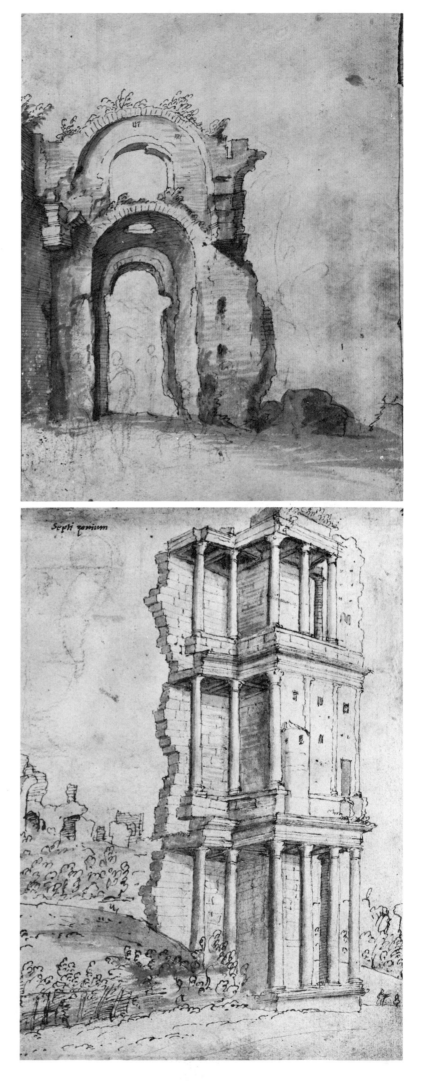

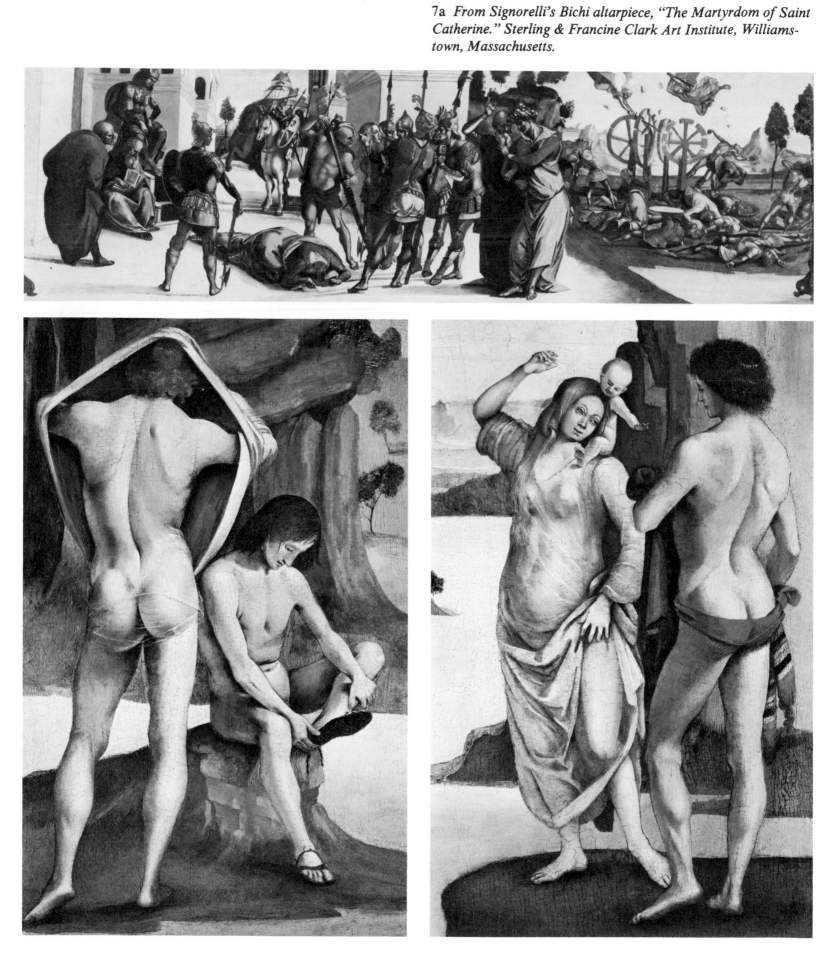

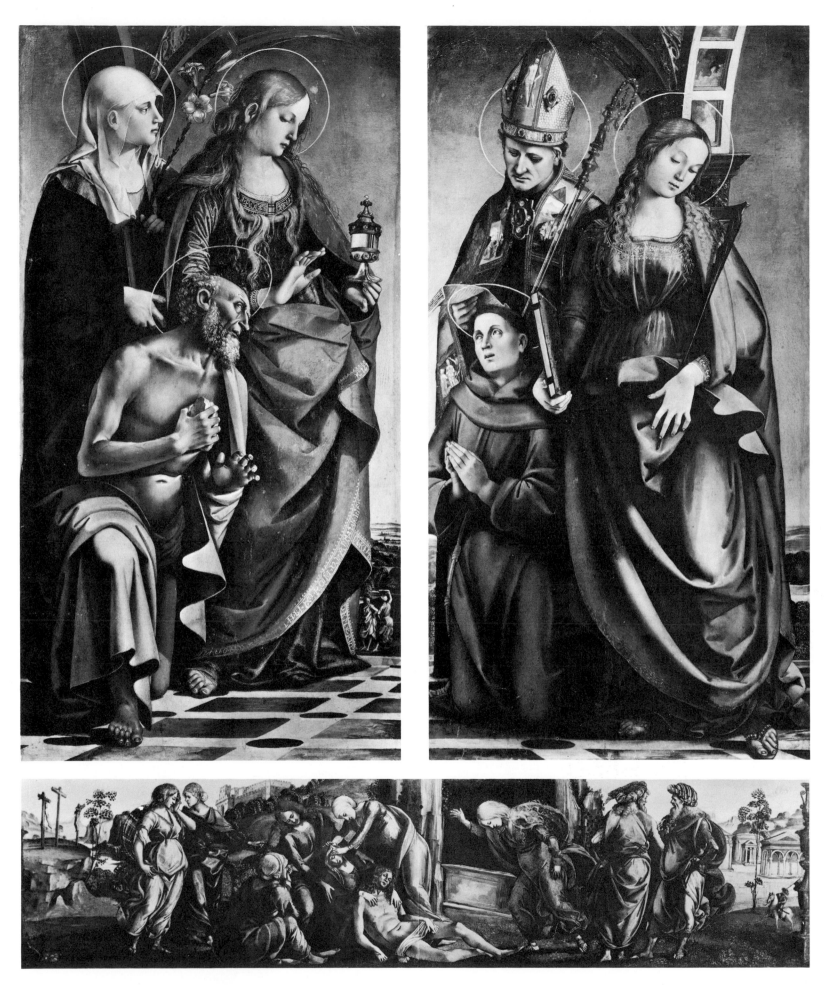

7d,e *From the Bichi altarpiece, two panels, "Saint Catherine of Siena, Saint Mary Magdalen, and Saint Jerome," and "Saint Augustine, Saint Catherine of Alexandria, and Saint Anthony of Padua." Staatliche Museum zu Berlin.*

7f *From the Bichi altarpiece, "Pietà." The collection of Sir John Stirling Maxwell, Pollackshaws, Scotland.*

7g From the Bichi altarpiece, statue of Saint Christopher. The Louvre, Paris.

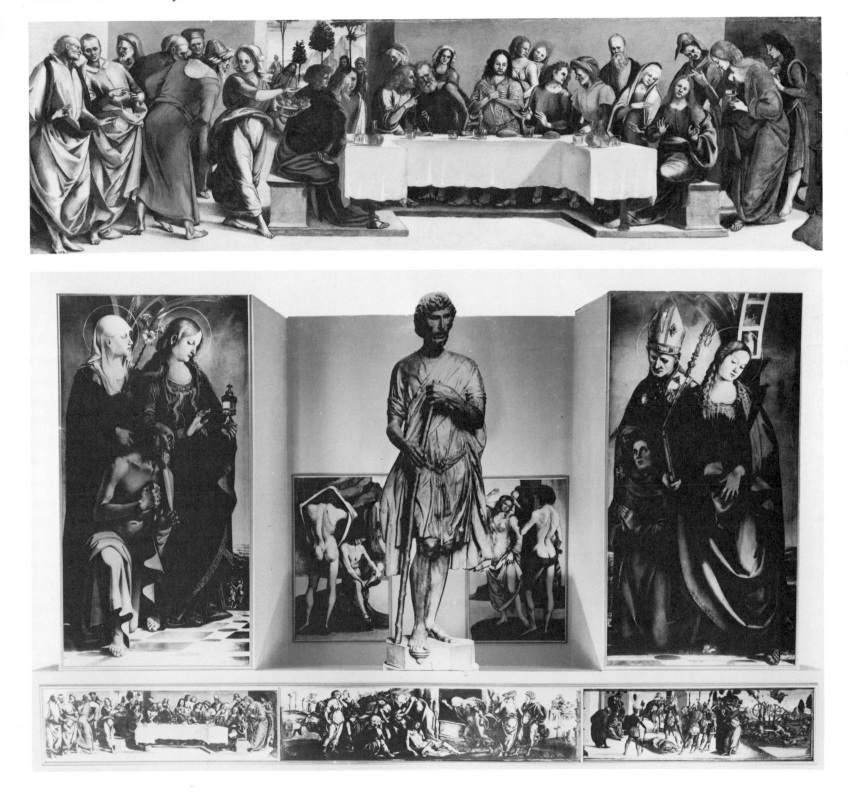

7h *From the Bichi altarpiece, "The Feast in the House of Simon." National Gallery, Dublin, Ireland.*

7i **This provisional assemblage of the Bichi altarpiece's diverse parts was created by the Sterling and Francine Clark Institute, Williamstown, Massachusetts.**

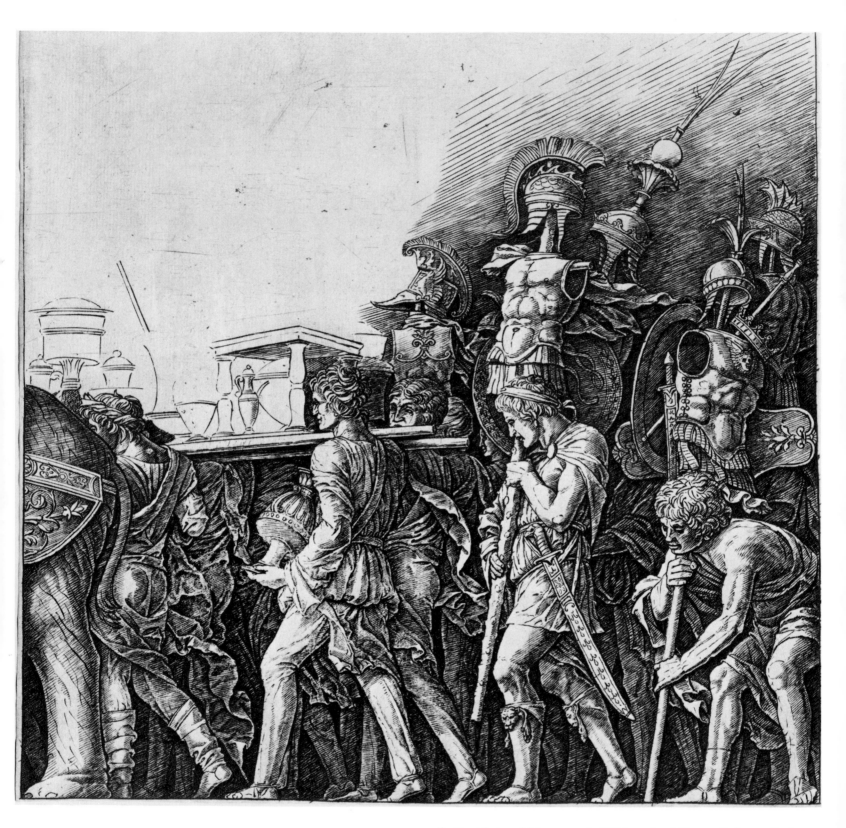

8 *Panel six of Mantegna's "Triumph of Caesar" shows the legionaries carrying trophies of battle in the triumphal procession. The engraving was apparently made from Mantegna's preliminary drawing for the panel; thus most of the background is omitted. But (by comparison with the painted panel) the soldiers of the engraving have much more the swing and stride of real legionaries; their armor (both that they wear and that they carry) is outlined in much more dramatic and spiky detail. And the emptiness of the armor being carried is emphasized by a detail such as the coronet dangling precariously from a stick stuck through the corselet being lifted by the little man on the right.*

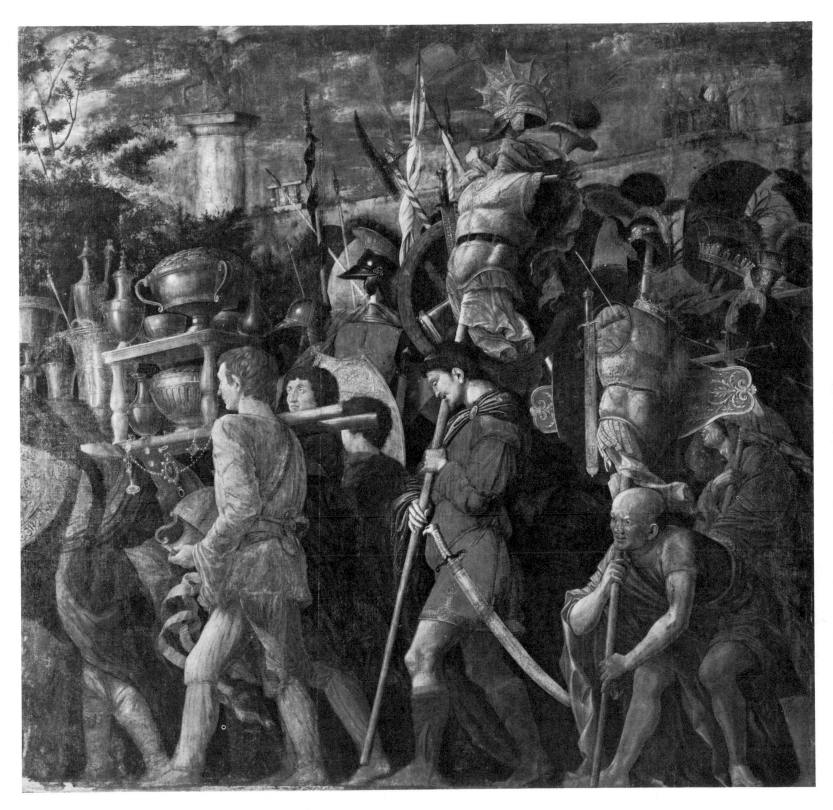

9 *The same panel, as most recently restored, in the painting at Hampton Court. Many details have been added or filled out, particularly the aqueduct in the background, the arches of which lead to an equestrian Caesar atop a triumphal pillar, reinforcing the onward movement of the procession. As for why the little soldier on the right, stooping to pick up his heavy load, has been rendered bald, Caesar himself was, of course, bald as an egg; Mantegna, who veiled the general's temples in the traditional oak-leaf crown when he represented him directly, may have wished to make indirect allusion to his peculiarity here.*

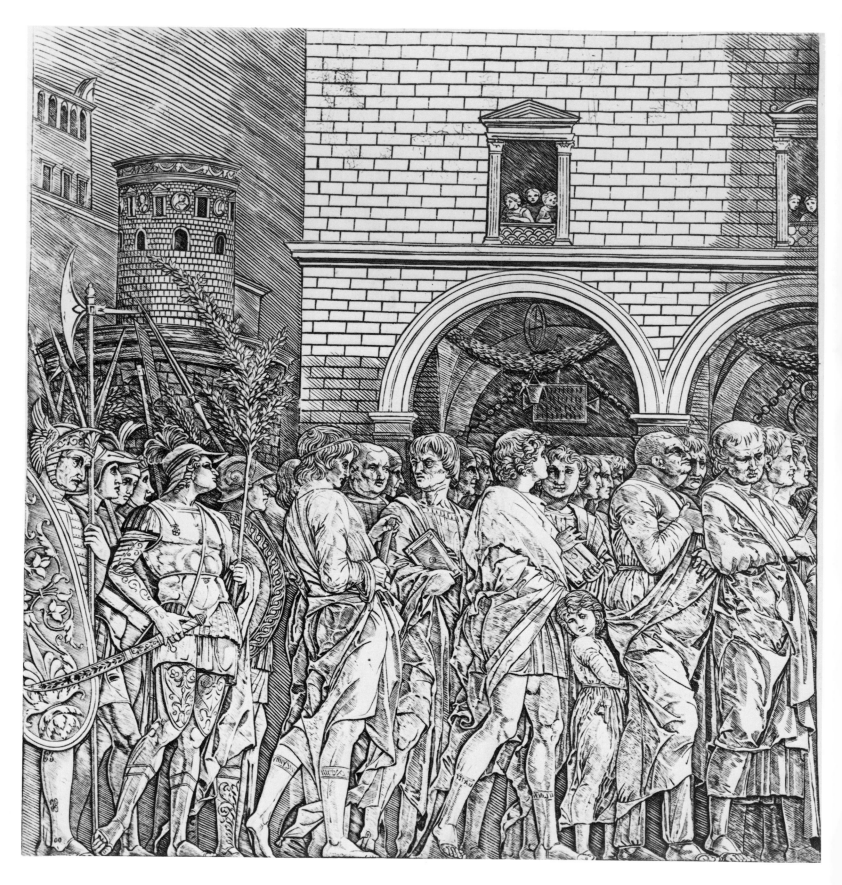

10 *The engraving known as "The Senators" (probably because of the figure in the second rank of the marchers) really represents a miscellaneous set of pedestrians in the "Triumph of Caesar." In any case, the scene never figured in the nine-part painted processional that Charles I bought from the Dukes of Mantua. Evidently Mantegna made drawings for this panel, but never got around to painting it; the engraving was made, probably by Zoan Andrea, from the preliminary drawings. Thus the engraving contributes a whole extra tenth episode, of which we should otherwise know nothing, to the history of Mantegna's immense decorative enterprise.*

antiquity was a ghost, almost a parody. Lately, the once-hopeless task of recapturing something like the original form of the paintings has been undertaken anew; and with the help of engravings made from Mantegna's work before Laguerre transformed it, skilled and devoted craftsmen have indeed made Mantegna's intent more visible. But whether this represents a recovery of the original or a new layer of overpainting, we must trust the experts themselves to tell us.

A repainted picture, however cleverly imitated, is not the original; but cannot a second casting of a sculpture from the same mold be indistinguishable from a first, or a rebuilt building be substantially the same as the first structure? The campanile on Piazza San Marco in Venice collapsed on July 14, 1902; within eight years it was rebuilt in careful replica, and of the myriad tourists who gape on it in a season, it's doubtful if more than a few can tell that it's a modern structure. Over the centuries, the Japanese shrine at Ise has been purposely demolished and rebuilt in exact replica at fixed intervals; is not the latest copy more true to the original than if the original had suffered a thousand years of deterioration? One could argue thus that the true way to preserve an original is to destroy it and rebuild it, periodically, systematically, carefully. Yet there's no need to wax metaphysical over such subtleties. "Destroyed" most of the time means simply "destroyed," by some blunt power—gelignite, bulldozers, fire—which renders an object no longer extant. Old Saint Paul's was destroyed in the Great Fire of London, as the monastery of Monte Cassino was blown to powder in the Second World War; new structures now stand where the old buildings stood, but they are something different. And nothing at all is left of Leonardo's Sforza monument, or of Michelangelo's statue of Julius II.

Destruction of old things is not always for the worse, of course. The picturesque cottage that we admire sentimentally in a Dutch landscape painting would prove a stinking unsanitary hovel if we had to inhabit it. Every day we see practical buildings that have outlived their usefulness going down and new ones springing up, as naturally as the human generations. Poggio Bracciolini tells us that in his time there were thirty-four triumphal arches in Rome; today there are but three, those of Titus, Constantine, and Septimius Severus. The smaller number is surely too few, but the larger number would not by any means be eleven times better. Human vainglory has no particular claim to survive in the teeth of human convenience; and of certain artistic forms Spiro Agnew's pronouncement on slums is almost right—when you've seen one, you've seen 'em all. Yet to the extent that a work manages to exist in the aesthetic dimension, it does have a certain claim against obsolescence. We don't destroy Giotto frescoes because they are outdated, or scrap one because there's another just as good somewhere else. And when beautiful things get in the way of other important activities, we generally find a way to move them, or channel the activities around them, or compromise in some way the two needs.

Art in fact has privileges, though only limited privileges, on which it can rely as long as it doesn't interfere too radically with the world's practical work. Buildings that get in the way of heavy traffic, high profits, or high-powered artillery, may be expected to go down quickly: there may be reasons in particular cases to protest this law, and a nation may even appear civilized as on special occasions it breaks the law, but overall, it's the way of the world. Portable art is likely to be looted rather than deliberately destroyed, though there are plenty of exceptions to this rule too, and looting itself never fails to involve the dangers of destruction. In addition, art is always subject to special perils of its own. The Byzantine iconoclasts of the eighth century, like the Dutch of the sixteenth and the English of the seventeenth, were motivated by a sense that the Supreme Being must not be represented, as the unnameable must not be named. It is a neat historical irony that we have an excellent image of an early image-hater in the act of expunging an image.

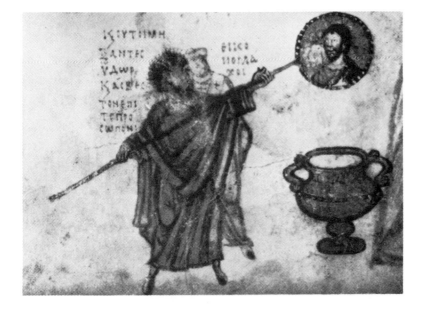

11 *That an image-breaker busily engaged in breaking images should be depicted in the act by a maker of images seems more of an irony than it actually is. The image-breaker may not hate images in general, just those that pretend to show the Divinity in earthly form; he might welcome an image of his destructive activities as a lively and instructive representation of moral conduct, likely to inspire others with holy zeal for sledgehammer and whitewash brush. Our image is from the Chludow Psalter, in the National Historical Museum, Moscow.*

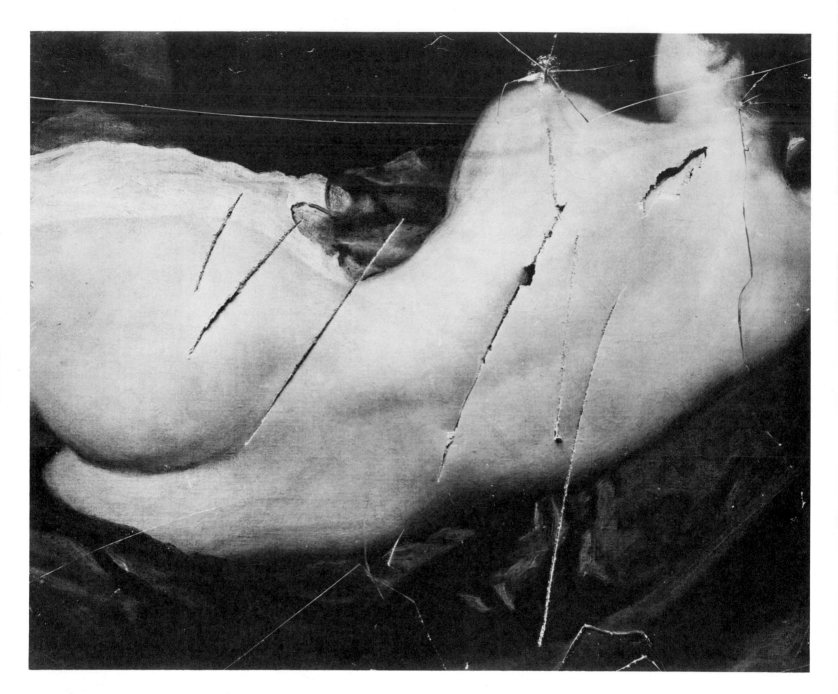

12 *Velázquez did very few nudes during his career, perhaps because he worked so largely for the stiff, prudish Spanish court. "Venus at Her Mirror" was probably painted before 1648, and she remained in the hands of Spanish noblemen (the Marquis of Elche, the Dukes of Alba) till 1802, when she passed into the hands of that crude, unscrupulous sexual politician Godoy, so-called Prince of the Peace. He sold her to an English agent named Buchanan, through whom she passed into the National Gallery, where she might have been thought safe. But in 1914 she was savagely slashed by a demented suffragette; our picture shows the incredible hatred animating this action. Repairs were made, and the picture's condition is now called "satisfactory"; but who is satisfied?*

13 *A careful comparison of the present Sistine wall with this early engraving by Martino Rota, which was made before the censorious overpainting by Daniele da Volterra, shows that "the pants-maker," as the Italians dubbed him, covered not only genitalia but buttocks, not only sinners but saints. The central figure of Christ was always draped, but the green dress on Saint Catherine of Alexandria (with a fragment of her wheel on the middle right) was new, and so was the improbable loincloth on the figure of Saint Bartholomew with his skin. Literally scores of figures were bowdlerized. On some of these corrections (done more often than not in garish new colors) the meddling moralist used, not mere tempera, but fresco—thereby rendering the corrections (or disfigurements) forever ineffaceable.* ▶

Closer to hand, art as a luxury item is the frequent symbol of an elite, an aristocratic class; when aristocrats are being hustled off to the nearest lantern post, their art is likely to get smashed as a gesture against the class enemy. In fact, it may be that as we surround art with the trappings of the sacred and the inviolable, we unintentionally incite the inevitable forlorn psychotic among us to attack it as an obscure way of "getting back." Psychiatrists are hardly needed to tell us why a crazed feminist slashed with a knife at Velázquez' unique nude Venus in the National Gallery of London, or why a failed sculptor with a sledgehammer tried to smash Michelangelo's Pietà in Saint Peter's at Rome. Many attacks on pictures in galleries are made by simple souls who feel that they are being watched, followed with malign intent by the eyes in the pictures; male nudes are sometimes disturbing to ladies who fear or hope that the great white images will fall on them and crush them dreadfully. From feelings like these, though much diffused and rationalized, grew the codes of morality which required that Michelangelo's nudes in the Sistine "Last Judgment" be veiled in decent panties; they were provided by Daniele da Volterra, but not till after Martino Rota made an engraved copy of the unabashed original. Fig leaves have by now been removed from most nude male statues in museums, but in the Vatican they still linger—probably not to anyone's serious detriment, except perhaps for the occasional child who is puzzled by some awkward questions but afraid to ask them. Still, the leaves remain witness to a problem in attitudes which earlier generations tended to solve with hammers and the cleansing fire.

High prudery needn't of course equate to destruction, but leads toward it. For almost a century, censorship forced underground a picture of Courbet's which contained strong intimations of Lesbian love. It is hard to know whether censorship or a certain kind of popularity caused such widespread destruction of the famous "Twenty Poses" which Marcantonio Raimondi engraved after long-lost originals by Giulio Romano, and to which Pietro Aretino wrote complementary sonnet-obscenities. By now they are far more comic than obscene, but more than either they are rare, after being almost proverbial in the Renaissance. Some of them were certainly thumbed to pieces by secret gloaters, others burnt in fits of wretched remorse; the few remaining sets are now consigned to the lowest depths of the "inferno" of the few libraries lucky enough to have a copy—though *Last Exit to Brooklyn* stands on the open shelves. So powerful is the force of tradition.

And as the climax of censorship, there are simple acts of deliberate destruction. Mrs. Fuseli destroyed as many as she could of her husband's pornographic drawings; John Ruskin, given a free hand with the drawings of his friend Turner, is said to have weeded out Turner's many drawings of whores and sailors at their favorite diversion and cast them into the flame. Because Ruskin accounted to nobody, the story remains hearsay, but it accords perfectly with everything that is known about Ruskin and Turner. The painter had a raunchy side, the writer was crawling with inhibitions—to give them their kindest name. Nothing in Ruskin's life suggests that he would have been in any way reluctant to destroy works which, in his opinion, would have blackened the reputation of his idol. And if Ruskin could do such a thing, it would have been much easier

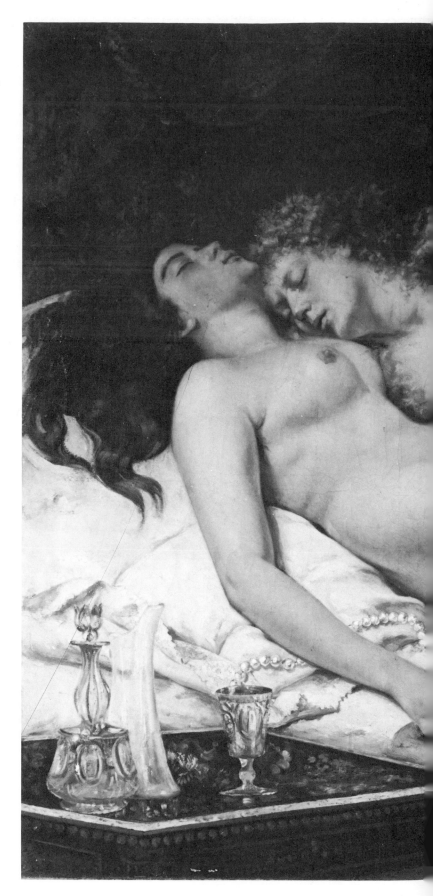

14 *In 1866 Courbet painted "Les Dormeuses," which he preferred to call "Sleepiness and Sensuality" for the Turkish ambassador; when the latter sold it, it disappeared for years into private collections whose owners neither exhibited it nor allowed it to be seen by visitors because of the scandalous theme. After spending some years in Switzerland (no one is quite sure in whose custody), it emerged in our more tolerant days to take its place on the walls of the Petit Palais in Paris and assert its claim to a position among Courbet's masterpieces. We reproduce it*

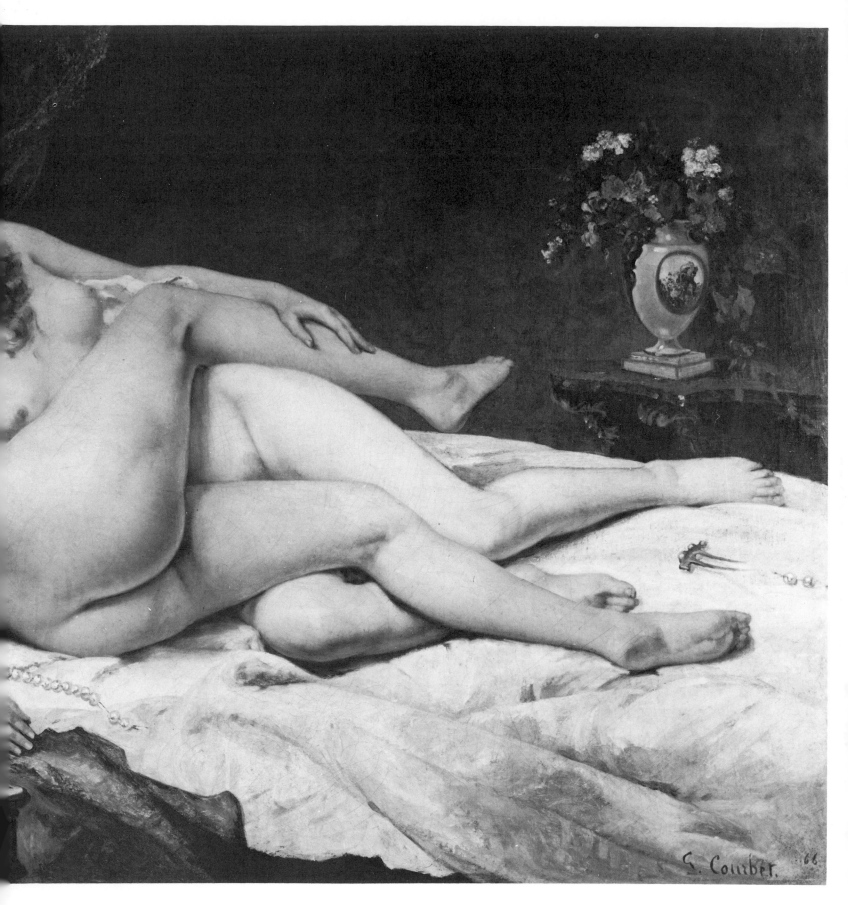

here to stand for the many others still buried in the closet which may emerge someday. Not impossibly, among them will be another painting by Courbet, "The Origin of the World," which few people ever saw, but which those who did see it describe in terms of shock, dismay, and awe.

15 *Early pornography tends to be more comic than stimulating, and the startled look on this lady's face fulfills the generalization. We note also a tendency to artistic degradation; from the painting of Giulio Romano to the engraving of Marcantonio Raimondi to this crude woodcut, the image is trending down to its lowest common denominator. Yet for all this, the "Twenty Poses" with their sonnets by Aretino, retain an ill-deserved reputation as the dirtiest of the dirty.*

16 *The "Tara" brooch, so-called (reverse side), is not a lost work of art but a rare and wonderful survival. It was found in Bettystown, County Meath, Ireland, in 1850. The workmanship dates it as of the early eighth century, and its survival in such an excellent state of preservation is absolutely inexplicable. Surely if one amazing art object has survived the vicissitudes of time and human greed, there must originally have been several, perhaps many, that have not.*

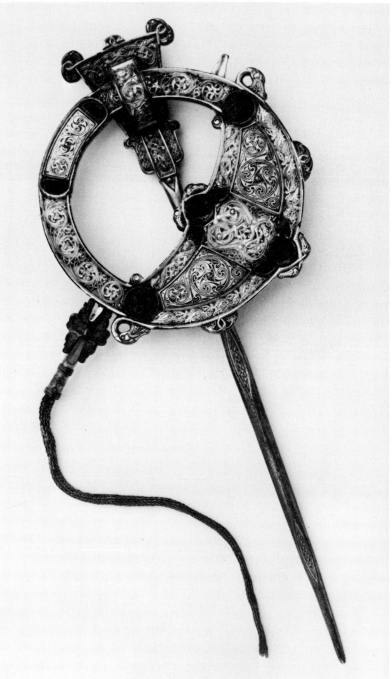

for simpler men, with fewer aesthetic impulses, and with standards of ethical propriety just as strict as his.

Still, it seems likely that willful suppression and deliberate violence against art, spectacular as they are, do less damage than the soft and gradual erosions of public taste which gradually move "old-fashioned" art from the parlor to the kitchen hallway to the junk-dealer's shop. We don't want to be thought behind the times; we get rid of the old stuff by putting it out of sight. Then mouse and spider go to work quietly in the attic, mold and mildew reduce the canvas to dust, while beetles munch their unseen way through the roof beams, slower than the wrecker's ball but just as deadly, till one day the whole structure comes crashing down on its contents. Rain, which seeps and soaks into crevices, then freezes, expands, and brings masonry walls crumbling to their knees, is the most insidious enemy; the great triumphs against time have been scored by manuscripts in the deserts of Egypt and Israel, through the help of an arid climate. And, say what we will, there is an element of luck in the matter of what will and will not survive.

A boy walking on the beach by Drogheda in 1850 found the great Tara Brooch, a major treasure of ancient Irish jewelry. It was not in a box, not associated with a wreck or a tomb, nothing else was found nearby: a solid-gold brooch ornamented with intricate filigree, glass, enamel, and amber, lying alone and unexplained on an empty beach. A few years later, another boy, pulling potatoes in an open field, found the wonderful Ardagh Chalice under a stone. The Book of Kells, if it could recount its early history, might tell of its long, slow making on a distant northern isle; of its flight thence to the Abbey of Kells where it lay hidden while the abbey was plundered in 899 by invading Danes, plundered again and leveled to the ground in 918, then rebuilt just in time to be plundered a third time in 946. Three years later Godfrey, son of Sitric, repeated the performance; in 967 the Danes were back, aided by the King of Leinster's son; in 968 they returned to pick up what (if anything) was left; and in 996 there was a final murderous assault. Seven plunderings in less than a hundred years; yet under the glowing roof beams and battered masonry, the great book lay hidden; and no monk, under torture or in hope of reward, ever revealed its existence. The book thus survived, only to be stolen in 1006, stripped of its first and last pages as well as its cover, and buried under sods, from which, after some months, it was recovered, ragged but still splendid. Already it was precious, a famous book, and it was to become the possession of kings, archbishops, and ultimately of Trinity College in Dublin, where it might have been thought safe. Yet a barbarous bookbinder, in the full glare of the early nineteenth century, did more damage to this priceless manuscript than seven visitations of Norse rapists had been able to achieve when he blindly trimmed the pages to uniform size and cut off the edges of many of the illuminations. The pages were tattered from the eleventh-century experience, to be sure, but to trim such a work of art for so trifling a reason as uniformity is like cutting down the Mona Lisa to fit an octagonal frame one has lying around.

Other ages, surely, did not prize art so highly as we do, least of all the art of their own time; not until the High Renaissance did men start to think of the great artist as a prophet-priest-prince whose work was the heritage of mankind. Earlier

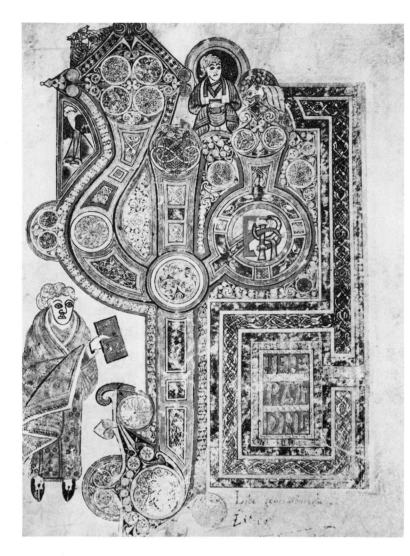

artists were commonly craftsmen, to whom subjects were assigned; the subjects were to be treated in a certain manner, using stipulated colors, and completed by a certain time—otherwise no payment. Such works might be better or worse, but they were rarely the objects of reverence: we find them listed in inventories under superficial designations with the furniture and drapes. Even nowadays, when documentation is almost a fetish, when auction-transactions are publicized internationally and catalogues are as complete as years of labor can make them, art works can quietly disappear from public ken almost as easily as forgeries can slip into the canon. We learn without surprise that Giulio Romano painted a picture for the sacristy of Saint Praxed's church in Rome, which disappeared sometime in the nineteenth century and was replaced by a quite different painting, the work of Simone Peterzano. For more than a century nobody noticed that anything had happened. Where the Giulio Romano is now, or if it exists at all (it was a "Flagellation"), nobody knows. And there is no major artist (and, *a fortiori,* no minor artist) of whom it cannot be said that one of his known works has somehow or other, quietly or violently, slipped out of public view.

All to the good, in some cases. Museum walkers often feel, not without justification, that they've had all the beefy Rubens ladies or all the low-Dutch genre scenes they can comfortably absorb: the more items of a given class we possess, the less tragic the loss of one of them. But the blind working of accident has struck just as hard at the exceptional and distinctive as it has at the routine—sometimes, it seems, even harder. An artist's masterpiece may be placed in a palace or mounted on a pedestal in a public square—perilous eminences, both. We know it now by sketches that survived in humbler but safer circumstances. The occasional work that an artist does, which is untypical of his style or out of harmony with the taste of his time, is particularly vulnerable to destruction or oblivion. And in addition, many artistic works, and these not the least interesting, were created for particular occasions and not designed to outlast them. However mutilated by restoration, Mantegna's "Triumph of Caesar" has lasted longer than anyone could have expected, for it was used at and probably intended for court festivals held by the Marquis of Mantua—its destiny was to act as a sort of scenic background at garden parties. The Crystal Palace was erected by Sir Joseph Paxton for the Great Exhibition of 1851, a show with a calculatedly brief lifespan. Sir Joseph was doubtless pleasantly surprised when his building outlived the display in Hyde Park and was moved to Sydenham, where it endured far beyond the life of its designer. He would be amazed to know that his overgrown greenhouse has proved an inspiration for modern builders in metal and glass. The Eiffel Tower, erected for the Exposition of 1889, is another provisional structure which seems to share in the queer vitality of the temporary; and the towers of the George Washington Bridge in New York were put up in their present form only as a substructure to be cased in stone, but they proved so imposing as they are that the idea of covering them up has long since been dropped.

17 *A trimmed page of the Book of Kells, showing the design clipped off on three of the four sides. The damage is evidently minor—as is the clipping of ten or twelve inches off the left side of Velázquez' "Venus at Her Mirror," or the knocking of two feet off one side of Rembrandt's so-called "Night Watch." And yet our sense of the work's balance is disturbed by these alterations—and all the more rudely in the case of the Book of Kells, because the slashing was so obviously unnecessary.*

18 *Not only the fact that it was constructed almost entirely of iron and glass, but also the fact that it was built on a strict module of 24 feet, made Sir Joseph Paxton's Crystal Palace an historic building. Erected for the Great Exhibition of 1851 in Hyde Park, London, the structure was 1850 feet long, in three tiers of diminishing width (408, 264, and 120 feet) with a domed central transept. Any resemblance to a gigantic greenhouse is far from accidental; most of Sir Joseph's previous architectural work had taken the form of greenhouses. The principle of modular construction proved itself, first in the ease and speed with which the Crystal Palace was erected, at a cost far below that of other proposals for more massive structures, and also in the ease with which, once the Exhibition was over, the vast structure was dismantled, adapted to a new site at Sydenham, and removed thither—where it stood till a fire destroyed it in 1936.* ►

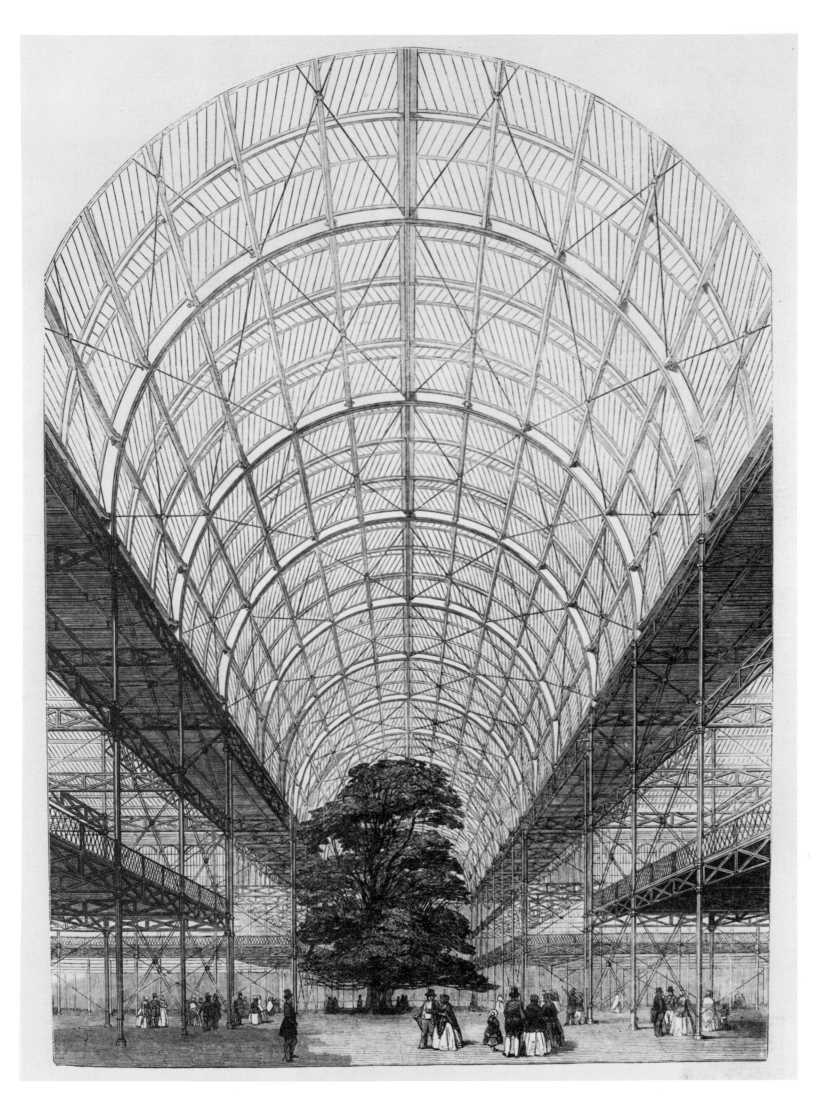

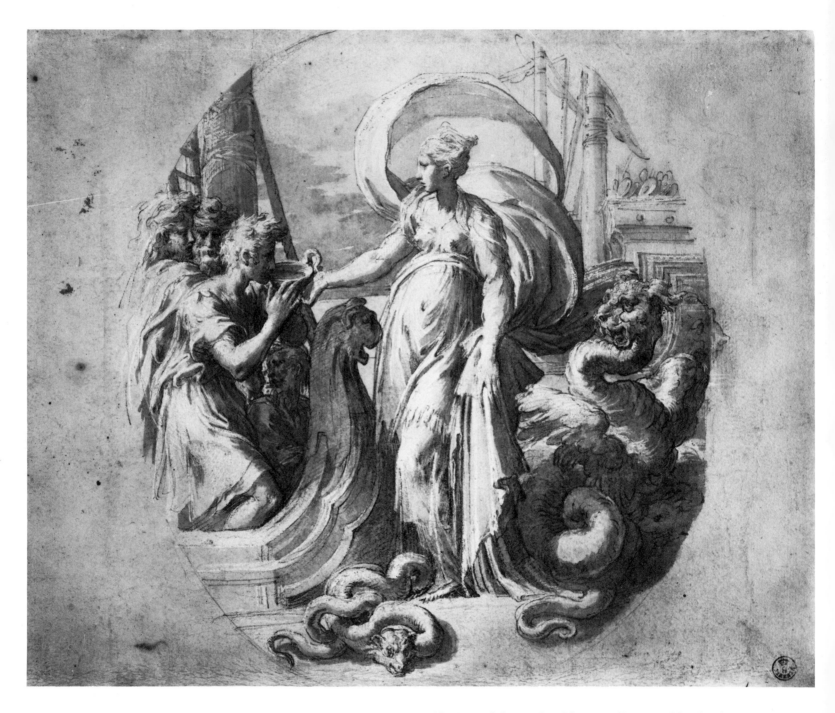

19 *One of the perils of fame is illustrated by the drawings of Parmigianino, which were so sought after that many were snipped into little pieces to bring the owner extra money. Fortunately, this drawing for a painting, never completed, of "Circe and the Companions of Ulysses," survived intact. Circe was a figure of particular fascination for the Renaissance because she represented the ambiguous aspects of witchcraft, alchemy, and sex—all of which are beneficent to the expert but destructive of the incompetent meddler. For Parmigianino, suave and sensitive in his painting as in his person, she must have seemed particularly dangerous: in his last years, he gave up painting for alchemy and turned, as Vasari tells us, into a kind of wild man, savage, neglected, and solitary. Perhaps it was intimations of this destiny that led him to make the drawing but prevented him from painting the picture.*

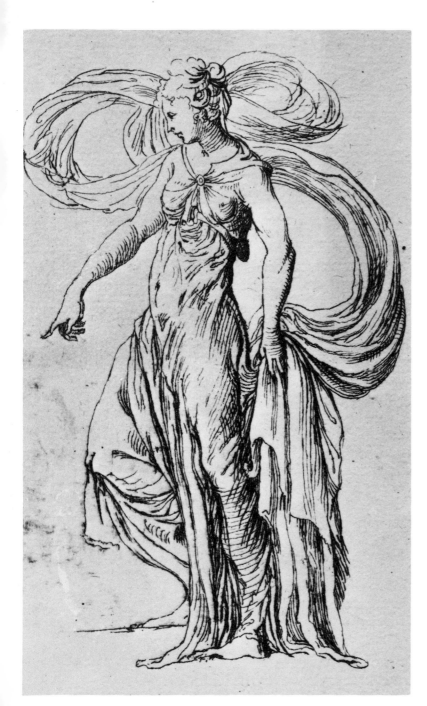

20 *Anne Claude Philippe de Tubières de Grimoard de Pestels
de Lévis, Comte de Caylus, Marquis d'Esternay, and Baron de
Bransac is generally known to history as the Comte de Caylus.
He was an amateur of archaeology and the arts and a very com-
petent engraver, fond of recording art works that he particularly
admired. All these drawings are after Parmigianino, and the ele-
gant witch is clearly Circe herself. Caylus, who lived in the
eighteenth century, managed in the course of his life to be a
soldier of distinction, an archaeologist, a numismatist, an artist,
a patron of the arts, and one of the most rakish gentlemen in the
Paris society of his time. He left, in addition to his more solemn
and learned works, a number of bawdy stories—and a great
many delightful sketches like these.*

The truth is, we cannot draw a very clear line between
ephemera and solid structures. Castles, forts, and Maginot
lines are as obsolete as the dodo bird, but an exquisite sketch
by Parmigianino flutters down the swirling air currents of time
as if on wings, carrying with it a rich recollection of that paint-
ing, "Circe and the Companions of Ulysses," of which it was a
promise or perhaps a remembrance. Whatever the ontological
status of that nonexistent painting, we are certainly the poorer
without it. Many Renaissance triumphs, like the masques
which are intertwined with them, were creatures of a day only;
but, transferred to paper by engravers of genius, they bring to
life the triumph of Maximilian as Burgkmair saw or imagined
it, the series of ornate arches through which James I advanced
into London for his coronation, and the set of festive struc-
tures devised by Rubens for the entry into Antwerp of Ferdi-
nand of Austria (1635). These florid public celebrations were a
striking feature of life in the Renaissance; we can't expect that
such occasional structures would come down to us in their
original dimensions, but representations of them enrich our
sense of the age.

Even structures which are substantial and powerful in
themselves sometimes survive because of a purely extraneous
and apparently trivial ephemeron. The magnificent temples at
Paestum, the glory of Magna Graecia, would have been torn
down long ago for the very substance that constituted their
strength, i.e., their marble building materials. They were saved
by mosquitoes, which spread malaria through the district and
prevented the demolition that would otherwise have taken
place.

A prudent collector or curator who wants to set forth the
work of an artist, first of all seeks out what is authentic in that
artist's *oeuvre;* what may be contaminated by the style of an
intermediate reporter or another medium, he inevitably and
rightly plays down. He is the worst of traitors, by his own stan-
dards and the world's, if he offers adulterate goods as the
equivalent of authentic work. But this bias puts him at the
mercy of the accidental processes just described—processes
which have resulted in the accidental survival of some things,
the accidental obliteration of others. I have hoped, by putting
forward this sampler of what has not survived, or has survived
only at second hand, to make evident how much richer and
more various the past really was than we can know simply by
looking at its authenticated remains. There is an old joke
about the man who carried around a brick to show people
what his house looked like; our relics and repositories offer us
a similar token. To make up an image of the house as it was
we will always have to use our imaginations, but this book
hopes to make available a little more material for imagination
to work with.

21 *The Procession of Maximilian I, the Holy Roman Emperor whose character Machiavelli etched in acid on the pages of* The Prince, *is a significant event mainly because it never took place. Just as some historical events nowadays never actually occur but are simply staged for the television cameras, so the procession of Maximilian existed only on paper and through the art of the wood-block engraver. Maximilian even arranged with his engravers to make a triumphal arch on paper—but swollen almost to life size by piecing together numerous wood-block prints into a*

single arch. For the first time in the West, we see a paper civiliza-
tion, in hundreds and thousands of copies, usurping and claiming
primacy over a literal, factual civilization existing in only one
copy.

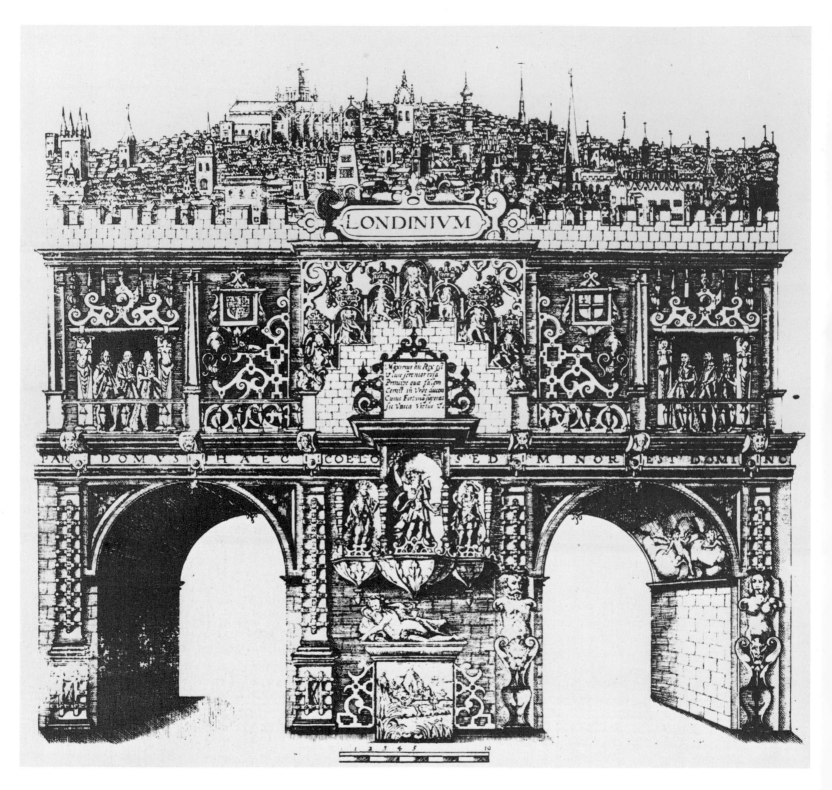

22 When James VI of Scotland came down, in the summer of 1603, after the death of his kinswoman Elizabeth Tudor, to take possession of his new kingdom and become James I of England, his new subjects vied vigorously to welcome and entertain him. There were masques, dances, and parties at the stately homes along the way, and the City of London prepared a particularly elaborate ceremonial. This giant double arch actually bore on its top a miniature model of the city, with the lofty brag below, "This House is Equal to Heaven, but Less than its Lord."

23 "The Joyful Entry into Antwerp of Don Fernando of Austria, Cardinal, Prince, and General of the Imperial Armies," took place after elaborate arrangements on April 17, 1635. Among the sumptuous scenery prepared for the prince's welcome, the Arch of Philip constituted the largest and most splendid piece; Peter Paul Rubens, who was responsible for all the decorations of the Joyful Entry, designed it and undoubtedly made sketches in oil for both its front and rear faces. The numerous paintings on the arch itself, some of which actually survive, illustrated the happy dynastic marriages of the House of Hapsburg; they were all based on original sketches by Rubens, none of which survive. But we do have an anonymous copy of a Rubens sketch for the entire arch, along with some engraved representations of the final product, to suggest the glittering panache of this splendid, ephemeral structure. ▶

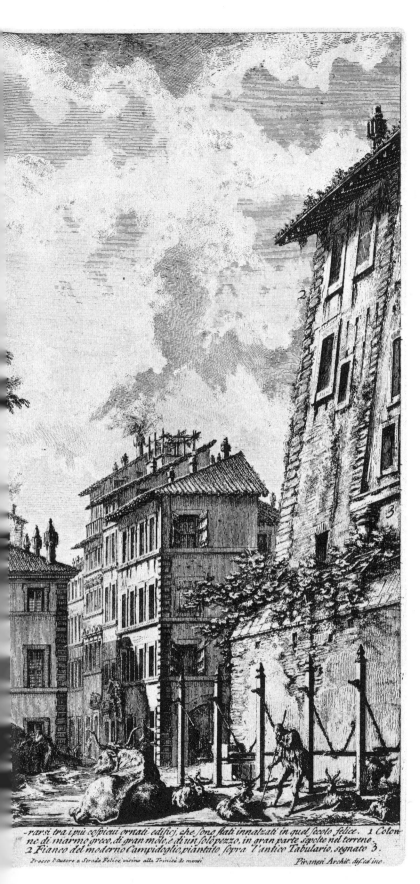

Though technically dead, the "classic" civilizations of Greece and Rome maintain a kind of half-life in our schools and museums, in our language, in our culture (popular as well as learned), in our imaginations, in the very texture of our lives. All sorts of people know about an Achilles' heel or an Achilles' tendon whose response to a mention of the *Iliad* would be no more enlightened than "Huh?" The names of our months include Roman emperors and Roman gods whether we recognize them or not, and even though the shorthand language of mythology is starting to fade from popular consciousness, a Trojan horse and a Herculean task are still operational metaphors. The languages of Greece and Rome are properly called "dead," but the cultures are in many ways powerfully alive within us. Before, behind, or around them lie the wrecks of hundreds of other civilizations, which might themselves have become our "classics," and strove by surviving to do so, but were cut down—civilizations such as those of Carthage and Persia, Scythia and Egypt, Troy and Etruria, and still other communities too deeply silted over by the sediment of time to have left their names for us.

That metaphor about sediment has its literal truth as well. Whether from Greece, from Rome, or from any ancient culture, what survives is almost always what has been buried. Even when we see them more or less "intact," ancient temples often have to be entered by climbing down from the level of a street that has risen by ten or fifteen feet since the structure was put there. The Roman forum, had it not been excavated, would by now be under ground. In Pompeii and Herculaneum, it is the buried that survives, and the catacombs in Rome have outlasted most of the structures placed on the earth above them. Indeed, though a building may be "razed to its foundations," as we say, those foundations themselves are likely to remain, providing at least a two-dimensional map of where a structure once stood. To destroy a city utterly, so that no trace of it remains, is very hard work, requiring extreme determination; yet even this has sometimes been achieved. After the Third Punic War the Romans obliterated Carthage. They killed all the men, sold the women and children into slavery, tore apart the entire city and burned the rubble, ploughed the ground on which it had once stood, and sowed salt there. In modern times, an ultimate indignity has been proposed for the center of old Carthage, which is to blacktop it over and make it into a parking lot; archaeologists have naturally protested, but perhaps the ghosts of the old Romans would be satisfied with nothing less. To obliterate a potent city and a rich civilization absolutely and for eternity is not easy, but it can be done.

24 *What Piranesi took for the temple of Jupiter the Thunderer, erected by Augustus, was really the temple of Vespasian, completed after the emperor's death by his son Titus. Augustus' building had disappeared so completely that Piranesi, who knew about it from frequent comments in the ancient biographers and topographers, could be excused for finding rudiments of it in this later structure—which was itself, as his engraving shows, gradually disappearing beneath the rising ground level of the Forum.*

25 *Scraped half-acre at the early-Neolithic village of Nea Niko-medeia in northern Greece.*

26 *The ancient abbey at Bury Saint Edmunds grew up around the burial place of King Edmund, slain by the Danes around 870; after centuries of growth, it was looted and dilapidated by the commissioners of Henry VIII. For a long time the ruins served as a quarry from which local builders could pick up precut stone, but the labor of carrying it away and incorporating it in a new structure was excessive. So a tribe of squatters set up residence in the rubble (as this print, made in the late eighteenth century, shows), building their burrows and nests like so many foxes or owls in the crevices and apertures of the ancient structure. It is the same process, essentially, as that by which the temples, theaters, and forums of ancient Greece and Rome were infested during the Middle Ages by hordes of little householders who could neither use nor destroy the ancient buildings as wholes, but scratched their warrens beside or within the pre-existing walls.* ►

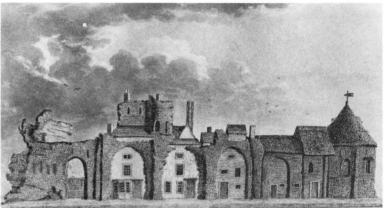

27 *An anonymous Italian visitor to Athens sketched this view of the Acropolis in 1670. It shows the minaret rising from a corner of the Parthenon and the somewhat raised roof in the center of the structure, covering the old Christian church of Santa Sophia. The artist has provided a list of the most interesting structures from his point of view; few of them survive now, or are known by the name he assigns them; but his "tempio di Pallade nella rocca d'Athene" is unmistakably the Parthenon.*

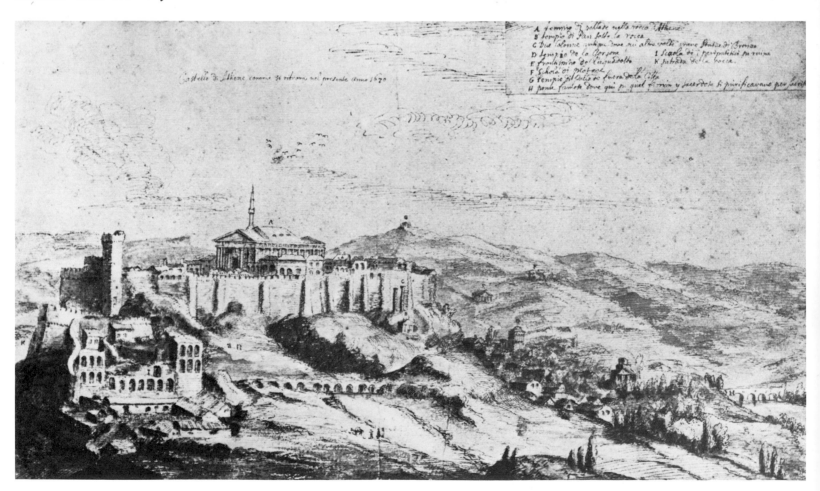

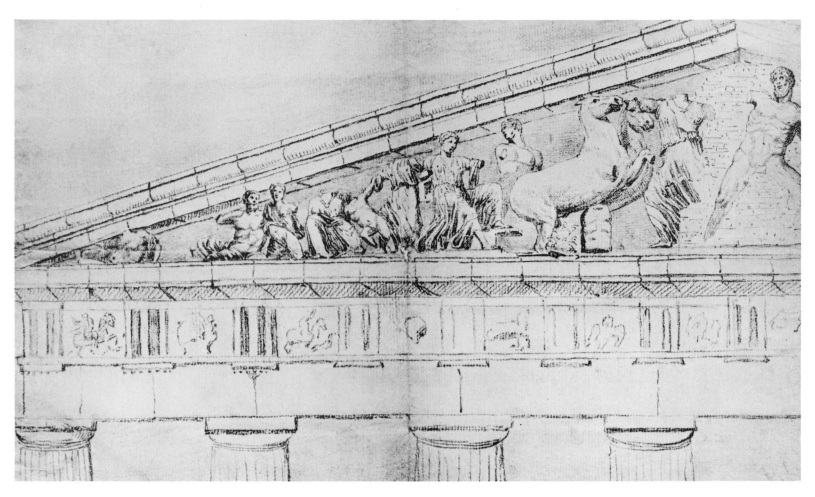

Cities, palaces, libraries, tombs, temples, bridges, obelisks, and arches have been swept away by the torrent of time and mingled with the immemorial and indistinguishable rubble. Yet absurdities in duration are everywhere; there are nearly as many things that shouldn't in all logic survive, but do, as there are things that seem as if they ought to survive, but don't. In the high, dry valleys of the Andes once flourished, well before the Incas, the civilization of the Nazca. Though the people themselves are extinct as a social and ethnic entity, some of their dazzling pottery remains; and so also, amazingly, do the miles-long, straight-as-a-die lines that they scratched in the desert floor—arrangements of dust and stone slight enough to have been made with brooms and bare hands, unaltered by the weather of the millennia, and absolutely enigmatic as to use or purpose. On the other hand, what survives of some ancient and famous cities of the Middle East is only what the desperate inhabitants, in the last terrible moments of a siege, threw down their wells or into their privies. Other cultures we know only from the contents of those coffins which were obscure enough to escape the greedy grave robbers. The tomb of King Tut, which staggers us with its magnificence, escaped major rifling only because the king was too short-lived and insignificant to merit a proper pyramid; what, then, must have been the contents of those more splendid sepulchres which were looted within a bare millennium of their laying-down?

New archaeological techniques are marvelously careful of the sheltering earth, which, if properly handled, can be persuaded to reveal the most ephemeral of records. Prehistoric lake villages existed in Macedonia as much as eight thousand years ago. The inhabitants knew not the use of metal, and put up no stonework that has lasted; their villages were constructed of wooden posts and marsh reeds, which in those boggy circumstances could hardly have failed to decay in less

28 *In 1674, a few years before the disastrous bombardment of the Parthenon in 1687, Jacques Carrey was appointed officially as designer and sketcher to accompany the French ambassador to Constantinople. He did some original sketches of Oriental life, but the job he did of copying the sculptures of the Parthenon far overshadows everything else in his life. Many of the sculptures on this west pediment were destroyed in the explosion and the period of neglect and looting that followed it. Seeing them* in situ, *as Carrey was one of the last to do, gives us a new perspective on them in more ways than one; deplorable as it is that they are in the British Museum, seeing them as they were when Carrey drew them must have been difficult and very inconvenient. And it is evident that even before the explosion, they had suffered much erosion from time and weather.*

than a century. Yet by carefully stripping off layers of earth, a fraction of an inch at a time, and taking at each layer an aerial photograph, investigators have revealed the outlines of a village, its streets and structures. Only scattered shards, bones, and odd artifacts remain, but the discoloration of the earth where posts were once driven and wattled walls once stood reveals the pattern of the village. The instance is special (one of the deepest soundings in time, recapturing some of the flimsiest evidence), but the techniques used in Macedonia are relatively common. Aerial photography, sometimes using infrared film, can be used to map the contours of once-inhabited land; special photographic probes can be lowered into subterranean chambers and used to record their contents, without the immense expense of digging. Metal-detectors and other gear for underwater exploration are the everyday tools of the scuba diver.

And yet, how much of the Greek and Roman civilizations remains forever inaccessible to us! We are missing not just specific buildings, statues, and pictures, but entire arts and fields of endeavor of which we have descriptions, sometimes quite detailed, but no examples whatever. We know that Greek statues and buildings were painted, but have very little idea of what the colors were like. Indeed, though we know the names of a great many Greek painters, we know even less of their art than of the other eighty-three plays by Aeschylus besides the seven that survive. We have accounts of ancient music, and some sense of how deeply men were moved by it, but of what it sounded like we haven't the faintest idea.

For a variety of reasons, Greek civilization has suffered far more radical losses than Roman. It is much older, for the most part, and it was plundered more often, notably by the Romans themselves. Pliny says the Romans of his day took thousands of Greek statues in silver, countless numbers in bronze and marble, and inconceivable numbers of Greek paintings, including murals detached from their walls and brought to Rome in wooden frames. Later looters were the generally uncomprehending and unsympathetic Turks, admiring but unscrupulous Western collectors, and by no means least, the uncouth natives, who as late as the nineteenth century were ripping apart the pillars of the temple of Poseidon at Sunium to get at the bits of metal that bonded the marble blocks together. This is but one instance of millions. For thousands of years, men have thought it perfectly reasonable to tear down exquisitely proportioned and beautifully decorated temples in order to patch up from the debris low hovels and minuscule chapels.

The most famous of Greek buildings, the Parthenon, got through the centuries surprisingly well till the end of the seventeenth, though it was several times looted and molested even in antiquity. The famous ivory-and-gold statue of Athena by Phidias preserved its essential form till the fifth century, when it was removed from the temple and, inevitably, broken up for its precious materials. At that time, the temple was rededicated, first and most appropriately to Santa Sophia, then to the Virgin. Making a Greek temple into a Christian church probably involved less interior damage than one might imagine, since builders of the early Middle Ages thought small, and tended simply to fit their Christian trappings inside the older structure without radical rebuilding. When the Turks took Athens in 1456, they were equally modest in their adaptive ef-

29 *In the middle of the eighteenth century, James Stuart and Nicholas Revett were sent to Athens by the Society of the Dilettanti in London to make studies of the Greek antiquities. For two years (1751–1753) they worked there, making drawings and detailed measurements; the result of their labors was published in 1762 as a giant folio volume,* The Antiquities of Athens. *The book is an early classic of scientific archaeology, particularly valuable since many of the structures they studied no longer exist. But, as the present engraving suggests, the book presented a very hard and precise image of the ancient ruins. Lord Elgin had not yet dismantled the remaining pediment or made off with*

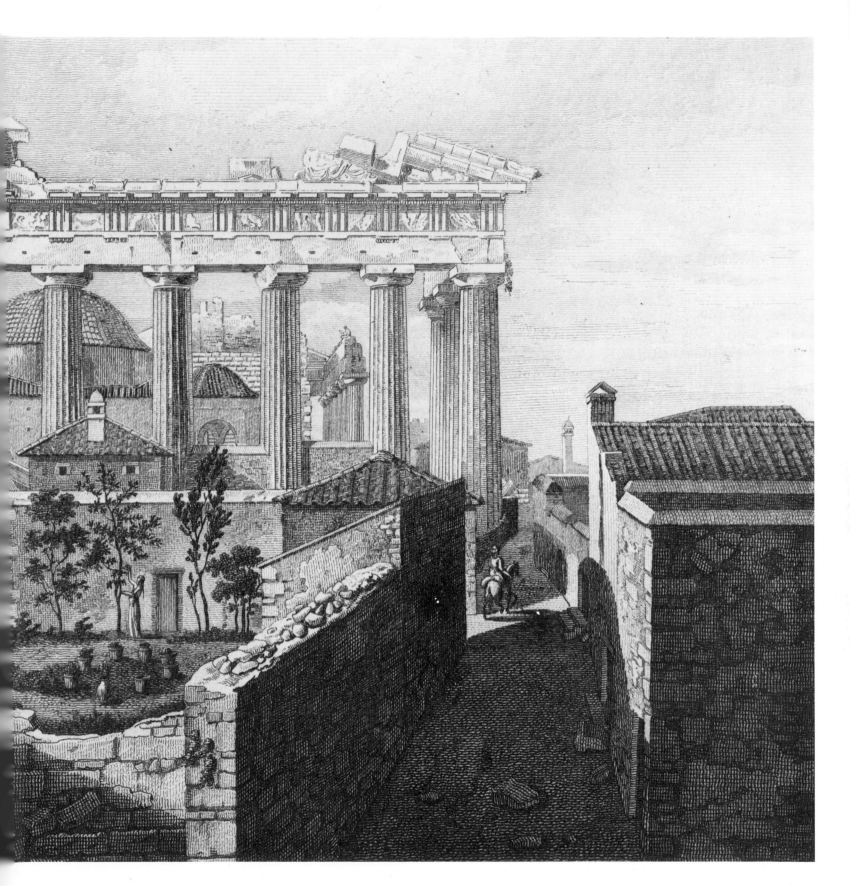

most of the frieze when this view was made; remnants of the
Turkish mosque still stood within the walls and columns battered
by the 1687 explosion.

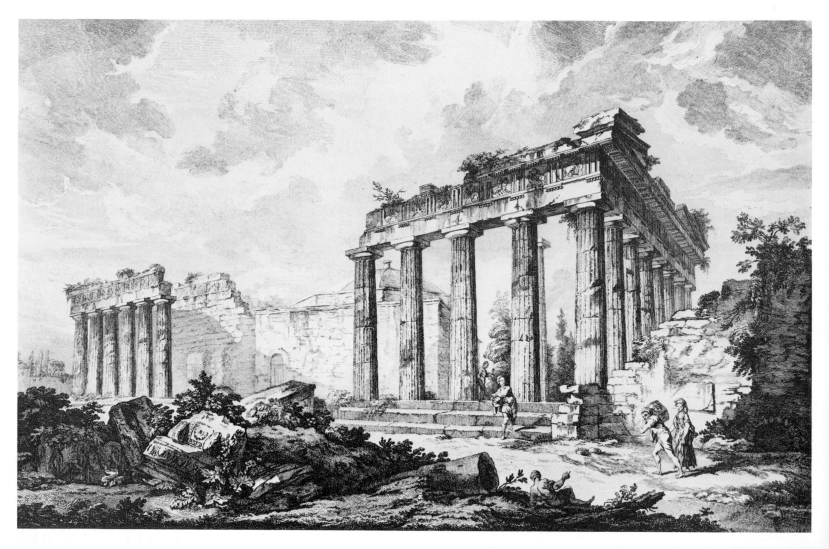

30 *Much less meticulous and detailed in his archaeological studies than Stuart and Revett, Julien David Leroy who drew the Parthenon about the same time they did gave a much stronger sense of the ruins as ruins, of the grandeur and picturesqueness of the damaged but still noble temple.*

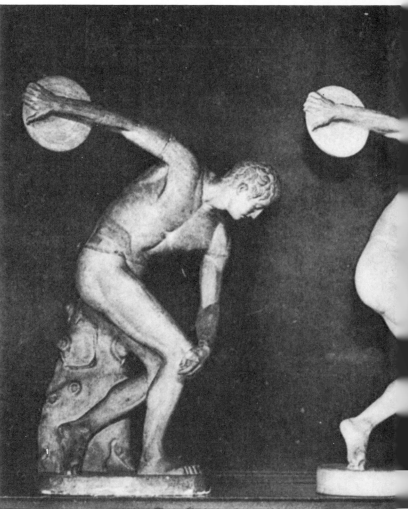

31 *Three reconstructed versions of Myron's Discus-Thrower. On the left, the Vatican copy with the head and left arm restored by modern craftsmen; in the middle, Professor Furtwangler's reconstruction, with the head from the Massimi-Lancelotti copy set on the trunk of the Vatican copy. On the right, the British Museum copy, with head and right arm restored by modern craftsmen.*

forts. They poked up a slender minaret through one corner of the already-damaged roof, but did no other harm; and in this grotesque but relatively protected posture, the Parthenon endured, to be drawn by an anonymous Italian tourist in 1670. Seventeen years later, frightful devastation was visited on it when the Venetian admiral Francesco Morosini bombarded Athens in the course of his campaign against the Turks. Whether the Turks invited the attack by storing gunpowder in the Parthenon, or the Venetians were at fault for blowing it up, is one of those endless, useless questions left behind by history. In any case, the war damage, catastrophic in itself, was augmented by Morosini's bungling efforts to carry off some of the sculptures of the pediment to Venice, along with the bronze horses he had already looted from Hagia Sophia in Istanbul.

By the early nineteenth century the Parthenon as sketched by adventurous travelers was in an advanced state of disintegration—colonnades falling down, statues helter-skelter upside down in the weeds and rubble, bas-reliefs cemented randomly into the walls of nearby huts and houses. This is the only possible excuse for the looting of the major sculptures by Lord Elgin between 1799 and 1803. His entire transaction with the Turkish commander of Athens was highly dubious in law and in equity, and removing the marbles directly jeopardized their survival since the vessel carrying them to England was wrecked en route, and nearly sank; Mediterranean piracy was yet another peril. But to leave them as they were in 1800 would also have meant their doom. Needless to say, this isn't an endorsement of Britain's stubborn refusal to return them to the present nation of Greece: if ever there was a case of "We stole them fair and square, and they're ours," this is it. On the other hand, any effort to put them back on the Parthenon itself, exposed to the corrosive smog and flying grit of modern Athens, would be the final deathblow. It's a modern Greek authority who tells us that marbles on the Acropolis have deteriorated more in the last twenty years than in the previous twenty centuries. So the question is simply whether the Elgin marbles should be in a London or an Athens museum. This isn't an unimportant question, but it's political, not aesthetic, and it takes for granted that the Parthenon can never again be even a remote facsimile of what it was.

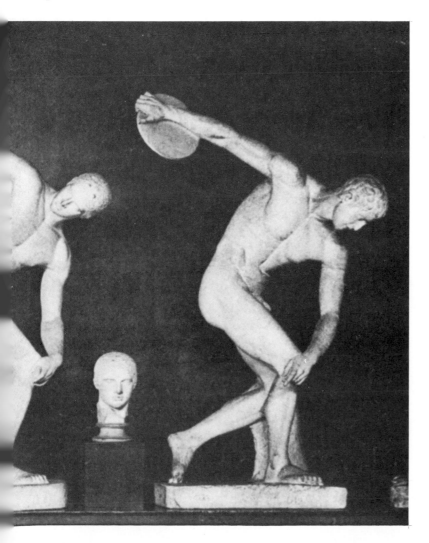

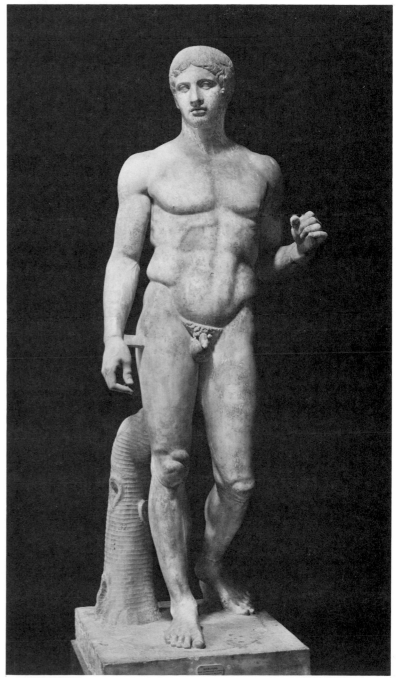

32 *Solid and no doubt athletic as he looks, this statue of a young man carrying a spear (it is a Roman copy of a Greek original and now stands in the National Museum at Naples) has few of the virtues that we think of as characteristically Greek. We have no other trace of the Polyclitus original, but if the Greeks valued his work as highly as they said, it is hard to think that it could have been as nerveless, as placid and unspirited, as this copy.*

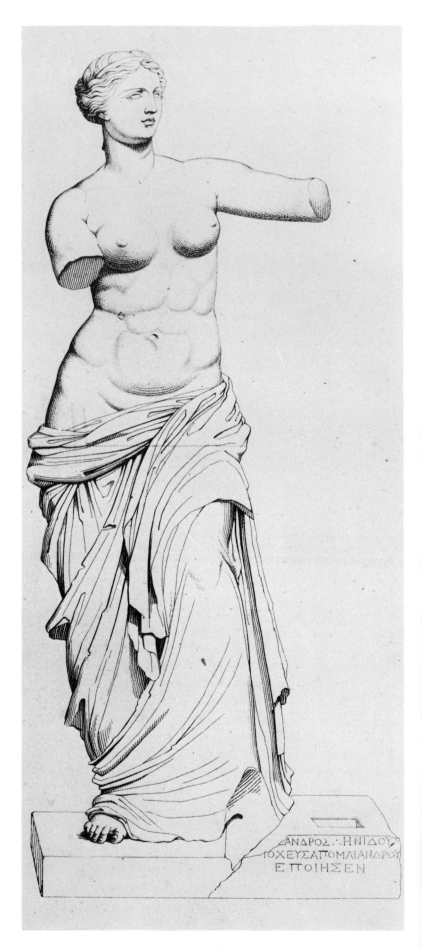

33 *Venus de Milo, drawn by de Bay, showing a much longer left arm than the modern statue can boast, and also a dreadful inscription naming the sculptor. This inscription has since mysteriously disappeared, evidently because it didn't have the right name on it.*

Greek sculpture of the classic age is known to us in much larger part through Roman or Hellenistic copies than in originals; and even when we have an original, it's hard to know whose original it is. We know the names of hundreds of Greek sculptors, but most surviving originals are assigned, frequently in defiance of obvious probabilities, to the six or eight most famous names, since this is what most enhances the status of the works. Still, Greek sculptors, even of lesser rank, were extraordinary artisans, and the inferiority of later copies to earlier originals is almost always plain. One would expect nothing less—though our current notions of what constitutes an "original" sculpture are pretty spotty. Since the days of Giambologna in the sixteenth century, most "original" sculptures have existed in several copies; some, and occasionally all versions are as much the product of a stonecutting shop or a bronze foundry as of the nominal artist, and many more have been made by machine from a plaster model. Roman copies of Greek originals were particularly liable to be debased because they were so often produced in quantity by slave labor for sale at a low price to undiscriminating clients, the rich and vulgar Trimalchios of the age. For reasons of economy, it also appears that many statues originally in bronze were copied in marble; and so vast was the traffic that very likely many of the copies we have are copies of copies. Add to this that most copies reach us in a fragmentary state and are subjected to the erratic approximations of restorers before they are deemed fit to be seen, and we appear to be at a far remove from the original. Myron's famous discus-thrower exists in several copies and fragments of copies, and sometimes we are looking at pieces of several different versions combined into one eclectic version. Indeed, one early reconstructer could not be persuaded that he had to do with a discus-thrower at all. Tilting the entire statue forward, he created a wounded warrior fallen on hand and knees, throwing up his right hand to ward off another blow. This is clearly wrong, but the fact that it was possible shows how little the early reconstructers had to go on.

For a long time the complaint stood against Polyclitus that his figures, such as the well-known spear-bearer, were too stocky and ungraceful; yet reservations were necessary, because the work was known only through Roman copies. In the twentieth century, excavations at Olympia have discovered, not, alas, Polyclitus originals, but the bases of statues inscribed with the name of Polyclitus as sculptor—and from the positioning of the feet on the base, it has been estimated that perhaps Polyclitus originals were not indeed as blockish as the Romans made them appear. To such hopeful speculations and conjectures are the apologists for Greek statuary reduced.

An important part of one major Greek statue is, it appears, permanently and deliberately missing. The Venus de Milo created a vast stir in 1820–1821 when French officials by a dramatic combination of bribery and brute force were able to wrench it away from the Turkish authorities and transport it from Melos to Paris. The British at that point were particularly cocky over their Greek plunder, since they possessed, in the Elgin marbles, work by Phidias; the French were therefore determined that in the Venus de Milo they must possess the work of Praxiteles or someone equally famous. Unhappily, among the miscellaneous marbles shipped to Paris with the statue was a large fragment of the base containing the name of the sculptor: "Alexander son of Menides, originally of Antioch of Meander." That placed the statue five hundred years after Praxiteles—in the first century A.D. instead of the fourth century B.C. Experts therefore decided that this fragment didn't really fit on the base, and to forestall troublesome debate on the point, they took the inscription away and conveniently lost it for good. But a drawing by de Bay shows statue, base, and telltale inscription all together. As for the much-mooted question of the arms, that's now beyond solution. The nineteenth century worried almost continually whether the lady had been holding an apple, a mirror, or an amphora—each object involving a different position for the arms. Almost all records agree that the statue as originally found did indeed have more complete arms than it does now; but, like the sculptor's name, though probably not for the same reasons, the extra pieces remain missing.

The near-total loss of Greek painting is particularly frustrating in view of the fact that so much Roman wall painting survived (at Pompeii and Herculaneum particularly, but also in Egypt), and also because the drawings we have on Greek vases are often so exquisite. Encolpius, the young scoundrel who is the hero of Petronius' *Satyricon* (more or less of the first century A.D.), could walk into a gallery and admire "several pictures" by Zeuxis, Protogenes, and Apelles; alas, not a shred, not a copy of anything by these painters has reached us. Pausanias the traveler, who lived and wrote in the second century A.D., has left us descriptions of certain paintings by Polygnotus at Delphi—descriptions so vivid and precise that certain painters of the late eighteenth and early nineteenth centuries tried their hands at reconstructing the originals. But the vast difference between two efforts to "reconstruct" the same picture shows how much the modern painters were determined by the style of their own times, and how little they owed to the words—admirable as they are—of Pausanias on which their paintings were ostensibly based.

Except in Egypt, where the dry climate preserved things wonderfully, almost all the "software" of antiquity—the wood and paper objects, the textiles, the leatherware—has vanished. Thus, if we don't have the original of a building or a work of art, we're not likely to have a representation of it either, since the representation was most likely made on materials less durable than the original. We can guess at some vanished works of art from schematic images on coins or bas-reliefs. Some Egyptian portraits painted on coffin lids show enough Greek or Roman influence to give us a notion of what might have been common in those countries during the last centuries B.C. But not till the Renaissance do we start to have any realistic drawings of the buildings of antiquity. And because Rome has always been more accessible than Greece, most of these drawings naturally deal with Rome, whose architectural outlines men were anxious to record as soon as they realized how swiftly they were slipping away.

34 *This is an imaginary reconstruction, after a description by Pausanias, of a picture originally by Polygnotus, who lived in the middle of the fifth century* B.C. *The picture, done by Louis le Lorrain in 1761 to illustrate an article by the Comte de Caylus, makes use of all the most approved heroic poses out of Poussin, not to mention some very knowing tricks of linear perspective, and manages to crowd nineteen separate episodes or special groups into a single image.*

As early as the sixteenth century Joachim du Bellay and Edmund Spenser, his English translator, described a kind of demonic energy which seemed to animate the city of Rome in raising new shapes continually out of old ones:

> *Then also mark how Rome, from day to day,*
> *Repairing her decayed fashion,*
> *Renews herself with buildings arch and gay;*
> *That one would judge that the Romane daemon*
> *Doth yet himself with fatal hand enforce*
> *Again on foot to rear her pouldered corse.*

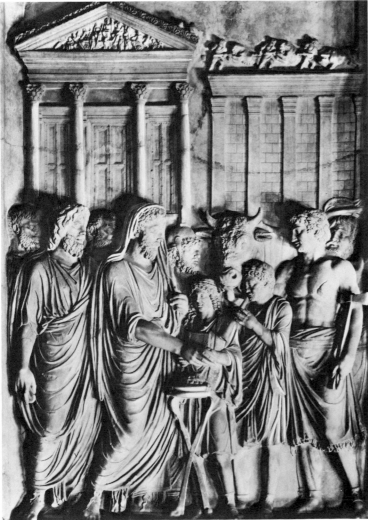

37 *Ancient Rome endured for more than a millennium and a half, so that the buildings from which we form our image of it were generally only the latest of a long series. The great temple of Jupiter on the Roman Capitol stood on the site of a temple allegedly built by Romulus, built anew by the Tarquins, rebuilt after a fire by Sulla, restored by Augustus, rebuilt after another fire by Vespasian, and rebuilt after another fire by Domitian—no fewer than five consecutive temples on the same spot, of which all that survive directly are a few bits of foundation-work and some fragments of the latest version. But this bas-relief of the Augustan age shows the emperor offering a sacrifice in front of a temple which has been identified as that of Jupiter Capitolinus—and that takes us back at least two temples before the final one.*

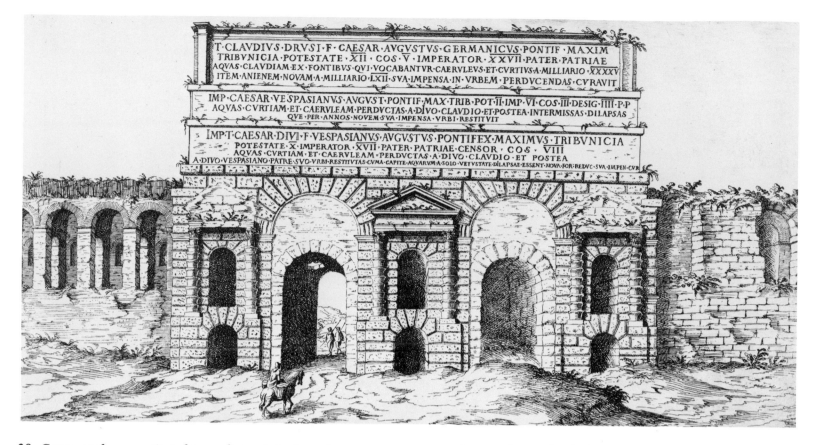

T·CLAVDIVS·DRVSI·F·CAESAR·AVGVSTVS·GERMANICVS·PONTIF·MAXIM
TRIBVNICIA·POTESTATE·XII·COS·V·IMPERATOR·XXVII·PATER·PATRIAE
AQVAS·CLAVDIAM·EX·FONTIBVS·QVI·VOCABANTVR·CAERVLEVS·ET·CVRTIVS·A·MILLIARIO·XXXXV
ITEM·ANIENEM·NOVAM·A·MILLIARIO·LXII·SVA·IMPENSA·IN·VRBEM·PERDVCENDAS·CVRAVIT

IMP·CAESAR·VESPASIANVS·AVGVST·PONTIF·MAX·TRIB·POT·II·IMP·VI·COS·III·DESIG·IIII·P·P
AQVAS·CVRTIAM·ET·CAERVLEAM·PERDVCTAS·A·DIVO·CLAVDIO·ET·POSTEA·INTERMISSAS·DILAPSAS
QVE·PER·ANNOS·NOVEM·SVA·IMPENSA·VRBI·RESTITVIT

IMP·T·CAESAR·DIVI·F·VESPASIANVS·AVGVSTVS·PONTIFEX·MAXIMVS·TRIBVNICIA
POTESTATE·X·IMPERATOR·XVII·PATER·PATRIAE·CENSOR·COS·VIII
AQVAS·CVRTIAM·ET·CAERVLEAM·PERDVCTAS·A·DIVO·CLAVDIO·ET·POSTEA
A·DIVO·VESPASIANO·PATRE·SVO·VRBI·RESTITVTAS·CVMA·CAPITE·AQVARVM·A·SOLO·VETVSTATE·DILAPSAE·ESSENT·NOVA·FOR·REDVC·SVA·IMPEN·CVR

38 *Gates, as they constituted immediate obstacles to important traffic, were particularly subject to abrupt destruction, but the citizens of Rome were proud of the walls that had protected their city from Huns and Goths; fully half of the gates survive. The Porta Praenestina-Labicana, however, succumbed, not to the pressures of traffic, but to antiquarian curiosity. It stood directly in front of an arch of the Claudian aqueduct, and contained in its central tower the tomb of a late Republican worthy, Virgilius Eurysaces. Though the gate dated back to the early fifth century A.D., when the consul Honorius was building up the city's defenses against Attila, Pope Gregory XIV wanted to see what lay behind or within it, and so had it demolished in 1838. Our representation was made by Etienne Du Pérac in 1621.*

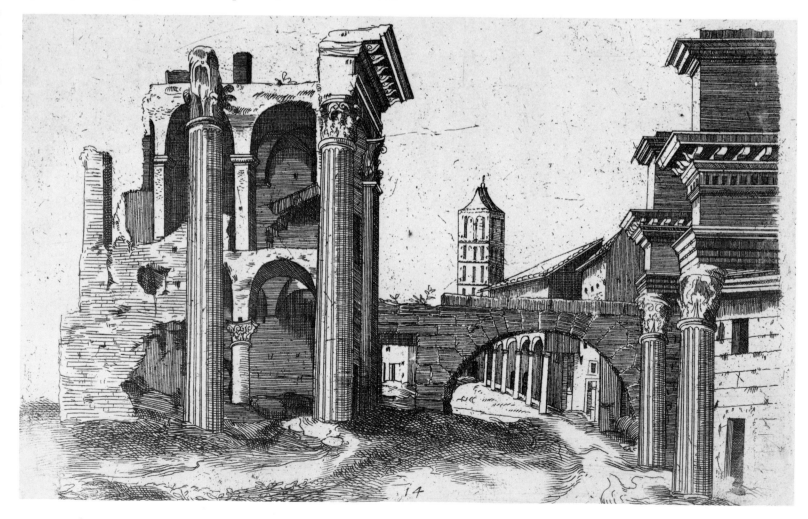

Within the illustration: Q·IN·BOVARIO / P·P· S·P·Q·R· / PRO·PAGATVM / IMP·COS·XII

DAFVSO AFVSO BV·⅓

40 *Giuliano da San Gallo's drawing of the remains of the Basilica Pauli near the Roman Forum.*

◄ 39 *Of all the Roman forums, the one erected in honor of Trajan was the largest and most spectacular; it is also the one that has been most diminished by the pressures of modern Rome, till today it amounts to little more than an acre or so of land surrounding the still-standing Column of Trajan. (Sixtus V is responsible for the paltry statue of Saint Peter that rests atop it.)*

But most of the magnificent temples, peristyles, basilicas, and the splendid Arch of Trajan which were designed as a unit by Apollodorus of Damascus, the greatest architect of his time, have been swallowed up by the city. An engraving by Giovanni Antonio Dosio (1569) shows the forum with many of its structures still struggling against the rising tide.

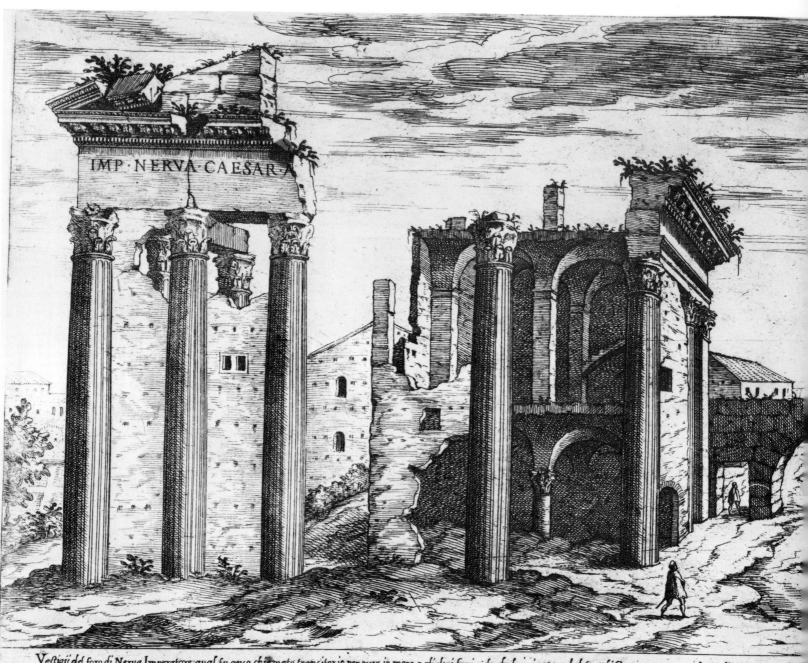

IMP·NERVA·CAESAR·A

Vestigij del foro di Nerua Imperatore, qual fu anco chiamato transitorio per esser in mezo a glialtri fori, e che da lui si poteua dal foro di Cesare passare nel foro d'Augusto et nel F statue d'homini Illustri, oggidi non si uede uestigij di foro in Roma piu intiero di esso, questi similli edificij seruiuano per negotiatori de litte ouer di merchanti et anco per piazze da u

41 *How lonely and empty these Renaissance drawings of classical ruins appear! Chickens scratch for food in the sloppy streets, a few isolated pedestrians pick their way through the muddle of fallen masonry and half-buried columns. Yet the terrain here represented now roars and rumbles with the thunder of downtown Roman traffic. The forum for which Nerva took credit (though much of it had been built by his predecessors) was once resplendent with colossal bronze statues of the deified emperors, and so thronged with Roman crowds that it was nicknamed the "Forum Transitorium." A particularly splendid feature of the forum was the temple of Minerva; Du Pérac's drawing shows us that in his day (1575), a good deal of it was still left, and no doubt more could have been patched up from pieces lying around or buried underground. But thirty years later, Pope Paul V fell on it in search of cheap marble and demolished it utterly.*

cessor of the present structure), snatched away the rest. These were the major depredations of which we hear. But what potent and determined forces tore apart and carried off the massive masonry of the temple, its enormous walls and heavy columns? Only a few fragments and a few low-lying foundations survive, some of which date back to the very first temple of 500 B.C. The sheer bulk of what is lost puzzles us. Fire does not feed on marble; weather does not demolish giant blocks; and when Rome was a village of no more than ten thousand inhabitants, as it mostly was during the Middle Ages, the citizens had no apparent reason to tackle such a gigantic engineering job as the demolition of a structure like the temple of Jupiter. One fatal circumstance, however, there was; marble is a variety of limestone, and being burned yields cement. The same stone that the Romans had used to build their temples was available at the same quarries from which they got it; but to save transportation costs, the cement-makers set up their kilns amid the ancient temples of Rome, and for hundreds of years slowly chipped away till the temple of Jupiter Capitolinus, the Circus Maximus, and hundreds of other structures—

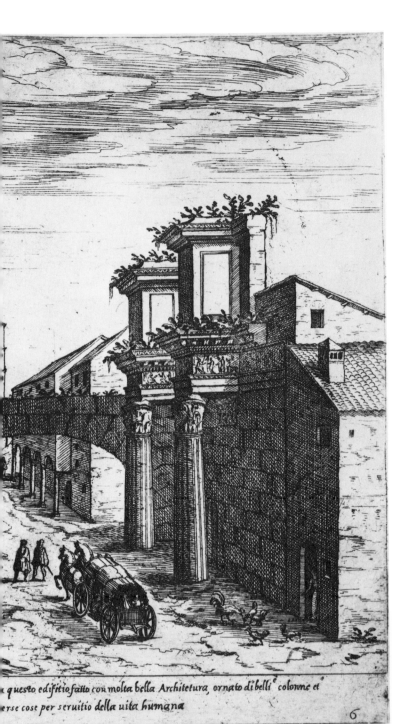

questo edifitio fatto con molta bella Architetura, ornato di belli colonne et verse cose per seruitio della uita humana

6

among them, the most beautiful and interesting in the Western world—were down to their bare foundations. Yet a relative handful survived long enough to be recorded.

The Basilica of Paul was built in the Forum as the Basilica of Aemilia and Fulvia; Pliny described it as one of the three most beautiful buildings in the world. It was already three hundred years old when it acquired as a next-door neighbor the temple of Antoninus Pius and Faustina. This newcomer had the good fortune to be converted, during the Middle Ages, to the church of San Lorenzo in Miranda, and has therefore come down to us relatively undamaged. Meanwhile, the Basilica of Paul, renowned in antiquity for its columns of Phrygian marble, was slowly picked away, but so slowly that a sizable though battered fragment survived into the sixteenth century to be drawn by Giuliano da San Gallo before disappearing for good. The temple of Minerva in the Forum of Nerva stood at least in part till the early seventeenth century, when Pope Paul V tore it to bits in order to restore an ancient aqueduct which would have the advantage of bearing his name (Acqua Paolina) in preference to those of Augustus

and Trajan, who originally built it. But the temple of Minerva is signaled to us, if only faintly, by the sixteenth-century book of Etienne Du Pérac, *Vestigii di Roma,* and by an anonymous fifteenth-century drawing now in the Spanish Escorial.

A more famous example is the grandiose Septizonium of Septimius Severus, erected on the Palatine Hill by that emperor as part of his palace, but also a kind of heraldic gateway for travelers approaching along the Via Appia from the south. Severus himself came from North Africa (his native tongue was Punic, not Latin), and he put up the Septizonium where it would be the first and most impressive thing his countrymen would see when they came up to the Capitol. (In addition to "Septimius" the odd name may refer to the seven parts [zones] of the structure or, as Septizodium, to the seven planets.) Indeed, it was so grandiose, with its several tiers of columns and wide basins of water, that though it had been mined for hundreds of years, a good-sized fragment still remained to be recorded by Maarten van Heemskerck and Antoine Lafreri before Sixtus V, busy building the cupola atop Saint Peter's, laid violent hands on it and razed it to the foundations. Those foundations still remain, to be measured and studied; but without the Renaissance artist and his sketchbook, we would not know what stood atop them.

Of the thirty-four triumphal arches within the city of Rome, which have now dwindled to three (but on the hopeful side we really have four, since the Arch of Constantine incorporates a lot of material from the long-destroyed Arch of Trajan), quite a number lasted long enough to be recorded by Renaissance artists. For example, the Arch of Claudius stood across the modern Corso till the middle of the sixteenth century, and a little north of modern Piazza Colonna stood a structure popularly known as the Arco di Portogallo, which was not torn down till 1665. The Arch of Titus, on the other hand, is a great deal more impressive now than it was two hundred years ago. During the Middle Ages it was incorporated into a fortress set up by the Frangipani family and crowded into a narrow ghetto street, where its appearance was anything but triumphant. Cleared as it has been of its constricting neighbors, and provided with much new decoration, it contributes importantly to the monumental center of Rome, but it is about one-third original materials; the rest is nineteenth-century restoration stuff.

The extent to which Renaissance Rome was built of materials cannibalized from the ruins of ancient Rome is literally incalculable. A very rough estimate by the city historian Lanciani would have it that eight thousand ancient columns are to be found in Renaissance buildings; and the amount of precut stone that was simply picked up and adapted with minimal effort to a new function cannot even be estimated. Old coins show the Colosseum with all its walls standing; as they fell, or were encouraged to fall, the fallen rubble was quarried for paving or building stones, or simply for fill. Even today, as Antonio Cederna has documented in his indignant volume *I vandali in casa,* owners of little villas along the Via Appia Antica are absolutely unscrupulous in mining the ground of any objects that can be found in it, without the least concern for their archaeological or artistic value—except, of course, so far as that can be measured in cold cash. What they can sell they sell, what they can't sell they plaster into a wall or use as rubble to make a driveway or a garage floor.

53

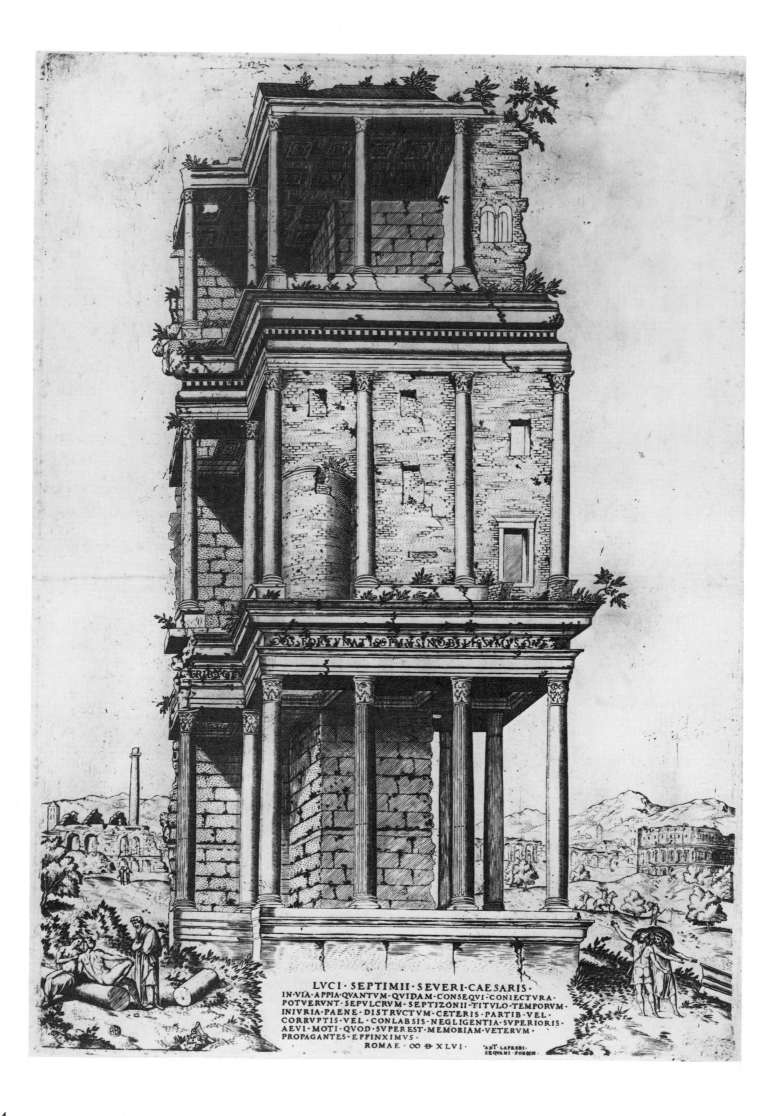

LVCI · SEPTIMII · SEVERI · CAESARIS ·
IN · VIA · APPIA · QVANTVM · QVIDAM · CONSEQVI · CONIECTVRA ·
POTVERVNT · SEPVLCRVM · SEPTIZONII · TITVLO · TEMPORVM ·
INIVRIA · PAENE · DISTRVCTVM · CETERIS · PARTIB · VEL ·
CORRVPTIS · VEL · CONLABSIS · NEGLIGENTIA · SVPERIORIS ·
AEVI · MOTI · QVOD · SVPER EST · MEMORIAM · VETERVM ·
PROPAGANTES · EFFINXIMVS ·
ROMAE · ƆƆ Ɔ XLVI ANT. LAFRERI.
 SEQVANI FORMIS.

54

42 Antoine Lafreri saw the Septizonium in 1546, only a little more than a decade after Heemskerck (plate 6); but, as the title of his book indicates, he saw it with different eyes: Speculum Romanae Magnificentiae, *The Mirror of Roman Magnificence. He brings out the magnificence of the last tattered remnants of the Septizonium as Piranesi would have done had he lived in the sixteenth century instead of the eighteenth. Heavy shadows, strong masses of masonry, and puny human figures contrasting with the structure's mighty dimensions all play up what Lafreri emphasizes in his inscription—the might of the ancients, the weakness and negligence of the moderns.*

43 The Arco di Portogallo which stood across Via Corso in the heart of downtown Rome got its odd name from the fact that the Portuguese ambassador lived for many years in the neighborhood. Actually, the arch was a patchwork of materials from the third and fourth centuries, less interesting as a work of art than as an historical curiosity. The Middle Ages knew it under a variety of odd and inaccurate titles, as the Arch of Tripolis or of Marcus Aurelius; and it was treated with respect till the advisers of Pope Alexander VII persuaded the pontiff that it wasn't a triumphal arch at all, and thus were able, half surreptitiously, to have it torn down. Our drawing was made in the latter half of the sixteenth century by Pirro Ligorio, famous as an antiquarian and a forger of antique inscriptions.

Partly because the old cities have been largely picked clean, partly because modern taste leans more to the archaic periods, the heavy looting nowadays goes on in the area of Etruscan tombs. How much is destroyed in this landslide of tomb-robbing, which the Italian government is wholly unable to control, is hard to know. The grave-robber has to have something salable, and with such a commodity he may be careful; but his temptation is to take things apart and dispose of them piecemeal, in souvenir-sized bits. He has no use for anything that isn't easily portable, and if he can't sell it, he doesn't want anything to do with it. Grab and run is his formula, and he will get into trouble by departing from it. This is deplorable, and it would certainly be better if all exploration of ancient monuments were carried out by disinterested scholars, acting with a scrupulous, exclusive regard for truth. But in the real world, where money is to be made from antiquities, and peasants desperately need money, slapdash piracy seems likely to prevail for the foreseeable future. One often feels that the past had better not be uncovered at all, rather than be torn apart and fought over by the vultures of the black market. And it isn't the black market *per se* that's at fault. Perfectly respectable archaeological triumphs are sometimes aesthetic disasters. An ancient city, dug out of the earth and exposed to the bare light of day, may amount to a bleak pile of barren stones, not very different (to the unprofessional eye) from other bleak piles of stone. But the old Forum in Rome, like the overgrown Baths of Caracalla, was a pastoral landscape of unique charm; and botanical volumes were written on the flora to be found within the charmed ring of the Colosseum.

That we have no visual record of the great temple in Jerusalem, destroyed by the soldiery of Titus in 70 A.D., is a matter of real regret, because it might have been represented realistically enough to give us an impression of what it looked like. But many of the great cities and structures of antiquity which have left no image behind could only have been represented in stylized and schematic form, because the conventions of the time allowed for nothing else. Tyre and Nineveh, Babylon and Samarkand, whatever they were in themselves, and however they might have been represented by the camera's glassy eye, would not have been seen or drawn by a contemporary artist in the kind of inclusive perspective, with the kind of proportioned detail, that for us constitutes "realism." By the standards of sixteenth-century cartography the map of Mexico City published to accompany Cortes' first accounts of his conquest was not a bad map; but it gives no idea at all of the various masses and profiles that must have met his wondering eye as he first entered the lake-island-city-fortress-temple of Tenochtitlán. Seeing is (for worse as well as better) much more than a physical process. What ancient men *saw* when they looked at a ziggurat, the magic pyramid of the Middle East, we should not really know even if we had a perfectly preserved ziggurat in front of us.

44 *Like many other medieval towns, medieval Rome was divided into districts controlled from their central palace-forts by members of warring families or clans. In the course of building the wall around their enclave, the Frangipani family took over the Arch of Titus, squeezing it into a line of masonry that encroached on its original dimensions but also helped to support it. From this wall it was chipped out only in the early nineteenth century—in a rather bad state of repair, as our picture shows. (But Giuseppe Valadier, the busy restorer and modernizer of the city for Pius II, tacked so much new material on it that J.-J. Ampere [philologist and son of the electrician] refused to walk under it—from pure resentment of the architect, he said, citing the Jews who for a thousand years had refused to walk under it because it celebrated the destruction of the Temple.) Piranesi did a typically grandiloquent view of the arch while it was still imbedded in the Frangipani wall (it is number 55 in Hind's catalogue of Piranesi prints).* ▶

Most Roman cities, it's been suggested, would look to us more like shapeless Oriental bazaars than like planned and ordered cities. They weren't usually thought of as planned or unified forms, and we would be unlikely to learn very much from the efforts of early artists to depict them. Indeed, it was a complex and difficult process by which men learned to order and arrange on a piece of paper something as large and intricate as an urban complex. The fourteenth-century drawing of Rome in the *World History* of Paulinus the Minorite shows most of the buildings lying on their sides or standing on their roofs. Where he needed something to fill up an empty space, the artist included a wholly improbable hunting scene; and because his imagination would not stretch to include a building without a roof, he put a dome over the Colosseum. His proportions were controlled by the significance he attributed to things, not by their actual dimensions; the statue of Marcus Aurelius and the colossal head and hand that lay beside it are represented larger than many houses. All this suggests that though we've lost all manner of interesting and beautiful things in the ruins of Nineveh and Babylon, it's anachronistic to suggest that they could really have been represented to us by those who saw them in their prime.

Among the lost early civilizations, perhaps the most extraordinary and fascinating is that of the Mayan peoples in Central America. How and why their splendid and terribly top-heavy culture vanished into the jungles of Yucatán and Guatemala we do not know; we can only estimate their extinction at about 900 A.D.—six hundred years, in other words, before Cortes imposed himself on their Aztec successors. For close to a thousand years the remnants of their temple-cities lay buried under mounds of impenetrable vegetation; they were first uncovered in the mid-nineteenth century and are known to us today partly through ruins and partly through reconstructions. But reconstruction of Maya buildings is likely to be pretty accurate, partly because the structures were often solid masonry, and so did not collapse, and partly because the jungle kept out, until recently, common looters and scavengers.

Mayan structures are particularly interesting because their buildings functioned so very differently from our own. They were built on a gigantic scale, but for use over a relatively short period of time; their uses were ceremonial and ritual, not in any immediate sense of the word practical. The notion of shelter, so important to the medieval artist that his imagination drew a roof on the Colosseum where no roof was, never concerned the Mayan builder. As his structures were largely solid, with no interior spaces, his main interest lay in the areas between them, where pageants and sacrifices could be organized. His buildings were almost oppressive in their weight and uniformity, to the effect, if not with the purpose, of making overwhelmingly evident the authority of the priestly caste. Indeed, it would seem that these gigantic complexes were commonly abandoned after the death of some particularly important hierophant, as if he had been the reason for their being, and without him the whole enterprise must be forgotten. Such a procedure suggests incredible prodigality on the part of the priestly caste with the lives and energies of the peons, who lived, it would seem, in the simplest of huts on the sparsest of diets, at the foot of the monumental buildings to which many of them must have devoted their miserable lives.

57

45 *This map was first published in Vienna in 1574 to accompany Cortes' account of his conquest of Mexico, originally written as a letter to the Emperor Charles V. The woodcut-engraver gathered that it was a town in the center of a lake. But for the rest he seems to have used the conventional Renaissance shorthand for city—some gates and towers, some lines of houses.*

46 *The oldest medieval map of Rome looks at the city from directly above. The Colosseum is at the center of the long aqueduct; just off to the right are the giant horse, head, and hand which were famous (though little-understood) "sights" of the ancient city. Castel Sant' Angelo is just beneath the hunting scene on the left, at about eight o'clock; and careful study will reveal other familiar structures. It is helpful to know that the top of this map is the east, and that consequently, to make comparisons with a modern map, one must lay the medieval view on its right side.* ►

59

47 *The murals discovered in the depths of a hideous jungle at Bonampak, Yucatán, in 1946 provided the first concrete evidence that the ancient Mayas were masters of this art. But the building containing these monuments of barbaric magnificence was hidden under masses of vegetation, so the first explorers never even saw it; and the murals themselves were largely covered by calcium deposits. This thick covering of limestone could be rendered only momentarily transparent by drenching it in kerosene; after the kerosene dried, the stony shield was as opaque as ever. The murals were photographed and copied by a painter, Antonio Tejeda F., of Guatemala City, and it is from the copies that they are now known.*

That the Mayan culture was never recorded by an outside observer need not surprise us; there were few tourists in Central America around the year 900. What is a matter for deeper regret is that neither Cortes when he captured Mexico nor Pizarro when he conquered the Inca empire showed any interest in recording or preserving the civilizations he had seized. Worse, they destroyed to the best of their ability such records and indigenous arts as they found existing in the land. Not a single pre-conquest manuscript survives from Mexico City, where there were once many libraries; all the Mexican codices we have are from the Mixtec and other provincial cultures, where the Spanish influence was not so oppressive as in the capital. And even the conquerors, though they wrote lavish descriptions of their adventures, never put much effort into representing the works and ways of the conquered peoples.

In fact, it seems to be much easier to write about an exotic culture than to portray it visually. Marco Polo on his travels through the Orient retained magnificent verbal memories of the great cities he had seen, as well as of some outlandish creatures that he hadn't. His description of Hangchow, which he knew as Kinsai, could not be more appreciative, or more vivid, but he did not represent visually and perhaps could not have represented even one of the wonders that clung so strongly to

his verbal memory. One would anticipate just the opposite—that what reaches the eye directly would be more easily and accurately reproduced than what must pass through the mediation of language. But it is not so, as we learn from, among other things, repeated efforts by early artists to represent camels or elephants. And so, by equal logic, with alien cultures; in dreaming of accurate representations by early travelers or first conquerors, we are dreaming of what certainly is not and probably could never have been.

No, our real losses lie closer to hand. There were men in fourth- or fifth-century Byzantium who could have represented for us the wonders of that city as it existed under Constantine. The great basilica housing a group of Muses from Helicon, the statue of Zeus from Dodona, that of Pallas from Lindos, the vast figure of Apollo set atop a porphyry column and radiating seven beams of light from his head—we hear of these, as of the equestrian statue of Constantine himself in the Strategion, and of still other artistic treasures.* Of a few we even possess what can be surmised to be broken fragments. But no man thought to go through the city, a building or a statue at a time, and draw what was before his eyes, so that after the sieges and lootings there should be some memory among men of what had been. It is these objects, not of remote

48 *This is the picture of "Temple B" along the Rio Becque in Campeche on the Yucatán Peninsula. Raymond Merwin took the photograph in 1912 on an expedition he made with Clarence Hay under the auspices of the Peabody Museum of Archaeology in Cambridge, Massachusetts. But after the 1912 expedition the temple was lost in the dense jungle for sixty-one years until a team under the direction of Gillett Griffith, using the 1912 photographs to obtain positive identification, and as guides the local chicleros (gatherers of chicle for the chewing-gum industry), managed to rediscover it.*

and exotic curiosity, but of intimate consequence to our own Western culture, the total disappearance of which we most bitterly regret. And since the magnificent mosaics of the Great Palace have been uncovered, and dated sometime in the sixth century, it is no idle speculation that men of that age could still draw with verve and total accuracy.

* For the obliteration of Byzantium, a measure of cold comfort is available in that losses during the Turkish conquest of 1453 would have been infinitely greater if the Fourth Crusaders in their Christian charity had not, in 1204, already pillaged, vandalized, and incinerated the city so thoroughly that Nicetas Acominatus wrote a separate volume exclusively on the statues they destroyed.

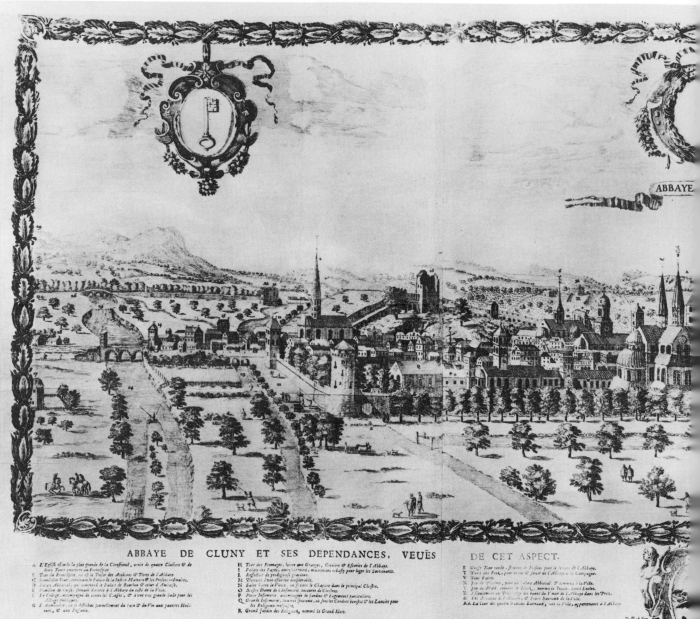

ABBAYE DE CLUNY ET SES DEPENDANCES, VEUËS DE CET ASPECT.

ABBAYE

DEDIE

Par son tres-humble, tres-obeïssant,

2/THE MIDDLE AGES

Men enter monasteries to escape the wicked world, but they are not long in creating for themselves another world within the walls; and whether or not it's as wicked as the one they left, it has a tendency to be—or become—more beautiful. Even monks who live spare and drudge long must have time to praise the Lord for whose sake they have renounced the flesh; and to praise Him, they resort to song, to verse, to art. The very vessels of the monastery, its plates, its chairs, its doors, and its gardens, must speak His praise. If the brothers as they sit in the refectory are to raise their minds above the cabbage in their dishes, they need an image of the Last Supper before them—thus the appetites of the flesh are countered with an appeal to the senses. Saint Bernard, even as he thunders against the illuminations of a Cluniac manuscript, betrays the sharp, appreciative eye of a meticulous aesthete—as if such an eye were not already implicit in the symphonic austerity of the Cistercian monastery, wherever found.

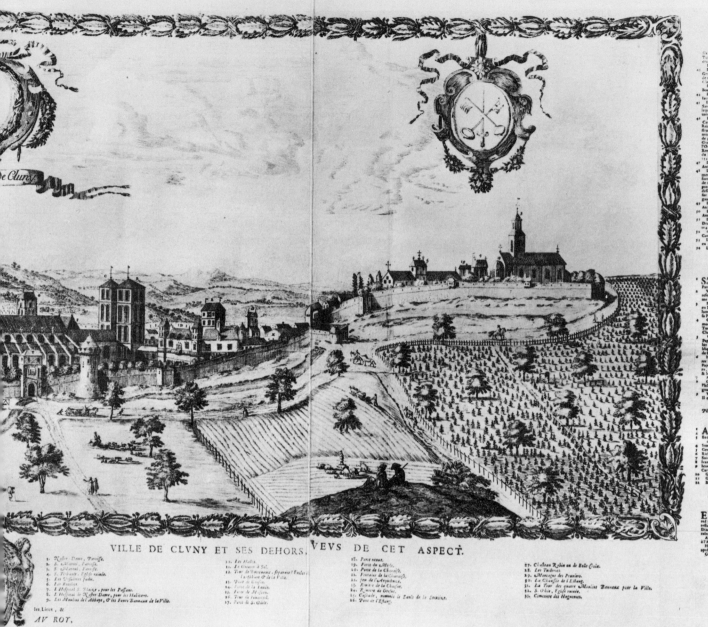

REMARQUES
CONCERNANT
LABBAYE DE CLUNY.

VILLE DE CLVNY ET SES DEHORS, VEVS DE CET ASPECT.

AV ROY,

49 *The abbey church of Cluny is portrayed here by Louis Prévost, a native of the town. The fifty-fourth abbot, the last whom he mentions, is Cardinal d'Este, who was abbot from May 30, 1668, to September 30, 1672. Prévost's engraving is obviously a labor of love, a capsule history of the monastery and the notables associated with it.*

Fifteen thousand Benedictine monasteries, it is said, had been established by the time of the Council of Constance in 1415. Evidently they answered a profound need of the Middle Ages; they also carried the seeds of their own destruction. However rigid the brothers might be in their personal austerity, they could not prevent land from being given to the abbey or monastery for pious uses—generally for masses to be said toward the repose of the donor's soul. And land in great quantities, however lofty the purpose to which it was devoted, couldn't help breeding jealousy of the organization holding it. Even the most nostalgic of us moderns might not like it if a quarter of the best national real estate were permanently held by ecclesiastical groups (something would be found in the antitrust laws). Still, the breakup of the abbeys and monasteries across Europe was accomplished almost everywhere in a particularly violent and indiscriminate manner, as if the work of an entire civilization had somehow been contaminated by the

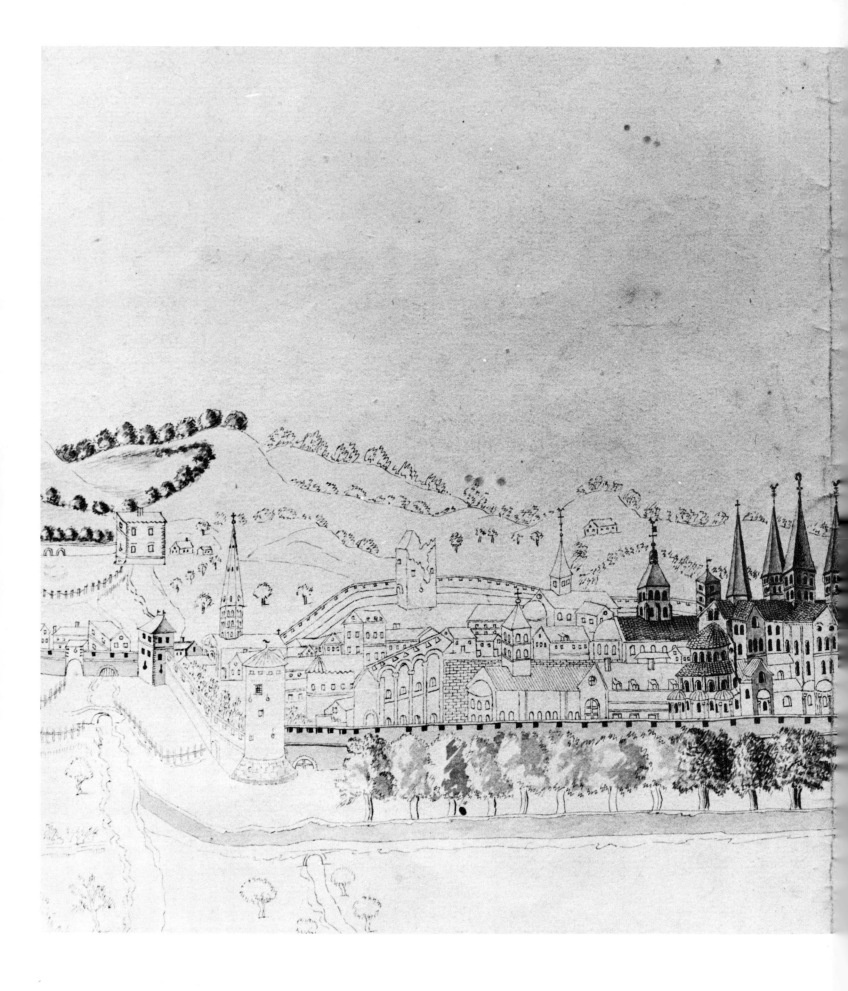

50 *This anonymous and obviously incomplete drawing of Cluny was made about the middle of the eighteenth century, a few years before the fatal assaults made on the monastery in the course of the Revolution. The large, partially demolished structure in the rear wall is the infirmary, but the greater part of the wall and the central complex of towers, steeples, chapels, and churches are as yet undamaged in this view.*

wrongs of that civilization, so that no merit at all could be recognized in it. Yet on the whole it wasn't the oppressed workers and injured peasants who wreaked vengeance on the monasteries so much as it was the ideologists and the profiteers. Sans-culottes don't as a rule go out of their way to smash art, because they hardly recognize it; their chief interest is loot, and in portable, instantly convertible form. So far as art is or contains loot, it is then in danger, but not on its own account. Ideologists have more limited targets, but they are more ruthless in seeking them out and destroying them. And nobody is more brutal and impatient, more omnivorous in his appetite for appropriation, than the man who sees a chance for a profit.

Of the thousands of pictures to be shown and stories to be told of church-spoliation, we can show and tell only a few, but they are crowded with episode. Once deprived of secular power and protection, the great monasteries of the medieval West were like *grandes dames* on pilgrimage—pampered, decorated, adorned (sometimes only with their superb chastity), and wholly unprepared for a hostile world. They had to encounter not only dragons who wanted to eat them and sometimes did so, not only paynims who wanted to slay them and sometimes did so, but rash and egotistical heroes who wanted to gussy them up against their own natures into romantic neo-Gothic actresses. The casualties far outnumber the survivors. From the early days of their foundation, monasteries, in addition to their basic concern for contemplation, served various practical functions. Some were fortresses, some schools, some embryonic cities, some workshops, others effectually private clubs for the aristocracy, with admission confined to those who could prove a certain number of quarterings. Still others, in England particularly, were episcopal residences. These extra functions often determined the fates of the complexes; and even when the central monastic headquarters broke up, the names of the orders were often preserved in subordinate houses. For example, the Musée de Cluny now occupies the structure which used to house members of the Cluniac order when they came to Paris on business—it was the town house, so to speak, of the order.

The monastery of Cluny, a little north and west of Mâcon in east-central France, was founded by abbot Berno in the year 910 through a grant of William I the Pious, Count of Auvergne and Duke of Aquitaine. Cluny is in the northern reaches of the Jura mountains, near that immemorial boundary line and power vacuum where Latin France confronts the Teuton world. At first there was little to distinguish Cluny from thousands of other Benedictine monasteries springing up across Europe. Its founder shared the dream of every other monastic founder since Benedict himself—to escape the corruption and laxity of earlier institutions, and to worship God in severe fraternal unity with like-minded brothers. Cluny enjoyed, in its origins, no special favor from authorities either civil or ecclesiastical; it was not on any of the grand pilgrimage routes, and displayed no visible signs of preeminence. But for some reason it attracted a series of extraordinary men to be its rulers. They were the true treasures of Cluny, an unbroken succession of worthy, even distinguished, abbots, who over a period of two hundred and fifty years guided the monastery to a position of enormous wealth, security, and prestige. They were practical men, with shrewd business instincts and acute political insights; they dealt skilfully between kings and popes,

dukes, barons, and emperors; they also valued a career at Cluny above all other distinctions. Sons for the most part of the local nobility, they enjoyed all the cultural values of their day. They collected manuscripts for the monastic library, they built magnificently both in the monastic complex itself and in the town that grew up around it. And they organized the life of their own community, and of the thousands of satellite communities that came to be annexed to it, into one of the most successful economic complexes of the Middle Ages.

> *Partout ou le vent vente*
> *L'abbé de Cluny a rente—*

so ran the old song:

> *Wherever the wind went,*
> *The abbot of Cluny had a rent.*

Their business acumen and enterprise made them famous; the monks of Cluny have been suggested as prototypes of the kind of frugal communist capitalist enterprise celebrated in Sir Thomas More's *Utopia*. But, like More, they also had a spiritual, even saintly, side. Of the seven great abbots, four were canonized; and one (Odilo) was so modest of demeanor, so steadfast in keeping his downcast eyes fixed on the floor, that the other monks nicknamed him "fossarius," the ditchdigger.

Though they are peripheral, the questions of what Cluny amounted to spiritually and economically are not altogether irrelevant to the question of what it amounted to artistically and culturally. No one looks into the history of the order without sensing that its extraordinary record of material prosperity and social authority casts a shadow over its spiritual character. The tradition at Cluny was certainly authoritarian and elitist; the style of doing things, grandiose. In spite of occasional complaints to this effect, it does not appear that the rule was particularly lax in granting the monks leisure, or in yielding to the promptings of the flesh. To be sure, intellectual work seems to have been emphasized at the expense of heavy physical labor; and the liturgy at Cluny was particularly long and elaborate. But Cluny was no Rabelaisian Abbey of Thélème, where "Do As Thou Wilt" was the rule; it was a severe and sober discipline, sustained over centuries, which caused the Cluniac empire to grow, and the abbey, as its apex, to become such an immense work of art.

How widespread was the Cluny network? Round numbers are not hard to come by, though they are not easy to crack into specifics. Six thousand benefices, according to one report, and two thousand separate religious houses were controlled by the abbot of the central monastery. But when one seeks concrete evidence of the Cluny connection in this or that religious establishment, it often turns up scant or ambiguous. All that is definite is that the abbey was very rich and very powerful, that its connections reached out through a great variety of subordinate organizations, as well as upward into the councils of state, the college of cardinals, and the papacy itself. But we should know far more of the Cluny regime and Cluny practices if the great library of the central monastery had not been destroyed in the late eighteenth century, along with the greater part of the monastery itself, by storms of religious dissent, social passion, and unbridled avarice.

What a structure it was! Before the building of Saint Peter's at Rome, the abbey church at Cluny was the largest in

51 *J. B. l'Allemand, while preparing an illustrated tour of France, made this drawing of the interior of Cluny in 1787. It not only suggests the giant proportions of the structure and gives us some notion of its style (as much Romanesque as Gothic), but*

grants us, in the remote ceiling of the apse, a glimpse of the fa-
mous mural of God the Father which was one of the church's no-
table ornaments.

CELEBRIS ABBATIÆ S BENIGNI DIVIONENSIS
Topographia

all Christendom. At 656 feet long and 130 feet wide, with a double pair of transepts and a narthex big enough to be a separate church in itself, it was of a plain but noble Romanesque, with a vast fresco of Christ in Majesty that brooded over the apse. And its furnishings were in proportion: we hear in the pages of Saint Bernard's "Apology" to William, abbot of Saint Thierry—pages still quivering with indignation—of the great corona, a jeweled wheel which hung from the vaulting of the nave, lit with 120 lamps, and of the seven-branched candelabra that stood eighteen feet high. The buildings around the church amounted to little less than a small city. In 1245 the tale is told that four hundred monks were in residence when a party of visitors came calling. They consisted of Pope Innocent IV, accompanied by twelve cardinals, a patriarch, three archbishops, the two generals of the Carthusian and Cistercian orders, King Louis IX (Saint Louis) with three of his sons, the Queen Mother, Baldwin Count of Flanders and Emperor of Romania, and the Duke of Burgundy with six of his attendant lords. The entire company, with all their attendants, whose number must be left to fantasy, were lodged within the monastery, each man according to his condition, without disturbing any of the regular monks quartered there.

But the height of Cluny's splendor was not long sustained. As early as the fourteenth and fifteenth centuries, the number of monks began dwindling, their discipline was impaired by faction fights, and their power began to shrink. Dur-

52 *The* Turin Book of Hours *was a beautiful illuminated manuscript, several pages of which were considered crucially important to art history because they might have been worked on by Jan van Eyck, and if so would conceivably have constituted an early vehicle of that master's influence on his Italian contemporaries. Whether this is so or not, the delicacy and detail of pages like the one we reproduce are beyond question. The manuscript was destroyed in a fire at the Turin library in 1904, but by good fortune it had been carefully photographed in its entirety just two years before.*

53 *This eighteenth-century engraving, made before the commercial encroachments of the nineteenth century, shows with eighteenth-century precision the monastery of Saint Bénigne at Dijon. What survives of this complex nowadays is simply* **A** *the church and* **D** *the dormitory, which now is an archaeological museum. What is particularly to be regretted is* **B,** *the very ancient church popularly known as the Rotunda. Like the crypt of the main church (where diggers in 1858 discovered the sarcophagus of Saint Bénigne himself, martyred by a process that seems to have included dismemberment of the fingers), this little round chapel likely went back to the ninth or tenth century. The present rather blunt and truncated cathedral has been in process of assemblage since the thirteenth century, with the spire and part of the facade dating from the eighteenth century.*

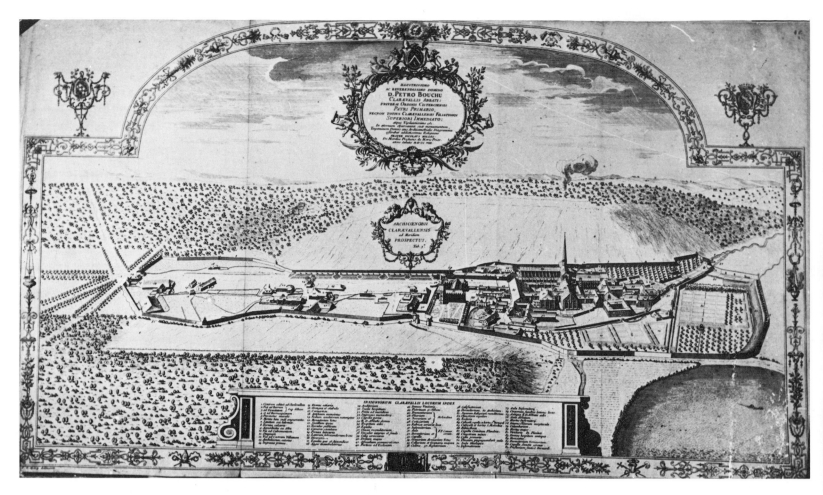

54 *Clairvaux, the abbey as it looked in the eighteenth century. From an engraving of 1708 by C. Lucas.*

55 *Where severely utilitarian columns now stand, the portals of Saint Denis used to be decorated with portrait statues (probably more typical than individualized) of the Merovingian kings and queens. During the French Revolution they were all ripped out and smashed; but in the early eighteenth century Dom Bernard de Montfauçon had made drawings of them for use in his giant volume* Les monuments de la monarchie française. *Poor as our reproductions are, and much as they suffer from the lack of an architectural context, the figures still suggest something of the grace and humanity that the early artists saw or imagined in their ruling lords and ladies.* ►

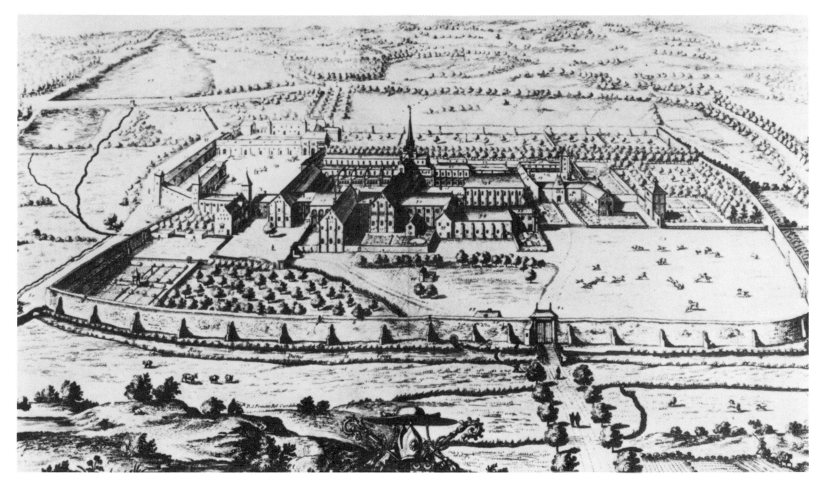

ing the sixteenth-century wars of religion, the church and its associated library suffered sporadic vandalizing at the hands of roving Huguenot bands; one group in particular, under the Vicomte de Polignac, took special pains in 1562 to befoul, dismember, and scatter abroad as many books and manuscripts as they could lay their hands on; Theodore Beza (himself a Protestant) explains, not without embarrassment, that the soldiers were mostly illiterate and were under the impression that every old book was a "mass-book." Few of these warriors for religion were, of course, so devoted to dogma that they would neglect picking up items of gold, silver, and jewelry wherever they could be found. Still, the masonry of Saint Hugh's enormous church was so massive that its enemies had to content themselves with minor acts of vandalism, such as burning a few books, cracking the nose off a statue, stoning a stained-glass window, or at most desecrating an altar—and so the church survived well into the eighteenth century. Our best representation of it is Prévost's print, made around 1670, showing both the abbey church and its surrounding town.

Stripped, scarred, impoverished, divided, and depopulated though it was, Cluny remained standing in its main structural features, as a shell for all practical purposes, but also as a potent if ambiguous symbol. In 1791 the local townsfolk had to plead with the Revolutionary authorities that the abbey buildings should be preserved. In 1792 they again rallied to defend their bells, a set known as Les Bisans, which were about to be melted down for cannon. But late in 1793 a Revolutionary army was deliberately sent to pillage Cluny. Troops smashed the remaining images, ripped out the last glass, overturned the altar of Saint Hugh, and collected all the burnable materials in the church—wooden statues, books, manuscripts, tapestries, and priestly vestments—for a giant bonfire in one of the squares of the village. Early in 1794 the Superior General

56 *The Cistercians, when they established their order, were particularly careful to lay down strict injunctions about all their monastic houses. Like the very name of the order, all their centers were to be modeled on the house at Cîteaux where Saint Bernard began his career; they were to be remote, plain and unadorned in their architecture; the monks were to live on the sparest of diets, observe rigorous rules of silence, and devote themselves almost entirely to manual labor. Yet with the years, even the austere mother-house grew into a little city, as this eighteenth-century engraving shows; and long before that, we find Rabelais speaking with awe of the giant wine-tun at Cîteaux as capable of holding almost enough wine for Gargantua.*

Veue de l'Eglise de S.^t Denis en France et du Mausolée de Vallois baty par Catherine de...

Iean Marot fecit. A Paris Chez Pierre Mariette, rue S.^t Iacques a l'Esperance Au...

57a,b; 58a,b *Two views of Saint Denis, as it was in the eighteenth century before the Revolution, and (on page 74) as it is today. The left-hand tower has been completely dismantled, and the general impression of richness and detail in the exterior view has given way to a grim and battered simplicity. What no illustration can properly represent is the loss of that immense quantity of stained glass, which the eighteenth-century engraving can do no more than suggest, and in which were united so strikingly the theological and aesthetic convictions of the original builder, Abbè Suger.*

of the order, Dom Courtin, and several of the last remaining monks were guillotined, and the buildings were put up for sale. But not enough was bid, so they were allowed to disintegrate five more years in relative peace. Then in 1799 the remaining masonry—walls, vaults, ruined roofs—was sold at auction to Citizens Bâtonnard, Genillon, and Vachier of Mâcon, who set demolition teams to work. They were dealers in junk, scrap, and rubble—secondhand building materials. Alexandre Lenoir, commissioner for the central government, who had managed to save a great deal of ancient art elsewhere in France, arrived belatedly at Cluny and could salvage only a few statues.

In 1801 the citizens of Cluny, still vainly trying to rescue their church, offered to buy it back from Bâtonnard & Cie.; and the Minister of the Interior took up the case. But Bâtonnard, determined to make the decision irrevocable, undertook to drive a street directly through the body of the nave, and when this could not be done fast enough with pickaxes and crowbars, resorted to high explosives. At each stage in the long process of hacking the great church to death, it seems to have been obligatory for someone to say, "A little while ago, the

structure might have been saved; but by now, it's too late." On this occasion too, the formula was not lacking. The prefect of Saône-et-Loire wrote to Chaptal, Minister of the Interior, saying the church could no longer be saved. Fortunately, the despairing citizens of Cluny did not see his letter, or believe it; and they managed in the end to rescue from Bâtonnard the parts of the complex that survive today. They are the south end of the grand transept, the tower of the Holy Water, the little clock tower, and the chapel of Bourbon, sometimes called the Palais du Pape Gelase. Everything else was swept away by the great tide of nineteenth-century money-making; and what the Huguenots could not do for love of God or hatred of the pope, and the sans-culottes could not do for love of country or hatred of God, Bâtonnard & Cie., purveyors of cheap building materials, were able to accomplish out of straight and shameless greed.

Ironically enough, Cluny was no sooner destroyed than the French began to regret its loss, and to blame one another for having destroyed it. Napoleon, the story goes, refused to visit Cluny because the inhabitants had disgraced themselves by allowing their magnificent church to be destroyed. Need-less to say, the local folk blamed everything on the central administration in Paris. Evidently, there was blame enough to go around—if for nothing else, then for brutal and wanton stupidity. Ernest Babelon, writing in 1910 on the millennial anniversary of the founding of Cluny, recalled that fifty years earlier schoolboys of the Cluny district used to make their *cerfs-volants* (approximately, paper airplanes) out of illuminated manuscripts from the ravaged monastery. The planes were prettier when made of many-colored parchment. Meanwhile, on a more exalted level, other paper planes about Cluny were being wafted through the atmosphere. Romantic books began to be written about Cluny and the glories of monastic life there, while romantic lithographs showing medieval Cluny (based on the few fragments rescued from Bâtonnard and his demolition teams) began to be circulated. Elegies and laments for what had been lost began to fill the air even before turf had decently closed over the remains of what was certainly the greatest and perhaps the most interesting monastic complex of the Western world.

Very often monastic churches were saved to become parish or episcopal churches, while the rest of the monastery was secularized or destroyed. This was particularly likely to happen in cities, as it did in Dijon, where Saint Bénigne was shorn not only of its complex of surrounding buildings, but of its own decorations; an eighteenth-century print gives an impression of its original dimensions and character. But Cîteaux and Clairvaux, famous Cistercian foundations in the deep countryside, were largely demolished, though a fragment of the latter survives because for some centuries it has been useful as a prison. Abbé Suger's famous monastic church at Saint Denis ran a special gauntlet of perils because, through a set of historical accidents, it had become, in effect, the mausoleum of the kings of France—as much a museum, therefore, as a church. During the Revolution proper, it suffered the usual indignities—the lead stripped from its roof to mold bullets, the Renaissance bronzes ripped from its tombs to found cannon—but when Napoleon turned imperial, a new set of perils appeared, in the form of "restorers" and "adapters."

The first architects to take the old church in hand for redemption were inept, to be sure, but they were also relatively restrained. Some important and beautiful statues, as well as a bit of Suger's beloved stained glass, had been rescued by Alexandre Lenoir and used to stock his new museum at the converted monastery of the Petits Augustins in Paris (it has now been reconverted again for use as the Ecole des Beaux-Arts). All this material, homogenized with scraps and pieces from other places and periods of European history, the new architects simply left where it was, and to fill the church shell perpetrated a few theatrical vulgarities of their own. Because they were working on the cheap, they limited themselves to performing mechanical repairs and made little effort to "reconstruct" the body of the church. As Napoleon's ambitions expanded, however, and his historical perspectives lengthened, new architects flushed with more money were charged with remaking Saint Denis not only into a mausoleum for past French kings, but also into a worthy burial site for a long line of imperial successors to come. More room was needed, and the crypt was briskly excavated so the old kings could be put there, and space could be saved in the church proper for the new line. But so little thought was given to the masonry foundations under the church's walls and columns that the structure came in immediate danger of collapsing. Finally, the contents of the museum in Paris, mixed indiscriminately with a great many other ecclesiastical leftovers from Saint Denis and elsewhere, were poured into the crypt—urns, busts, inscriptions, carved coffin lids, and funeral paraphernalia of all sorts, jumbled together without the least regard for congruency or historical accuracy.*

Two more hairbreadth escapes awaited Saint Denis in the first part of the nineteenth century. In 1811 an architect named Pierre Fontaine decided that it was barbaric to have the pavement of the nave at a different level from that of the choir. Had he simply raised the floor of the nave by the necessary six

* In the turmoil of the Revolution, a similar fate also befell a set of twenty-eight thirteenth-century monumental sculptures on the facade of Notre Dame de Paris. Though they actually represented the kings of Judah, the Revolutionary government of 1793 thought they were kings of France, and ordered them destroyed. But the heads were bought and secretly buried by a crypto-esthete, and in 1977 most of them were dug up—terribly mutilated, yet still very striking for the delicacy of workmanship, for traces of pigment still surviving from the thirteenth century, and for the pure nobility of the features. Twenty-one survivors are now in the Musée de Cluny.

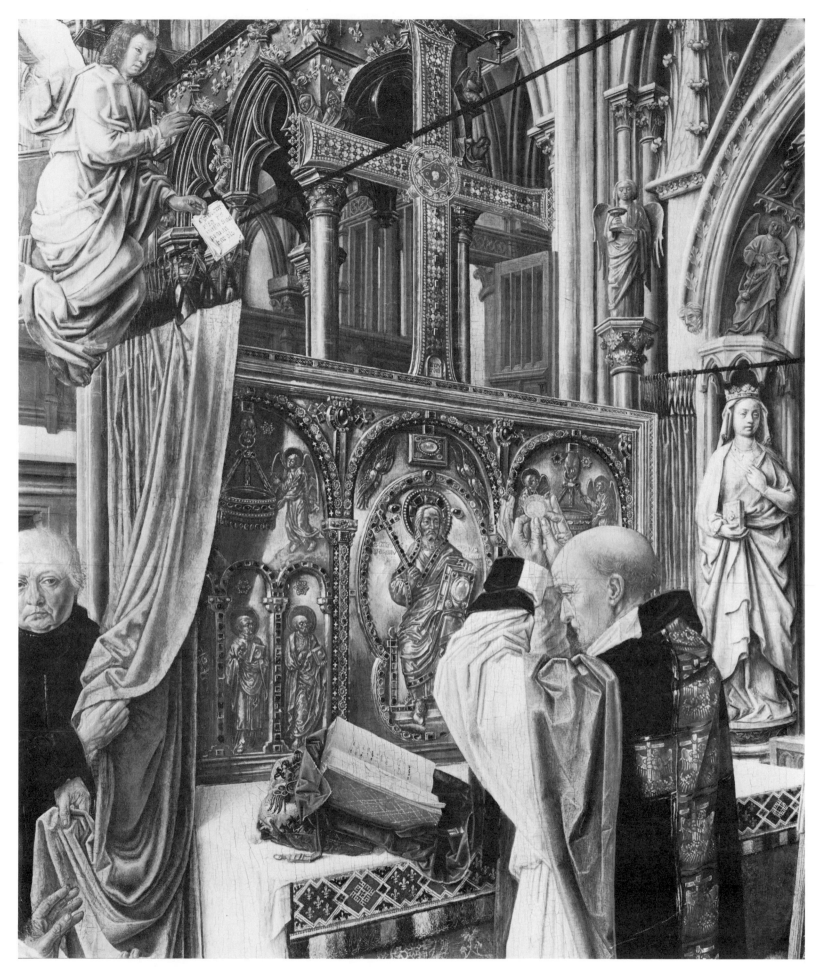

59 *This picture by the artist known simply as "The Master of Saint Giles" represents the saint saying mass before the gold altar frontal presented to the church of Saint Denis in the ninth century by Charles the Bald. The painting was done sometime between 1490 and 1510, and of course at Paris. The altarpiece* *was looted and destroyed during the Revolution; but the meticulous, particular style of the painter preserves its details with almost archaeological precision.*

60 *Boethius, the last of the great Roman writers and philosophers, fell under the displeasure of the Ostrogothic emperor Theodoric whom he was trying, against all hope, to civilize. Convicted of treason and magic, he was condemned, first to prison in a tower near Pavia, and then to death. During his last days of imprisonment he composed his most memorable book,* On the Consolation of Philosophy. *A thousand years after his execution, a tower was still standing, known by popular tradition as the Tower of Boethius. Whether it really was the identical tower cannot be positively stated; events of the sixth century are very dark, and political prisoners, however famous they later become, don't leave monuments behind. But there is no other candidate for the Tower of Boethius, and this certainly ought to have been the structure, if only because of its striking, Dantesque appearance. It was demolished in 1584, and this drawing by Giuliano da San Gallo is the only full representation of it that remains.*

LA TORE DI PAVIA DOVE ISTE T PRIGONE BVEZIO
E DE TVTA DITERA COTA

feet, no risk of catastrophic damage need have been run. But then the pillars would not have seemed to rest on bases. So the workmen simply stripped the bases off the bottoms of the columns and stuck them on six feet higher up, leaving the columns themselves supported on feeble cores of underground rubblework. By sheer luck, the entire structure did not collapse. Then a few years later a man named Debret was faced with a crisis when the north tower of the church was destroyed by lightning. Heavy-handed Debret rebuilt so massively, and with such a weight of masonry, that not only the lower part of the tower but the entire facade of the church began to crack apart. Less than ten years after the "restoration" was started, it had to be demolished to save the church from total collapse. Debret was dismissed, and the church fell into the hands of Eugène Viollet-le-Duc, then just embarking on his long career as a Gothic restorer.

Viollet-le-Duc is one of those highly charged and deeply ambiguous figures in which the history of artistic restoration abounds. But while his work on Saint Denis shows the two faces of his character, he in fact did more good than harm—though we can't be sure the balance was intentional. First and foremost, he kept the church from falling down: he reinforced the masonry of the crypt, returned the nave to its original level, and reinforced the foundations under the pillars. He knocked down or dragged away the worst of the Napoleonic additions, rearranged the tombs with an eye to historical accuracy, and tried to restore to the church some of its medieval character. Had he been left to pursue the project further according to his own lights, it seems inevitable that he would have begun to "reconstruct" it, as his fashion was in later years. There was nothing underhanded about this: Viollet-le-Duc thought he knew what a medieval craftsman might have, or ought to have, wanted to do, and saw his function as helping the ancient artisan toward the goal they both shared. Because he wanted to see medieval buildings as logical structures, he tended to minimize the fact that different builders across the centuries built with different logical schemes in mind. He saw one logic where they had seen several. And sometimes he in effect entered into competition with the men whose work he proposed to restore. As his voice could be very easily heard, while theirs couldn't, the outcome was scarcely in doubt. Fortunately for Saint Denis, Viollet-le-Duc's attention was distracted by other projects when he had barely embarked on his project of *really* restoring the church. He went on to triumph over other competitors, leaving Saint Denis to the gentler ministrations of modern conservators.

In the British Isles, the destitution of the old religion took place much earlier than in France, under the impulsion of different motives, and in two or three separate instalments. The rough, butcherly work was done under Henry VIII, while fine points were cleared up in mid-seventeenth century by the Puritans, and generous credit cannot be withheld from the "restorers" of the nineteenth century. About the first and most radical of these destructions we know least of all: tremendous as it was, we have trouble documenting or even describing the Dissolution of the Monasteries. For one thing, there aren't many reliable representations of these old and often remote buildings: artists did not very often go voyaging with their sketchbooks in the early sixteenth century, at least not in England. For another, there were no museums and only a few libraries in which the plunder of the monasteries might be

61 *Rievaulx Abbey was founded by monks of the Cistercian order in the twelfth century, was largely built by the thirteenth, but required enlarging in the fourteenth to accommodate a population of one hundred and forty monks and nearly five hundred lay brothers. Set among the remote Yorkshire hills, Rievaulx was closely modeled on the great house at Cîteaux and was notable for the clean austerity of its lines. But its population dwindled during the fifteenth century, and when all the religious houses were dissolved by Henry VIII in 1539, there were only twenty-two monks in the old building. It quickly went to ruin, yet for more than four centuries now (just about as long as the building stood undamaged) the remains have been admired as among the most attractive and suggestive of all England.*

stored. Then, the destruction was anything but systematic; sometimes it was not even deliberate. Abbey lands were generally the main focus of interest; once they were sold to their new owners (Henry needed money for his French adventures too badly to give anything away), what happened to the buildings on them tended to happen gradually, piecemeal, and as a rule silently. In a largely agricultural community, many structures were applied to practical purposes of the humblest order—chapels became warehouses, stables, sheepfolds, piggeries, barns. The Benedictine Abbey of Malmesbury was sold to a clothier, fitted with looms for weaving cloth, and converted to a factory. If there was no need for a building, the materials, particularly lead, precut stone, secondhand brick, and used timbers, were always in demand. When Sir Thomas Audley was demolishing the priory of the Holy Trinity in Aldgate, it was said that any man in London city could have a cartload of hard stone at his doorstep for sixpence or sevenpence, carriage included. Most of the structures out in the countryside were allowed to stand and disintegrate, often to elegant aesthetic effect: witness the ghostly, half-transparent apparition of the ruins of Rievaulx and Fountains Abbeys in the Yorkshire hills. But there was a lot of frank and brutal looting too. The sixtieth and last abbot of the historic abbey of Glastonbury was summarily executed on the marvelously ironic pretext that he was guilty of high treason for "robbing Glastonbury church." No sooner was he dead than the church, once one of the oldest, largest, and most cherished in England, began to be robbed in deadly earnest. It was stripped, smashed, ravaged, dismembered, and turned to secular uses; yet so vast was the structure that it wasn't finally picked to pieces till the nineteenth century, when scarcely one stone was left atop another.

Henry had a special loathing of Saint Thomas à Becket, whose opposition to Henry II seemed to him an act of particularly ill omen; so he attempted to erase the saint's name from the books, to deface his images and pictures, and to wipe out the famous shrine in Canterbury, goal of Chaucer's pilgrims. An anonymous Italian described the shrine about the year 1500, saying,

> The magnificence of the tomb of Saint Thomas
> ... is that which surpasses all belief. This, notwithstanding its great size, is entirely covered over with plates of pure gold; but the gold is scarcely visible from the variety of precious stones with which it is studded, such as sapphires, diamonds, rubies, balasrubies, and emeralds; and on every side that the eye turns, something more beautiful than the other appears. And these beauties of nature are enhanced by human skill, for the fold is carved and engraved in beautiful designs, both large and small, and agates, jaspers, and cornelians set in relief, some of the cameos being of such a size that I do not dare to mention it.*

When this ornate structure was demolished, we hear that eight strong men could barely carry the looted gold out of Canterbury Cathedral. They managed, however, somehow; and the

* C. A. Sneyd, ed., *A Relation of the Island of England about the Year 1500*, p. 30.

whole job of historic erasure was so successful that only one crude miniature, surrounded by much apologetic writing to explain what the original was *really* like, survives to suggest this shrine, once famous throughout Christendom.

For good measure, Henry also destroyed the ancient and opulent abbey of Saint Augustine in Canterbury. But he was somewhat more embarrassed by the shrine of Edward the Confessor in Westminster Abbey, for Edward had been a king, and the shrine was a royal tomb as well as a saintly one. For a man of the king's prickly conscience, it was a difficult dilemma, which he solved with characteristic delicacy by taking to himself all the gold and precious stones and scattering the relics of the saint, but leaving the bare coffin of the king. Later, under Mary, the shrine was patched up with wood and plaster to a meager facsimile of its earlier self, but never regained anything like its original splendor.

Indeed, wherever we look in England we find traces of the Dissolution. Whitefriars and Blackfriars, where Elizabethan plays were staged, recall the thirteenth-century foundations that stood there; Charterhouse School gets its name from a Carthusian house; the White Ladies in Worcester recalls a

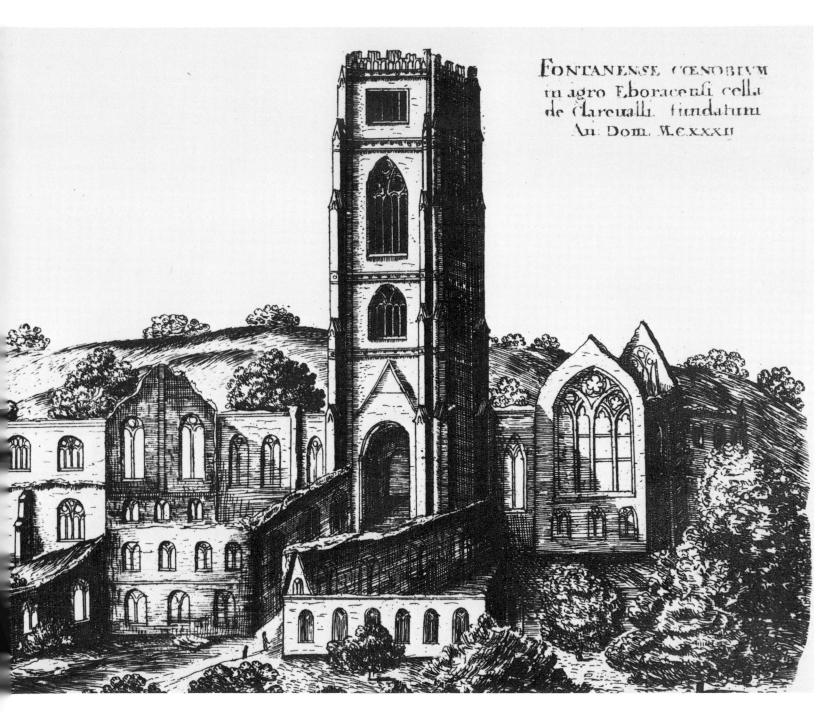

FONTANENSE COENOBIVM
in agro Eboracenfi cella
de Clareualli fundatum
An: Dom. M.C.XXXII

62 *The abbey of Fountains in the county of Yorkshire as it appeared in the seventeenth century, a hundred years after its ruin at the hands of Henry VIII.*

Figura Scrinij S.Thomæ Cantuariensis ex M.S. in Bibliotheca Cottoniana desumpta.

Deauratū pondo lx. vnciarum. Deauratū pondo lxxx. vnciarum. Deauratū pondo lx. vnciarum.

Quæ Saxeo operi eminebant, è ligno fuere singula. Clinodia aurea gemmosa, aureis laminis tecta, & vinculis deaura tis nexa; gemmis insuper aureis, mo- nilibus vtpote, Ge- niorū imagunculis anulisque decem puta, aut duodeci in auream aream composito.

Spolia hæc sacra cistas binas, quales vix sex aut octo robustissimi è Templo deportare valebant, impleve runt. Gemam insignem vna, cum Angelo eam indigitante, quam Galliarum Rex obtulit, Henr icus ille annulo inseruit, & in polli ce rapaci gestavit.

Loculus ille, quem vides ferreun, ossa Tho.Becketi cum calva, necnon rupta illa cranij parte, quæ mortem inferebat comple ctebatur.

63 *The extremely bad quality of this illustration is a special cause of its modern interest. It represents what was left of the shrine of Saint Thomas à Becket; the illustration is taken from the* Monasticon Anglicanum *of Sir William Dugdale and based on a manuscript of the Cotton Library in the British Museum. The text on the right describes the precious stones and heavy gold work that once covered this plain and rather disagreeable-looking box. The three ornaments at the top are assessed in terms of the amount of gold they contain: we are assured that the treasure stripped from the shrine amounted to two big basketfuls which six or eight powerful men could hardly carry from the temple. The outstanding gem, presented by the King of France, was taken by "that" Henry who, we are told, had it mounted on a ring and wore it on his rapacious thumb. The little box below contained the bones and skull of the saint, along with that very piece of his brainpan the fracture of which caused his death.*

nunnery; Tintern Abbey (to whose ecclesiastical history Wordsworth was so ostentatiously indifferent) had been a Cistercian house; and Westminster Abbey, its roots sunk deep in the darkness of early history and mythology, was until 1539 the Benedictine Abbey of Saint Peter's at Westminster. Of all those we have mentioned, it is the only one that has survived, though constantly patched, adapted, and reworked by generations of restorers from Sir Christopher Wren to Sir George Gilbert Scott. But the great palace at Westminster, though as a secular structure it was exempt from the Dissolution, was burned to the ground on October 16, 1834, when, as a result of the abolition of the Exchequer, thousands of old-fashioned tally-sticks were tossed into a fireplace, and a chimney overheated. The old building was a fascinating composite of styles and additions across the centuries. Of particular interest were some wall paintings in Saint Stephen's Chapel, where the House of Commons sat. They were exposed briefly in 1800 when the chamber was being enlarged to accommodate the newly incorporated Irish members, and were copied on that occasion by John Thomas Smith before being destroyed by new construction. Thirty-four years later, not only the remains of them but the entire ancient building went up in smoke, to be replaced by the present structure, work of Sir Charles Barry

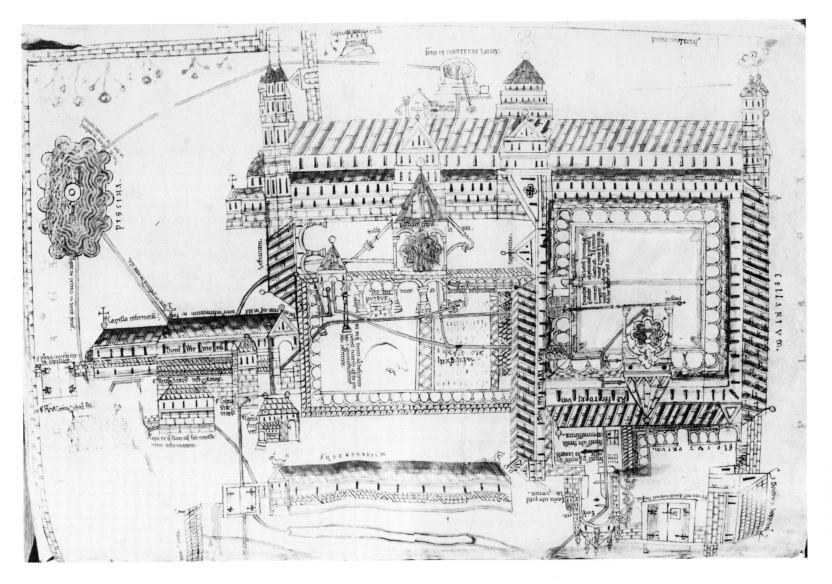

and A. Welby Pugin. But we still have pictures, both of the old palace and of its paintings.

The Puritans of the seventeenth century were more discriminating in their destruction than the agents of Henry VIII. One reason was that, being largely under clerical leadership and direction, they weren't so greedy to alienate church lands—of which, by the seventeenth century, there were precious few left. Sensual allurements were their particular loathing, and while they did some image-smashing and glass-breaking (at Lichfield Cathedral, for example), the idols they thought they recognized in crucifixes bore the brunt of their fury. Commissioners were specially appointed to search out those ancient roods, or representations of the crucifixion, which had escaped Protestant vigilance under Edward VI and Elizabeth; the work was so successful that in all England not a single rood remained undisturbed. Anything that suggested withdrawal from the world, or self-absorbed contemplation, was suspect; thus the community of Nicholas Ferrar at Little Gidding, which devoted itself to prayer, fine bookbinding, and exquisite needlework, was broken up by the Puritan troopers in 1646 and ransacked. So deep was Puritan antipathy to stained glass that when the city of York capitulated, after a long resistance, to parliamentary forces in 1644, the citizens wrote into the articles of surrender a special proviso that the stained glass in the minster and other churches of the city was not to be damaged. In the early days of English iconoclasm, churchwardens sometimes buried stained glass or hid it in cellars; thus it occasionally survives in a form to show what it

64 *Plan of the Monastery of Saint Augustine at Canterbury. The eleventh-century drawing is from Trinity College, Cambridge, where it is numbered Cod. R. 17. Henry VIII demolished the monastery itself. This is one of but two plans of medieval monasteries; the other is a ninth-century plan of Saint Gall in Switzerland, recently reproduced and studied in majestic detail by Professors Walter Horn and Ernest Born of the University of California. Such plans provide immense quantities of information not only about the arrangements of the monasteries and the ideal values governing them, but about such fundamental matters as the system of mensuration, and the accuracy of which it was capable, at a particular stage in history.*

65 *Print of the fourteenth-century wall paintings in the destroyed Saint Stephen's Chapel of Westminster Palace. The recording artist was regarded as such a nuisance by the authorities that he was allowed access to the paintings only at night, when the workmen were not busy hacking them to rubble; and he tells us it was not infrequent that the paintings he finished copying in the morning (cold, weary, and frantic with anxiety) were obliterated by nightfall, as the workmen chopped remorselessly away. The paintings had to be removed, along with the wall they were on, because the Commons were being enlarged to include new Irish members—the ancient and relatively free Irish parliament having recently been abolished. All in all, it was a happy occasion for everybody.*

66 *Drawing by Hans Baldung for a stained-glass window, now destroyed, showing the Abbess of Hohenburg Cloister near Strasbourg with her flock of pious nuns. The writing at the foot of the drawing contains instructions for the glazier; presumably the shields would have been filled in with appropriate armorial bearings, providing a touch of aristocratic hauteur to balance the humility of the nuns' posture.* ▶

was like, even when the rest of the church has been finely smashed up.

We do not often have actual drawings or paintings of stained-glass windows, perhaps because artists despaired of rendering the rich colors, or because they did not think the windows worth reproduction. But a drawing does survive from the Continent, by Hans Baldung, toward a stained-glass window representing the Abbess Veronica von Andlau with five of her nuns of the Hohenburg Cloister near Strasbourg— and we cheerfully move a step out of our way to include it for the sake of its poised and quiet elegance.

In all this story of Protestant image-breaking and idol-smashing, a curious mixture of motives prevailed. Some of the smashers really felt that sensual allurements distracted and detracted from the purity of spiritual devotion, the intensity of spiritual warfare. But many of the practicing iconoclasts went about their work in a spirit of singleminded greed or mischievous vandalism. After the gold and jewels on shrines, they were particularly eager for the lead guttering on church roofs, the leading in glass windows, and the brass or bronze from statues and reliefs. When these were exhausted, they tended to run wild, hacking statues of Christ to pieces, hallooing and racketing around cathedral aisles with broadsword and pistol, eager to smash anything they considered an idol, whether it was an image of the Virgin, a bust of an ancient worthy, or a funeral brass.

As noted, they were specially fierce against crosses and representations of the crucifixion; and here a wide field of destructive opportunity stretched before them. Since early Saxon times the notion had prevailed of setting up crosses of wood, stone, or metal by the sides of roads or at intersections. (Anyone who had the privilege of walking through the Tyrol and the Dolomites some forty years ago—probably the last place and time they could be experienced so frequently—may recall the enchantment of these wayside shrines.) In early England, the crosses ran a gamut of elaborateness, from the pair of sticks set up to commemorate deliverance from a runaway horse, to intricate and expensive monuments carved by master craftsmen. Medieval piety lavished itself on great stone crosses, often adorned with runic inscriptions, religious symbols, and arabesque decorations; later, the crosses grew more architectural, like little chapels. Scott's Albert Memorial was modeled on the memory of some of these old crosses, and preserves some sense of their character. Most famous of all were the crosses set up by King Edward I in memory of his deceased wife, Eleanor of Castile. The queen having died in Lincoln (November 1290), her body was carried to Westminster Abbey for burial; and wherever it rested along the road, the king erected a special cross. So many Eleanor crosses were smashed and ruined over the centuries that even the memory of where some of them stood has grown dim. Three remain, at Hardingstone near Northampton, at Geddington near Kettering, and at Waltham Cross; but those at Lincoln, Stony Stratford, Woburn, Dunstable, St. Alban's, West Cheap, and Charing Cross in London have all vanished. As it happens, we have an etching by Wenceslaus Hollar showing the Charing Cross structure under attack by Puritan fanatics.

No doubt, if the Puritans had not destroyed the crosses— as they did, ruthlessly, systematically, vindictively—modern traffic would have done so. But Puritan antipathy to the "superstitious" symbols went far beyond the bounds to which

83

The Prospect of Couentre Croße

P M
GVIL. ABAVI
P
GERV:HOLLIE

67 *Coventry Cross was typical of hundreds of medieval crosses that stood throughout England before Puritan iconoclasm dragged them down. They were gallant and ornate structures, patriotic and religious at the same time, but perhaps too gentle and nostalgic in the feelings they incited to be tolerated by the fiercely austere men who smashed them.*

even the automobile would ever be able to reach. On the ancient holy isle of Iona among the Inner Hebrides, where Saint Columba lived and died, and where the Book of Kells was patiently illuminated, the crosses once stood thicker than barley stalks amid the stony fields; and like barley stalks they were mowed down. At the time of the Reformation there were said to be 360 of them; today there are three. Most of those now missing were deliberately thrown into the sea by order of the synod of Argyll. But the high cross of Kells, where the great book of Iona sought refuge, was demeaned even further: it lasted long enough to serve as a gallows on which to hang the rebels of 1798, and was then broken up by the "authorities." (Lately, though, it has been put back together.)

The "heroic" age of smashing our medieval heritage is by now long past, and though the results are often painful to contemplate, the process in all its large brutality was somehow necessary. We can't afford, we couldn't populate, fifteen thousand Benedictine abbeys. At Bruges, we are lucky to have, more or less intact, a good part of a medieval, or at least an early-Renaissance, town; but, as sanitary, social, and commercial entities, we couldn't afford to have many of our towns built like Bruges—which, no less than Venice, owes a great deal of its charm to its uniqueness. So elsewhere. The seventy-two towers that once defined San Gimignano so magnificently against the sky are now reduced to fourteen; this is a loss to be lamented, for San Gimignano is one of the best examples we have left of what fortified Italian hill towns were like. But as medieval streets are not fit to take modern traffic, so medieval towers are not practical forms of modern housing. For these models of medieval city life, a pattern or two is perhaps all we need. What we can really lament is the loss of illuminated manuscripts, rich embroideries and tapestries, sacred statuary, and intricate decorative arts, which the Middle Ages, as an age with plenty of time on its hands and a passion for curious intricacy, developed beyond all others. An ultimate irony resides in the fact that to study French monumental brasses, one must visit, not France (where nothing survived the Revolution), but the Bodleian Library at Oxford, where are preserved some drawings made in the mid-eighteenth century by Richard Gough.

Presumably we are now beyond the passions which chopped down the crosses, ripped up the manuscripts, and defaced the ornate statuary. Presumably: yet less than fifty years ago the magnificent monastery of Sigena in Spain, once headquarters for the Knights of Saint John, was put to the torch, with the priceless thirteenth-century frescoes of its chapter room. We cannot say that the images of that structure were wholly lost, for they are preserved, after a fashion, in Barcelona's Museo de Arte de Cataluña—roasted to a uniform rich brown color, the intricate designs barely decipherable, the whole quality of the work just faintly, remotely recognizable as from a vast distance. It is one of the saddest experiences, perhaps, in Europe; and the sadness is mitigated only slightly by the existence of a photographic record, made just a few weeks before the conflagration.

A questioning mind might well wonder why medieval building, and Gothic in particular, produced such extreme reactions pro and con. Its association with the Christian religion is only part of the answer: for some haters it was a purely aesthetic hate, as for some lovers it was a largely secular love. A French architect of the late eighteenth century named Petit-

The 2 of May. 1643. y^e Crosse in Cheapeside was pulled
downe, a Troope of Horse & 2 Companies of foote wayted
to garde it & at y^e fall of y^e tope Crosse dromes beat tru-
pets blew & multitudes ... of Capes warre throwne
in y^e Ayre, & a greate ... Shoute of People with ioy,
y^e 2 of May the Almana- ... ke fareth, was y^e invention
of the Crosse. & 6 day ... at night was the Leaden
Popes burnt, in the pla- ... ce where it stood with
ringinge of Bells, & a ... greate Acclamation &
no hurt done in all ... these actions.

10 of May the Boocke of Sportes vpon the Lords day was bu-
rnt by the Hangman in the place where the Crosse stoode, &
at Exchange.

68 *"The Destruction of the Cross in Cheapside," an engraving
by Wenceslaus Hollar. It's curious to find Hollar, much of whose
life had been devoted to recording monuments of antiquity—
most of them "papist" by the standards of the day—recording
the destruction of this harmless and picturesque memorial with
such evident complacency.*

69 *Because things have survived for hundreds of years, we tend
to think that a few more years won't hurt them. Of the hundreds
of stone crosses that once stood on the holy isle of Iona, this
fragment was one small piece when it was sketched in 1859. The
artist then reported that the piece that had flaked off the front
(right-hand view in the illustration) was lying loose in the vicin-
ity, or was occasionally balanced atop the stone. By now the last
eroded stump of this once elegant and intricate piece of stone
carving has weathered away, and nothing is left.*

70 *The ancient monastery of Sigena stood in the isolated hill country to the west of Barcelona; its chapter house was decorated with elaborate Biblical murals which have been linked, stylistically and thematically, with a twelfth-century English school of manuscript illumination in Winchester. But neither remoteness nor antiquity served to save the monastery during the Spanish civil war of 1936–1939; it was put to the torch, and the murals were burnt up or reduced to muddy obscurity. Fortunately, a set of pictures had been made a few months before the arson. Cain and Abel are shown on the left side of this arch, Noah on the right.*

Radel earned himself a measure of notoriety by publicly propounding, at the Salon of 1800, an original technique for demolishing a Gothic church in ten minutes: dig away the base of the pillars, shoring them up for the moment with blocks of wood, then set the wood on fire and stand back to watch the church—Notre Dame, Chartres, Amiens, as fancy directs—come crashing gloriously down. We note that M. Petit-Radel was not hostile to church architecture as such, just to Gothic. He demonstrated as much when he dressed the Gothic columns of Saint-Médard in Paris in a kind of Doric pantaloons, producing an effect marvelously grotesque in our eyes, but clearly superior in his to the harmonious and wickedly Gothic originals.

And yet within a few years we find enthusiasts like John Carter, Bishop Milner, A. Welby Pugin, and the thunderous John Ruskin implying or saying directly that it is sacrilege to lay a finger, even with the best of intentions, on the ancient Gothic monuments. The most famous restorer of Gothic structures in England was James Wyatt, nicknamed by his purist enemies "The Destroyer." Pugin summed up his view of the man in a single majestic sentence: "All that is vile, cunning, and rascally is included in the term Wyatt." And Ruskin certainly had Wyatt in view when he wrote, memorably: "Neither by the public nor by those who have the care of public monuments is the true meaning of the word *restoration* understood. It means the most total destruction which a building can suffer: a destruction out of which no remnants can be gathered: a

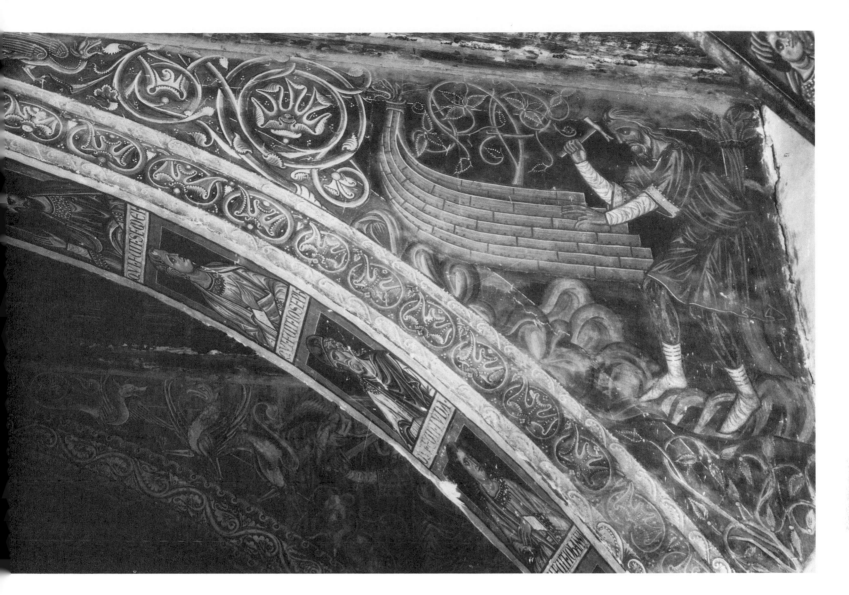

destruction accompanied with false descriptions of the thing destroyed."

By general consent, the worst things that Wyatt did can be seen in his "restoration" of Salisbury Cathedral between 1782 and 1791; and, indeed, they are pretty bad. He believed, not altogether absurdly, in the grandeur of the structure on which he was working. But he thought that grandeur could best be appreciated, within the cathedral, by giving the viewer an uninterrupted sweep of vision from west to east; and therefore he demolished or removed whatever interfered with that vision. Medieval donors and builders were not, on the whole, devotees of the "one big room" theory of cathedral-building; each contributor to the structure had his particular chapel, shrine, or memorial to create, and was not only ready but eager to fence it off from competing attractions. These screens and obstacles Wyatt destroyed outright; and in order to get the ancient tombs out of the way as much as possible, he lined them up in severe order between the nave piers. For the sake of a "unified effect," he removed the two porches, north and south; and, finding that the two rich and ornate chapels put up by the Hungerford and Beauchamp families were in precarious state, he prevented their collapse by tearing them down. One of the features of the old cathedral was a massive bell tower that stood apart from the church proper, a curious and imposing structure, which Wyatt demolished because, as he said, making it safe would cost too much. Finally, the "restorer" of Salisbury Cathedral tore through the old stained-glass windows, which had miraculously survived the Reformation and the iconoclasts of the seventeenth century, like an avenging storm. Perhaps the most remarkable relic of his work is an often-cited letter, dated 1788, from John Berry, glazier, of Salisbury, to a Mr. Lloyd of Conduit-street, London:

> Sir. This day I have sent you a Box full of old Stained & Painted glass, as you desired me to due, which I hope will sute your Purpos, it his the best that I can get at Present. But I expect to Beate to Peceais a great deal very sune, as it his of now use to me, and we do it for the lead. If you want more of the same sorts you may have what thear is, if it will pay for taking out, as it is a Deal of Truble to what Beating it to Peaces his; you will send me a line as soon as Possoble, for we are goain to move our glasing shop to a Nother plase, and thin we hope to save a great deal more of the like sort, which I ham your most Omble servant—
>
> John Berry

Down to the artless spelling and single-minded economic motivation, this is a classic document of innocent vandalism; by itself, it would almost justify the various epithets later applied to Wyatt—barbarous, destructive, dishonorable, and so forth. Yet in our contempt for the architect who sanctioned such destruction, we shouldn't overlook the fact that he was the paid agent of others, whose tastes and values he in part reflected.

71 *The church of Saint-Médard, not far from the Jardin des Plantes in Paris, still bears the traces of M. Petit-Radel's efforts to obliterate its shameful Gothic origins.*

72 *Salisbury Cathedral was engraved by Wenceslaus Hollar in the early seventeenth century, long before its "restoration" in the late eighteenth. This view is particularly useful because it shows, in the two low chapels to the left and right of the apse, the highly decorated Beauchamp and Hungerford chapels, and on the right the ancient bell tower. All these structures were demolished by James Wyatt, the restorer. Hollar's engraving does not and cannot show the ornate stained-glass windows, which were a particular loss at Salisbury because the fabric of the structure was to a large extent simply a frame for these gigantic colored pictures. Ever since Wyatt worked on it, the cathedral has been complained of as "cold," and with good reason. But it wasn't cold before he set to work improving it.* ▸

He did not come upon the Beauchamp chapel when it was in a state of pristine newness—on the contrary, it had been allowed to disintegrate for centuries. We do not know how much it would have cost to repair, or what budgetary limitations were imposed on the architect. Of course nothing justifies the destruction of the stained glass, which would have been easy to store and can hardly have yielded much money when sold to Mr. Lloyd and his like. But with regard to some of the other decisions faced by Wyatt and his successors—Victorian restorers like Sir George Gilbert Scott—it's easy to be wise after the event, and difficult to calculate what a right policy would be.

When one deals, for example, with a composite building, constructed, repaired, and modified over a period of centuries, the purist is almost as dangerous as the pragmatist who blithely imposes his own contemporary notions of seemliness on what he repairs. For the purist operates behind a mask, and is emboldened by the thought, sometimes a delusion, always a deliberate and conscious creed, that he knows what the original craftsman wanted to do. Sir Nikolaus Pevsner confesses that he has been led to suspect original stained glass of the seventeenth century as a Victorian alteration because it appeared too correctly Gothic. When he is not adding to the ancient structure, and out-Gothicking the Goths, the purist is likely to be stripping away inferior and later work which is not Gothic enough for his taste. Reduced to its essential nub of original work, a building may be one hundred percent authentic at the cost of being ninety percent dull. More complicating still is the

Ecclefia Cathedralis,
SARISBVRIENSIS,
Facies Orientalis,
Impenfis
DECANI & CAP:
hujus Ecclef;

fact that over a century or two, restorations and substitutions within ancient structures tend to acquire an interest of their own, along with such historical patina as accrues by standing in a single place for a good long time. An ironwork screen by Sir George Gilbert Scott is not an authentic thirteenth-century piece, but the way one decides it is a fake may be by judging that it looks far too genuine; and then, though it clearly isn't thirteenth-century, it may be of the very greatest interest as a piece of neo- or pseudo-Gothic of Victorian provenance. If we start ripping out Victorian additions to cathedrals, we shan't be long in tearing out Georgian alterations too, or Late Norman, or Perpendicular additions to buildings begun in an earlier style and with different intentions. Viollet-le-Duc's heresy in France had its counterpart in England, where purists as

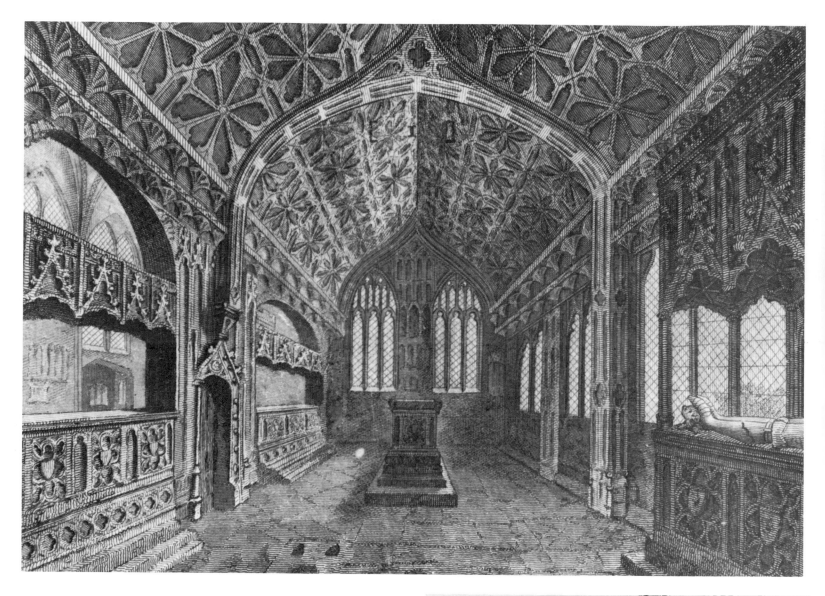

73 *Interior view of Bishop Beauchamp's chapel in Salisbury Cathedral, just before its destruction by James Wyatt. Much of the funeral statuary had evidently been smashed or removed, and all the stained-glass windows were already gone, presumably as a result of iconoclastic activity in the sixteenth and seventeenth centuries. The old wood paneling, on the other hand, was all but intact, and the official excuse given, that the structure was "unsafe," is particularly fishy. It is not uncommon for structures judged "unsafe" to defy the wrecking ball, the bulldozer, and the use of high explosives, thereby making plain that the real reason for getting rid of them is some sort of aesthetic disapproval—or the fact that it would cost too much to "modernize" them.*

74 *The work of Sir George Gilbert Scott in restoring the cathedral church at Oxford included ripping out an authentic fourteenth-century window in order to replace it with this nineteenth-century copy of a twelfth-century design which the architect thought would render the structure more correct.*

75 *Church of the Holy Sepulchre, Cambridge, before its restoration.*

76 *Church of the Holy Sepulchre, Cambridge, as it is now after its radical "restoration" in 1841 by Salvin with the encouragement of J. M. Neale, Benjamin Webb, and their magazine,* The Ecclesiologist. *Apart from the encroachment of the town on all sides, and the diminution of the building by contrast with its neighbors, the church has been cut down almost to toadstool proportions by its devoted "restorers," and deprived of its original sturdy, fortresslike character.*

early as 1842 were urging that the restorer must recover the original scheme of the edifice, recover it "either from existing evidences *or by supposition,*" and must repair later additions when necessary "or even carry out *perhaps more fully* the idea which dictated them." A fine, fair franchise, this—one which commonly involved bestowing on a structure such a character as it never once possessed before. Supposition and extrapolation could lead even Scott (who professed milder principles, at least on paper) to tear out a genuine fourteenth-century window in the east wall of Oxford Cathedral and replace it with a new rose window of his own devising, though in the style of the late twelfth century. Whether this should be thought a fulfillment of the building or a betrayal of it must clearly be a matter for individual decisions. But it isn't an easy decision. Pictures of the Church of the Holy Sepulchre at Cambridge show it before and after restoration; and the reader may well ask himself whether this is an example of ruthless desecration or bold recovery of the architect's original intent.

One thing is for sure: whatever it amounted to at the upper end of the scale, when trained architects were playing with castles and cathedrals, restoration when it dealt with humbler structures like parish churches tended to be a brutal and degrading procedure. "Improvements" were inflicted on ancient buildings wholesale and on the cheap. One man alone, Evan Christian, is said to have "restored" more than three hundred and fifty parish churches in England, and he rarely failed to fulfill Ruskin's awful definition of "restoration."

Alongside the Dissolution of the Monasteries, the French Revolution, and the internal-combustion engine, a signal place must be reserved among the destroyers of ancient architecture in Europe for the well-intentioned, wholehearted restorer—a man wise, alas, in his own conceit and nowhere else.

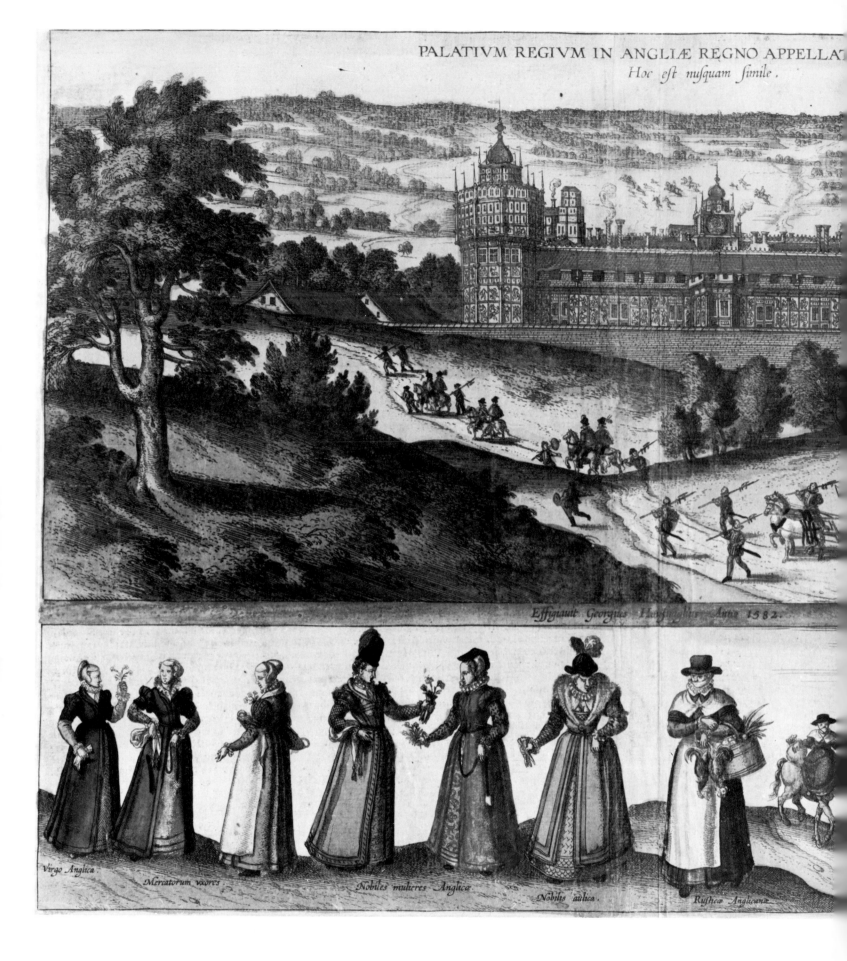

PALATIVM REGIVM IN ANGLIÆ REGNO APPELLAT
Hoc est nusquam simile.

Effigiauit Georgius Hoefnaglius Anno 1582.

Virgo Anglica. *Mercatorum uxores.* *Nobiles mulieres Anglicæ.* *Nobilis aulica.* *Rusticæ Anglicanæ.*

92

Paremptitius

Modus vendendi Lupos pisces apud Anglos.

77 *The Dutch artist Joris Hofnagel, who portrayed Nonsuch in this engraving of 1582, was clearly baffled by the problem of spelling the castle's name in a way that Dutch readers could pronounce: his solution was an excellent phonetic rendition of a sneeze. Then, to fill up some empty space below, he gave his viewers portraits of English ladies of several social classes. The square pattern of the castle is evident, as are the elaborately decorated panels adorning the first two stories all around, the clock tower in the middle, and the gallantly pennanted towers at the four corners.*

3/THE RENAISSANCE

During the sixteenth century Western Europe received three gigantic, one-time legacies—the first from the world of antiquity because it was excavated and understood, the second from the Middle Ages because their accumulations were dispersed and destroyed, and the third from America, where precious metals accumulated over centuries by the natives were quickly and savagely plundered by Europeans. Distribution of these good things was bound to be uneven; originally at least, Southern Europe got more of the first and third legacies, Northern Europe of the second. In themselves, these inheritances originated nothing, as inheritances generally do; but they gave impetus to several different varieties of renaissance that had already got under way. The study of the classical Greek language and of the ancient arts of building, the revival of painting and sculpture, the development of international banking and trade facilities, the unification of national states—all these new currents had begun to flow in the fifteenth century and even earlier. But the floods of new capital, intellectual as well as financial, that poured across Europe in the sixteenth century and swirled irresistibly around the courts of princes and kings, helped the Renaissance spread into a fantastic array of giant shapes.

The new monarchies of France, Spain, and England were fabulous centers of display, and of splendid if feverish artistic activity. Even princes as far down the power scale as the Sforzas of Milan and the Estes of Ferrara, and popes like Julius II and Leo X gave law to the greatest artists of their time. Leonardo da Vinci occupied himself about the court of Ludovico Sforza with games, toys, and the machinery of ephemeral pageants; while Michelangelo spent part of his precious time on earth making snow men for the Medici children. Even the most substantial of Renaissance achievements often have about them something inflated and whimsical, as if a dream or a fantasy had been frozen in time by an act of sheer will. The Escorial is Saint Lawrence's gridiron magnified a thousandfold and thus disguised as a palace; the interior of the Palazzo del Te in Mantua is twisted out of all practical shape to satisfy the giant fantasy of Giulio Romano or his patrons; the Château de Chenonceaux is built (against all prudence) in the middle of a river; and the most whimsical, magnificent, and temporary structure of all was the fabled castle of Nonsuch, erected in Surrey by command of Henry VIII.

In effect, Nonsuch was one of Henry's seismic whims. Growing fat and gouty, but retaining his love of the chase, he wanted his favorite diversions to be available near Hampton Court, and in suitably civilized surroundings. This meant, of course, something more than a modest hunting lodge and a few acres of park: it meant a palace, surrounded by miles of woodland, stocked with game from all across the nation. Having settled on the locale for his new castle, the king engineered a forced sale from the owners of a manor house who had inherited it from their ancestors time out of mind. The old house became a barracks for workmen, the local church was demolished, and Merton Priory, not far away, was also dismantled to provide cut stone for the king's new lodge. Press gangs roamed the countryside forcing laborers into the royal service, and construction began in April 1538. The project was gigantic; all across the countryside, trees were felled, trimmed,

78 *We don't always realize how liberally men of the Renais-sance interpreted their commission as artists. Hans Holbein the Younger created a vast number of designs for jewelry, from which hundreds of pieces were executed; but not a single one of them survives in its authentic gold and precious stones. The*

"Jane Seymour Cup," for which we have two drawings, was made for Henry VIII at the time of his marriage to Lady Jane about 1536. The inscription around the top of the base reads "Bound to obey and serve," which was the lady's motto. In 1625 the finished cup was inventoried among the royal collections

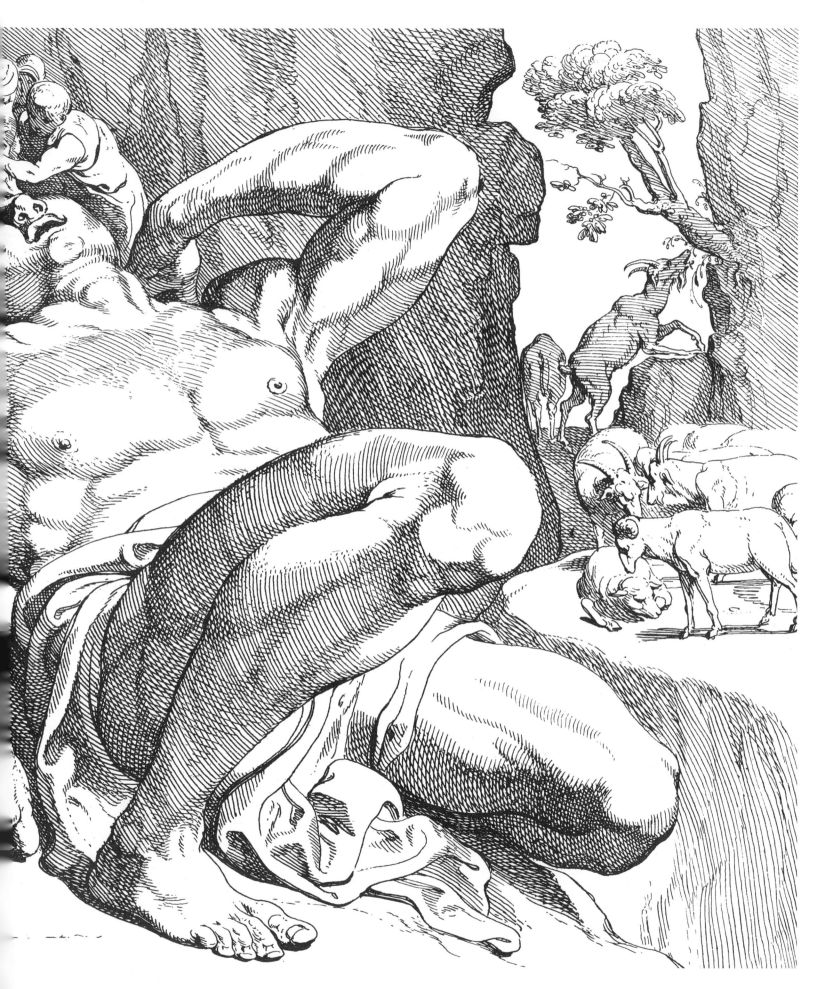

when *Charles I acceded to the throne, but it disappeared shortly thereafter, and no trace of it remains, save two exquisite drawings by the original designer.*

79 Panel ten of the "Ulysses Gallery" at Fontainebleau illus- *trates the blinding of drunken Cyclops in his cave by Ulysses and his companions. The sheep by which the Greeks will later make their escape are shown on the right, inexplicably mingled with some goats, for which there is no Homeric precedent. But the Cyclops in his brutal vastness is a very satisfying Cyclops.*

80 *Van Thulden's "Circe" engraving after Niccolò dell'Abbate's "Ulysses Gallery" at Fontainebleau is to be read in a circle: in the right foreground, Mercury arms Ulysses with the fabulous herb moly, in the main scene to the left Circe offers the hero* her poison, at the foot of the stairs to the rear he threatens her with his sword, and at the top of the stairs they are shown safely bedded. In their animal shapes, the companions of Ulysses are wonderfully grotesque, and the finale of the story, on the

couch upstairs, shows that Niccolò understood the tale as something much more interesting than a mere temperance test for Ulysses—as in fact Homer obviously did.

and dragged down muddy lanes; immense loads of local stone were quarried, shiploads of finer stone were brought in from France, brick and mortar kilns were established nearby. Apparently, there was no formal architect (as distinct from a builder), and the plan of the house was quite simple. There were two oblong courtyards, about 115 by 135 feet; they were separated by a clock tower, and the structure of the palace surrounded them, with two octagonal towers flanking the front facade. Stables and kitchen were built around the basic house, and the whole thing was surrounded by a wall with a gatehouse. But this very plain structure was magnificently decorated—and here we have a few names of workmen and designers. Henry had half an envious eye on the structures raised by François I at Fontainebleau and in the château country of the Loire valley; out of emulation, he hired several Continental craftsmen. Nicholas Bellini of Modena certainly worked on Nonsuch, and Antonio Toto del Nunziata may well have done so. As a result, the basically rectangular English house, which was the palatial part of Nonsuch, was adorned with statues, medallions, heraldic insignia, turrets, columns, fountains, stucco bas-reliefs, arches, emblems, clocks, carvings, tapestries, pennants, sundials, and an immense set of wall paintings, with elaborately carved slate paneling on the outside. As one wandered away from the palace proper, one found a profusion of groves and gardens, pyramids, a labyrinth, a grotto, orchards, tennis courts, and at a little distance beyond the highly contrived "wilderness," a separate banqueting house, where His Majesty might take an occasional lunch *al fresco*, as a respite from murdering his animals. Visitors were staggered by the ornate and elaborate brilliance of the establishment; "Nonsuch" was translated into other languages to make explicit its uniqueness—Nonpareil, NusquamSimile. We have a fine engraving of what it was like, made by a visiting Dutchman. Whether Henry ever slept in it, or even saw it, we do not know; it was not finished till after his death in 1547, and most of his last two or three years he was away, fighting with his army in France.

The finishing touches were added to Nonsuch by Lord Lumley and the Earl of Arundel, two noble kinsmen who owned the property from 1556 to 1592, when it reverted to Queen Elizabeth. She used it quite regularly as a royal residence, and so, to a lesser extent, did the first two Stuarts. But during the civil wars, Nonsuch was taken over by the Parliamentary forces, and the long business of picking it apart began. At first this process was relatively slow; some of the decorations were put up for sale, and many of the trees in the park were felled to build up the new Cromwellian navy. Then the palace itself was sold to the Parliamentary general John Lambert in 1654; he neither wanted it for its own sake nor took part in looting it, but simply saw it as a good investment; and the Cromwell government used the proceeds to pay off (at fractional rates) some of its discontented ex-soldiers. At the Restoration, it reverted, somewhat battered by now and in increasingly bad shape, to the royal family, and in 1665 some sizable sums of money were spent on repairs. But Charles II, as generous as he was careless, bestowed the estate on his mistress Barbara Villiers, Lady Castlemaine, who administered the deathblow. The new owner never occupied her palace, preferring to live in Paris when she wasn't at court. Lord Berkeley, who as lord keeper was responsible for managing the estate, took steps to which she objected—basically,

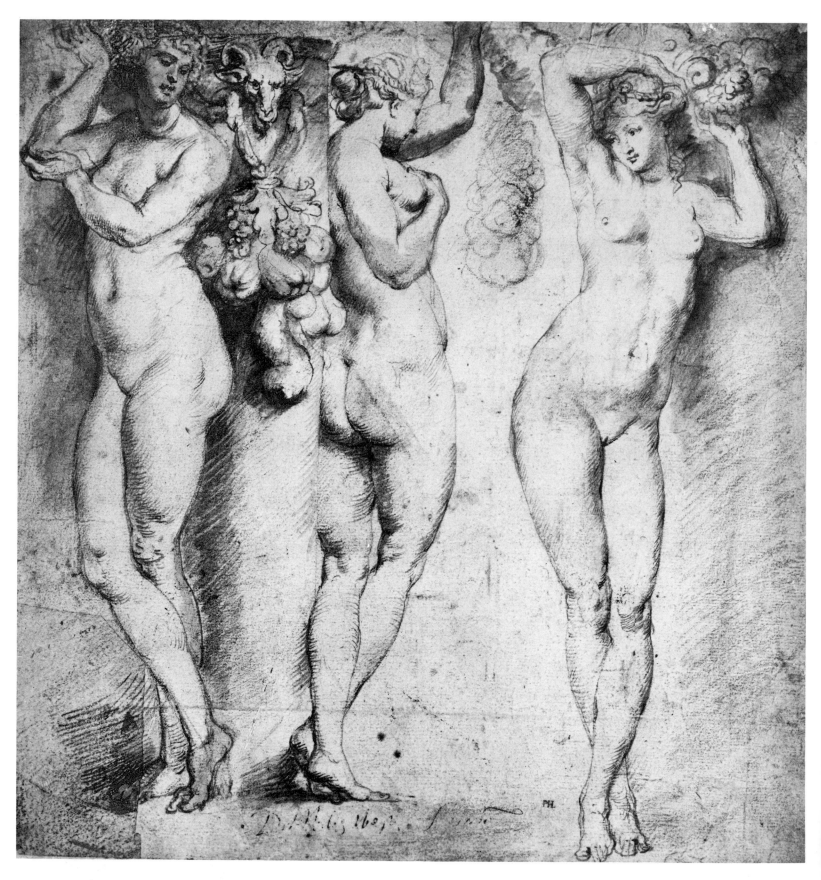

81 *The work of the Italian mannerist Primaticcio for the Châ-
teau de Fontainebleau was particularly ill-fated, and an immense
amount of it has been either destroyed or restored out of all pos-
sible resemblance to the original. This drawing was made by
Rubens after Primaticcio originals. The way the sinuous and ele-
gant line of Primaticcio shines through the fuller fleshy feeling of
Rubens makes this drawing a special delight.*

she felt he wasn't getting enough out of the old place to keep up with her gambling debts, which were enormous. So in 1682 as the Duchess of Cleveland she sold all the structures on the property for £1700 to a man named Firth or Fryth; he wanted to tear them all down and sell the materials. But Lord Berkeley saw that this was too good a deal to be missed; he bought Firth out, demolished the palace himself, and used the materials to rebuild his house, Durdans, in Epsom. Additionally, some pieces of Nonsuch are said to be incorporated in Loseley House near Guilford. Having been thrown up quickly, Nonsuch was demolished even more quickly; the work was done in 1682 and 1683, and at the end of it nothing was left but a mound of rubble and a few ditches.

In all this the Duchess of Cleveland acted thoughtlessly and perhaps selfishly, but she was in frantic need of cash, and knew nothing of the place she was ruining except that it was falling to pieces (roofs leaking, timbers rotting, stones crumbling) and required great outlays for maintenance. If the house were demolished, the park and gardens might be turned into profitable farmlands. It would have been great good luck if Nonsuch had fallen into hands that were willing to preserve and restore it; its destruction has been called the greatest loss to English architecture since the Dissolution of the Monasteries. But what happened was not abysmal bad luck, just normal, natural economic attrition.

Given the brutal and sacrilegious way in which its building materials were acquired, it's nice to know that the stones from Merton Priory brought a built-in revenge with them, by deteriorating faster than any others. Later owners must often have cursed Henry VIII's appetite for cheap building materials. After literally centuries of neglect, the site of Nonsuch was vigorously but carefully excavated in the summer of 1959; in addition to the footings and foundations, which made apparent for the first time in modern days the floor plan of the palace, some carvings, glass and pottery pieces, and even remnants of old ironwork were discovered. But that was all that remained of the most spectacular building ever raised in England, which lasted, from start to finish, fewer than one hundred and fifty years.

The splendors of Fontainebleau, which inspired Henry VIII to such extravagant emulation, were slower of growth than Nonsuch, and have lasted correspondingly longer. The original château goes back before the twelfth century, but successive Renaissance rulers added to it, with François I, Henri II, and Henri IV contributing the largest increments. What survives is enough to give us an impression of what it must have been; but much has been lost, and much that technically survives has been subjected to clumsy restoration. Altogether destroyed by the improvers of the eighteenth century were the Pavilion of Pomona on which Primaticcio collaborated with Rosso Fiorentino, and the Gallery of Ulysses, on which he collaborated with Niccolò dell'Abbate. It is a partial good fortune that Theodore van Thulden recorded some of the "Ulysses" engravings before they were destroyed; but his stiff engravings are poor substitutes for the originals. And we have a copy by Rubens of a lost drawing by Primaticcio, evidently toward a lost statue for the gardens of Fontainebleau. Even the still-spectacular "Gallery of François I" and "Room of the Duchesse d'Estampes," which come closest to giving us an impression of the building as it was when the three great Italian mannerists made it a center of artistic influence throughout

Northern Europe, have been damaged by restoration and improvement. In addition to swathing the nudes in heavy plaster decencies, Abel de Pujol removed some of the pictures early in the nineteenth century, repainted others, and rearranged still others, so that analyzing the allegorical overtones of the sequence has become a test for the reconstructive ingenuity of iconographers. It's a particular crime that Primaticcio should have been so roughly handled at Fontainebleau, because we have relatively little of his work and that which we know is of a peculiarly poised and delicate character—as one can tell from the cool, sinuous elegance that infuses even Rubens' copy of his drawing. To sense the quality of one artist through the style of another produces a specially ambiguous sense of synthetic pleasure.

A close French counterpart to the Castle of Nonsuch was the Château Gaillon, erected at the beginning of the sixteenth century by Georges d'Amboise, Cardinal of Rouen and trusted political adviser to Louis XII. Like Nonsuch, it was the work of both native and Italian designers; the architect, or at least the consultant on the architecture, was Giovanni Giocondo of Verona. Leonardo's pupil Andrea di Solario did some of the painting; there were statues, fountains, and a complete copy of Mantegna's "Triumph of Caesar"; there was a magnificent chapel with stained-glass windows and a set of predominantly Gothic decorations, as against the prevailingly Renaissance style of the rest of the building. Jacques Androuet du Cerceau drew it beautifully in 1576, before it started falling into disrepair in the eighteenth century and underwent catastrophic demolition during the Revolution. A few bits and pieces were carried off to Paris by Lenoir, where they now stand in the courts of the Ecole des Beaux-Arts; a few other fragments at Gaillon itself have been built into a modern barracks.

Space must be found, amid a listing of lost extravagances, for the amazing family villa of the Gonzagas at Marmirolo near Mantua. It grew gradually over the centuries, under various Gonzagas—Gianfrancesco I, II, and III, Federigo I and II, especially the second Federigo, who employed Giulio Romano to extend a series of frescoes that began with Mantegna. At its height, the structure contained no fewer than 280 rooms and some 150 beds. But the great days of the Gonzaga family were the fifteenth and sixteenth centuries; during the seventeenth century, they produced an almost unbroken string of weak, cretinous, and extravagant scions, who alienated most of the family estates and let the rest go to ruin. Marmirolo was smashed up in 1702 as a result of some suicidal disputes fomented by Ferdinand Charles, the last of the Gonzaga strain; it was smashed up some more in 1756, and finally demolished by a French army in 1798. Heemskerck made some drawings in the 1530s after the decorations, but they convey not even a hint of what the palace must have been like.

A last ruined palace of the Renaissance, of which we don't possess so much as an authentic fragment or an identifiable drawing, but of which we can still get a good idea, was the one that stood at Pavia until the great battle of September 4, 1527, when French artillery blew the whole structure to powder. The historian of Pavia, writing in 1570, describes as from personal recollection its spacious square jousting room, surrounded by archways supported on marble columns, and staircases so constructed that a man could ride his horse up them; and he emphasizes the riches of the painted walls, frescoed by Pisanello: "The skies were colored with the finest azure, wherein were placed all manner of beasts done in gold, like lions, leopards, tigers, greyhounds, beagles, stags, boars, and others. Especially on the side overlooking the park (which, as I have said, was ruined by the artillery of the French army . . .) in which (as it was when I saw it whole) there was to be seen a great Saloon seventy feet long and twenty wide all painted with most beautiful figures that represented hunting and fishing and jousts and other amusements of the Dukes and Duchesses of this state."

Unhappily, we don't have anything that can be specifically identified as Pisanello's work for the palace of Pavia, but the Vallardi Codex in the Louvre contains a great number of his studies of animals, and in the Palace of the Dukes in Mantua there has recently been uncovered a large if now tattered and fragmentary mural dealing with chivalric themes. Between the two, we can get at least an impression of what the Pavia salon must have been like—and of how much we all lost in that ill-fated, far-distant bombardment of 1527.

The equestrian statue is a statement of personal authority almost as impressive as a castle or a palace. It is destined for a public position and implies a public statement, it embodies a permanent act of domination implying superhuman arrogance, it enacts, physically as well as morally, a dangerous imbalance; so it rarely fails to be the target of spiteful forces. In Italy, its precariousness is the theme of many jokes; since it is safe to raise an equestrian statue to a man only after he's dead, proposing to put one up for a living leader is a way of suggesting he'd be better off upstairs. Between the statue of Marcus Aurelius on the Roman Capitol (preserved for us by the happy medieval delusion that it represented Constantine) and Donatello's statue of the general nicknamed Gattamelata (erected at Padua in 1450) no life-size equestrian statue was erected in Western Europe. But the Renaissance, with its emphasis on princes and commanders, called for a number of them. Bartolomeo Colleoni, the Venetian condottiere, ordered one of his own (probably out of envy of Gattamelata's), and was lucky enough to get the superb statue by Verrocchio which still stands in Venice, though not exactly where the hero wanted it. (He specified the Piazza San Marco; the prudent senate decreed no statues in San Marco; and Colleoni with his horse stands in Campo San Zanipolo.) The greatest and most unfortunate of all equestrian monuments was Leonardo's statue of Francesco Sforza intended for the city of Milan. Leonardo, who was always more interested in horses than warriors, completed the animal in plaster before disaster overcame the House of Sforza and its head, Duke Ludovico; the plaster model was used for target practice by Swiss archers, and the project, like so many of Leonardo's, was abandoned. But splendid sketches of the project remain.

82 *Château Gaillon was constructed by Georges d'Amboise, no doubt with the savings on his salary as Cardinal of Rouen. Like so many palatial Renaissance structures, flung up to please the luxurious tastes of a particular individual, it started to decay as soon as he was no longer there to prop it up, and it had almost*

entirely disintegrated before the Revolution came along to sweep away the last few relics. Yet in its heyday it must have been a gay and gallant structure—as our drawing by Jacques Androuet du Cerceau shows.

La fasse du danant Du
pres Paris, Laquelle

83 *That a structure like the Château de Boulogne, commonly
called Madril or Madrid, could disappear completely, without
leaving a trace or a memory—and this within a few miles of the
civilized city of Paris—will surprise only those unaware of the*

*Chasteau de Boullongne
se Veoit geometrallement*

corrosive power of time and history. The building, raised by
François I, was razed during the Revolution, and du Cerceau's
drawing is one of the few that remain.

103

84 *This drawing by Maarten van Heemskerck was made during his Italian journey of 1532–1535 and preserved in his sketchbook. Almost certainly it was made, not from nature, but from a fresco done by Giulio Romano and his helpers for Marmirolo, the great country seat of the Gonzagas outside Mantua. Romantic use of ruins in landscape painting reached a climax in the eighteenth century with the work of Panini and Piranesi, but even in the early sixteenth century Giulio Romano was not without precedents, and Heemskerck evidently responded to the vast, wild vision.*

Though Marmirolo survived, at least as a shell, for more than two hundred and fifty years after Heemskerck's visit, representations of the estate are few and far between, and copies of Giulio Romano's work for it are—present company excepted—nonexistent.

85 *Pisanello, drawing of a fawn. That this or any other drawing by Pisanello that we now have was destined for use in decorating the great saloon at Pavia, destroyed in the bombardment of 1527, is more than we can say. But a room full of creatures like this must have been a constant delight.*

Because they were so monumental in their own right, equestrian statues often survive in smaller models after the massive constructions on the public squares have been pulled down. Giambologna did a splendid equestrian statue of Henri IV which for many years represented that angular, arrogant warrior upon the Pont Neuf, which he built; but it was pulled down during the Revolution to be melted and recast as cannon. (A statue of Henri IV has returned to stand on the Pont Neuf, but it is earthbound nineteenth-century work.) And so too with François Girardon's largest work, the supercolossal equestrian monument to Louis XIV, 21 feet high and cast in a single piece. Erected in 1699, it stood for less than a century, determining the name of its square as Place Louis le Grand (now Place Vendôme) before being torn down to cast Revolutionary cannon. But there were many small copies of it, and in this instance, where the original was very outsize indeed, some may feel that we're quite as well off with a little Louis le Grand as with a big one. There's no doubt that equestrian stat-

86 *Scenes from Pisanello's long-lost fresco of love and war in the Palace of the Dukes in Mantua. This spectacular, tangled complex of episodes from the romances is like a visual* Faerie Queene *spread across the walls of the palace—one of the great rediscoveries of our time, and interesting also as it suggests the quality of that long-lost and definitely unrecoverable room that Pisanello decorated in the castle at Pavia.*

87 *Leonardo was engaged in doing equestrian monuments for both Francesco Sforza (father of his Milanese employer Ludovico "Il Moro" Sforza) and Gian Giorgio Trivulzio, an Italian general long in the employ of Louis XII. Which monument this drawing prognosticated we cannot know: neither of them was ever erected. But the heroic firmness of the animal in this sketch, had it ever been embodied in bronze, would have assured a splendid statue, whichever ironclad warrior was put on his back.*

88 *Giambologna's life-size equestrian statue of Henri IV was originally on the Pont Neuf in Paris. Its loss to the casting furnace during the French Revolution is especially to be regretted, because of its austere and angular energy, the sense of living* muscle in that ironclad leg, the ease and assurance with which the rider dominates his splendid animal. This is a table-size copy of the original.

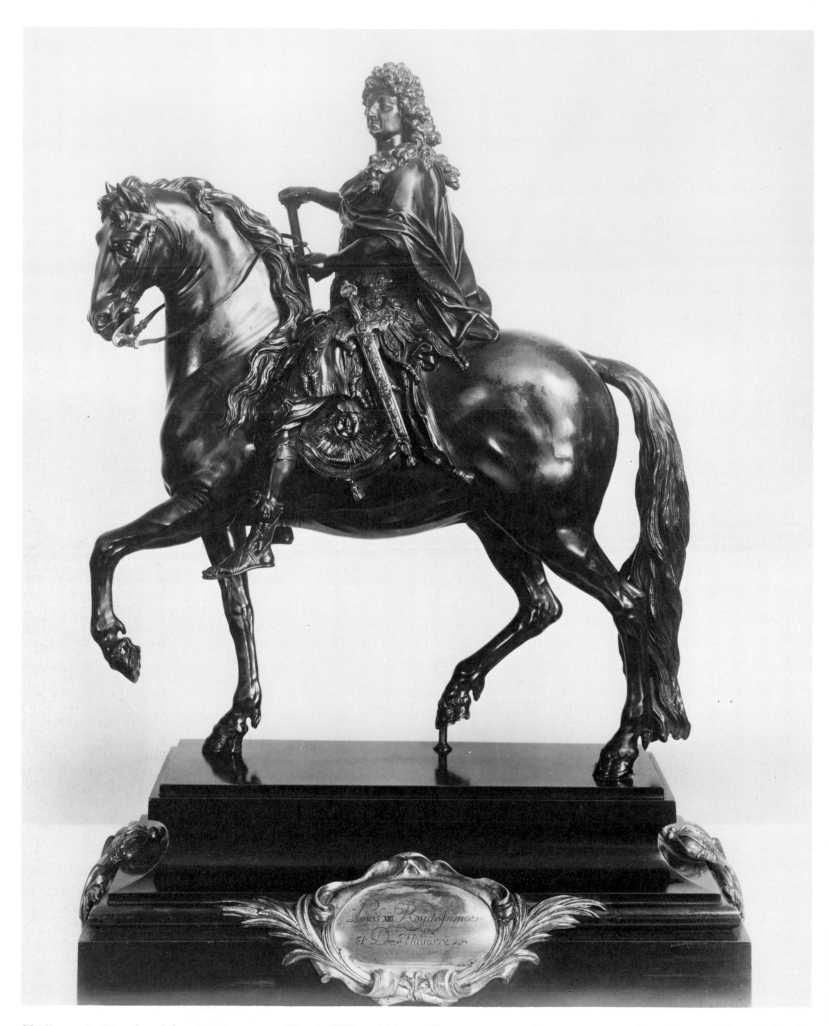

89 *François Girardon did a gigantic statue of Louis XIV and his horse of which we now possess only this much-diminished copy. The play sword, the merry-go-round horse, and the windblown,* *fluttering monarch contrast curiously with Giambologna's hard-bitten Henri IV.*

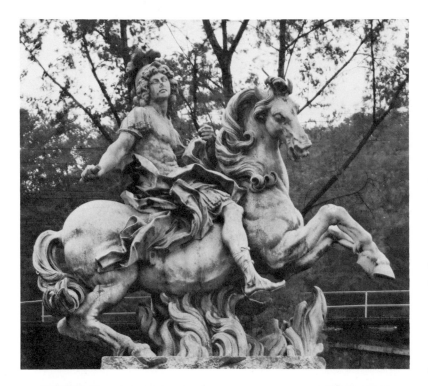

90 *In the outer gardens of Versailles, not far from the railroad tracks, stands the disgraced statue of Louis XIV by Bernini, now transformed into a statue of Marcus Curtius hurling himself into the fiery abyss. Could he see it, the Cavaliere Bernini, never a placid man, would probably want to throw both the statue and its royal original into one fiery abyss or another.*

91 *In making a terra-cotta model of his equestrian statue of Louis XIV, Bernini necessarily had to give it a more substantial foundation than the finished statue would have had. Still, it looks pretty unstable, and the agitated equine must have impressed the king with the suggestion that his seat might not be very secure. Actually, he is rather too large for his animal—it looks more like a pony than a warrior's steed. In any event, and for whatever reasons, the king had a horror of the finished statue—whose sad fate can be read in figure 90.*

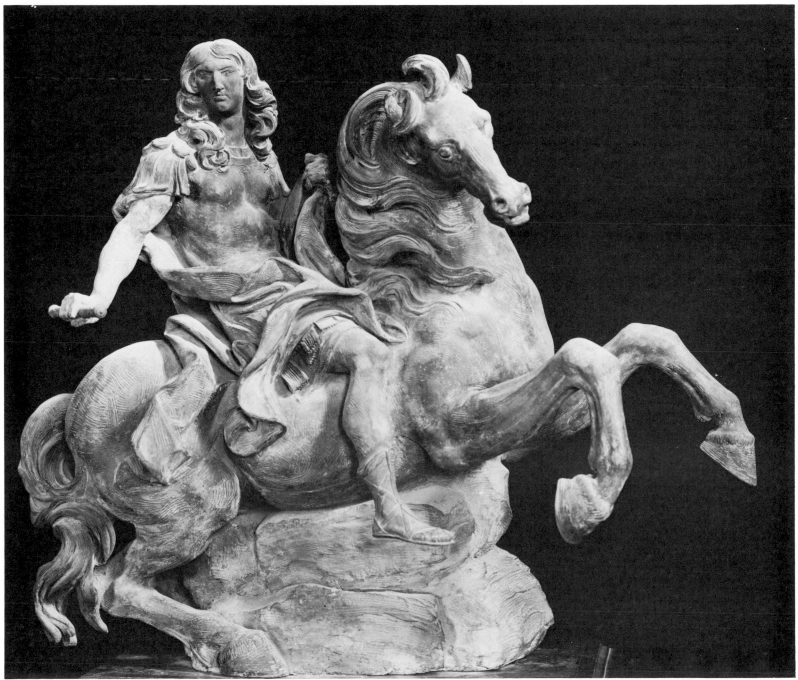

92 *Leonardo's proposed murals in the Signoria at Florence never got much beyond the cartoon stage; though there is talk nowadays of trying to revive them, not even modern science can recover a painting that was never there. But the cartoons were a*

painting school in themselves, and Rubens, visiting Florence more than eighty years after Leonardo's death, recaptured in all its vitality the swirling, savage action of the central scene, "The Fight Over the Standard."

ues, as a class of objects, lead perilous lives. But none suffered quite such indignities as Bernini's 1665 statue of Louis XIV. To begin with, the king detested it because it was too agitated, too restive, not *noble* enough by half. So Girardon was commissioned to change the subject from Louis XIV leading his troops into battle (a notion amazing in itself) to that of Marcus Curtius hurling himself into the fiery abyss. The change was not hard to effect; Girardon altered the rider's features, trimmed his wig, and built a symbolic fire under the horse. And then, when nobody liked it even in its new guise, it was relegated to a remote corner of a Versailles garden, to keep company with nymphs, satyrs, and other ornamental statuary. A sketch of the original remains in the Villa Borghese to suggest the spirit and fire of Bernini's too-bold conception.

Lethargy and indifference may be as dangerous to works of art as vanity and resentment; one is appalled at the ease with which masterpieces can disappear from the notice of men, even when the light of "civilization" seems to be shining most brightly. A fascinating phantom by Giambologna is a group described as "two men fighting," which in a lead copy survived as late as 1881, only to be sold for scrap to a local plumber by the principal and fellows of Brasenose College in Oxford. Perhaps indeed it was a copy of "Samson Smiting a Philistine," the marble original of which, after lying long unrecognized in Yorkshire, was finally brought in 1953 to the Victoria and Albert Museum. (Destruction of the copy might then be thought of as the Philistines' revenge upon Giambologna.) But perhaps, as another story indicates, the lead copy was all that remained of a long-lost original bronze on another theme entirely. Some day we may know the truth; at the moment we do not; whatever it was a phantom of, the Brasenose phantom vanished in solder and bathroom facilities.

More famous, more abruptly, and just as completely removed from our knowledge is the bronze statue that Michelangelo cast to celebrate the victory of Pope Julius over the Bolognese in 1508. We know of it only that it was of colossal size, that it showed the pope seated on his throne in the act of benediction, and that it was to adorn the still-unfinished facade of San Petronio, the largest and most central church of the city. Michelangelo when he undertook the commission had worked very little, if at all, in bronze; he knew hardly anything of the techniques, had to hire several assistants, and must have made dozens, if not hundreds, of sketches. The task occupied him for fifteen months, in the center of Italy, where he was already a famous man, the subject of constant observation. The statue was completed, it was placed on the facade of the church, and for a while it even stood there. Yet not a single sketch, model, or direct representation in any form has come down to us. As for the original, those unregenerate Bolognese, who hated Julius from the beginning as a usurper, took the first opportunity to drag his statue off the front of San Petronio, roll it through the streets, and throw it into the casting furnace. Our only guesses at the lost colossus (Michelangelo's one major venture in bronze) must be made on the basis of other statues by other artists who may have copied Michelangelo's pose—and this is very guessy guessing.

EX TABELLA PROPRIA
LEONARDI VINCII MANV
PICTA OPVS SVMPTVM
A LAVRENTIO ZACCHIA
LVCENSI AB EODEMQVE
NVNC EXCVSSVM . 1558.

93 *So numerous and various were the engravings after Leonardo's Anghiari cartoons that Lorenzo Zacchia felt impelled to inscribe his copy with a certificate to the effect that he had made it while standing in front of the original, seeing it with his own eyes and transcribing it with his own hands. For all this, the art historians retain reservations, and a modern student of Leonardo, Professor Pedretti, can find no better words for Zacchia's work than "an unsuccessful attempt at reconstructing a fragmentary model."*

During the Renaissance, even major works by Michelangelo, Raphael, and Leonardo—works bought only by the rich and famous, works prized practically as sacred objects—were known to drop from sight; but as a rule they left traces behind. A great number of artists were at work, and they were often eager to borrow new ideas from one another. One mode, familiar to us today, the Renaissance did not know, the painting specifically labelled "After So-and-So." (Van Gogh, for example, often inscribed his paintings "After Millet.") Renaissance copying was less explicit, but no less widespread. Even before they were fairly completed, some projects were being studied, copied, criticized, and adapted—generally in the details, not in the overall composition. Poses, gestures, and facial expressions were freely transferred from artist to artist, and the standard teaching device of imitation made it natural for even the greatest artists to copy someone else's work from time to time. One of the most ambitious decorative projects of the age, which never reached fruition but became a rich resource for generations of students, called for both Leonardo and Michelangelo to decorate the great hall of the Firenze Signoria (the Salone dei Cinquecento) with murals of the Battle of Anghiari and the Battle of Cascina respectively. Neither project ever got beyond the stage of preliminary cartoons, but young Raphael studied them both for an abortive project of his own, a mural

94 *The war that Florence waged against Pisa between 1362 and 1364 was one of the lesser episodes in the tormented history of those two adversaries, but the climactic battle of Cascina was what Michelangelo chose to illustrate in the murals he was commissioned to paint in 1504 for the Palazzo della Signoria in Florence. Only the "cartoons," that is, the preliminary sketches, were ever completed, and as they have perished, we know them only through copies. (The tablet in the lower left witnesses that this is Veneziano's copy, made in 1524.) They showed a group of Florentine soldiers who had been bathing in the Arno and were surprised by the approach of the Pisan army. Michelangelo chose this scene because of the chance it gave him to portray male nudes in violent action; it is an early instance of his terribilità.*

95 *Aristotele da San Gallo, copy in grisaille of Michelangelo's cartoon for "The Battle of Cascina." This is surely the most complete, and probably the most accurate, reproduction of Michelangelo's lost project.*

of an unnamed battle for which studies exist in the Ashmolean Museum in Oxford. Peter Paul Rubens copied the central action of Leonardo's cartoon in a splendid drawing, the accuracy of which can be checked against a drawing made and engraved by Lorenzo Zacchia, as he tells us on it, from the original. An etching by Agostino Veneziano and a fullscale grisaille copy by Aristotele da San Gallo provide our best evidence for the battle scene projected by Michelangelo.

Engraving was one of the chief means by which knowledge of Renaissance art spread through Europe; far from feeling threatened by the new duplicating process, most artists fostered and encouraged it, though Andrea del Sarto and Michelangelo remained outspokenly hostile. Raimondi, the fa-

vorite engraver of Raphael, was given special access to his works and became responsible (in those days of difficult travel) for their being known far beyond the district where the originals were located. In the same way, Lucas Vorsterman was the hand-picked engraver of Rubens. Each engraver has preserved traces of masterpieces by his chosen (or choosing) painter that would otherwise be totally lost to us. Vorsterman provides the only record we have of a grandiose Rubens triptych on the theme of "Saint Job," the original of which was devoured by flames during the Brussels siege of 1695. And Raimondi's plate "The Judgment of Paris" is based on a Raphael drawing that no longer exists. The source of the themes in the picture is so obscure that for many years the story was

96 *Under the influence of Michelangelo's cartoons for "The Battle of Cascina" and Leonardo's for "The Battle of Anghiari," youthful Raphael made several drawings toward a large battle painting of his own. Shortly thereafter he departed Florence for Rome, where ecclesiastical patronage for many years directed him away from military subjects. But the present drawing of a struggle over prisoners suggests something of what his battle might have been like.*

115

current that Raphael, after copying several antique bas-reliefs, destroyed both them and his own drawing—deliberately, so as to leave no suggestion of where the images came from. Thanks to contemporary scholarship, we now know that Raphael combined motifs from two separate classical sarcophagi which he didn't destroy at all, and can see that his vision underlies the composition of Edouard Manet's "Déjeuner sur l'herbe," which so fluttered the Parisian dovecotes in 1863. But the link binding the whole elaborate complex together is simply the engraving of Marcantonio Raimondi, without which all the other components would be no more than disparate and unrelated fragments.

In fact, engravings, which make no pretense of rendering color and have very limited resources for indicating shades of tone, are pretty poor substitutes at their best for an oil painting, and even worse as a means of representing a sculpture. The technique was sometimes used as we now use frankly inadequate black-and-white photographs or minuscule color transparencies: for cataloguing purposes. The grandest enterprise of this sort was carried out by the younger David Teniers, who in 1660 published an engraved catalogue of 244 pictures belonging to the Archduke Leopold Wilhelm; the *Theatrum Pictorium* survives, and some of the pictures illustrated there do not. Teniers also painted a number of "gallery" pictures, in which the archduke is represented standing in front of some forty or fifty of his favorite canvases. This too is a sort of historical record, but one must take "survival" at a pretty humble valuation to rejoice greatly over such an achievement. Finally, in the work of a real vulgarizer like Hieronymus Cock, whose Antwerp shop "Aux Quatre Vents" turned out hundreds of copperplate prints after Bosch, Breughel, and lesser artists during the latter half of the sixteenth century, we sometimes get little more than a few outline-figures and the shape of a composition. That is all that remains of a lost triptych by Bosch; it is our only access to a number of drawings by Breughel that were evidently done with the reproduction process in mind as the final form of the art work. But indeed we have little cause to grieve that some of the Sistine tapestries which Raphael designed have been mutilated or lost, since seven of the ten full-sized original cartoons have miraculously survived and can be seen in the Victoria and Albert Museum.

It's more frequent than we readily suppose that a work of art which we value highly was created for the sake of a further process, the result of which we value less. Many of Goya's paintings, in the Prado and elsewhere, were done as color sketches or cartoons from which tapestries were to be woven; so also with many of the paintings of Rubens, whose whole life was entwined with the tapestry-makers. The cartoons of both masters are likely to be prized as the intimate handiwork of great artists, the finished products dismissed as the mechanical labor of mere artisans. This judgment implies some ideas about the value of absolute "originality" that are peculiar to a still-romantic generation and historically troublesome; it also invites us to think that a tapestry (for example) is a would-be painting carried out in a cumbersome and inappropriate medium. In fact, tapestry, like mosaic, makes very little use of perspective and tends to emphasize intricate designs and flat patterns. We are in great trouble when we have a tapestry made after an original painting that has disappeared; for example, Rogier van der Weyden did four much-praised paint-

98 *Marcantonio Raimondi, "The Judgment of Paris," after a lost drawing by Raphael based on two antique sarcophagi (those of Villa Pamphili and Villa Medici), which still survive. The three competing goddesses are carefully identified by their attributes: Hera by her attendant peacock, Aphrodite by her son Eros, Athena by her shield and helmet; their pose is a variant on that of the three graces. The three figures to the lower right lent their arrangement (across the distance of three and a half centuries) to Manet's "Déjeuner sur l'herbe," a painting which scandalized Napoleon III and his Empress in 1863.*

ings on the theme of Justice for the town hall in Brussels, none of which have come down to us; but in the Historical Museum of Berne, Switzerland, there is a tapestry made from one of these paintings, representing two tales of exemplary justice. We should think very poorly indeed of a painting that looked anything like the Berne tapestry, with its heads all crowded together, its flat and undramatic rendering of the stories. Of course, where we must be content with the reproduction of an original, the ideal situation is to have the secondary work done, in a not too limited and inflexible medium, by the origi-

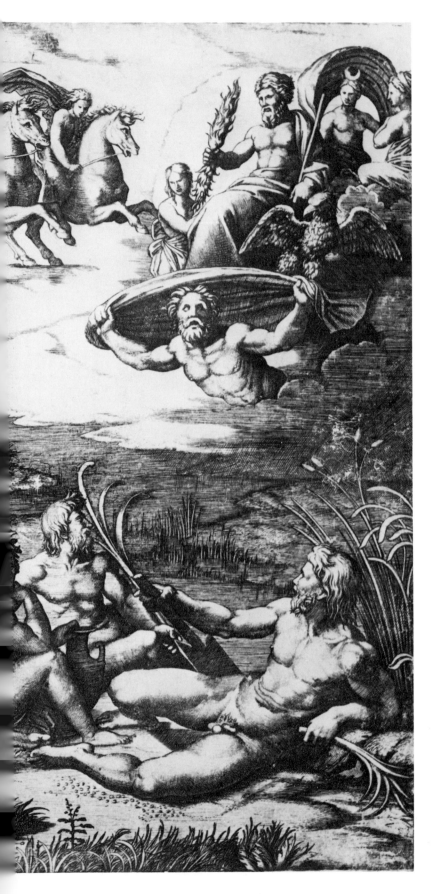

nal artist himself. Since we cannot have the original oil of the "Repentant Magdalen" by that mysterious man Georges de La Tour, we may count ourselves truly fortunate to have an engraving of it from the hand of Georges de La Tour. And though we don't have Bernini's bust of Charles I (it was incinerated in the Whitehall fire of January 5, 1698), hardly anyone thinks of that when he looks at the triple portrait by Van Dyck which was done with that bust in view—as a set of notations on the king's appearance, so to speak, for the sculptor's use

99 *A Roman statue evidently suggested this composition to Raphael; the statue has been lost, but the drawing survives, and so does the engraving made from it by Marcantonio Raimondi. If the drawing, which is in the British Museum, were not by Raphael himself, one might accuse it of being a bit dumpy; the Raimondi engraving, on the other hand, is svelte and poised. It cannot have been unusual for engravers with style and polish of their own to use the name of an artist like Raphael to lend cachet to an effort which on their part was largely original.*

Often we must be content with partial and questionable survivals. The name of Masaccio is legendary in the history of early Florentine art; he died in 1428 at the age of twenty-seven, and we now possess only a fraction of the work he did for Santa Maria del Carmine in Florence. Even that fraction, the Brancacci chapel, has been so damaged, patched, repaired, and supplemented over the centuries that (as with Leonardo's "Last Supper" in Milan), one has to be an archaeologist with a gift for divination to distinguish the few bits of original pigment from the mass of other work. But a figure or two from a now completely demolished painting of Masaccio's, "La Sagra del Carmine," can be glimpsed through a drawing done by Michelangelo while Masaccio's fresco could still be seen; it gives us an idea of the stately solidity of the figures, which made Masaccio's painting a school for artists in the grand style. The dates themselves, in this story of vicarious survival, are intriguing; Masaccio's original painting was done in the 1420s and destroyed in the 1590s; Michelangelo's copy was made around 1502 and reposes in the Albertina Gallery in Vienna to this day; already the scrap of paper has thus lasted nearly three times as long as the solid wall.

The work of art survives less by its own qualities than by the shelter it finds; the plaster miniature survives the full-scale bronze, the sketch outlasts the fresco, and both represent the original long after its splendid dimensions have crumbled to indistinguishable dust. Renaissance buildings often bore elaborately frescoed facades; a few of these images remain, though faded and dim; the majority have weathered away entirely, but reproductions still preserve an intimation of what many were like. Domenico Beccafumi decorated the Borghese Palace in Siena with a set of paintings representing bronze statues of the classical gods standing in painted niches; at the same time, and in open competition with Beccafumi, Sodoma was decorating in fresco the Bardi Palace in the same city. Our aesthetics, which place so much emphasis on authenticity in the use of materials, will perhaps be distressed by such flagrant illusionism. But the Renaissance shared few of our romantic presuppositions, and he who compares the bare facade of the Borghese Palace as it exists today with Beccafumi's sketch of his decorative scheme will not necessarily think the present blank walls an improvement.

100 *Most of the paintings depicted in this visual catalogue of the collection assembled by the Archduke Leopold Wilhelm are still in the Vienna Kunsthistorisches Museum. Teniers' picture-of-pictures is at least useful in telling us how early they entered the collection. Others have migrated to different collections; and some are missing altogether, and must be presumed lost. Unhappily,*

their presence in this painted catalogue does not help us to appreciate them much better than would their names in one of the old written inventories.

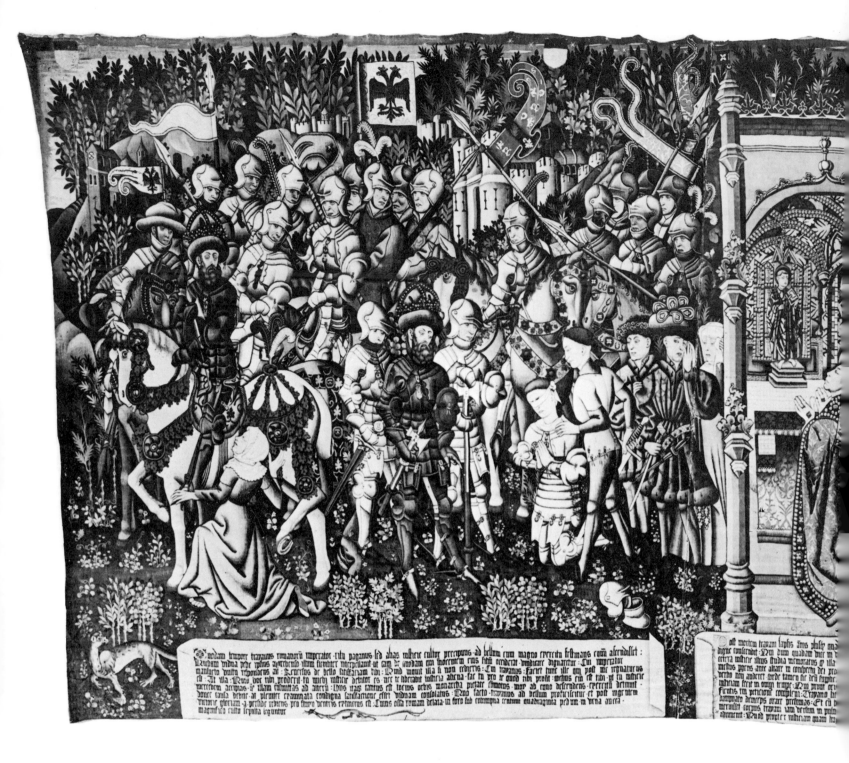

101 *A Hieronymus Cock engraving after a lost triptych of "The Last Judgment" by Hieronymus Bosch. As we can learn by comparing a Cock engraving with one from the same original by another engraver (cf. "The Beleaguered Elephant," figures 136 and 137), Cock was not always meticulous in following the details of the work in front of him. The present engraving, though, is the only representation we have of this particular painting, though the fact that Bosch's original once existed is proved by documents. So we must take Cock's word, if only with reservations, as to what the Bosch was like.*

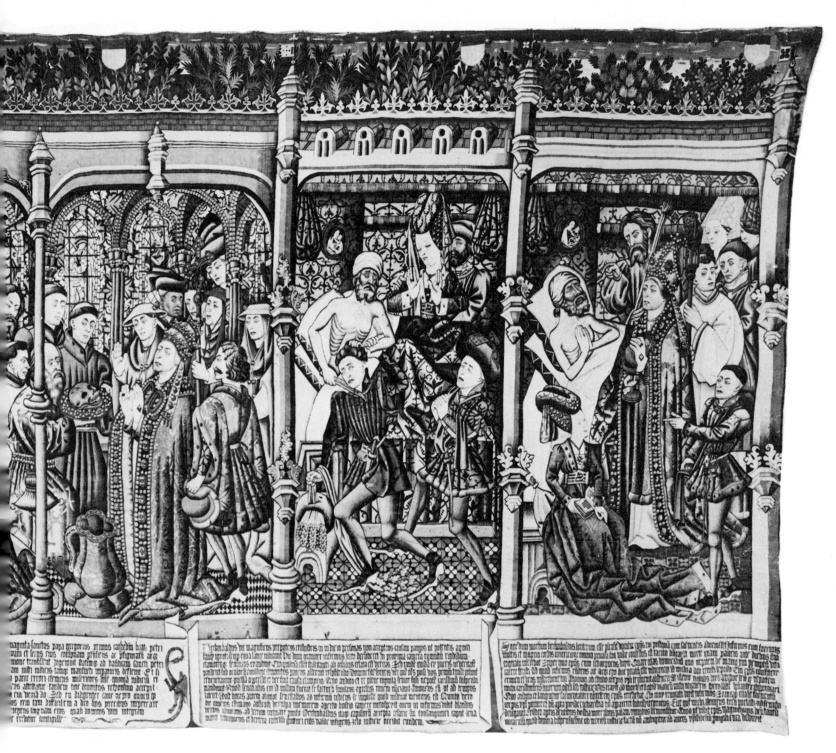

102 *Rogier van der Weyden painted four murals for the newly erected town hall of Brussels during the first part of the fifteenth century. He was town painter of Brussels as early as 1436, and one of the paintings is said to have borne the date 1439. The entire town hall was destroyed in the siege of 1695, and all that survives of Rogier's paintings are copies in various media—among others, this tapestry in the Historical Museum at Berne depicting "The Justice of Trajan" and "The Justice of Herkinbald." The legends, though slightly disgusting, are very edifying. Trajan broke off a campaign to heed the pleas of a widow whose son had been murdered; as a result of his decision, the villain was brought to justice. Long after the emperor was dead, the tongue which pronounced this virtuous decision was found, fresh and vital, in his skull: Pope Gregory quite properly declared it a miracle. As for Herkinbald, even while lying on his deathbed he found energy to cut his own nephew's throat for debauching a maiden. For this deed the bishop wanted to refuse him absolution, but the dying man, opening his mouth, showed that there was already a host in it.*

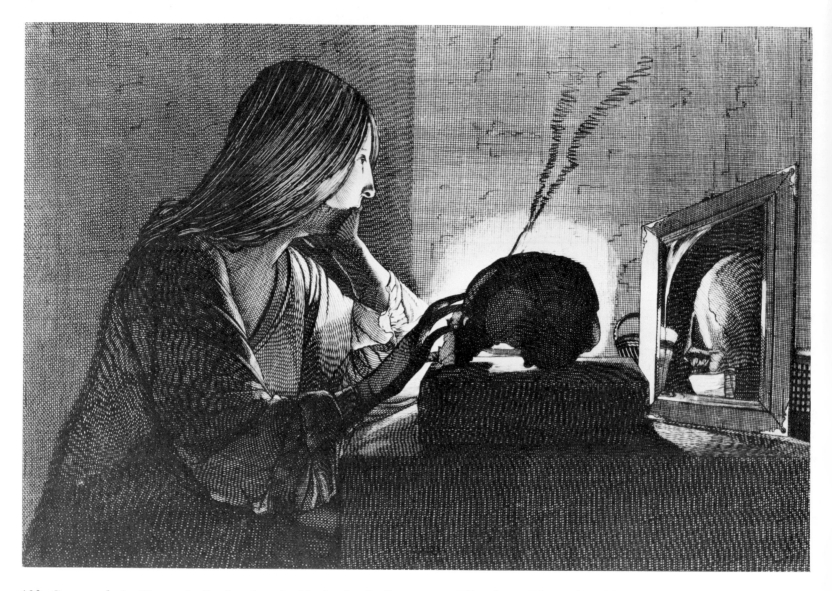

103 *Georges de La Tour, who lived and worked in the first half of the seventeenth century, spent his entire life in Lorraine, in circumstances of such obscurity that his very existence has had to be reconstructed over the last half-century. He was particularly fond of the theme of the repentant Magdalen, painting this picture many times over with slight but significant variations. Some half-dozen Magdalens by La Tour survive, and this engraving (by La Tour himself) is evidence of another one which did not.*

Giorgione did a series of frescoes on the facade of the Fondaco dei Tedeschi in Venice, which would be of extraordinary interest if they survived, for we think of Giorgione as a painter of mysterious, evocative landscapes and dark allegories. But the frescoes on the Fondaco dei Tedeschi (of which we get the best impression from later engravings) were a public statement—they couldn't be the same as those richly colored and mood-dominated easel paintings. Or could they? On at least one detail the etchings help us to sense that even here on a public building Giorgione was an intricate and allusive man. The Fondaco was erected as a headquarters for German trading and banking interests in Venice; in 1510 a breakdown occurred in economic relations between the two powers, over which the Venetians felt aggrieved. Consequently Giorgione worked into his fresco the figure of a German soldier concealing a sword behind his back and assuming a posture recognizable from the emblem books as that of Treachery. We know the character of the fresco from an early, and relatively bad, engraving by Piccino. Zanetti did a later, and technically much better, engraving of it in the late eighteenth century; but by then the treacherous German had flaked off the wall completely. So that here, as many times elsewhere, the worse reproduction is the more useful report.

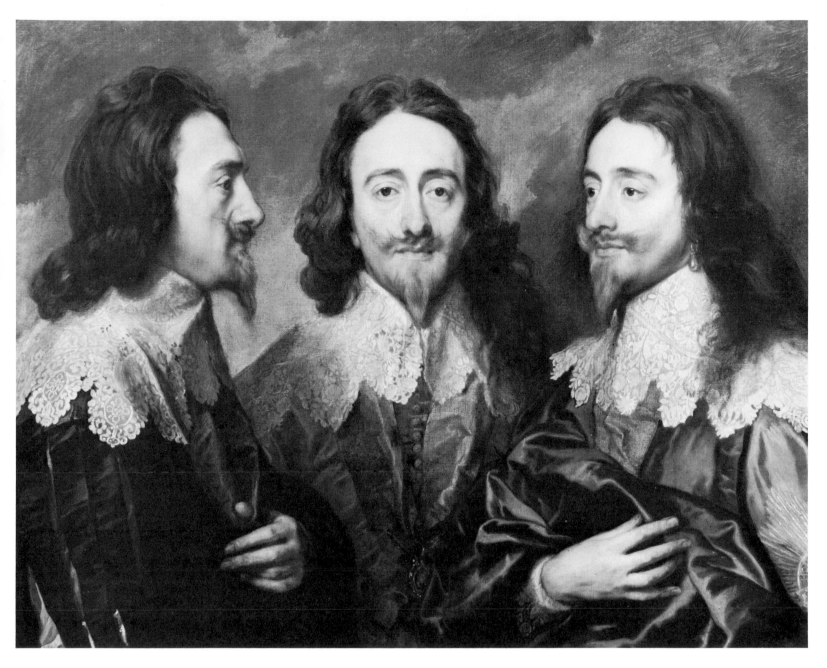

104 *To enable Gian Lorenzo Bernini to make a portrait bust of England's Charles I, Sir Anthony Van Dyck was commissioned to paint a triple portrait of His Majesty. Bernini's bust was cast, sent to England, and lost in a fire; the triple portrait survives, to represent just those qualities of the noble and ill-starred monarch that we think might have led him to his fate. Though gallant and heroic enough, he simply does not look like a man of broad sympathies.*

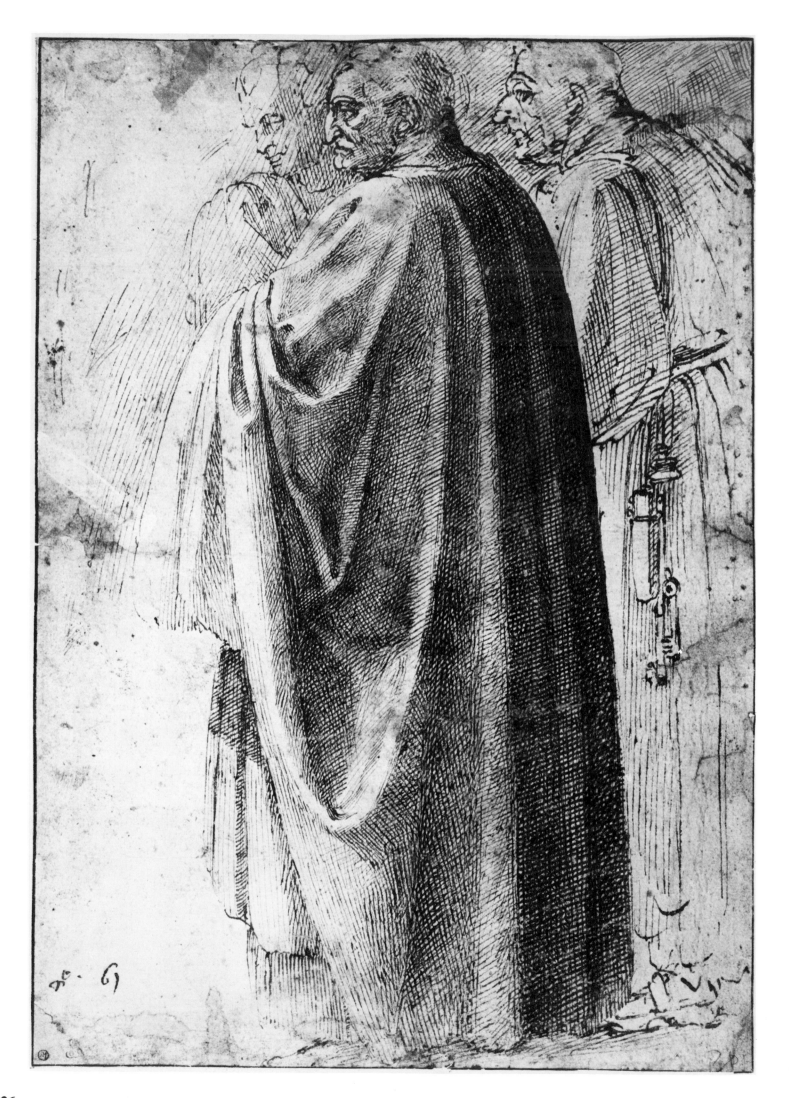

126

105 *Michelangelo's drawing after Masaccio's lost fresco "La Sagra del Carmine" reveals not only the massive solidity of Masaccio's work, but also the fact that, like Michelangelo, he was no great respecter of persons. The procession he painted evidently included many portraits of actual Florentine citizens, and the ones Michelangelo has preserved for us do not fall far short of caricature.*

106 *Domenico Beccafumi painted the façade of the Borghese Palace in Siena around 1512; at the same time, according to Vasari, the painter nicknamed Sodoma was painting the façade of the Bardi Palace in the same city. The paintings themselves both weathered away, Sodoma's faster than Beccafumi's, but in both instances till nothing was left. The drawing we reproduce was first identified by Erwin Panofsky as a study by Beccafumi for his decoration; it may stand as a meager reminder that painting the exterior of buildings, either as a permanent decoration or by way of celebrating a particular occasion, was common practice in the Renaissance. In the nature of things, such paintings were extraordinarily vulnerable, and we must exercise our imaginations to conceive of a civilization in which the public streets were, in effect, galleries of fine painting.*

We know very little about Giorgione except that he was a man about whom there was obviously a great deal to know. An engraving by Wenceslaus Hollar after a Giorgione original once in the famous Arundel collection, but now lost, preserves for us the image of a self-portrait he painted, depicting himself with a curiously intent expression in the allegorical person of David. Did he think of himself as, like David, the redeemer of his country from the Philistines? Whatever Florentines might do, Venetians did not generally strike such heroic poses. But Giorgione was not typical of anything but himself—and it is thanks to these reproductions of lost paintings (among other things) that we have so complex and rich a sense of the mystery of his personality.

In America, where private houses are made predominantly of wood, their life expectancy is calculated in decades; when they last a century they are remarkable, and two centuries are likely to earn them a bronze plaque from the local antiquarian society. In Europe, where brick and stone are more often the materials, the shells of domestic houses tend to last much longer, but it's still very rare for them to last through several generations with their furnishings and decorations relatively undisturbed. More than five hundred years have passed since the Venetian condottiere Gattamelata died (1443) and Andrea Mantegna (or so the story goes) painted, over the mantelpiece of a house in Padua where he was living, the terrible scene of the mourning for the dead leader. The painting is long since gone, along with the house it decorated; but there is a drawing either from or toward it in the Wallace Collection, London. Two sixteenth-century historians of Padua support the story that Mantegna did such a painting, and two prints of the design, one made in the sixteenth century, one in the eighteenth, also make the attribution; yet modern art historians have decided that there is more than a trace of Antonio Pollaiuolo in the drawing—though Pollaiuolo, who was a Florentine, had no particular reason to bewail Gattamelata, and was only fourteen years old at the death of the condottiere. Of course the drawing looks more like Pollaiuolo than like Mantegna; but if we take away from Mantegna everything that does not look like our idea of Mantegna, we shall perhaps be creating, not simply defining, the characteristics of our artist. Ben Jonson, one notes, wrote a number of poems that sound very much like Donne—it is a strong argument for widening our notion of Jonson's poetic capabilities, but not for reconsidering attributions.

TICIANVS Pinxit Steffäo, Scolari forma uenetia.

128

108 *Giorgione's portrait of himself in the guise of David was engraved by Wenceslaus Hollar while it was momentarily in the Arundel collection early in the seventeenth century. Several painted replicas also survive in Braunschweig and Budapest, but neither of them is as challenging and direct in its expression as Hollar's engraving made from the long-lost original.*

107 *Giacomo Piccino, engraving after Giorgione of the "Treacherous German" painted on the Fondaco dei Tedeschi in Venice sometime after 1510. The original fresco was sometimes titled "The Triumph of Justice," but the figure of justice looks very much like a female David triumphing over Goliath, and this theme cannot help reminding us of Giorgione's self-portrait (figure 108) in which he himself assumed the image of a David. Since Piccino did the engraving, in 1658, the entire picture has disappeared. Incidentally, the engraver's comment that Titian did the original painting is not wholly mistaken, since Titian was Giorgione's assistant in the project.*

130

131

Anterior facies musiuea veteris Vati:
canæ Basilicæ à Gregorio IX ornata.
Atrium, Pinea, Porticus, &
Palatiu̅ Innocentianu̅.

Pinea aenea.

109 *The Venetian general Erasmo de Narni, nicknamed Gatta-*
melata, died at Padua in 1443, to the intense dismay of the Vene-
tians, who had not lately had many generals whom they could
trust. Mantegna, though he was only twelve when the general
died, must have been impressed by the event, because we know
from several documentary sources that in later years he had over
the fireplace of his house in Padua a painting of "The Lament
for the Death of Gattamelata." For years this drawing passed as
a representation of that painting, and so it may be; but a con-
sensus of art historians seems inclined to attribute the drawing,
on stylistic grounds, to Pollaiuolo. Certainly if a painting of this
general character were in any sense Mantegna's work (and no-
body says anything about a Pollaiuolo painting on this theme), it
would require a considerable expansion in our view of Man-
tegna's expressive range. And if it were Pollaiuolo's painting, as
well as his drawing, it would make us aware of an interest on his
part in recent Venetian history, which otherwise we should have
no reason to suspect.

110 *Old Saint Peter's, predecessor of the present basilica. The*
drawing has been damaged, especially on the right page, by
printed plaques drawn on the back of the sheet which have struck
through. A curious feature is the "Pinea aenea" or brass pine-
cone in the center of the courtyard; it was one of those odd ob-
jects left over from antiquity of which the Middle Ages and the
Renaissance were fond, simply as curiosities. It is still to be seen
at the Vatican, in the Belvedere courtyard.

111 *Whether it was Parmigianino or someone else who made this drawing of Raphael's now-long-destroyed Roman palazzo, he saw it so differently from Palladio that it seems like a quite different building. Since there may well have been as much as a fifty-year difference in the date of the two drawings (Palladio's being the later), it is possible that the rustication which plays such a large part in the later drawing was either an actual or a proposed modification of the original design. This is the more likely because the structure in the earlier sketch looks undeniably topheavy.*

112 *Two men recording the same building may give us very different reports, depending not only on their moods but on their professional interests. During the last years of his life, Raphael, working with Bramante, built a town house appropriate for the sort of artist-prince he had become. Both Palladio and an artist who may or may not have been Parmigianino made drawings of it. Palladio's drawing shows his clear interest in the structural details, his power to record swiftly and economically just those elements of a design that would be of most use to him. He drew, in other words, as a professional, and, having recorded one corner of the house and a detailed view of the lower windows, knew everything he needed to know. The drawing attributed to Parmigianino probably isn't by him at all, and though it is said to be in the Uffizi, the Gabinetto delle Stampe there has been unable to locate it.*

113 *Given the climate of Buffalo, New York, Frank Lloyd Wright could not make use of an open courtyard as a core of his building for the Larkin Company. But he did give it an airy, open quality most unusual for its day (1904).*

Buildings in some cities seem to have much higher mortality rates than in others; the intricate story of the several structures that previously occupied the ground where Saint Peter's Church now stands is only typical, in its successive constructions, destructions, reconstructions, and adaptations, of building in Rome across the centuries. Private "palaces," as the Italians call them (but we should more likely refer to them as town houses), rose and fell even more rapidly than the churches. Raphael designed such a house for his own use, but it lasted barely long enough for one sketcher, doubtfully identified with Parmigianino, to make a drawing of it, and another to suggest a remodeling of it, before it was completely demolished. Rome, as we've noted, was famous throughout the Renaissance for this quality of tearing itself up; one could contrast it with a city like Vicenza, which has changed very little since Palladio stamped his character on it, or Siena, which has accepted gracefully existence as a backwater. But surely no place or period in the world's history bears comparison with

114 *Richardson's Marshall Field building in Chicago looks so massive and impressive in this photograph that it seems built to withstand the ages. But the price of prime land in any major downtown area forces almost any structure that is erected on it into premature obsolescence. Richardson's store was much admired and widely influential, but it was demolished barely forty-five years after being put up.*

115 *Caravaggio painted "The Martyrdom of Saint Matthew"*
for a chapel of San Luigi dei Francesi in Rome. The commission
was one of his first in that city, he may have been unaccustomed
to working in large dimensions, and from the first, his work was
under intense and not very friendly scrutiny because his figures
seemed to lack nobility. The story depicted here, of the saint's
martyrdom, was based, not on Scripture, but on the Acta Sanc-
torum; *King Hirtacus of Ethiopia, according to this pious legend,*
was responsible for the death of the evangelist. But Caravaggio
boldly made the brutal executioner the central figure of his pic-
ture. For the many alternate versions through which the painter
struggled before his picture reached final form, we must look at
the X-rays (figure 116).

America as a devourer of its own past. The story is too large to
be written here as a mere appendage to a discussion of the Re-
naissance; but as we marvel at the readiness of Rome to de-
stroy the work of its greatest designers and architects, and to
throw up new structures quickly, we should recall that in our
own time much of the pioneering work done by Frank Lloyd
Wright and other major American architects has fallen under
the wrecker's ball. Wright's Larkin Building in Buffalo, an
imaginative achievement of first importance, was erected in
1904 and sold for salvage in 1949. H. H. Richardson's Mar-
shall Field department store in Chicago, massive and substan-
tial as it appears in its photograph (exactly like a Renaissance
palazzo, as a matter of fact), endured for precisely the same
length of time; erected in 1885, and given unqualified praise
by Louis Sullivan, it was demolished in 1930. Compared with

116 *X-ray photographs of a picture are taken one area of the canvas at a time and then pieced together; they do not clearly discriminate one layer of underpainting from another. So it is no wonder if the X-rays of Caravaggio's "Martyrdom of Saint Matthew," which the artist repainted several times, appear a good deal of a mess. The saint's posture has been completely altered, the winged angel at lower right has been eliminated, so has a bearded man toward whom he was evidently reaching, and so have the terrified features of a girl who can be located by counting from the lower left corner three squares over and four squares up.*

117 *The story of Andrea del Castagno's reputation as an artist is almost entirely the story of how his paintings have been recovered from under other things. In 1847 an entire fresco cycle was recovered in Villa Pandolfini near Florence; in 1899 "The Trinity with Saint Jerome and Two Female Saints" emerged from behind blank walls in the Girolamo Corboli chapel of the Santissima Annunziata; in 1953 scenes from the Passion of Christ were recovered in the refectory of Saint Apollonia. Finally in the great Arno flood of 1967, water so soaked the fresco of "The Trinity with Saint Jerome" that the painting was detached from the wall to save it, and an extremely interesting sinopia, showing a very different version of the finished picture, was revealed underneath it.*

such mushroom rises and precipitous falls, the Renaissance rage to build and destroy seems almost mild and temperate.

In one area of our dealings with old buildings, however, modern technology has scored outstanding and unquestionable successes. If anything whatever of painting or decoration survives on an old wall, at whatever depth, in whatever state of repair, the skill of modern restorers and conservers can bring it out.* Vast romantic frescoes by Pisanello have been recovered from under layers of plaster and whitewash on the walls of the Palace of the Dukes in Mantua; there is even talk now of recovering some traces of the "Battle of Anghiari" images made by Leonardo on the walls of the great hall of the Palazzo Vecchio—images which have been considered hopelessly out of reach since the first part of the sixteenth century. Not only is it possible, using modern techniques, to strip off inert and worthless material covering a painting; it's possible in some cases to uncover an original painting without destroying the second painting with which it was covered; or to look with X-rays beneath the various overpaintings of a picture on canvas—for example, Caravaggio's "Martyrdom of Saint Matthew"—to reveal the painting that the artist originally had in mind, and the stages of its development toward a final version. A technique developed only during the past few years has become almost commonplace in the study of frescoes; it is to detach the painting proper from its supporting wall, so as to mount it (or as much of it as survives) in a more secure position; under it, investigators are likely to find the artist's original chalk drawing, known from the city in Asia Minor where the reddish-brown chalk originated, as a sinopia. Very often the sinopia is different from or even more forceful than the finished painting. For example, when Andrea del Castagno's fresco of Saint Jerome between two saints in the Santissima Annunziata was damaged by the great Florence flood of 1966, it was carefully taken off its wall, and the sinopia underneath was just as carefully preserved. It shows in the first place that the whole upper half of the picture was not originally worked out in such detail as the finished image contains, nor was the lion present; more important than these details, which Andrea could have left for later development even though he had them in mind from the beginning, is the handling of the drapery in the original sketch, much more fluid and delicate than in the finished picture. Sinopie of this sort are not properly lost works of art, even though they haven't been seen by human eyes for four or five hundred years; but they do exist and they are available now for recovery. What they suggest is the great quantity of art that is concealed by other art—the paintings hidden beneath other paintings; the statues reworked into other statues (a crucified Christ converted hundreds of years ago into a San Vicenzo and only re-

*Only recently have we had simple, safe, standard chemicals to kill the borers and tunneling worms which for centuries have been working through the wood panels on which old pictures were often painted. Altarpieces that were gradually being reduced to the consistency of a sponge not only can be spared further erosion, but by safe and simple means can be given a new firm texture. Inpainting (that is, filling in lost sections of a painting) is still a problematic procedure. But routine operations, like clearing away previous overpaintings and corrections, or merely cleaning off the accumulated grime from a painted surface, may result in tremendous improvements. It's not too much to say that Europe is experiencing a wave of new interest in restoration procedures. Many shows are organized around this theme alone. Even minor works in provincial museums, when viewed from the rear, may turn out to be supported on a structure of finely tuned drums and struts, newly stretched canvas, pegs, braces, and closely fitted inserts that make one think of the works of a fine piano.

118 *In the sinopia, the trinity is only vaguely indicated, the lion is missing, the saint's expression and the direction of his glance have been radically changed, and the whole focus is less upward than in the finished picture. In the language of gesture, which counts for so much in figure painting, there is a world of difference between the saint's left hand and arm in the sinopia and in the final fresco.*

119 *An ancient Inca wall standing inside the church of Santo Domingo in Cuzco, Peru. Even though the Spanish wall was built with stones dragged out of earlier Inca structures, the relative looseness of their building is apparent, alongside the massive solidity of the Inca work, which in addition to its colossal dimensions is absolutely precise in using no mortar to fill the joints and in being calculated to exact astronomical specifications. For centuries past, it goes without saying, a major function of the Spanish overstructure was to hide from sight the impressive Inca substructure.*

120 *Titian was asked to finish or redo Giovanni Bellini's "Feast of the Gods" because Bellini was old and his style did not harmonize with that of three other paintings done by Titian alone for the studiolo of Alfonso I d'Este in the Castle of Ferrara. In repainting Bellini's original, Titian vigorously altered the landscape; he also made many alterations in the figures, changing their postures, undressing the nymphs, and causing Neptune casually to push his hand between Cybele's legs. X-rays show that Bellini's painting was different from Titian's, but they are the only way we can get at it to compare the two. Thus within a single frame we have two major Renaissance paintings, one of which is separated from our view only by a single precious millimeter of pigment, constituting the other. A full study of the picture has been made by John Walker under the title* Bellini and Titian at Ferrara.

cently brought to light); the marvelously constructed Inca Temple of the Sun in Cuzco, buried for hundreds of years under the slapdash rubble masonry of the Church of Santo Domingo erected by Peru's rude conquerors, and only now being gradually dug out.

A special aspect of art-overlain-by-art has to do with fakes. Especially nowadays, when elaborate chemical techniques are available to analyze canvas and pigments of a painting pretending to antiquity, the tricksters of the art world are likely to take as the basis of their swindling a genuinely old but completely undistinguished canvas, which they touch up with details they consider characteristic, or at any rate likely to enhance the price. For example, a decent dull portrait of a respectable Dutch burgher easily turned into a portrait of Henry VIII, but was just as easily stripped of its borrowed plumes, at least over half of its area, by an unsympathetic student of fraud. Repainting an old picture, or adding to it, may be a way

of disguising the fact that it's been stolen, or it may be simply a way of adapting an old painting to the tastes of another period. A perfectly good figure from the Paumgartner Altarpiece by Dürer was botched up with a new landscape, mostly cribbed out of Dürer's engraving "Knight, Death, and the Devil," simply because as an isolated figure of Saint Eustace it seemed to make little sense out of its original context. Thus the original crime of disintegrating the altarpiece was compounded by repainting the various pieces to make them pictorially self-sufficient—to the effect of first destroying the original as a complex, and then redestroying its various individual pieces as well.

121 *In addition to erasing the full grove of trees that Bellini had used as the background for his pagan festival, Titian introduced emblematic devices such as the caduceus of Mercury, the eagle of Jove just over Cybele's shoulder, and the trident lying at Neptune's feet. And he radically altered the neckline, not to mention the proportions, of the nymph bearing a jar on the right-hand side of the picture.*

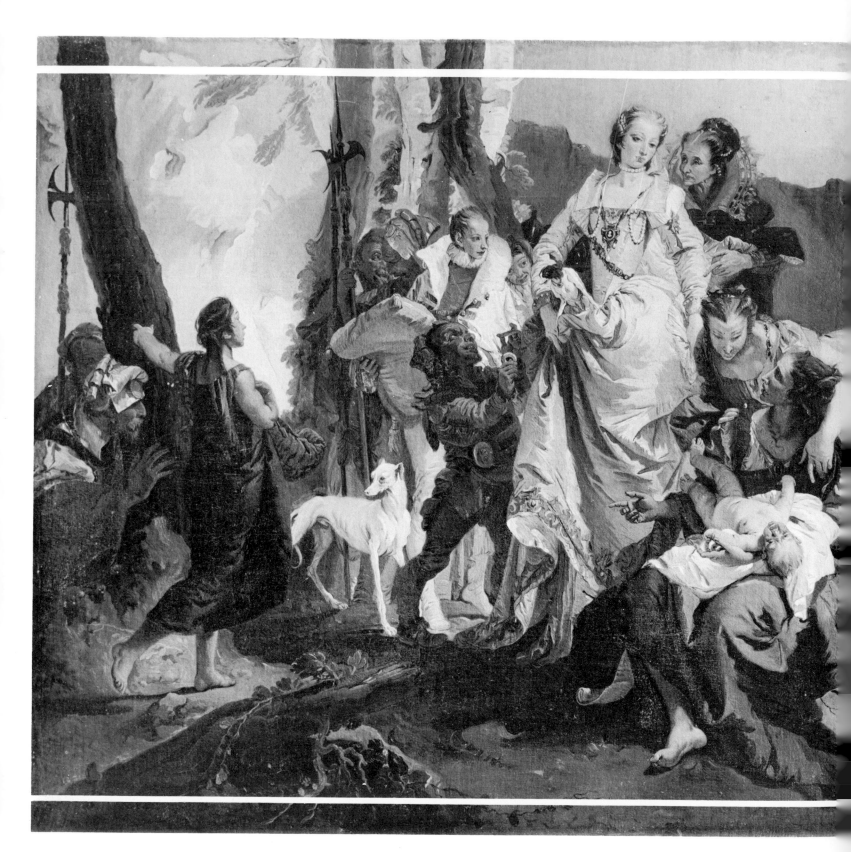

122 *The dismemberment of Tiepolo's "Moses Saved from the Waters" is indicated here by lines drawn on the photo of an old copy made before the original was cut up. If one were visiting galleries, one would naturally want to see the original, or at least the bigger and more interesting piece of it, at Edinburgh. But if one were preparing a photographic color reproduction, to be run off in thousands of copies on high-speed presses requiring quick-drying inks, it's quite possible that the qualities that make the original superior to the copy would hardly come through at all—*

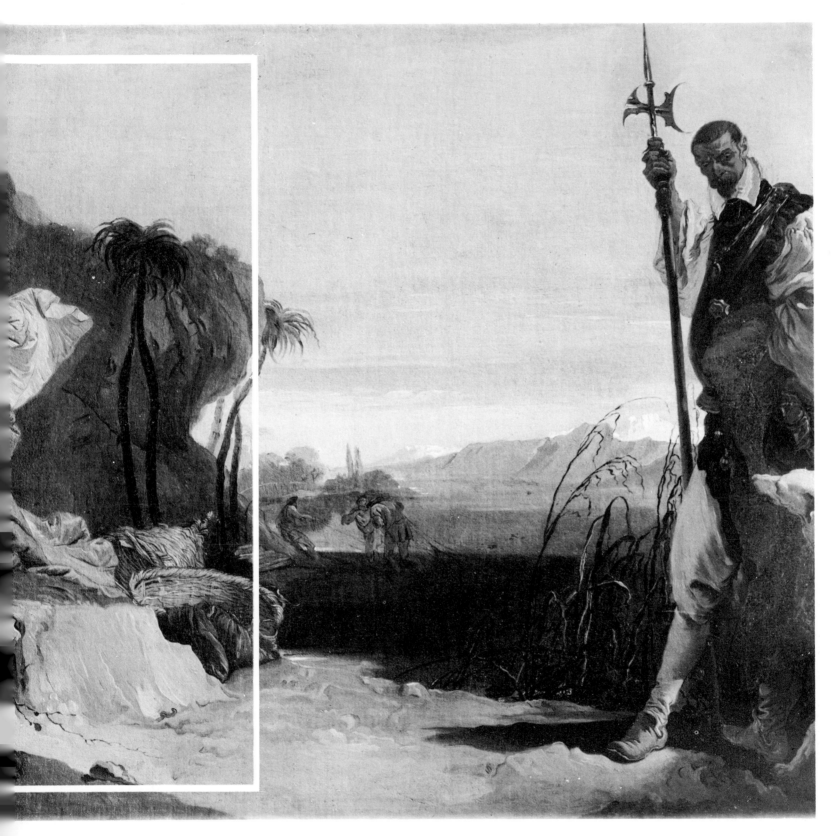

whereas the copy at least preserves the broad shape of Tiepolo's intent, including the Nile River, some bulrushes, and a counterpoint of halberds. To think carefully about the painting and what it reveals of the painter's vision, one would clearly have to know it under both aspects; so that, in effect, as a work of art creating a single unequivocal visual impact, it has been destroyed for us. We can see its real texture only in Edinburgh and Turin, its real spatial architecture only in Stuttgart.

144

Even perfectly good intentions may impose on a dead and therefore unprotesting artist false standards of taste. Stuttgart has a copy of Tiepolo's picture "Moses Saved from the Waters" as it was before being cut up and cut down. The main part of the splendid original is now in the National Museum, Edinburgh, but a separate figure of a Halberdier is in a private collection in Turin. When joined together, they made a very different and rather spaced-out picture. In addition, the differing dimensions of the two sections show that the top was trimmed off the Edinburgh canvas. Perhaps these changes look like minor matters, or even improvements, since they focus one's attention on the central scene of Moses and Pharaoh's daughter. But this desire to have a pre-focused scene is typical of a society brought up on easel paintings; Tiepolo's special quality of cool, disengaged sensuality, of air and balance and a kind of wandering option for the eye, is lost when his stretched-out original is cut down to two well-made paintings. An immense early Tiepolo in the Brera, the *Madonna del Carmelo e le anime del Purgatorio,* is full of wide, vacant (but taut) spaces now, as it was when first painted for the church of Sant'Apollinare in Venice; but when taken to France by Napoleon, it was sawed in two, the better to fit the taste of the times.

Let us end this turbulent chapter on a calm and quiet note. How much richer our knowledge of the past would now be if more men had lived of the retiring and contemplative disposition of Pieter Janszoon Saenredam. He was a native of Haarlem, a cripple, and something of a recluse; he lived during the first half of the seventeenth century and devoted his life to church interiors. They are cool and meditative pictures; close students of the work assure us that they are literally accurate, down to the last meticulous detail. But they are not sharp, hard architectural drawings: the mood is all-important and it is always hushed, the human figures are few and remote. The church and its atmosphere are everything, and as numbers of these churches no longer exist, Saenredam's pictures are our best, and sometimes our only, authority for what they were like. For example, Saint Peter's in 's Hertogenbosch was demolished in 1646, and the nave of Saint Martin's Cathedral in Utrecht collapsed during a 1674 hurricane and was never rebuilt. But in the luminous painting of Saenredam, these buildings still live. He is the Vermeer of architectural drawing, and one can only regret that what he did with such quiet, painstaking authority was not attempted more widely elsewhere and by others.

123 *Pieter Janszoon Saenredam, the interior of Saint Peter's Church in 's Hertogenbosch. The church was demolished in 1646, fourteen years after the drawing was made.*

124 *Saint Martin's Cathedral Church in Utrecht, by Saenredam; the church was largely destroyed by a hurricane in 1674.*

S.t Maertens Doms kerck, binnen uijttrecht.

The label in the image reads: TICIANVS INVENTOR MARTINVS ROTA SIBE F.

148

4/THE MAKING AND BREAKING OF COLLECTIONS

Fires and wars, like earthquakes and floods, we always have with us; but they are particularly destructive to works of art when gathered together in large collections. Indeed, the practice of collecting is a deeply ambiguous activity as far as the survival of art is concerned. On the one hand, collecting art is an obvious form of preservation. The works are kept in a relatively secluded place where they can be seen in a proper light and receive some form of physical protection from the elements, as well as from greasy-fingered, graffiti-writing viewers. Collections also function to art's generous advantage because they lead to cataloguing and identification. Such work was difficult at best in the days before photography, and all but impossible when the works of any given artist were mixed with those of his imitators and diffused through an array of darkened churches, private galleries, and royal suites to which only flunkies and visiting nobility were admitted. In museums and collections, we can compare closely several works by the same artist, and see confidently what they have in common. We can also distinguish styles that look the same but aren't. Copies and forgeries have been a problem since earliest antiquity; collectors, with their pride of possession, were among the first to be interested in the authenticity of works of art, and that interest carries with it careful study of the specific piece, identification of the artist's characteristic traits, concern for documentation, and, ultimately, aesthetic training.

On the other side of the coin, collectors can be extremely bad for art. They are predatory and often violent in the pursuit of what they want; they will rip paintings or statues out of churches or chapels, and dismember intricate decorative unities to get for themselves at least a piece. Just in the process of moving delicate things around, they manage to break a good many of them, from sheer avidity of possession. Worse still, once collections are assembled, large numbers of artworks are *ipso facto* exposed to danger from single acts of war, sabotage, fire, and neglect. Big fish eat little fish: it is the law of collectors. In 1632 Gustavus Adolphus captured Munich and looted the vast collections of Maximilian, as Maximilian had previously, in 1623, looted the collections of the Elector Palatine Frederick V. Collections of art are fat prizes of portable wealth; apart from becoming the prey of conquerors and thieves, they serve as badges of privilege, and are attacked as such in the course of social upheavals. Even when established in a collection and free from outside danger, the work of art is not altogether safe from its owner. Collectors with preconceived ideas of what a particular artist should look like tend to persuade the paintings they own to look like that—they clean, they patch, they overpaint, they scrape off layers of varnish and with it the layers of glaze painfully applied by the artist. (This is why so many old paintings in German museums look like candy-box covers.) And though, ostensibly, they are wary of forgery, in fact collectors encourage the practice, first through their avidity in collecting, and then through self-interest, once stung. The owner who has a forgery and knows it becomes an instant accomplice of the forger because he wants to get his money back and protect his self-esteem: in order to dispose of the fake, he is bound to proclaim its genuineness. Collectors have even been known to have copies (i.e., forgeries)

125 *No cataclysm accounted for the disappearance of Titian's much-admired and unusually agitated "Death of Saint Peter Martyr"; one quiet day in the middle of the nineteenth century it simply burnt up. The print, by Martino Rota, is from the sixteenth century. Not everyone who has been in a position to make the comparison of Rota's copies with his originals has been impressed by his accuracy or delicacy of touch. He was a Dalmatian, or, as we would say, a Yugoslav, and some national jealousy may have entered into criticism of his work. But as to his copy of this Titian painting, we are faced with Hobson's choice—it's "this or nothing."*

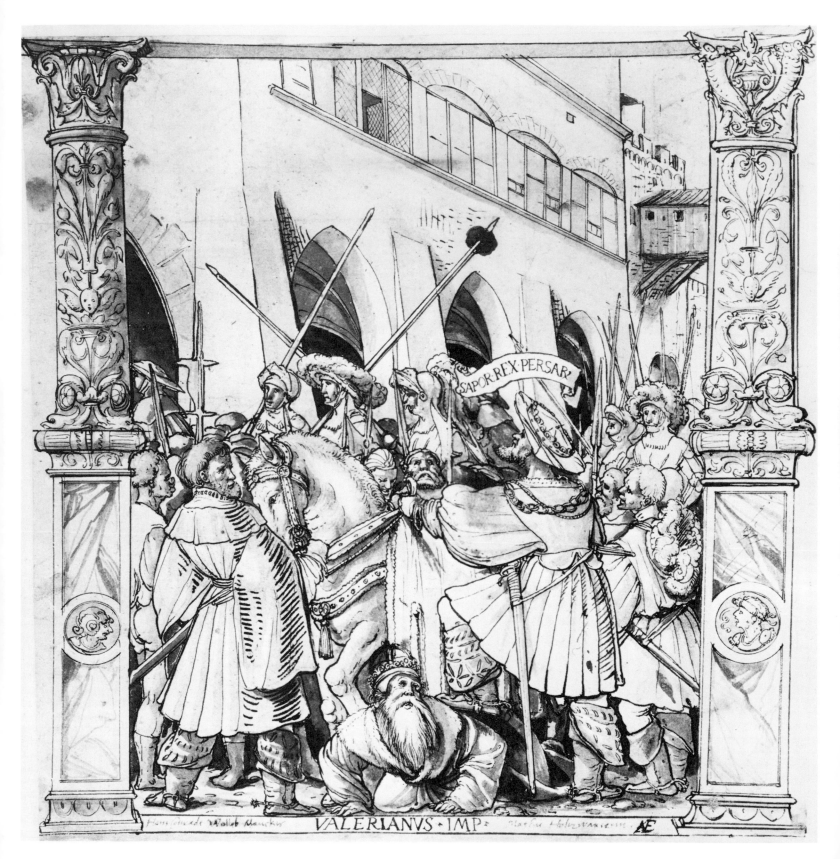

SAPOR·REX·PERSAR·

VALERIANVS·IMP·

126,127 *Hans Holbein the Younger fancied himself not merely a portraitist and a jeweler but a muralist, that is, a painter of large scenes with significant public moral points to make. "The Bride of Sapor" depicts a king of the Persians who used Emperor Valerianus as a footstool, and "The Suicide of Charondas" represents the ancient lawgiver who accidentally violated his own law against bringing a sword into the senate, and when his error was pointed out, promptly used the weapon to dispatch himself. Both these drawings were created to serve as a basis for larger murals in the town hall of Holbein's native Basel. The murals have long since moldered away; the drawings remain.*

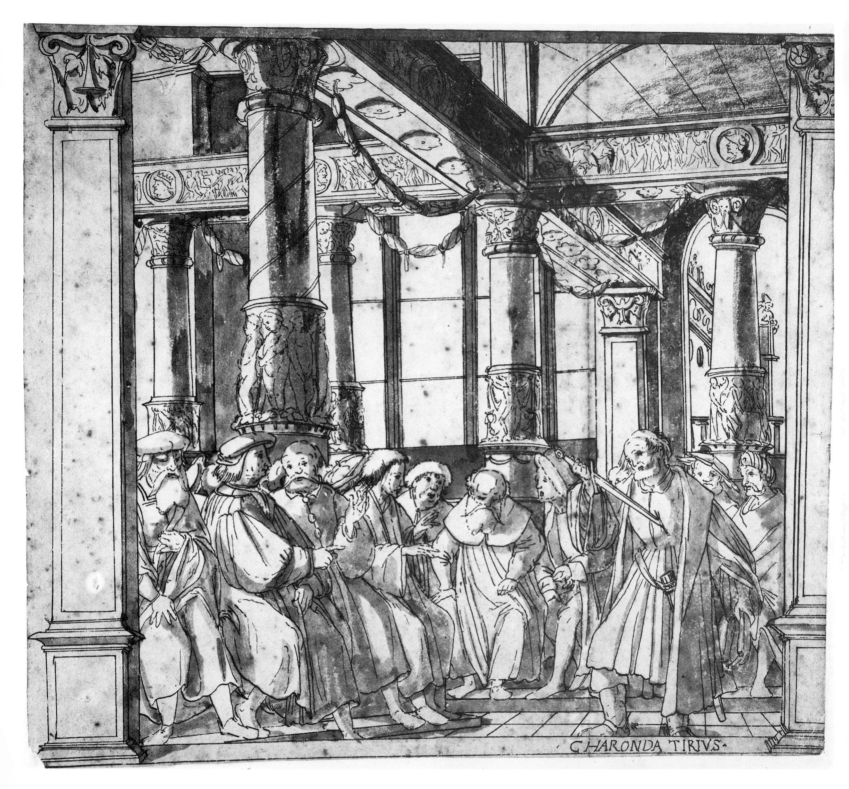

made to replace originals that they wanted to abstract from their established places without arousing too much indignation. This was a frequent practice of Baron Vivant Denon, Napoleon's commissar in charge of art theft.

We note in passing that the collection- or museum-experience has qualities of its own which radically color our response to individual paintings. A picture is simply not the same object when it is the focus of a quiet little chapel as when it is hanging on a long wall competing for attention with four or five hundred other paintings. A collection emphasizes "masterpieces"; where hundreds of paintings are gathered together, the viewer whose time is limited will want to see "the best," i.e., those that he's told are the best. If he isn't under the control of a guide, he will look at the nameplates under the pictures rather than the pictures themselves, training himself thereby in appreciation by rote, which is the palest possible ghost of real appreciation. Besides, masterpieces not only push all their competitors into a blurry, undistinguished background, they are often tonally incongruous with one another, so that a full-blown Rubens rubs shoulders with a gaunt El Greco, and pale Fra Angelico is washed out by the ripe colors of Veronese. The visitor, forced to adapt to each in turn, or all at once, suffers like a chameleon on a Scotch plaid. All this means is that viewing art collections requires some self-im-

128 *Famous sculptors are often asked to do portraits of famous people on whom they have never laid eyes. In 1818, when Washington had been dead almost twenty years, Antonio Canova was asked to represent him for the North Carolina State House in Raleigh. Drawing on his imagination and on the popular image of Washington as a man of peace as well as war, he produced an image halfway between that of a Roman commander and that of a landscape artist in action. In the back of his mind was no doubt a deliberate contrast with Napoleon, whom Canova had seen and represented as a young firebrand. But the statue of Washington cannot be pronounced a striking success, and the plaster model at Possagno probably represents the lost original about as fully as need be done.*

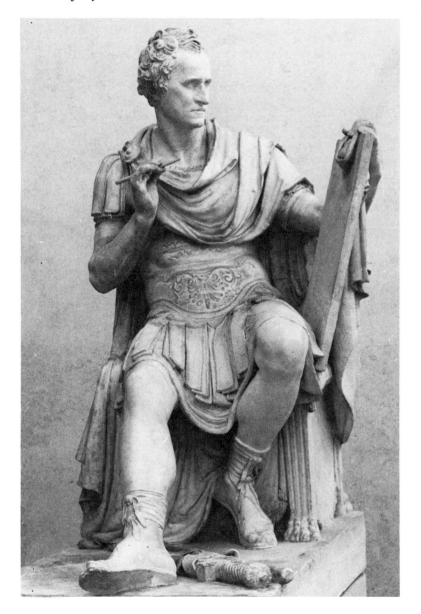

129 *Michelangelo's painting of Leda was originally (1529) created for Alfonso d'Este, duke of Ferrara, but the messenger sent to pick it up was so rude that Michelangelo, in a rage, gave both the picture and a cartoon for it to a student and assistant, Antonio Mini. Mini tried to sell the painting to Francis I, but lost it to a treacherous banker and died in the process of trying to get it back. The painting itself has disappeared (perhaps burnt in a fit of prudery by Anne of Austria about 1640, or else ruined by*

clumsy restorers), but several copies were made, of which that by
Cornelis Bos, though it's a mirror image of the original, is partic-
ularly interesting because it shows the act of intercourse, the egg
that resulted (with Castor and Pollux dimly outlined inside it),
and the two boys, after hatching, in the background. Most of the
painted versions show none of these; Bos, with his strong stomach
for the grotesque, was up to representing it.

130 *Even though Hollar saw Old Saint Paul's before the great fire, and before its breaking up by the Puritans, he never saw it as he represented it here—with its steeple still intact, as he imagined it might have been before lightning struck it in 1561.*

posed discipline and a bit of practice if one is not to suffer that sickish sense of visual indigestion that afflicts the globe-trotting tourist on a tight schedule. On balance, collections surely do more good than harm, but that they do some varieties of harm is also sure.

Time as a rule erodes the heritage of the past a very little bit at a time. Titian's dramatic "Death of Saint Peter Martyr," long considered the high point of his art, survived abduction by Napoleon's scavengers and the return journey to Venice, and was at home in San Zanipolo when on August 16, 1867, it was consumed by fire; an engraving by Martino Rota preserves the memory of it. In 1695 the charming, brave, and utterly incompetent Marshal Villeroi was laying siege to Brussels for what he doubtless supposed was the advantage of his master, Louis XIV. Not knowing how else to subdue the most beautiful city in Europe, he lay back and fired into the heart of it with red-hot cannonballs—managing to destroy in short order four thousand houses and sixteen churches, not to mention the city hall with its historic frescoes by Rogier van der Weyden and that spectacular Rubens triptych on the story of Job, which we now know only in part through an engraving by Lucas Vorsterman (figure 97). A famous set of Holbein frescoes (like van der Weyden's, on the theme of Justice) were

ECCLESIÆ CATHEDRALIS
St PAULI
AB OCCIDENTE PROSPECTVS.

To the
Right Rev⁴
Father in God
WILLIAM
Lord Bishop
of CARLISLE

This Plate
is Most Humbly
Dedicated

once found in the town hall at Basel. They represented one whole side of the painter's aspiration; he wanted to be remembered not just as a portraitist but as a painter of historical and dramatic scenes. The frescoes long ago moldered into damp invisibility, but survive at least partially in a few drawings. The North Carolina State House in Raleigh burned up in 1831; it contained, remarkably, a marble statue of George Washington by Antonio Canova, which calcined in the flames. The plaster model from which it was made remains in Canova's personal museum, the Gipsoteca at Possagno. Silently, inexplicably, permanently, a beautiful and curious Leda by Michelangelo dropped out of sight, but not before it had been represented by the burin of Cornelis Bos.

Such is the murmuring, unremitting sound of history's undercurrent, gnawing, burning, snatching a bit at a time from the heritage. The giant catastrophes in the destruction of art stand out against this background, and they result, often enough, from the making of a collection or the ambition to make one. Without collections, the worst natural disasters make little impression on the world of art, because the owner of three or four paintings can often move them out of harm's way, while the owner of three or four thousand cannot. Even a

131 *The new portico for Saint Paul's, created by Inigo Jones during the 1630s as part of Archbishop Laud's program for bringing to England "the beauty of holiness."*

155

DOMVS CAPITVLARIS S. PAVLI
Meridie Prospectus.

VERO NIL VERIVS

Ne memoria domus Capitularis
in qua ordo et disciplina Dei servientibus
non stergulinia et stercora equoru ac pri
vari solebant tori venalitu billo subpe.
tuntur ALBERICVS de VERE XX cius
dem stirpis et agnominis Comes OXONII
hanc ejusdem Domus prospectum:
per magis posteritati commendari
curavit.

132 *When we speak, in a nicely rounded phrase, of a cathedral being destroyed, we are likely to forget how many separate buildings are actually involved in that catastrophe. Paul's Cross was a forum from which every preacher of note addressed the London populace, and the chapter house was more like a distinct and rather elegant little church than a mere meeting place for the canons. The inscription records that thanks to Aubrey de Vere, twentieth and last Earl of Oxford, posterity may now see what manner of structure was left by the iniquity of the times to house*

the filth and ordure of a stable. The engraver did not of course foresee the final ruin of the great fire.

133 *The only complete figure to be rescued from Saint Paul's after the great fire was the statue of Dr. John Donne in his winding sheet, carved by Nicholas Stone from a painting made just before the famous preacher-poet's death. The statue carries numerous scorch-marks and discolorations from the fire, but it is an authentic and exceptional survival. How worried people were*

that the Puritans (who effectively controlled the country from 1640 to 1660) would leave nothing behind them is shown by this engraving, made at the instance of Margaret, wife of Sir Christopher Clapham; she had it engraved lest impious and sacrilegious hands bring both the church and its monuments to ruin. For the almost miraculous survival of the statue we must be grateful; but we are still left lamenting the loss of the picture from which it was made.

134 *Sketch by Hans Holbein the Younger for "The Triumph of Riches," a painting originally commissioned by the Guildhall of the Steelyard—that is, the colony of Hanseatic merchants resident in London. Its companion piece, doubtless less popular with the merchants, was "The Triumph of Poverty." For a time the two large paintings in tempera belonged to the House of Stuart, then to the Earl of Arundel, and they are last heard of in Paris shortly after the English Restoration. This drawing, now in the Louvre, offers many enigmas to the curious viewer. Sicheus, for example, is Dido's husband, murdered by his brother for his great wealth. P. Ventidius Bassus rose in Roman society from the lowest to the highest rank; as the favorite freedman of Claudius, Narcissus amassed a tremendous fortune. Midas, Croesus, and Cleopatra are figures as obvious as their relation to Nemesis. But Leo Bizantius, Vividius, Pathius, and Crispinus are not so obvious, and to this day represent toys for the amusement of picture-puzzlers.*

conflagration as gigantic as the great fire of 1666 in London, while it destroyed many curious and fascinating monuments that we would be delighted to have today, hardly rates as a major episode in the ruin of art, because there simply weren't that many great works of art gathered together in the city of London. The two great collections of painting formerly in England, those of the second Earl of Arundel and of Charles I, had long been dispersed; and the English middle class, still inhibited by its fear of old masters as papists and servants of idolatry, had not yet taken up collecting. The great loss in the fire was essentially in the old churches of London, including Old Saint Paul's Cathedral, and even this was less than it might have been because the Puritans had had twenty years in which to smash and desecrate whatever appealed to their active spirits as overgaudy or smacking of the flesh. Though Old Saint Paul's was always an interesting, and had been remodeled under Charles I into a beautiful building, it never was the

FORTVNA

PLVTVS

NEMESIS

LEO BIZANTIVS

TANTALVS MYDAS CRESVS CLEOPATRA

NIVIDIVS

THEMIS TOCLES

CRISPINS VENTIDIVS GADAREVS NARCISSVS

sort of dynastic and cultural shrine that Westminster Abbey had come to be.

Thus, though the fire caught Saint Paul's at what was potentially a high point in its long and troubled history, it found relatively little to destroy apart from the building itself. That, of course, was no trifling loss. The structure known to Restoration London was nearly six hundred years old, and had been building most of that time—as, for that matter, religious structures had been rising and falling on that spot for centuries before. Saint Paul's had never really been completed: a blaze in 1135 delayed the work, and a spire was added over the crossing in the fourteenth century. But then in 1561 a bolt of summer lightning destroyed the spire, and only makeshift repairs were performed. Thus during the late sixteenth and early seventeenth centuries the ancient fabric steadily deteriorated, while a riffraff of idlers, peddlers, and con-men invaded the nave. Only in the 1630s did Archbishop Laud, with the sup-

135 *Copy by Rubens of a portrait by Titian of Charles I (the future Emperor Charles V) and his bride the Empress Isabella. The Titian original, long thought to have been lost in the Alcázar fire of 1734, slipped out of sight after 1636—either given to a careless favorite or transferred from El Pardo to another royal residence, and there somehow destroyed.*

HIERONIMVS BOS INVĒ. H· COCK EXCVD.

TEMERITATIS SVBITI, VT VEHEMENTES SVNT IMPVLSVS: Q

136 *The original painting from which Hieronymus Cock made this engraving seems to have been inventoried in the Palacio Royal at Madrid at the death of Philip II, and may therefore be supposed to have perished in the fire of 1734. Cock may well have made his engraving as much as twenty-six years after Bosch created the painting; so there is no great reason to put stock in the moral he engraved underneath it: "Sudden and*

TIBVS HOMINVM MENTES CONCVSSÆ, NEC SVA PERICVLA RESPICERE, NEC ALIENA FACTA IVSTA ÆSTIMATIONE PROSEQVI VALENT

fierce are the impulses of recklessness: under their onslaught, the mind of man can neither heed its own dangers, nor judge fairly the deeds of others." There is a still less probable interpretation which takes the picture to represent the battle described in First Maccabees, 6, 28–46, between Eleazar Avaran and Antiochus Eupator. But of course it is very hard to interpret Bosch's picture when we know it from two such very different representations.

161

port of King Charles, undertake a thorough housecleaning of Saint Paul's; and even then the work was done in the teeth of sullen Puritan recalcitrance or outright opposition. Still, the task was splendidly performed. Great care was taken, for example, to preserve the Gothic decoration of the choir and to recase the transepts in fine Portland stone. Finally, to provide an alternate place for money changers driven out of the temple, Inigo Jones was assigned to build a splendid new portico for the west front of the church where they could be out of the weather but also out of the nave. To create such a portico, which would be compatible with the Norman structure behind it yet would possess a Palladian poise and dignity of its own, was a complex assignment, on which Jones worked with characteristic determination and remarkable success. A contemporary (though admittedly a prejudiced one) bragged that with this portico Jones had "contracted the envy of all Christendom upon our nation for a piece of architecture not to be paralleled in these last ages of the world."

The hyperbole might have proved accurate, as surviving sketches of Jones' work show, but it never had a chance to do so. The civil wars descended upon England, and the entire fabric of Paul's was systematically and savagely desecrated. The Puritans had never liked cathedrals, and a good many of them didn't like churches, least of all handsome and decorated churches. So cavalry were encouraged to stable their horses in the nave of Paul's; the statues atop the portico were flung down and smashed; shopkeepers, to support the roofs of their little sheds, hacked holes in Jones' carefully chiseled columns; and Paul's Cross, where so many famous preachers had spoken in the open air to the citizens of London, was demolished and dragged away. Before the structure could be brought back to acceptable condition under the Restoration, the 1666 fire gutted it beyond redemption.

We don't by any means imply that the loss of Old Saint Paul's represented a negligible event, above all since the famous tombs of Sir Philip Sidney and Dr. John Donne went with it. In fact we are grateful to have such representations of the old church, by Hollar, as remain to us. But had the flames encountered anything like the Arundel collection, with its fifty-five Van Dycks, forty Holbeins, thirty Titians, and five hundred other paintings (this according to a catalogue made after years of attrition in the collection), our knowledge of the historic past would be vastly constricted. To have lost Paul's, and those fifty parish churches (out of a total of eighty-five), is a blow softened by the brilliance of Sir Christopher Wren in devising replacements. But for a major art collection there would have been no replacements.

The great London fire of 1666 is legendary in the history books not so much for loss of life (it killed but six people), or for loss of art (Saint Paul's was the greatest loss, and the English people had shown over the centuries how little they cared for it), but simply for loss of property. A lot of valuable real estate got burnt up. But by contrast the great 1734 fire in Madrid, known only to a few art historians, devastated the art record of Western Europe. The fire started for the most trivial of reasons. The royal palace (Alcazar) in Madrid was being readied for the arrival of King Philip V, who was expected to spend the Christmas season there. He was a monarch in very questionable possession of his senses, who had to be cajoled by an aria from his favorite castrato into getting out of bed a-morning to wash his face and comb his hair; at intervals, he

137 *To compare the two versions of this Bosch painting is an agreeable and rather tantalizing diversion; often the element that one thinks has been omitted entirely by one of the engravers turns up in a new form a considerable distance away. Du Hameel indulges freely in sometimes-mythical beasts—unicorn, bear, deer, lion, bull, swan, and perhaps camel; Cock eliminates them all. The flag atop Du Hameel's elephant looks very much like the flag of Turkey, but there are lots of other symbols scattered on pennants across the battlefield—a shoe, a serpent, a camel, a pair of scissors. The grinning devil who presides in the background over a church sliced in two like a loaf of bread by a knife may be the spirit of schism and discord himself—a theme that would be carried out by the numerous people-fragments scattered over the battlefield.*

bosche MAMEL

163

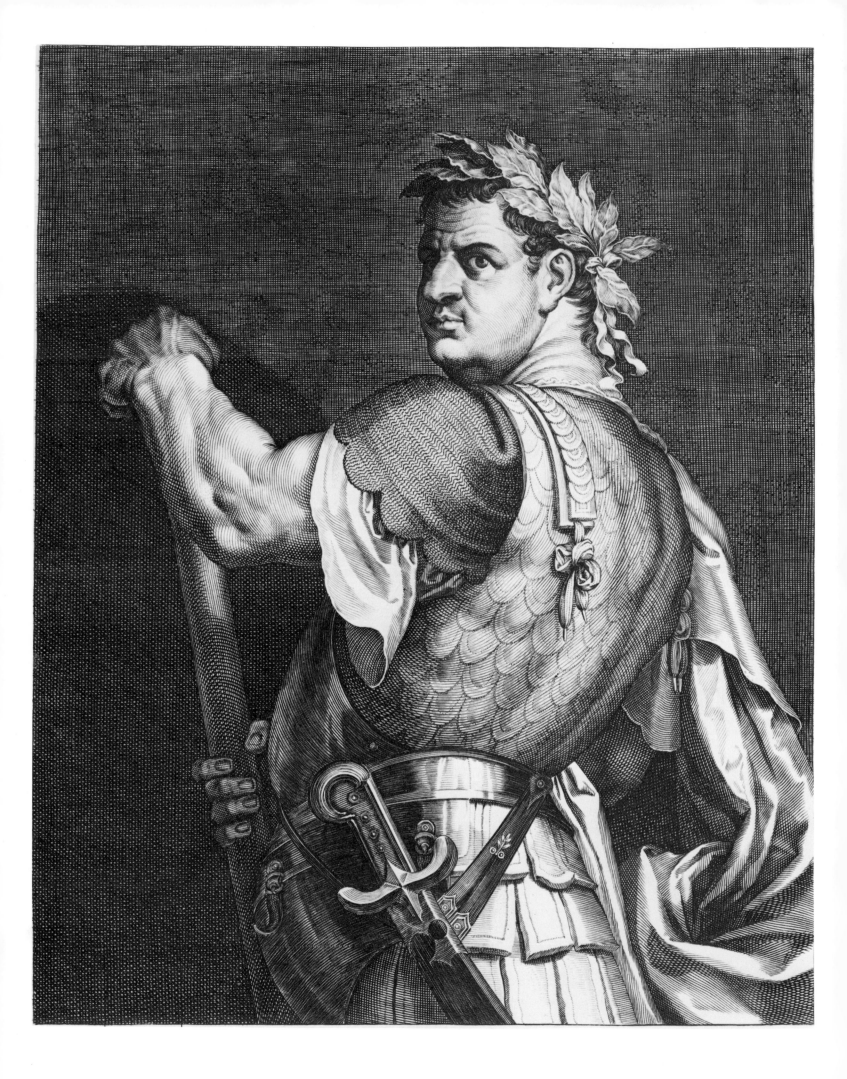

164

conceived himself (not unreasonably) to be a toad. But it wasn't the fault of this inauspicious inaugurator of the Bourbon dynasty in Spain that the servants, in trying to heat up the enormous palace, overloaded one fireplace and touched off a blaze that consumed not only the palace structure but most of its lavish contents. The hundreds of rooms contained an enormous number of the art works accumulated by the Spanish monarchy, especially the dynasty of the Hapsburgs, which had started with Charles V in the early sixteenth century and had just dwindled away. From foreigners who visited the palace just before its fiery ruin we have awed descriptions of the incredible treasures it contained—the miles of tapestry, mountains of massive plate, ornate furnishings, cabinets of coins and jewels, as well as magnificent pictures by the great names of European painting. Almost everything in the building was destroyed, except for a few of the best-known paintings by Velázquez, now in the Prado; and even some of those were singed in the furnace. Of Velázquez alone the flames devoured a "Last Supper," a "Venus and Adonis," a "Psyche and Cupid," an "Apollo and the Flaying of Marsyas," and an "Equestrian Portrait of Philip IV," as well as pictures titled "The Entry of Philip IV into Pamplona" and "Philip III and the Expulsion of the Moors from Spain." For some of these paintings preliminary drawings survive, but in no instance do we have a proper representation of the finished work. There is a noble picture by Ribera, now titled simply "Una Mujer," which was cut out of a canvas the rest of which was burnt to a crisp; there are three major Titians in the Prado, a "Saint Margaret," an "Ecce Homo," and a "Salome," which are better known by copies than by the scorched originals. The original of a fantastic Bosch, titled "Beleaguered Elephant," apparently disappeared in the Alcazar; we know it nowadays only through two engraved copies, one by Hieronymus Cock, the other by Alart Du Hameel. And for the great mass of the royal treasure we have nothing but a long list of doubtful attributions, perhaps invented titles, and sketchy descriptions in a catalogue compiled by a chamberlain; from such indications, however, it is clear that over five hundred major paintings were destroyed.

The original collectors were kings and popes, partly because they had money to spend on art, partly because they had palaces in which to keep their purchases and successors who could be trusted not to dissipate or neglect the heritage. In France, Cardinals Richelieu and Mazarin were ferocious collectors who used their royal master's armies as liberally as his money to get art treasures for themselves, and sometimes even laid violent hands on the property of the very church within which they were, ostensibly, princes. In any event, most of their collections flowed inevitably into the royal collections now assembled in the Louvre. Italian princelings like the Medici, the Gonzagas, the Sforzas, the Montefeltri, the Della Roveres, and the house of Savoy tended to augment their collections through dynastic marriages and advantageous trading. We think of the Uffizi collection in Florence as having led a relatively undisturbed existence since the days when Lorenzo the Magnificent was famous as a patron of the arts; and so indeed it has—relatively speaking. But the Medici collections were repeatedly looted by indignant citizens of Florence itself—in 1494, in 1527, and again in 1537—and so sketchy are the inventories of those early days that we can

138 *Titian's imaginary portraits of the twelve Caesars were gems in the collection of King Charles I; they came to England from Mantua, where the last of the Gonzagas were half-nudged, half-bribed into letting go of them; Daniel Nys, the king's agent, did most of the nudging and bribing. After the new owner fell on evil times, the pictures (by then consisting of eleven Titians and a Van Dyck) were bought up by the Spanish ambassador and shipped to Madrid, where with fine Spanish tact the English ambassador was sent out of town to be spared the humiliation of seeing his country's artistic treasures arriving by oxcart from Cromwell's England. Once in Spain and installed in one of the royal family's many galleries, the paintings disappeared from view; only these engravings by Aegidius Sadeler remain.*

The Flavians were a rough-and-tumble, good-natured, practical clan who changed very little after Vespasian first elevated them to command of the Roman Empire. Titian, who took his hints from phrases in Suetonius and perhaps from portraits of the emperors on coins, has caught the character of Titus in this imaginary portrait.

The East Front of Cannons in Middlesex, the Seat of his Grac[e]

To whom this Plate is most Humbly Inscrib'd by his Graces most Obed.t Servan[t]

J. Price Delin.t

hardly decipher what was lost on these occasions. There was a particularly destructive fire in 1732; there were losses in the nineteenth-century wars and revolts. What's for sure is that only an insignificant proportion of the present collection has come down from the early days of the family; the largest body of acquisitions dates from the early nineteenth century, when the monasteries were being disestablished. Even a relatively late collection, such as that in the Dresden Museum which grew so remarkably in the late eighteenth century, owes most of its astonishingly high quality to later curators and directors who systematically weeded out and traded up. The turnover in this museum, as in most good collections, has been very high; for collecting is nothing if not an active process.

Cataloguing and identification, as we've said, are crucial aspects of the collection phenomenon, and particularly valu-

James Duke of Chandos. &c.

hn Price. Architect. Built. Anno 1720.

139 *The powerful influence of Palladio is felt in this image of the palatial country seat erected by Baron Chandos. The "Chandos Hymns" of Handel were composed in this grandiose establishment of Canons, and one learns without surprise that they featured a Te Deum.*

able when accompanied by illustrations. This isn't so rare an event as one would think. Parts of the vast Arundel collection were engraved by Hollar, and in a few instances the engravings survive when the originals have been lost. And Archduke Leopold Wilhelm, as we've noted, hired David Teniers the Younger to make visual records of his collections. Such records were useful not only to the owner of the collections, but to the visiting tourist who wanted some souvenir of what he had seen, as well as to the prospective traveler who wanted to know what he might see. And of course to modern scholars even the scantiest of records are precious. Little as we know about the dispersed seventeenth-century collections of Charles I, James II, and the Duke of Buckingham, we should know even less without the antiquarian efforts of George Vertue, the eighteenth-century engraver, who compiled catalogues of

these long-lost private museums.

Nowadays, when documentation is not only systematic but elaborately scientific and widely diffused, we are no longer dependent, as students of the arts used to be, on gossip, hearsay, and uninformed rumor in order to learn where the works of a particular artist can be seen, and what some of the basic facts about them are. But the minute we move back a little in time, we become dependent on slapdash notations, guesswork, and the reports of amazingly incurious, uncaring people. At the death of Henry VIII, an inventory was taken of his royal possessions—furniture, clothing, tapestries, and pictures, or "tables" as they were called—in two folio volumes. The "tables" were carefully measured and described, but with one omission that we should think fairly consequential: the name of the artist is never mentioned. Abraham Vanderdoort, who catalogued the collection of Charles I, was more specific, and it is sometimes possible to recognize, through his descriptions, specific paintings now hanging in the great galleries of Europe:

> Item. A little piece of Andrea Montanio, being the dying of our Lady, the Apostles standing about with white wax lighted candles in their hands; and in the landskip where the town of Mantua is painted in the water lake, when a bridge is over the said water towards the town, in a little black ebony wooden frame, *painted upon the wrong light.*

For all the sad syntax and dark expressions, this is evidently Mantegna's "Death of the Virgin," now in the Prado. But most of Vanderdoort's descriptions are not so easy to identify, and it is exceptional that we have, for example, engraved versions, by Aegidius Sadeler of the Twelve Caesars by Titian, which Charles I of England bought from the degenerate Gonzagas of Mantua in 1627. The originals are long lost, and without the engravings we should have nothing but names.

Collections formed by private citizens, even if they are as wealthy as the Earl of Arundel or Agostino Chigi, who was banker to Pope Julius II, are not likely to last as long as those of princes who have a chance of establishing dynasties and defending their possessions with force. In addition, the private citizen who becomes a collector, a virtuoso as the eighteenth century called him, is likely to indulge his private tastes in ways that nobody else wants to support later. The Duke of Chandos is a fine example of this kind of dead end. He was the eighth baron of his line and the first duke. The family had first distinguished itself around the court of Henry VIII, and over the following centuries had already earned a reputation for lavishness and display. The fifth baron had been called the "King of the Cotswolds" from his regal style of life at Suddeley Castle, where he held open house for the entire countryside three days a week. The Duke got a chance to surpass even this splendor when, from 1705 to 1713, he served during the War of the Spanish Succession (the war that put cretinous Philip V on the throne) as paymaster-general under the Duke of Marlborough. As a result of their strenuous but not unrewarding labors together, Marlborough built the palace of Blenheim, and Chandos built a stately home in the now-suburban district of Edgware. The property had been named "Canons" while it was under church control, but the eighth baron transformed it. Had he been the usual parvenu, with more money than taste, Canons might easily have been a grotesquely oversized piece

140 *From the somewhat severe exterior of Canons, as presented in an architectural engraving, one would not be very likely to guess what the ornate and elegant interior was like. Fortunately, some of the cream-and-gold interior work, some stained-glass windows, and some ceiling paintings were purchased when Canons was dismantled and were transported to Worcestershire by Lord Foley, where they were used to decorate the interior of what is now the parish church of Great Witley.*

of uncoordinated and vulgar display, such as Alexander Pope ridiculed under the name of "Timon's Villa" in his "Epistle to the Earl of Burlington." But in fact Chandos had taste as well as money. He hired three foreign architects and imported painters from both France and Italy; what they put together was large, no doubt, but it was also built to well-considered principles of taste, expressive of the baron's individual preferences. His architectural choices ran to a rococo somewhat more florid and ornate than the average Englishman of his day could appreciate. Some of the cream-and-gold interiors of Canons anticipated the mode of French building later in the century, while the frescoed ceilings by Louis Laguerre and the stained-glass windows from designs by Sebastiano Ricci were decorative features unusual in a private house. But then, Canons was not altogether a private residence, since the everyday household numbered over a hundred persons. Chandos was passionately fond of music and entertained Handel for two years at Canons while the master was composing his oratorio "Esther." The household choir, which performed nightly at dinner, must have been on its toes during the visit.

Unhappily, the money that created Canons did not suffice to keep it going; the duke was in serious financial straits before he died, and his palatial residence was dismembered almost immediately thereafter. Some houses in town got part of it, but another major buyer was Lord Foley, of a famous and fabulously wealthy family in Worcestershire. He carried off some of the interior decor, including the much-admired stained-glass windows, to refurbish a decaying medieval church on one of his estates, Witley Court at Great Witley.

The manor house itself has long since been reduced to bare walls, and the church exterior is as rough as that of any other weatherbeaten parish church in rural England; but the interior still preserves for us a flavor of that golden elegance which was the vision of Canons during its brief noontime of prosperity.

As collections become works of art in themselves—encrusted ways of life almost, pearly shells elaborated around the life of a single inner organism—they tend to become fragile and ephemeral contrivances. Horace Walpole's establishment at Strawberry Hill was the history of his life and tastes, recorded in a set of acquisitions; the house remains, the collections which filled it were dispersed at public auction in 1842. Individual items from the amazing collection no doubt survive here and there; but the ensemble, which was so spectacular in its own time that people quarreled to obtain the indispensable ticket of admission to Strawberry Hill, is no more. Even more remarkable was the private museum and fantasy-mansion created by Walpole's rival William Beckford during the late eighteenth and early nineteenth centuries. At the age of eleven, Beckford had inherited an enormous fortune from his father the alderman: it was a fortune in Jamaican slaves, of whom he owned thousands, and it enabled him to act out all the promptings of a fervid, gigantic imagination. In 1796, when he was thirty-six, Beckford decided that his country seat at Fonthill in Wiltshire would no longer do. It was an almost new Palladian temple of more than respectable dimensions, especially for a widower with no intention of re-marrying; but Beckford craved something darker, vaster, and more ruinous. James Wyatt, who later became famous as "the Destroyer" of ecclesiastical structures, was the architect who undertook to provide the squire with what he wanted. For eighteen years the money flowed, the five hundred workers toiled in day and night shifts, and the pile mounted. The halls were properly cavernous, the library and the several picture galleries were labyrinthine, the tower rose to a height of 260 feet. Apart from his library (the core of which was the six thousand volumes formerly owned by Edward Gibbon the historian) and his immense collection of fine prints, Beckford had some remarkable paintings on his walls, including a famous Raphael, a Bellini, a Veronese, a van Eyck, numerous paintings by Holbein and Claude Lorrain. He was, after all, a man of some taste and considerable urbanity—as well as of a farouche taste for solitude. Within its giant medieval stage setting he lived a life of almost complete seclusion—seclusion broken by an occasional festive event such as a visit from Lord Nelson, but generally enforced (to the fury of his fox-hunting neighbors) by a twelve-foot-high, six-mile-long stone fence around the property. The "Abbey," as his seat inevitably became known, was one of the curiosities and one of the mysteries of the countryside; but Beckford always had pre-monitions about it, reinforced by occasional crumblings of the hastily flung together structure. He also suffered financial re-verses, probably connected with the approaching emancipation of Jamaican slaves (which actually took place in 1834); so in 1822 he put the entire establishment up for sale and moved to a less titanic but still extravagant establishment near Bath. Within two years the great tower at Fonthill collapsed, involving most of the rest of the "Abbey" in its fall, and ful-filling prophetically the nickname that would later be given to its architect.

141 *The vast dimensions of Fonthill Abbey are suggested, per-haps exaggerated, by contemporary prints; its kitschy medie-valism was apparent in the four "nunneries" (North, East, South, West), within which no nun ever set foot; in the "Duke's" and*

"Duchess's" bedrooms, where peers of the realm hardly ever slept; and in "King Edward's Gallery," of which one shouldn't ask which King Edward was commemorated, or why. Other glories were the "Oratory" and the "Crimson Breakfast Parlor."

But the library was authentic and splendid—it was of Gibbon's, rather than Beckford's, collecting.

142 *Interior view of the great Western Hall at Fonthill, leading up to the Grand Saloon or Octagon, which stood directly under the magnificent, but ill-fated, tower. The architecture and feeling of the building were all quasi-ecclesiastical.*

143 *From Rutter's book on Fonthill, a collection of miscellaneous objects alleged to be of rarity and value, and very likely really so, if one could see the titles of the books. But the deliberately antiqued spelling "groupe" gives away the whole assemblage as collectors' kitsch. (That a collection of perfectly genuine articles can look like, and in fact be, kitsch will come as no news to anyone who has visited the Hearst castle, in San Simeon, California.)*

How deeply should we regret the disappearance of such magnificent eccentricities—whims and offshoots of swollen bank accounts and imaginations afflicted with acquisitive elephantiasis? If only in their wantonness, they fulfill an instinct of play that enters into all building beyond the most primitive: every house worth thinking about is in some sense a dream house. Men with enormous visionary perspectives and enormous wealth naturally build enormous playlands, macabre like Bomarzo near Viterbo in Italy, pastoral, illusionistic, melancholy, or exotic, as the spirit moves them. Private Disneylands dot the landscape of the eighteenth and nineteenth centuries, and while it's just as well that few people have that sort of money any more, we should be the poorer if we forgot them entirely. Eccentricities such as the Folie Sainte-James at Neuilly, with its carefully moralized landscape—a mausoleum, a temple by a waterfall, a lake, a shrine, all overwhelmed by masses of artificial nature—wrote a *sic transit gloria mundi* largely across the countryside. More remarkable still was the Parc Monceau designed during the 1770s for the Duc de Chartres; it included Tartar tents, Dutch windmills, a carefully ruined Temple of Mars with a desolate obelisk. The whole thing was designed deliberately to resemble a series of stage-flats at the opera, so that one might move imaginatively through space and time across the scale of world history, enjoying at one moment a vision of Roman naval combats in a flooded arena, at another moment an illusion of the steppes of

144 *Gabriel de Saint-Aubin did this painting of Parc Monceau, an early nineteenth-century assemblage of prefabricated ruins. The amphitheater provided seats from which to view the ready-mutilated columns and sketch pre-contrived scenes of melancholy desolation. Quite appropriately, the park once belonged to Louis Philippe, the bourgeois monarch, who was almost a prefabricated ruin himself. He must have wandered here often, reflecting on the corrosive influence of time, and on the curiously regenerative power of nostalgia when backed by large sums of money.*

173

145 *Mantegna's great triptych in the basilica of San Zeno, Verona, was shipped bodily to Paris during the Napoleonic era, to take its place in the conqueror's new Musée Napoléon. In 1815 it was ordered returned to Italy, but by a series of prevarications, obfuscations, ruses, and delays, the French succeeded in holding onto the three small, but superb, pictures of the predella.* *To this day one of them remains in the Louvre, the other two in the Musée des Beaux-Arts, Tours. Copies have been reluctantly substituted in the altarpiece at Verona. Why copies do not hang in the French museums, while the originals resume their place in San Zeno, is one of those awkward, brutal questions that history delights to leave in the moral mist.*

146 The Chapter of the Basilica of Santa Barbara in Modena used to possess a silver bowl by Cellini, 55 centimeters in diameter, representing "The Wedding of Neptune and Amphitrite." French armies carried it off in 1796, and as it hasn't been heard from since, one isn't hard put to guess what happened to it. What remains is a plaster cast, made by M. Sigismondo Fabricci while he was engaged in cleaning the silverware of the Chapter. A most peculiar feature of the cast is the unmistakable presence of Santa Barbara herself in the little spechietto at the center of the bowl, with the wedding of the two pagan deities going on orgiastically around her. Best guess is that the spechietto didn't have this character in the original silver, but that it was inserted on the plaster model as a sort of signature, to identify the piece as having belonged to the Basilica of Santa Barbara.

central Asia. Bouvard and Pécuchet, in Flaubert's novel, created similar fantasies during their gardening phase.

Privilege delights in artifice, manner, indulgence; much building of the *ancien régime* in Europe, like much building of the antebellum South in America, has about it the quality of a stage set—as if the structure were only waiting for Dorabella and Fiordiligi to step forward and warble a duet. Utilitarian societies accustomed to calculating building costs in dollars per square foot (as if any one square foot were exactly equivalent to any other square foot) can only gape at these fantastic structures and the often idiosyncratic collections they housed. But all these lesser collecting games and toys pale before the vast collective appetites and collective hatreds unleashed by the French Revolution and its master-creature, Napoleon.

Napoleon inaugurated the era of massive international art-looting—wholesale, methodical, indiscriminate; in this respect, as in so many others, he was a prophetic innovator. Of course conquerors from time immemorial had plundered art, for works of art tend to be a very portable and concentrated form of wealth. But Napoleon for the first time put the whole operation on a routine and systematic basis, draining off (to the best of his ability) the entire artistic heritage of the nations he conquered, and assembling the spoils, without the least evidence of conscience, without the slightest attempt at concealment, in a national repository. Verres, whom Cicero prosecuted for looting Sicily, was a mere vulgar thief satisfying appetites of an inordinate but basically human dimension; the Napoleonic operations were of another order of magnitude entirely. Ancient and contemporary art, religious and secular art, major and minor art, the details made no difference; art as a commodity poured into Paris, filled the Louvre, filled the various imperial residences, and was sent to the provincial museums, according to a strict system of keeping the best of everything in Paris. The art works were not taken for ransom; nor, at least after the early days, were they taken as trophies (though the bronze horses of Saint Mark's were paraded through the streets of Paris as if they were enemy flags captured on the field of battle). As a rule the art works were not held in private hands; they simply became the permanent property of the state of France. They were so many, and the legal, semilegal, pseudolegal, and directly illegal devices by which they were acquired were so elaborately confused and obscured, that undoing the tangle proved impossible, later. Some of Napoleon's treaties gave him the "right" to so-and-so many paintings from particular cities; insurrections by his enemies gave him the "right" to plunder particular cities for particular periods of time; the taxes his governments imposed forced aristocratic families to "sell" their historic pictures at ridiculous prices to Napoleonic agents; the expropriation of the monasteries, voted by Napoleon's governments, provided an excuse for grabbing their art works; even the kings that Napoleon installed in Spain and Italy (his own relatives, for the most part, or his generals) found occasion to show their gratitude by shipping art works to Paris; and the marshals who, while executing his orders, snatched priceless art collections for themselves, put up a show of virtue by donating a tithe of their pillage to the Musée Napoléon.

Napoleon and his bureaucratic henchmen did not completely get away with his amazing shift in the cultural geography of Europe; but for everything they had to give back in 1814 and 1815, there was something they kept. Of the five

hundred paintings that left Italy and of which the destiny can be traced, fewer than half returned; by subterfuge and bravado and outright lying, the rest were kept. What the French themselves did with the art treasures of Antwerp and Seville, Parma and Venice, Vienna and Kassel and Brunswick, was quite bad enough, but the example they set encouraged a trend, already evident in the late eighteenth century, for tourists, dealers, diplomats, virtuosi, failed artists, idlers, forgers, and miscellaneous profiteers to swarm through Italy, Spain, and Greece, picking up openly or stealthily whatever wasn't nailed down. "I know not how it is," said George III in honest bewilderment, "but I never sent a gentleman in the public capacity to

Italy, but he came back a picture-dealer." The monarch was not too bewildered to pick up from his Venetian consul, Joseph Smith, a £20,000 collection of Venetian paintings which became his major contribution to the royal art galleries of England.

Fortunately, only a part of this huge subject falls under our theme. Pictures painted for a Gonzaga palace or a Spanish cloister are not actually destroyed—though they may indeed be changed—when they are carried off to hang in the Louvre. But in the process of being stolen and carried away, many works of art inevitably get smashed, lost, disfigured, or dismembered—especially in those days before railroads, motor

147 *The monastery at Montserrat in Catalonia had been a center of pilgrimage for many centuries—one of the two great holy places in Spain, the other being Compostela. A visitor in 1599 reported that every day six hundred pilgrims sat down to dinner at Montserrat, and on high festivals between three and four thousand. Naturally the shrine was rich in adornments, decorations, and tributes left by the faithful—whether grateful or just hopeful. But during the Napoleonic wars, the entire complex was smashed, burned, looted, and razed to the ground. Just before that fate overtook it, Alexandre Laborde engraved this peaceful view of the monastery's main church for his* Voyage pittoresque et historique de l'Espagne, 1806–1820.

148 *Saint Margaret, who represents the power of innocence, is commonly portrayed as a little girl walking confidently past a ferocious dragon. (It isn't just your basic dragon, however, it is the Infernal Serpent himself, who ate up little Margaret, but couldn't keep her down when she calmly made the sign of the cross in his stomach.) Zurbarán, who had a special fondness for virgin saints and painted a formal series of them, did two versions of Saint Margaret, both times going against his normal custom to portray her in contemporary Spanish dress. The original of the version that Laborde copied here is last heard of at the end of the seventeenth century; but his reproduction is so primitive that one cannot tell whether he was working from the original or a copy. The original of the other version is in the National Gallery in London.*

trucks, and surfaced highways. Everything that was looted in Italy, Spain, or Germany had to be transported at least once and sometimes twice over hundreds of miles of mud and cobblestones, through all sorts of weather. The French did the best they could (after all, they thought it was French property they were protecting), and their best was amazingly good. Not very many of the art works they stole were fatally damaged. Yet even they sawed pictures in two when they seemed too big for easy transport, or left them in open warehouses for months on end. No wonder Canova wept when he saw the Venus de' Medici being thrown into the cart for her return journey to Florence.

The most famous of the Italian pictures in the Louvre, Leonardo's "Mona Lisa," is there by authentic right: François I bought her from the artist for four thousand golden florins. But Veronese's gigantic "Marriage at Cana," done for the monastery of San Giorgio Maggiore in Venice, hangs in the Louvre by right of theft and no other. Because it was outsize, the French sawed it in two to bring it to Paris, and then used the fact that for a return trip it would have to be cut apart as an excuse for holding onto it. Similarly, the great altarpiece that Mantegna did for the church of San Zeno in Verona was taken bodily from that city as revenge for an uprising against the French, but when restitution was ordered in 1815, the altarpiece was divided up, to evade the requirement that it be returned. The three large upper panels were returned to San Zeno, the three smaller, lower ones were divided, two going to the museum of Tours, one remaining in the Louvre. Thus nothing got destroyed outright, except the ensemble.

Fragile and precious things suffered most, of course. Some famous Etruscan vases belonging to the pope got smashed beyond repair while on the way to Paris. A silver basin displaying mythological scenes, done in elaborate repoussé designs by Benvenuto Cellini, was liberated from the church at Modena in 1796, and disappeared. Fortunately, a mold of it had been made just a year or two before. Furniture, ceramics, coins, medals, small bronzes, cameos, and things of that sort were the preferred loot of the French soldier; pictures, especially when they hung in the halls of great houses, tended to change hands more subtly. But nothing was really safe. Many of the great Italian paintings were frescoes, and the French tried zealously to strip some of them off the walls to bring them to Paris. They contemplated carrying off Trajan's column from Rome, and were deterred only when calculations proved it too heavy. The Lion of Saint Mark fell and was shattered into bits while being carried back to Venice; that at least gratified some Frenchmen, of whom one was heard to say, "If we don't get it, at least *they* won't." But it has since been repaired and restored to its proper column at the end of the Piazzetta looking out across the lagoon.

Still, even stealing, as we've said, isn't *necessarily* destroying; and in Italy, where the French occupiers were not resisted by an infuriated populace (weren't resisted, indeed, by much of anyone, since they sometimes appeared as liberators of the Italians from the Austrians), stealing wasn't even stealing, it was just taking. The Napoleonic looters got to be very good at this. They knew exactly what they wanted, they took it quickly and decisively, with no explanations or apologies. Bitter ironies sometimes resulted—as when, in 1811, Madame de Souza went on a Parisian shopping expedition in the company of Cardinal Albani but had to cut it short when the Cardinal

burst into tears after a dealer offered to sell him a Virgin by Sassoferrato which had been looted, with several hundred other paintings, from the Villa Albani in Rome.

But in Spain, where the Napoleonic art-bureaucracy was never fully established, leaving the generals and their armies to plunder spontaneously and on their own accounts, the French were far more brutal in their looting and destructive in their behavior than they were in Italy. In addition to being left pretty much on their own, the soldiers were opposed in Spain by a popular, partisan movement, ferocious in its determination to resist them; they were ambushed, assassinated, sniped at. Priests, whom elsewhere the French invaders regarded as cowardly and slothful, served in Spain as leaders of the popular resistance. Towns such as Zaragoza, which had no business giving them so much trouble, turned into flaming fortresses, where the women fought on barricades beside men and there was no thought of surrender till the town was reduced to rubble and the populace practically exterminated. The Napo-

149 *Few of the surviving Zurbaráns have the dramatic power of this splendid canvas, burnt up in the Flakturm fire in Berlin in World War II. From the group of querulous (and apparently bibulous) priests on the left, a chain of linked hands leads irresistibly up, past the useless books, to the alcove where the curtains seem drawn apart, almost by a gust of wind, to reveal the true source of Bonaventura's doctrine, in the figure of the agonized, inspired Christ. That Saint Thomas was a Dominican and Saint Bonaventura a Franciscan is emphasized by their robes; the point at issue, not only between the two men but the two orders, was the relative importance of direct religious inspiration. Zurbarán leaves us in little doubt as to where he stands.*

179

150 *Many of the works that we have lost, like many of the "sights" that people used to travel to see (the Holy Coat of Trier, or Moses' brazen serpent at Milan), have disappeared because a skeptical and cosmopolitan age saw that they were inauthentic. The titles placed under paintings, sometimes in an attempt to lend them a factitious interest, have been particularly subject to deflation. For Laborde, this was a portrait of Cortes, the conqueror of Mexico, by Velázquez, and a very remarkable work indeed, since Velázquez was born more than fifty years after Cortes died. But, alas for the truth: the picture, though it's a genuine Velázquez, and survives, and hangs to this day in the Prado, represents a buffoon of King Philip IV, known derisively around the court as "Don John of Austria." There is a sad possibility that much of the rich and entertaining past the loss of which we now regret would, if it survived for our critical inspection, be a good deal less rich and entertaining than it has been represented to us.*

leonic campaigns in Spain aimed at breaking the national will; and to this end, destruction was visited wholesale on the populace and their most revered institutions. For example, the monastery at Montserrat was the holy place of the Catalan people, their national shrine. The religious institution had been there, high in the strange, rocky crags of a Pyrenees outcrop, since 700; over the centuries, the monastery had been enlarged and enriched, and vast treasuries of art had accumulated there, the gifts of famous Spaniards who had retired to this hermitage to end their lives in the odor of sanctity. The French did everything within their physical power to wipe the monastery from the face of the earth; they stole, burned, smashed, and exploded till the last traces were gone; they even searched out the remote grotto where the precious statue of the Virgin (Montserrat's principal religious treasure) had lain hidden till its discovery by Bishop Gondemar in 818, and blew up the cave. There is a monastery at Montserrat to this day, and it remains the object of an immense popular cult among the Catalans (as one need only visit it on a festival day to see); but it is entirely the work of the last hundred and fifty years. Only prints and pictures remain to preserve the memory of the earlier structure, over which Giuliano della Rovere once presided as abbot, before assuming the triple crown as Pope Julius II.

Because they felt they were fighting a treacherous and inhuman foe, because they had been corrupted by years of war and plenty of ruthless bad examples in the leadership, the French behaved with unparalleled ferocity in Spain. They went after the library and art collection in Valencia, the home town not only of Juan Luis Vives the humanist, but of Ribalta, Ribera, and a prolific school of early-seventeenth-century painters. What they thought of value, they took, everything else they deliberately destroyed. In Tarragona they set up headquarters in the cloister attached to the ancient cathedral, dragged the tapestries from the wall, and cut them into strips for use as carpets. (Many of them were in fact French tapestries from the Gobelins factory, and of course French generals, even the coarsest of them, would never have dreamed of behaving that way in a French château; but in Spain another law prevailed.) In Burgos they invaded the royal convent of Las Huelgas, where the ancient kings of Castile lay buried, and broke open the tombs in search of plunder—crowns, rings, necklaces, cloth of gold. The core of the collection of ancient fabrics that now occupies Las Huelgas is the rags of brocade and embroidery ripped from the skeletons of medieval Spanish kings by the French soldiery. As for the rape of Córdoba, in June of 1808, it is literally indescribable.

There is hardly a town in Spain which cannot recite its tale of losses in the peninsular wars. But the worst looting of Spanish culture was the traffic in pictures—a trade the real dimensions of which cannot be calculated. One figure that can be more or less checked tells us that a single exporter shipped into Marseilles from Spain during the war years approximately fifteen thousand paintings; there were other shippers to other ports, and there were art agents, both from Britain (a man named Buchanan) and France (a man named LeBrun), who were constantly active during the war years. There was land transport. Joseph Bonaparte, installed by Napoleon as king, ran off in 1813 with what he supposed were the prizes of the royal collections, cutting them out of their frames and stacking them atop one another like crêpes; for better or

worse, his flight was intercepted by the English, and he was deprived of most of his pitiful scroungings. And this wholesale looting of art was particularly destructive because it was so widespread—so appallingly democratic, if that's the word. When a field marshal or a generalissimo snatched a likely work of art, it used traditionally to be carried off in high style, under good guard, and placed in the grand salon of a château. Because it was famous and valuable, records of a sort were often maintained. But when the sergeants and corporals started looting (in imitation of their superiors if not their betters), they knew very little of what they possessed, had only primitive means to care for and transport it, and of course kept no records. Most of the paintings taken out of Spanish churches, monasteries, public buildings, and private homes have disappeared without a trace, even though some may still be hanging, dark with age and obscured by overpainting, in the homes of descendants of the Grande Armée.

We can follow a little better the acquisitive career of Marshal Soult, who was after Joseph Bonaparte the most exalted of the pillagers of Spain. He was a brave and resourceful soldier tested in a hundred battles across the length and breadth of Europe; he was also an unscrupulous politician and a man with the appetite of a vacuum cleaner for anything of value in his neighborhood. The story is told that his army never moved without an advance guard of scouts armed with the guidebook of Céan Bermúdez describing the art of the churches and museums that lay in his path. We might know something of his doings in Spain just from the records there, for he went after large paintings and famous ones, the best to be had according to the taste of his times. But the records of his later life make the story much clearer and fuller. With the proceeds of his military career he built a castle (what else would he call it but Soultberg?) near the village in the Midi where he had been born, the son of a poverty-stricken notary; and there, full of years, crimes, and ill-gotten wealth, he died in 1851. His collections amounting to 159 major paintings were sold at public auction in Paris over a period of three days (May 19, 21, and 23 of 1852), and they included many of the crown jewels of modern museums, such as the Louvre, the National Gallery and the Wallace Collection in London, the Hermitage in Leningrad, and (alas) the now-deceased Kaiser Friedrich Museum in Berlin.

Among the choicer items that left Spain with Soult were ten of the eleven large paintings done by Murillo during the 1640s for the cloister of San Francisco in Seville. We know that he sold at least one of them to Louis Philippe for installation in the latter's "Spanish Gallery" of looted art in the Louvre. From the bourgeois monarch it passed in due course to the Dresden museum. Murillo's "The Immaculate Conception" stayed for more than a century in the Louvre, from which the Prado recently, after some sharp bargaining, was able to get it back in exchange for a Velázquez portrait. Another painting stolen by Marshal Soult (who, after raping the hospital of La Caridad, the convent of San Francisco, and the Cathedral of Seville, was clearly in no mood to hesitate before a mere Franciscan cloister, the Mercenarios Descalzos) was a magnificent Zurbarán depicting the moment when Saint Bonaventura, challenged by Saint Thomas to explain his extraordinary theological insights, simply pointed to an image of Christ. The painting, which in the auction of 1852 changed hands with several other Zurbaráns as a "lot," and not a par-

151 *For the French public which first got to look at large numbers of Spanish paintings as a result of the Napoleonic lootings, Spain was the country of deep religious devotion, blazing erotic passion, and abysmal cruelty. It was a place where nature reigned, untouched by French irony or French standards of correctness. Very influential in producing this impression was José de Ribera, who seems really to have enjoyed painting macabre subjects. His picture of "Cato Tearing Out His Entrails" rather went out of its way to emphasize the gruesome quality of Cato's suicide at Utica. But after being brought to France, the picture was lost in the turmoil and confusion of 1815, and the only remaining trace of it is this print from C. Blanc's* Histoire des peintres de toutes les écoles.

152 *Grandiose as it was on the outside, the Palais des Tuileries never served as a full-time royal residence, and by comparison with other royal habitations was never richly decorated or elaborately furnished. What the Communards burned was essentially the wooden flooring, the tapestry hangings, and some official portraits. The shell of the structure was not destroyed and it stood for about ten years, gaping and empty, before being finally torn down. Various parts and pieces were sold or stolen before the final demolition—one of the biggest chunks going to Pozzo di Borgo (kinsman of Napoleon's nemesis), who re-erected it on his estate in Corsica.*

ticularly expensive lot, ended up in the Kaiser Friedrich Museum in Berlin, where it was incinerated during World War II.

These are but a few of the traceable stories attached to the paintings grabbed in Spain by the avid Marshal Soult. Obviously he didn't care a rap what sort of waste land he left behind him in Spain; but, apart from that, he cannot be linked to very much deliberate physical destruction of art. His piracies aimed, of course, at benefiting nobody but himself; yet they served after a fashion to spread the knowledge of and interest in Spanish art beyond the Pyrenees. Other French marshals in Spain, like Sebastiani, Suchet, and Victor, were just as crude as Soult but had less taste or less luck; and the lower ranks were left to scour up the leavings. This in fact is where the real tragedy lies, in the thousands of pictures that left no story behind. Even if they had not been properly catalogued or identified in Spain itself, at least their position, in this church or that, would have made efforts at identification possible. Whenever people started to care about these things, they might have known what local records to search. But as wandering pictures, untitled, undated, unattributed, unassigned, often patched and repainted or cut into bits for easier transport, then buried for years in a family attic, and finally resurrected by a dealer or speculator, they have no fixed identity at all. Most of them naturally gravitate toward a famous name, and are attributed, with or without evidence, to Velázquez or Zurbarán, because that's where profit lies for the present owner. Thus a very high percentage of the paintings pretending to be the work of those artists are, to say the least, doubtful—somewhere between one-half and two-thirds of the Zurbaráns, according to a recent student. And meanwhile their shadowy existence as pseudo-Zurbaráns or dubious

Velázquezes may well be clouding our ability to recognize the existence of other quite as intriguing talents in seventeenth-century Spain.

For sheer lack of space, I have passed over Napoleonic picture-snatching in the Low Countries and east of the Rhine, the blackmail of Vienna, the rape of Kassel. In moments of rhetorical ecstasy, the *commissaires* in charge of art-snatching were apt to defend their procedures in language which we of the twentieth century have learned to associate with a German accent. The inferior peoples, so the Napoleonic enthusiasts declared, were incapable of appreciating or taking care of their own art works; as an act of kindness, the splendidly civilized French would take them over—give them a good home, as the saying goes. During the actively atheistic days of the Revolution, some patriots had trouble choking down the Catholic content of the art works being shipped to Paris by the people's armies, but the accommodations were not hard to make. And the least indefensible part of the whole operation was the fact that thousands of works of art were in fact made available to the public—"liberated" rudely enough, no doubt, but made accessible to people without special connections or influence in high places. The Musée Napoléon was a harbinger of the great public museums of the nineteenth century, which by one process or another converted the treasure rooms and private cabinets of kings into public galleries. Yet there is another side to this clearly enlightened and beneficial process; for no sooner does one open up the art of kings to the general populace than one reminds them forcibly that they are not themselves kings, do not think like kings, do not live like kings, and in fact are what they are (that is, miserable and oppressed) because of kings. Harbinger of this new phase in art destruction—a logical extension of the French Revolution, but also in some respects its dialectical negation—was the Paris Commune of 1871.

The proletarian movement has always been of two minds about history, art history included. On the one hand, the past is a long record of oppression and wrong, which the rising dawn of the workers' paradise will dispel like an evil dream. On the other hand, the past is a set of indispensable stages leading by complex, inexorable logic to the revolution, and worth studying precisely as a guarantee of the revolution. The key to present and future history is provided by accurate understanding of the past: without such a key, socialism has no hope of being scientific. All this is very lucid but unhappily contradictory; and what proletarian strugglers will do in particular moments of practical decision is, accordingly, quite unpredictable. The Commune provided an early test of attitudes. It was proclaimed in March of 1871, in the wake of France's defeat in the Franco-Prussian war; left-wing leaders of various persuasions united to declare Paris a free city. The regular government of France immediately laid siege to the embattled city, and the Germans sat back complacently in a ring around Paris to watch. (A number of them were quartered in the little town of Louveciennes near Versailles where before the war there had lived a hitherto unsuccessful painter named Camille Pissarro; German troops converted his studio into a slaughter-house, and, to keep their boots out of the mud and manure in the yard, spread it with two or three hundred of the finished paintings that they found in the artist's house.) Meanwhile, within Paris, Frenchmen of opposing persuasions furiously slaughtered one another. It was a savage struggle, which lasted

153 *The Salon de la Paix in the Palais des Tuileries before its incineration during the Commune. This rare interior view is from a collection of old stereoscopic slides of the variety that used to ornament every well-bred parlor in the days before private photographic albums became commonplace.*

some six weeks, and ended, of course, with the collapse of the city's defenses. In the last days of their power, with the ring tightening inexorably around them, the Communards evidently decided that since they must go down, they would take with them as many of their enemies as possible, and as much of the aristocratic culture associated with those enemies as they could put to the torch. They inaugurated the kind of symbolic logic brilliantly sketched by Joseph Conrad in the false "anarchists" of *The Secret Agent* who try to blow up Greenwich Observatory. The Communards wrote their protests in blood and fire across the face of Paris. They shot all the hostages they held, including the archbishop of Paris; they burned to the ground the Palace of the Tuileries and the Hôtel de Ville, they set fires in the Palais Royal, the Palais de Justice, the Prefecture of Police, the Légion d'Honneur and the Conseil d'Etat; they tried to incinerate the Ministry of Finance, in one wing of the Louvre, to the imminent peril of the art collections in the other wings; and they came within a hairbreadth of blowing up Notre Dame and the Panthéon. They had already gone through the ceremony of tearing down the Vendôme Column, made from the cannon captured in 1805; it was for them a symbol of the hated imperial tradition, and Gustave Courbet himself took the lead in pulling it down. The logic of this destruction could perfectly well have led to blowing up the Arc de Triomphe, smashing the Sainte-Chapelle, and sacking the Louvre collections, had the extremists had time to work out the implications of their position. Fortunately, they didn't, but the legacy of their logic is still with us in the terrorist and urban-guerrilla movements of the modern world.

It can't be said that the actual losses in the Commune were overwhelming. The Tuileries contained a great quantity of painting and sculpture, accumulated by the royal house of France, and hateful on that account, but a good deal of it was secondary, merely decorative work. The Hôtel de Ville was a heavier loss: it constituted a three-hundred-year repertory of French artistic life, and the Delacroix ceilings were widely reputed to be the painter's supreme achievement in the monumental style. We know them now only by a color sketch and some preliminary drawings. But mostly the story of the Commune is one of almost-destructions. The Louvre collections might have been terribly damaged, Notre Dame might have been dynamited, the Venus de Milo was saved by a happy accident when a waterpipe burst and sprayed her packing case while the building around her burned. It was the demonstration of intent that counted in the Commune, rather than the

actual amount of destruction accomplished. The burning of the Hôtel de Ville was exemplary in this respect. It was the work of a carpenter named Pindy, who had been appointed official executioner to the building. He waited to the last minute—till the city was surrounded, all escape routes cut off, resupply impossible, total surrender merely a matter of hours—before pouring out his kerosene, tossing his match, and sending the vast, historic structure up in flames.

Perhaps it was not altogether an irrational act. Humane and aesthetic values don't mean much to a man in the process of losing what Pindy and his fellow guerrillas were losing. Reduced as they were to making symbolic gestures, it's understandable that their last gesture should be of hate—for bourgeois authority, bourgeois values, bourgeois sensibilities in any form. Probably the Hôtel de Ville was not for them a work of art; over the months of their power they had lived

there, haggled there, slept there, made the place their own. They didn't see that it contained works of art, and was a work of art; but even if they had, they wouldn't have cared—indeed, they doubtless destroyed it the more gladly because they knew it was precious to those they hated. For men to feel this way in moments of desperate personal crisis may perhaps be natural. But only ideologies can convert crisis into a matter of every-day policy, domesticating ruthless and vindictive but essentially random violence as the norm of civil life. The class war, as fought down winding corridors of ambush and surprise attack against targets protected only by their conspicuous irrelevance, is established as a political mode of our time. It is a program of moral sabotage, in which works of art precisely *because of* their conspicuous irrelevance are destined to play a major part. World War II and the events surrounding it have taught us many lessons along these lines.

The Second World War set all sorts of records in the annals of art destruction. The damage done was the most carefully documented on record; we know in close detail about the major episodes. Almost all the participants took specific and sometimes elaborate precautions to protect works of art; and the aggregate destruction was probably greater (given the short concentration of time in which it occurred) than in any other period of human history. The victorious Allies made a good deal of the cultural values for which they were fighting, and may indeed have boasted among their leaders men with cultural standards higher than those of Goebbels or Mussolini; but in the amount of artistic destruction they visited on the world, there was not much to choose between any of the combatants. Aerial bombardment caused most of the damage, but ordinary earthbound artillery accomplished a lot, and there was the usual quota of vulgar looting, of deliberate, mindless destruction, and of sheer carelessness.

Contrary to the popular impression, and to give the devil his due, it's not clear that the Nazis, in the course of their campaign against everything they called "Jewish degenerate international modern art," destroyed a great deal of it. They did dreadful things; they threatened artists and blockaded galleries, roaring and swaggering against the most vital art currents of the day. They banished to the lumber room paintings and sculpture of which they disapproved, they drove Kandinsky, Kokoschka, and Klee out of Germany, along with George Grosz and architects of the stature of Gropius and Mies Van Der Rohe. They forced powerful expressionists such as Ernst Barlach and Emil Nolde to stop working altogether (though Nolde had tried briefly to ingratiate himself by joining the party). They even burned some works of art, along with the better-known books, which they thought reprehensible and degenerate. But they were generally careful to keep out of their bonfires works they thought valuable enough to be sold. Greed, which is very often the motive for works of art to be destroyed, here served for their preservation. Auctions held at Zurich and Lucerne in 1939, while they purged Nazi Germany of its "degenerate" art and provided a bit of much-needed *valuta* for the German economy, also gave evidence that someone somewhere in the German cultural service was not altogether victimized by the official propaganda line. But about what they thought unsalable, the Nazis were altogether ruthless. Over a thousand oil paintings and sculptures, in addition to nearly four thousand drawings and watercolors, went up in a bonfire staged by the Berlin fire brigade during the early 1930s.

In itself, the Nazi regime from 1933 to 1945 will not rank, any more than the Soviet regime since 1917, among the great episodes of art destruction. Both regimes, by different means but in about the same degree, were deadly to the creation of new art. The Nazis had a flourishing art movement to crush, the Russians had a smaller one to isolate and discourage. But neither took part in any major program of cold-blooded iconoclasm; it was the war, and particularly the new technique of bombing the enemy's entire industrial plant—his cities, wherever located, his civilian populations, however far removed from the "lines"—that produced the most spectacular and deplorable art casualties. The first demonstration of what

156 *"Abstract Room" by El Lissitzky was a pioneer experiment in creating a total environment composed of abstract forms and abstract works of art. Created in Hanover in 1927, it was destroyed by the Nazi authorities. The original construct included furnishings and decorative details in abstract designs, as well as paintings and sculpture by Lissitzky himself, Picasso, Léger, Mondrian, Gleizes, Baumeister, Dexel, Marcoussis, Klee, Kandinsky, Schlemmer, Gabo, Moholy-Nagy, and Archipenko. While an effort was made to reconstruct the original in 1968, almost all the works in question had vanished beyond recall, and no proper reconstruction of the original vital experiment is now possible. Nor, for that matter, could the global experience of a room be properly reproduced by a photograph on a flat page; much of its intended effect came from surrounding the viewer on all sides. The "Abstract Room" was thus unconditionally and irrevocably destroyed.*

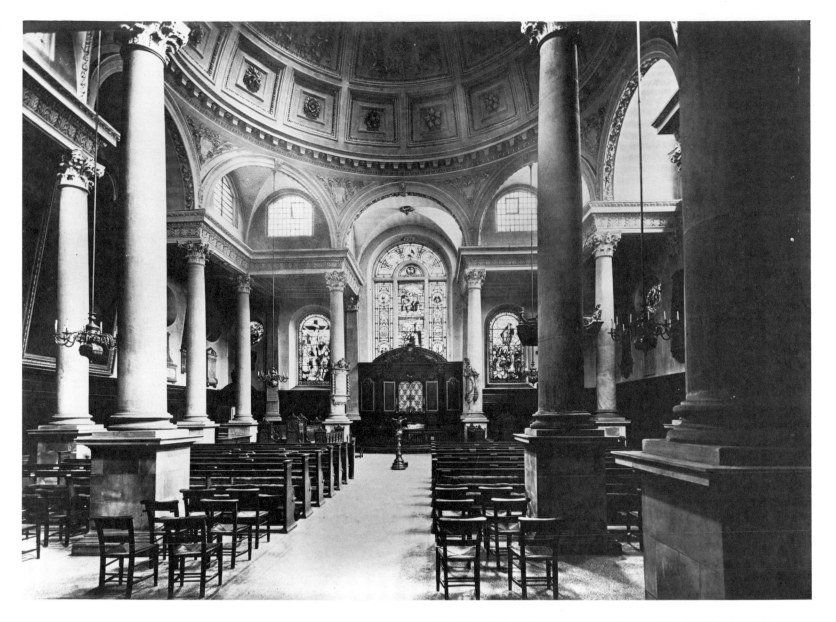

amounted to a program of random bombing and indiscriminate terror was inflicted upon England, mainly London, during the Battle of Britain. By comparison with later raids involving more bombers and vastly greater tonnage, the first efforts of the Luftwaffe were not statistically impressive. But they were destructive out of proportion to their statistics because the German flyers were not trying to hit or knock out anything in particular; the planes did not generally carry a few big blockbusters, but rather thousands of smaller incendiary bombs which they scattered broadcast across London city. That Saint Paul's Cathedral survived—rocked, battered, and surrounded by a sea of fire—was a major miracle; but of the fifty-two churches built by Sir Christopher Wren after the great fire of 1666, more than a dozen were ruined, and a number more suffered heavy damage, not quite beyond repair. Saint Clement Danes and Saint Mary-le-Bow, for example, were gutted, and the airy interior of Saint Stephen Walbrook was smashed, not quite irreparably. It would be silly to pretend that all the Wren churches were equal architectural masterpieces; but they were the jewels of the city, consecrated by centuries of affectionate familiarity, and to have even a quarter of them wiped out was a heavy blow. Apart from London, another major loss occurred in the saturation bombing of Coventry on the night of November 14, 1940, when Saint Michael's Cathedral was reduced to rubble. While dramatic use has been made of the gaunt ruins by half-incorporating them

157 The light, almost levitated dome of Saint Stephen Walbrook was firebombed during the war (our photograph dates from before that event), but the playful pattern of the pillars was relatively undamaged, as was most of the ornate wood-carving of the interior. And by now the dome too has been rebuilt, so that what threatened to be a cataclysmic fate for the church turns out to have been little more than a wretched episode.

One could work up much more indignation at the wanton destruction of English art and architecture by German bombing in World War II if the English record for preserving their own treasures were better. Not only churches but theaters, government buildings, and splendid private residences have been demolished, through the years of London's history, to make way for structures ostensibly more profitable but aesthetically deplorable. Like the great fire of 1666, World War II simply hastened and randomized a process which had its own long-established momentum.

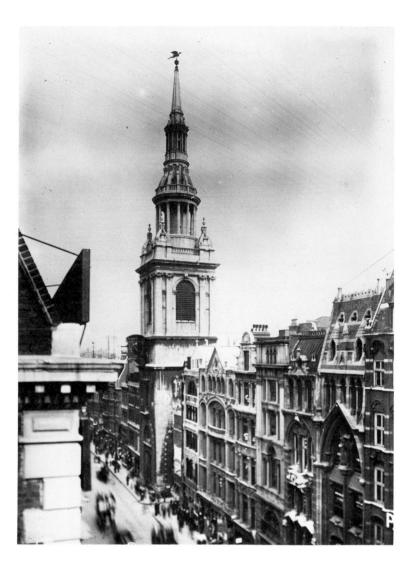

158 *Saint Mary-le-Bow jutted out into the London City street known as Cheapside, and to be born within sound of "Bow bells" was to be an insider in the closest circle of all. But the church had aesthetic qualities as well; of all Sir Christopher Wren's London churches, it has the most satisfying exterior. The steeple rose through a graceful cluster of columns through a little temple, and then through an order of smaller columns to a smaller temple, atop which rose an obelisk spire. None of the individual elements was startling in itself, but the combination was both free and harmonious. The church was totally destroyed in 1941, and was rebuilt after the war in expensive facsimile.*

159 *In this view, taken just after the First World War, Rheims Cathedral looks a bit scarred and battered, but not profoundly damaged. The photograph, however, does not show the burned-off roof, the collapsed apse, the hundreds of statues in the side porches calcined or smashed to bits, the dozens of shell-holes in the fabric. Though it was not always possible to count individual explosions, because on some crucial days they came too fast to be distinguished, during the war's five years the cathedral was hit by over three hundred shells, the heaviest concentration falling in 1918. The worst damage, however, resulted from a major fire on September 29, 1914, which was fed by a wooden scaffolding erected to protect the north tower (on the left in the picture).*

A special problem in learning the true story of Rheims Cathedral is that the Germans, for obvious reasons, have little or nothing to say of it, while French books on the subject are literally incoherent with rage. ▶

with the new church, one can gain an impression of the old one only from graphic representations of it.

Two useless consolatory remarks after the destruction of a major art object are that it wasn't destroyed on purpose, and that other items of the same class are left. Both are a little bit true when applied to the Wren churches of London and the cathedral at Coventry. Wren designed or supervised more than fifty churches; nearly forty of them remain. Of the nineteen cathedral churches in medieval England, no fewer than seventeen survive, among them Canterbury, which would have been an easy target from the Continent had the Germans at any time wanted to concentrate on it. Indeed, most of the destruction inflicted on England by the German air force during the war can be called random, because the bombs weren't aimed at anything specific. The raids were generally made at night, without radar, against a target no more precise than a metropolitan area. And, later, the V-1s and V-2s were impossible to aim accurately. This is probably the most horrifying thing about bombing in general—that it's so mechanical an act, so serenely unrelated to its unimaginable consequences. In any event, it's a half-truth that the Nazi bombings in England were not a cold-blooded destruction of architectural treasures like the deliberate, day-after-day, year-after-year shelling of Rheims Cathedral in World War I. The other half of the truth may be something much worse—a kind of callousness and indifference to the consequence of one's actions that is so blank and negative a quality one can't either denounce or satirize it. From our limited point of view it's enough to say that a building of artistic quality is unique, and it's in the law of averages that firebombing a city like London, or for that matter a city like Dresden, is going to ruin a certain number of these unique structures, as well as a larger number of replaceable, but for all that, miserable, people.

Italy is the last country in the world where the lover of art would want a major military campaign to be fought; and here, because the Allies had from the beginning complete air superiority, most of the blame falls on the Anglo-American forces. For example, it was a squadron of American B-25s which on March 11, 1944, swept in over Padua and bombed the Eremitani church, along with its Ovetari Chapel which had been decorated by Andrea Mantegna in the fifteenth century with frescoed scenes from the lives of Saint James and Saint Christopher. The loss is hideous, irreparable; at a stroke, there disappeared from the earth a major fraction of the surviving work of a major master. But there are consolations even here, and not altogether empty ones. The paintings had been carefully studied and repeatedly photographed, down to minute details. And they had not been handled very carefully over the centuries since they were painted. For one thing, the damp soil and climate of Padua attacked some parts of the paintings on the lower level of the chapel wall; pigments were discolored, plaster flaked away. About 1865 three of them (depicting the Assumption of the Virgin, the Martyrdom of Saint Christopher, and the Removal of the Saint's Body) were removed from the wall and fastened to canvas. In addition, the "Assumption of the Virgin" was for some reason radically, and unfortunately, lengthened in the vertical dimension. Ironically, these pictures, the most seriously damaged of the cycle before the American raid, are the only ones that survived it. And even here, where we do still possess the originals, we must resort to copies to see what the originals were once like.

188

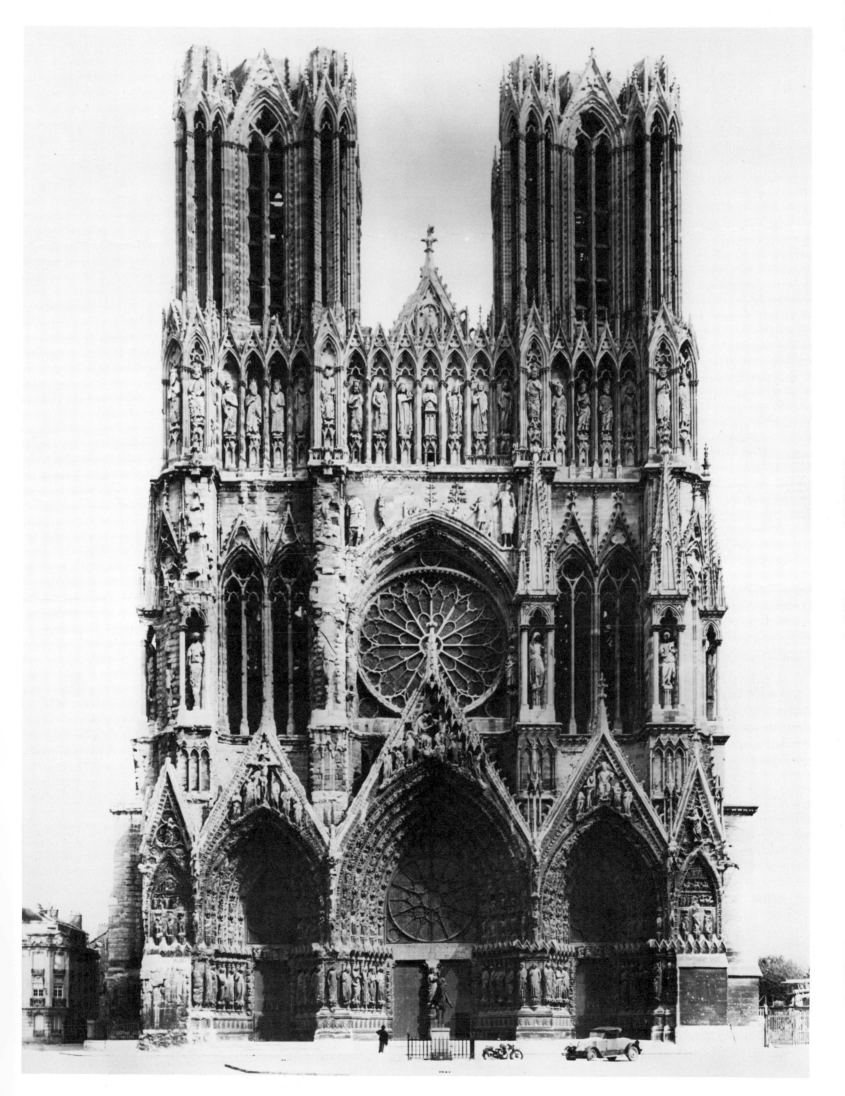

189

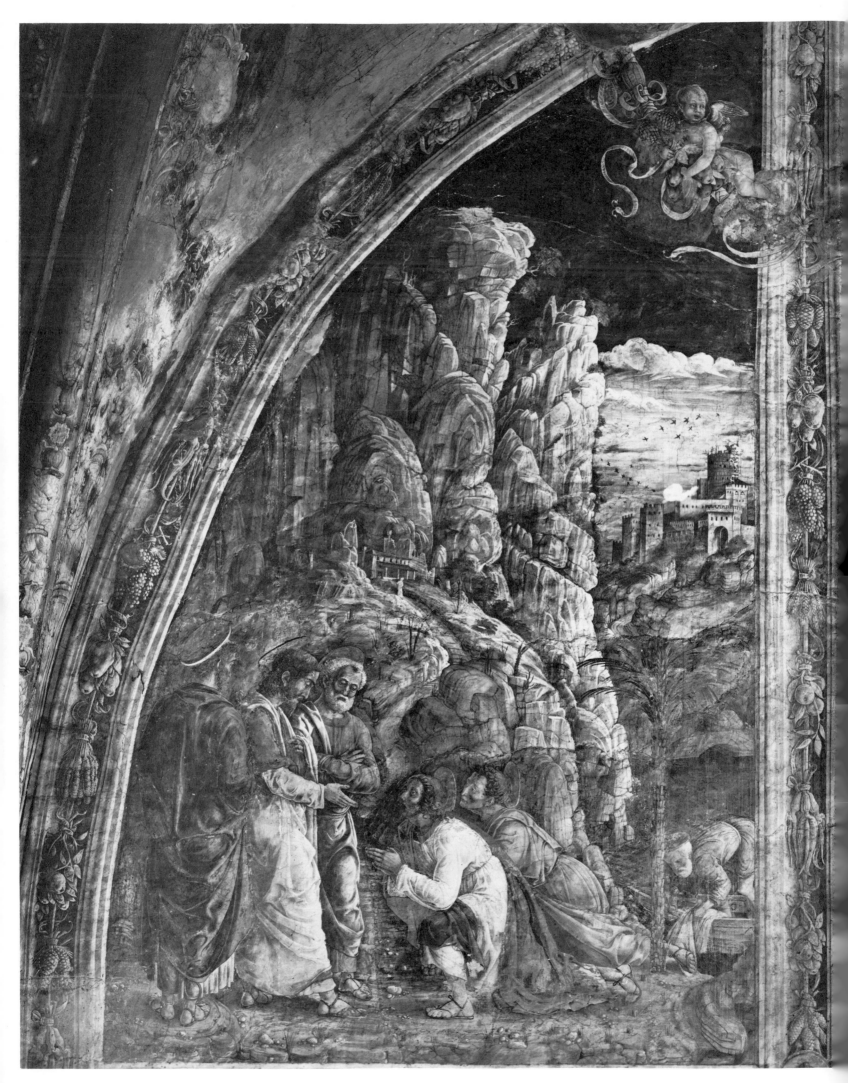

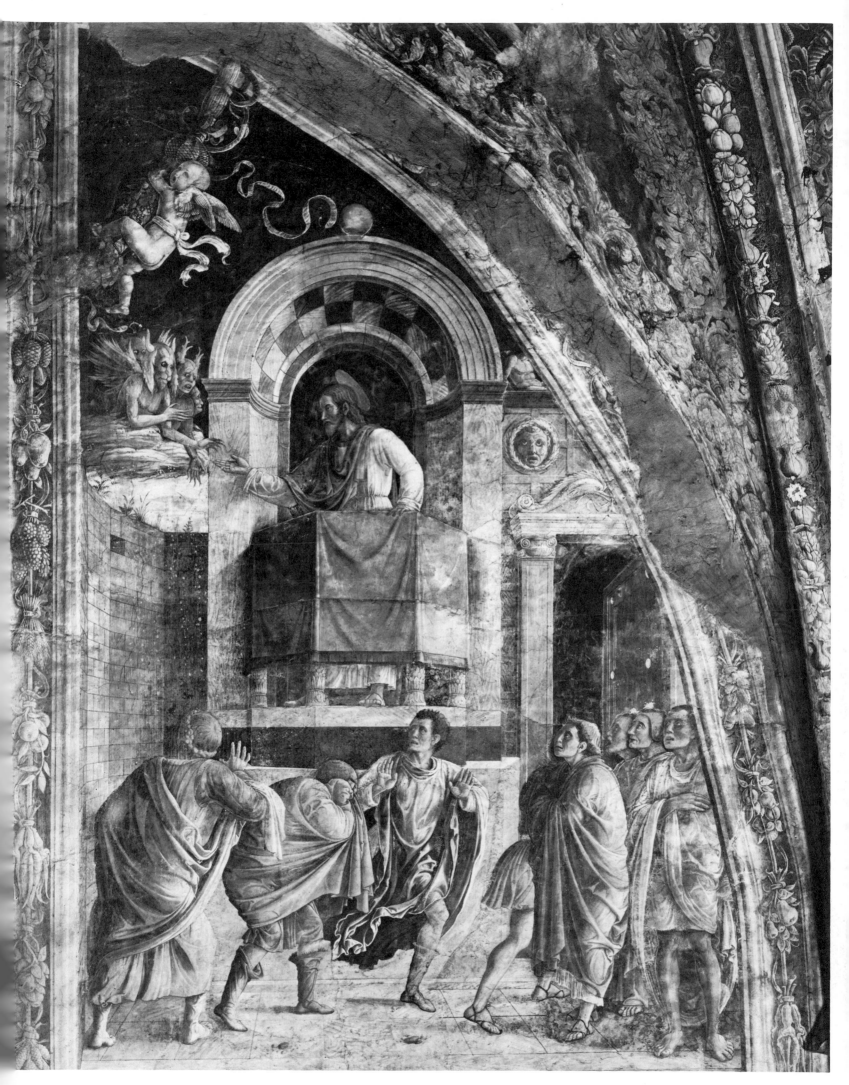

◄ 160 *"The Calling of James and John [or Andrew: there are two Biblical passages] to the Apostolate" was a fresco by Andrea Mantegna in the Ovetari Chapel of the Church of the Eremitani in Padua. The entire chapel was bombed to powder by the U.S. Army Air Corps in World War II. Perhaps because they were placed high along the walls of the chapel, these pictures never became as well known as the larger, lower ones; they also suffered less from the damp Paduan soil beneath the building. Lovers of the rocky Mantegnan landscape, which seems always on the point of stammering forth a symbolic word, and sometimes does so, will particularly regret loss of this picture. And the figure of Peter, tugging at his nets in the lower right, is a particularly human and appealing image of the saint.*

◄ 161 *"Saint James Speaks with the Demons," fresco by Mantegna in the Eremitani, Padua. According to the* Golden Legend, *the wicked mage Hermogenes, in one of those spiritual arm-wrestling contests so frequent in antiquity, sent some demons to bother James in his apostolate. But at the sight of the saint, their courage failed them, they begged for his mercy, and confessed that Hermogenes had sent them. The rest of the story can easily be surmised. Apart from the demonic demons, a nice feature of the picture is the terror of that beribboned* putto *hanging from a swag uncomfortably near some sharp horns and claws.*

An engraving by Francesco Novelli, made just before the 1865 operation, shows the original proportions of "The Assumption of the Virgin." And, better yet, we have good copies of the scenes showing the Martyrdom of Saint Christopher and the Removal of the Saint's Body. Both copies were made not long after the original frescoes were painted, and they have survived the intervening years much better than the originals, as comparison will show. But of the Mantegna originals which before the war were still in the best shape, not so much as a recognizable fragment remains.

At Pisa, the monumental district is so clearly defined and so rich in artistic treasures (the cathedral, the baptistery, the Leaning Tower, the Campo Santo) that one would think ground soldiers at least would have no trouble avoiding it. After all, Rome, Florence, and Venice had already been declared open cities, the Germans had already retreated almost the full length of the peninsula, and the main battles of the war were being waged far to the north. But the Campo Santo in Pisa was shelled by American troops in early August of 1944, and the cloisterlike structure caught fire, burning all night and destroying a famous series of twenty-four fresco paintings by Benozzo Gozzoli. Sixteen years of Benozzo's creative life went into making these paintings; they were of particular historical interest, not only in their own right, but because reproductions of them figured largely in the rise of the Pre-Raphaelite school in England. We still have some of Benozzo's paintings, notably in the Medici-Riccardi palace in Florence, where he filled the walls of one small room with frescoes of incomparable charm. But it's probably true to say that the Campo Santo episode destroyed more than half of this minor master's surviving work.

As they retreated north through Tuscany, the Germans deliberately left as difficult a path as they could for the pursuing Allied armies: this is the rule in warfare. All the bridges across the Arno at Florence were accordingly mined and blown up, except the Ponte Vecchio; and, to keep that from being used, the Germans blew up a line of buildings along both approaches to it. Many people considered the Ponte Santa Trinità in particular a work of art, and so it was; but it was also a very practical path across an obstacle, and a prudent commander who cared for the lives of his troops would probably blow it up every time, regardless of its artistic value. The whole idea of blowing up bridges across the Arno has its absurd side, since the stream in midsummer is no more than a shallow, lukewarm brook; but in wartime, delaying the enemy, if by no more than a few hours, is of supreme importance. And it's this immense urgency of immediate, short-term values that makes all warfare inherently uncivilized—which isn't to say that, if one were a German footsoldier retreating sullenly down the long road to the north, one wouldn't be glad to see bridges blown up behind one. At all events, the Ponte Santa Trinità was blown, most of the pieces were fished out of the Arno bed (except for the statues that once adorned the structure), and the bridge has now been put together so effectively that hardly anyone appreciates or recalls the perils through which Ammanati's masterpiece recently passed.

A very different judgment must be passed on those special German detachments assigned to ship large quantities of Italian art to the north. This was part of a major roundup of European art attempted by Hitler and partly abetted, partly

sabotaged, by Goering. The Nazi agents stole in every conceivable way—by forced purchase, by direct expropriation, through pretended gifts or exchanges; and they stole from everybody—from conquered countries, from members of "inferior" races, from ostensible allies, from the citizens and institutions of their own state. They stole to "protect" the works of art from enemies real or fictitious; they stole on the pretext that the original artist was German and his work thus part of the racial heritage; they stole because the owner was a Jew and "unworthy" to possess anything of value. They stole from one another, slyly and without scruple. But their intentions were always to set up collections of their own. They coopted into their service museum directors, curators, and art historians, all of whom knew something about handling works of art; consequently, as with Napoleon's *commissaires,* it was exceptional and accidental when something was irreparably damaged or irretrievably lost.

Italy was only one of the countries the Nazis undertook to loot, and they did not start large-scale looting there until after September 1943, when Italian resistance to the Allies crumbled, and the "Axis" became an empty name. Even then the Nazis pretended they were moving art to the north only to keep it from falling into American hands. The pretext was no more than a pretext, because there had been, and as the event proved, there was to be, no significant American looting. Stories to the effect that the Kress collection in Washington was part of a Jewish conspiracy to spirit away all the European art masterpieces, and that the American army was the tool of this conspiracy, were riddled with absurdities. Kress wasn't Jewish, and his collection was acquired by purchase long before the war; both American and British armies had teams of experts specifically assigned to prevent damage to art works or stealing of them. More significant by far than these propaganda-fantasies was the real danger to which works of art were exposed by being moved in lorries across northern Italy at a time when Allied fighter-bombers were strafing anything that appeared on the roads. In this whole matter, the German claim to have been disinterested guardians of the culture of Europe shouldn't be allowed, even by implication, to stand unchallenged. Hitler was a colossal art thief, and the fact that his personal tastes in art were pitiful didn't prevent his experts from laying greedy hands on practically everything in sight. What Vivant Denon was for Napoleon, Dr. Hans Posse was for Hitler, and the project for a Führer-museum at Linz, where art trophies from the conquered peoples would be assembled as at a second Musée Napoléon, had been common knowledge since the days of the Austrian Anschluss in 1938.

There are many stories of folly and hypocrisy connected with the survival of art treasures in wartime, and some of quiet, courageous devotion. But one general point seems clear, that shuffling them around under wartime conditions—from salt mine to railroad tunnel to ancient castle or distant cellar— is always dangerous and sometimes fatal. Before conflict breaks out is the time to move them for safekeeping, and cities are always more dangerous locales than well-guarded storage depots in the country. But the worst losses are generally those that occur in transit from one depot to another. The paintings which were shuffled so desperately around northern Italy would have been far safer had they been left on the walls of the Pitti and the Uffizi. As it was, many things got lifted and

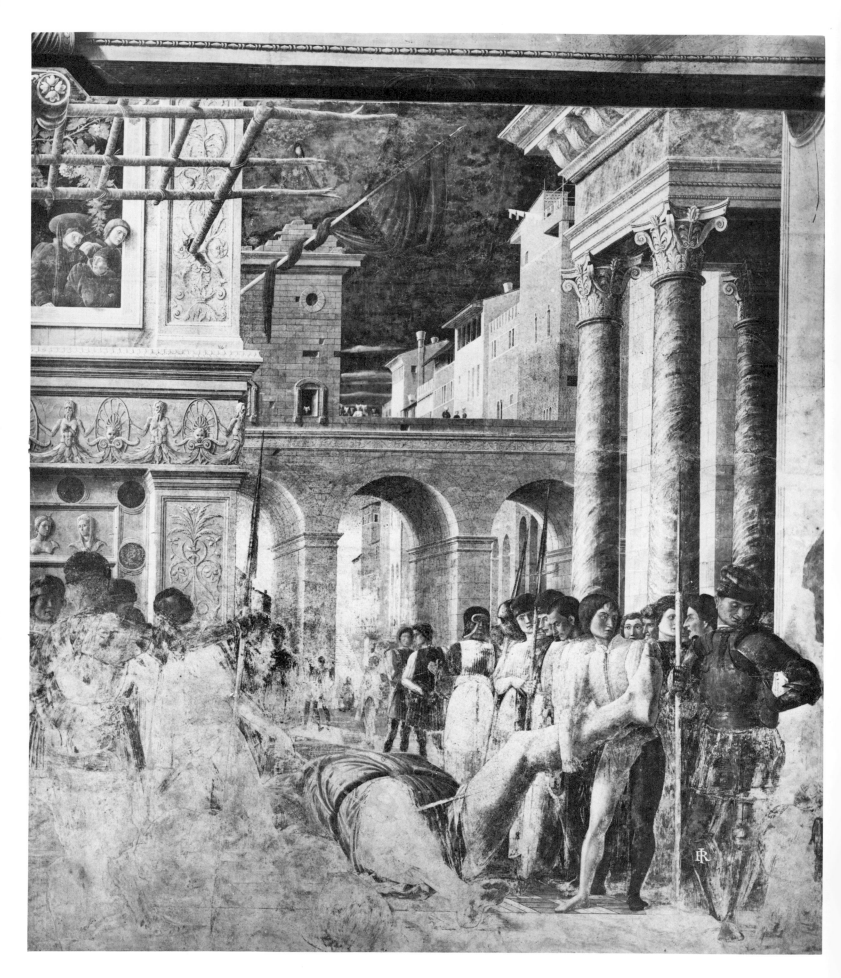

162 *The lower frescoes of the Ovetari Chapel suffered severely from the damp, and this picture shows how much of the pigment had flaked off the fresco representing the "Removal of the Beheaded Body of Saint Christopher" before the whole fresco was destroyed in the war.*

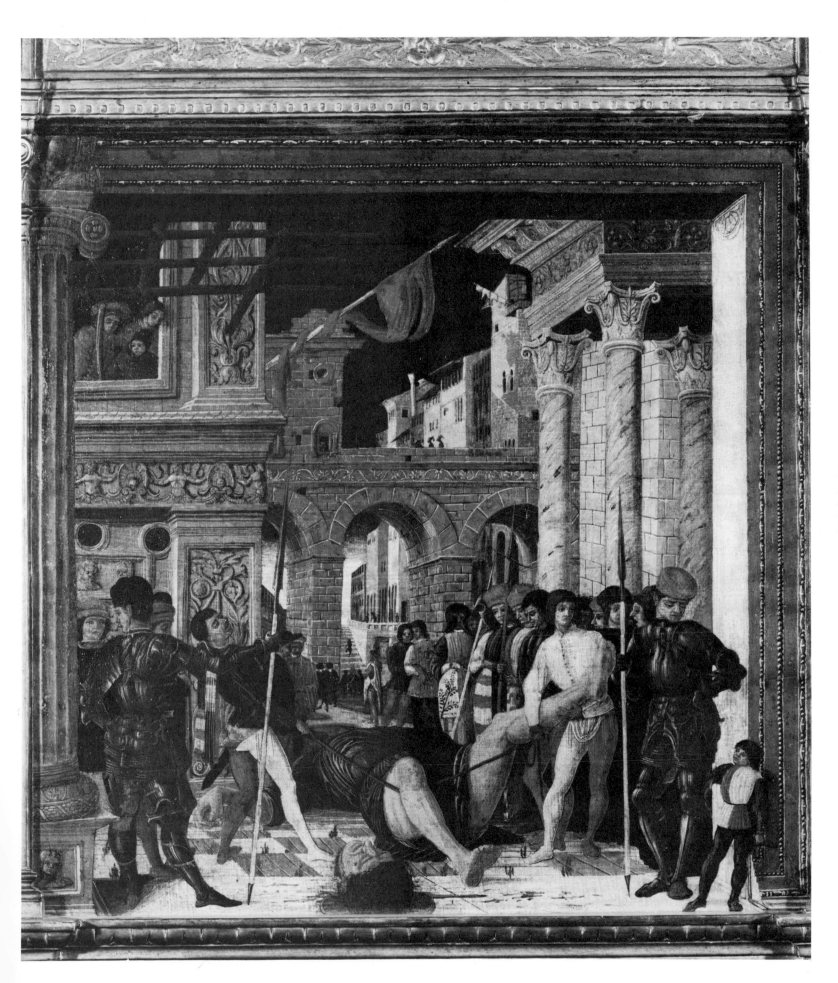

163 *By contrast with the disintegrated original, this early copy of Mantegna's Saint Christopher fresco, which is preserved today in the Musée Jacquemart-André, is in pretty good physical shape. It enables us to identify the figure of the page on the right, and to be sure of the position of the saint's head, at which we would oth-* erwise have to guess. *Some details have dropped out of the copy that can be identified in the original; among these are figures on the viaduct in the background, some bunches of grapes, and a bird on the trellis. Evidently, we were much better off with both versions of the picture than we would have been with just one.*

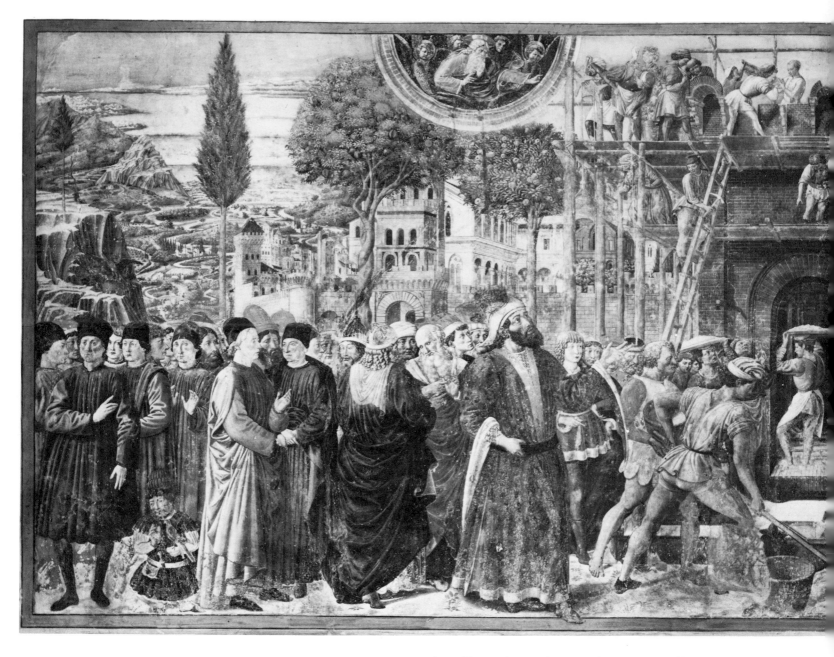

lost, if not always destroyed. Hans Memling's "Portrait of a Man in a Black Cap" disappeared from the Uffizi walls; in the rummage and shuffle of the war's last days, it silently disappeared, and is still "missing"—probably in the Swiss bank vault of some aesthetic pervert who gloats over it now and then. Two little but famous Pollaiuolos also disappeared in the turmoil, only to turn up years later in Pasadena, California, in the custody of an ex-Wehrmacht man promoted to café waiter. There were outright losses too, a mystic number from the Uffizi alone—or at least paintings which, after disappearing during the war, have not yet reappeared.* And it's estimated that several hundred, including the Van Marle collection from Perugia and the collection of the Bourbon-Parma family, are still missing. In addition, many great Italian paintings suffered during the war that sort of low-level wear and tear—from dust, motion, uncontrolled humidity, and just plain handling—that conservators exist to repair. But, overall, it is remarkable that the great collections of Italy got through the war with as little damage as they did.

*In fact, nobody knows how many paintings that were in the Uffizi before the war are not there any more. It is said, but without much assurance, that the Honorable Minister in charge of the Historic and Artistic Patrimony knows, but if so he's not telling. One cogent reason for not releasing the figure, perhaps the only one, is that it's distressingly high.

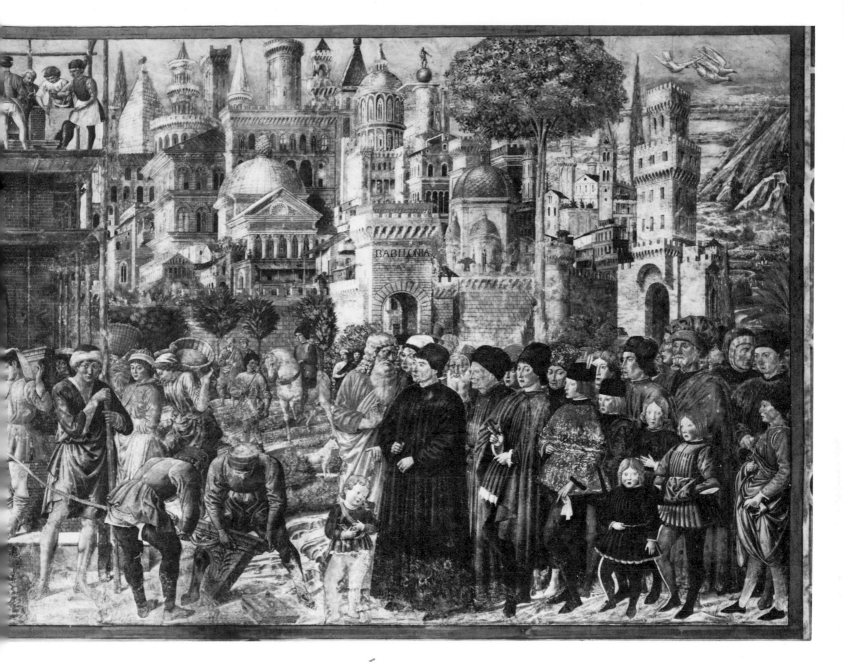

164 *"The Building of the Tower of Babel" by Benozzo Gozzoli, part of the cycle of frescoes in the Campo Santo, Pisa, destroyed in World War II. If the tower itself, in this picture, is less impressive than in other representations of the story, nothing could surpass the richness of human and architectural detail surrounding on all sides the central work of the bricklayers. It was (alas for the past tense!) a jewel of a painting.*

165 *"Autumn," one of the sculptures on the old Ponte Santa Trinità in Florence. The structural pieces of the blasted bridge could be fished out of the Arno, or replaced with new stones, but none of the statues were recoverable.*

166 *It is not the rarity of the painting, nor the giant achievement of the artist, that makes remarkable the disappearance of Hans Memling's "Portrait of a Man in a Black Cap," but the fact that it was abstracted from the Uffizi, one of the super-museums of the world. Even in peacetime, the security of Italian museums and churches leaves a great deal to be desired; during the war, the whole system broke down, and the total number of works lost is still a guessing game. The Nazis did tend to "liberate" works of Germanic artists (Memling was of course Dutch) on the score that "inferior" peoples didn't deserve to possess them. But this painting didn't, apparently, fall victim to chauvinism; it seems simply to have been pilfered during the hectic days of the war, when on both sides the moral climate was about like that described in Joseph Heller's* Catch-22. ▶

Among the big architectural–artistic losses must be recorded two historic Tiepolo ceilings in Milan (the Palazzo Archinto and the sacristy of San Ambrogio) and one in Verona (the Palazzo Canossa), all bombed to fragments; we note the absolute ruin of the ancient Benedictine monastery of Monte Cassino, not itself surpassingly endowed with art, but dating back to the tenth century and rich in associations. (The collections of the Naples Museum had been removed to Monte Cassino for safety, but were then moved, before the great battles at the monastery, to the Vatican, being picked over on the way by Nazi officers; they weren't reassembled until after the war.) We pause to regret the historic church of Impruneta, recorded in a famous etching by Callot during the seventeenth century, long before it was senselessly bombed to bits in the twentieth. The Cathedral of Benevento, the Church of Santa Maria della Verità at Viterbo with the frescoes by Lorenzo da Viterbo, the splendid if long disused Farnese theater in Parma, the palace of the Archiginnasio in Bologna, the frescoes by Melozzo da Forlì in San Biagio of that city, numerous churches and palazzi in Genoa, the church of Santa Chiara in Naples, all, all are gone, or have been so radically damaged that their present appearance only vaguely recalls what they once were.*

But all this destruction is as nothing compared with that inflicted on German cities and art collections. The Frauenkirche at Dresden, the town hall at Augsburg, large parts of the Residenz at Würzburg, the whole medieval quarter of Nuremberg, all disappeared. It would be easier to enumerate the buildings that survive in Frankfurt, Cologne, or Danzig than to list those that were destroyed. The Residenz in Munich went, as did the Old and New Palaces in Stuttgart, along with buildings in Lübeck, Bremen, Aachen, Berlin, Hildesheim, Heilbronn; one could make not simply a book but an encyclopedia of the damage suffered by German cities in the Second World War. Let it suffice for our purposes to describe the misfortune that overtook, in three different forms, three famous German museums.

Badly hit yet not altogether wiped out was the famous collection at Dresden; for though the buildings in which the art works were normally lodged suffered total destruction during the terrible raids of February 13 and 14, 1945, the collection had been largely removed to safer quarters. Especially after 1942, when the dangers of bombing radically increased, the pictures were divided among no fewer than forty-five storage places, far removed from the urban center. But early in 1945, when the Russian armies were advancing swiftly from the east, some German bureaucrat ordered that the pictures in the castle of Konigstein be moved further west. To do this by lorry, over winter roads, in the face of heavy bombing, was terribly hazardous; and the worst thing happened. A lorry carrying 154 pictures was caught in the open; among the paintings incinerated on the spot were Courbet's famous "Stone-breakers," Parmigianino's "Portrait of a Young Man as Saint Stephen," and pictures by Cranach, Breughel, Luca

*In one Italian town after another, the postwar tourist finds that the important church still stands where it did—in name only. The local banks and associations have contributed generously; the local craftsmen have exercised their legendary skills, the general shape of the temple or tower has been reproduced. But all that is left of the old church, apart from common rubble, is a few plaques and heads of statues distributed around the edges of the church, occasionally a column or two. Such is the case with San Biagio in Forlì, with San Domenico in Ravenna, with the Duomo in Arezzo—and the list could be many times multiplied.

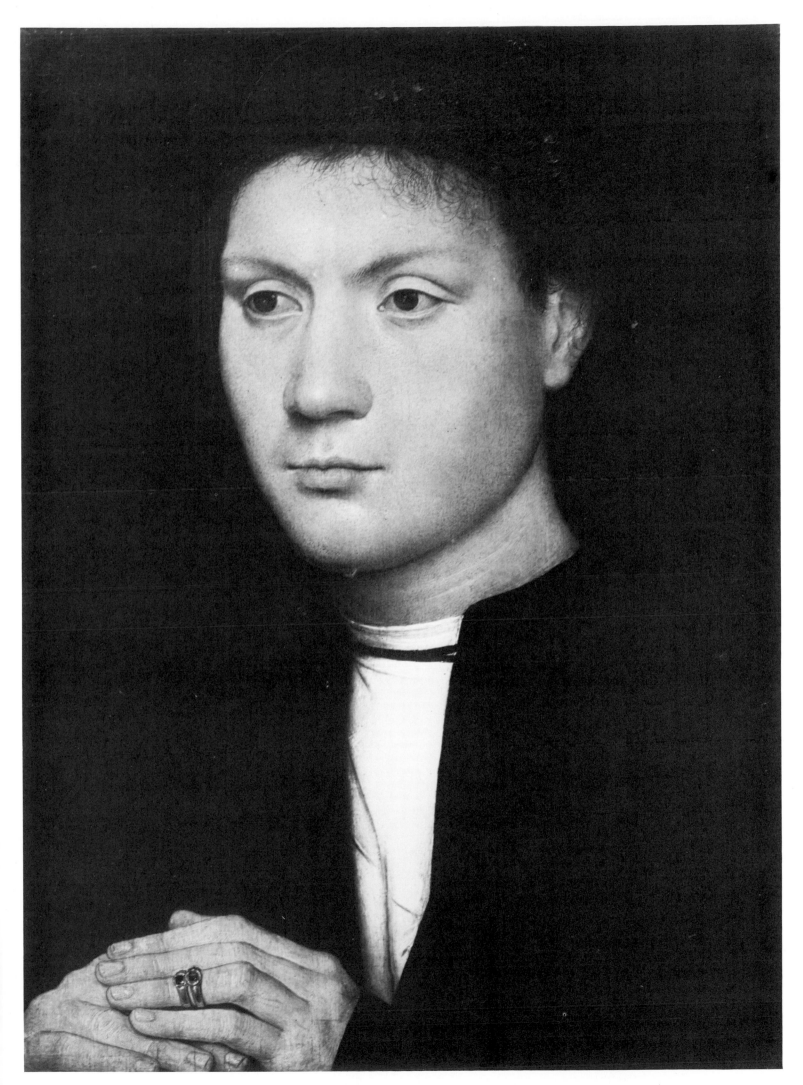

167 *This detail from a Tiepolo ceiling in the former Palazzo Archinto, Milan, portrays Juno with Fortune and Venus; the photograph was taken for a book* (Tiepolo, Antonio Morassi, Instituto Italiano d'Arti Grafiche) *that appeared in 1943 a few months before the ceiling, the palazzo, and the entire files of the photographer were incinerated in a deadly series of air raids. The only record of the ceiling is in the book, from which this copy was made.*

168 *The little town of Impruneta near Florence has long been famous not only as the center of a gigantic fair (vividly portrayed by Jacques Callot in the seventeenth century), but as the residence of a particularly influential statue of the Madonna. When plague struck heavily at the Florentines, a remedy of last resort, throughout the Renaissance, was always to call for the Madonna of Impruneta and parade her through the streets. But she could not protect her church from the bombs and shells that collapsed its roof, ruined its precious della Robbia altar, and buried the Madonna herself in rubble. Basic repairs have been performed where possible, but the church will never return to anything like its prewar state.*

169 *The Cathedral at Benevento as it was before the war. Once again, bombs shattered it.*

· NATI· MATER· ADEST· PVERI: NATIQ VE· PARENTIS ·
· FILIA· TAM· CASTI· SPONSA· PVDICA· VIRI · ·QVAE
 GA

170 *Many Renaissance painters never left their natal towns to enter the mainstreams of art flowing through Rome, Florence, Venice, and the courts of the north; staying at home, they became essentially town painters, without for all that forfeiting their claim on our interest. Such a man was Lorenzo da Viterbo, whose major work, for the Church of Santa Maria della Verità* in Viterbo, *was smashed up almost beyond repair in the last war. The text below praises Mary as the modest spouse of such a chaste man, and contains comfort for Joseph as well: "What greater joys could you hope for in your old age than to be the father of so dear a pledge?"*

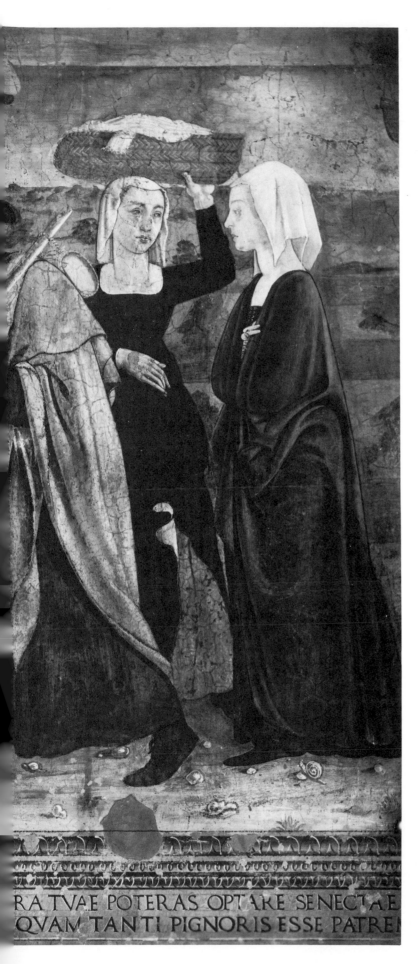

RA TVAE POTERAS OPTARE SENECTAE
QVAM TANTI PIGNORIS ESSE PATRE

172 *When work by a major master is destroyed, we commonly have other works to remember him by; at least we have detailed records, in the form of copies or photographs, to remind us of the lost object. But lesser artists can often be wiped out completely when a single structure is bombed or shelled. The major work of Marco Melozzo was the fresco painting in San Biagio, Forlì, and*

171 *High-explosive bombs reduced the Teatro Farnese in Parma to a mound of chalky plaster and splintered rubble on May 13, 1944; but the event may have been a blessing, thoroughly disguised. The theater had been hailed as the last word not only in technical innovations but in decorative splendor when it was built in 1618; but the Farnese family found only occasional use for it, to house court spectacles and gaudy royal weddings. Then, during the nineteenth century, the Teatro Ducale, later renamed the Teatro Regio, became the accepted home for the turbulent operatic life of Parma; and the Teatro Farnese continued to molder away, as shown in our photo. After the bombing, there was an awful moment when it seemed that the last fragments would be bulldozed away and a concrete variety-theater and hippodrome substituted. But at the last minute a decision was taken to renew (in effect, rebuild) the old Farnese with its glowing wood interior. How the new theater actually works as a place to hear drama or concerts, I do not know; but to stand inside it is like standing in a giant freshly varnished violin, almost atremble to be filled with music.*

it was bombed to powder in World War II. We are lucky to have this photograph to remember him by.

174 In addition to the strong yet upward-leaping Frauenkirche of George Bähr (shown here), the Catholic Cathedral of Dresden with its florid baroque lines, the opera house of Gottfried Semper, and dozens of other churches, palaces, museums, and time-honored structures were bombed and burned out in 1945. By the sort of irony all too familiar under such circumstances, the industrial plants of Dresden, which constituted more or less reasonable military targets, went wholly unscathed during the Allied raids of February 13 and 14, because they were located in the suburbs and the bombers zeroed in with deadly accuracy on the historical center.

173 The Golden Room of the town hall in Augsburg was built by Elias Holl in the early seventeenth century. Those were the days when the Fugger family and the less-well-known Welsers served as bankers to many of the crowned heads of Europe; the Golden Room, with its splendid dimensions and profusion of gilt ornament, was a place where they could be welcomed with grandiose ceremony. But incendiary and high-explosive bombs wiped it from the face of the earth during the later stages of World War II.

Giordano, P. G. Batoni, and others. In addition to the paintings burned up in the lorry, some forty paintings that had been left in the Dresden Gallery because they were thought too big to move were also destroyed.

When the Russians did finally overrun the Dresden area, they promptly shipped off to Kiev and Moscow about two hundred and fifty paintings in urgent need of shelter or repair; and cynics might have anticipated that these art works had disappeared for good, at least from Western eyes. But this was not so. Evidence is that the Russian museum personnel not only treated their new visitors with scrupulous care, but in due course returned them with complete documentation, both of their original condition and of the procedures taken to preserve them. As we shall see, this was very different from Russian behavior elsewhere with regard to works of art; and it couldn't have been more timely. The collections at Dresden represented the sifting and purification of an originally enormous and very heterogeneous potpourri of art, in the acquisition of which Augustus III and his art-loving ministers literally bankrupted the state of Saxony. During the late eighteenth century they acquired, along with a tremendous lot of second-rate and mislabeled material, a number of authentic masterpieces, the like of which could not possibly be reassembled today. The Dresden Gallery was particularly lucky to fall into the hands of such understanding and considerate conquerors.

Unlike the great gallery of Dresden, the Kunsthalle at Bremen was of relatively recent growth and modest reputation; it did not lose many works, but those it did lose were of considerable importance. Among other precious objects, it held no fewer than eight of Dürer's surviving watercolors; they disappeared along with two Dürer paintings, a Gauguin, a Goya, a Guardi, a Monet, a Renoir, a Tintoretto. The special feature of the losses at Bremen was that, while firebombing took its toll, many of the most important paintings seem to have been simply stolen while being stored for safekeeping. In Frankfurt, Cologne, Leipzig, Magdeburg, Weimar, Munich, Dessau, Gotha, the end result was the same. A simple catalogue of the paintings lost in Germany between 1939 and 1945 runs to hundreds of pages; and within this listing, an entire collection sometimes occupies only a couple of lines—the whole thing is lost, a careful inventory was never made of its holdings, we shall never know what has disappeared.

175 Courbet, "The Stone-breakers," incinerated in a truck while in transit from a depot of the Dresden Gallery. When first exhibited in the Paris Salon of 1850, the picture aroused much debate as to whether it implied democratic or radical sympathies. It certainly did; and so did others of Courbet's paintings, to the point that one of them stimulated Napoleon III to slash at it with his riding crop—a high compliment indeed. But there were other things about Courbet besides his radicalism and his realism—he was a dark earth-poet as well, and we are all diminished by the loss of any specimen of his work.

176 *P. G. Batoni, "Repentant Magdalen," a painting from the Dresden Gallery destroyed in World War II. The inward and meditative mood of the painting, and its almost underground setting, contrast painfully with the fiery violence of its final end.*

Finally, the most terrible loss to befall any collection of art in more than two centuries was visited on the Kaiser Friedrich Museum of painting in Berlin. This was one of the great European collections of Renaissance art; it represented purchases made over several centuries, as well as the consolidation of a great number of lesser museums. Under pressure of Allied bombings, the paintings were moved to an armored structure housing anti-aircraft batteries, known as Flakturm Friedrichshain. There they were indeed safe from bombing, but when the Russians overran the city in May 1945, they captured the tower and its contents; and, whether out of ignorance, indifference, or spite, they set or allowed someone to set the whole thing on fire. For three days it burned—not out of control precisely, because nobody tried to control the flames,

and not quite spontaneously, because the fire apparently had some help in spreading from the first to the second and third floors of the structure. The fire has been said to represent the greatest disaster to the figurative arts in Europe since the 1734 fire in Madrid. Losses in that earlier fire are relatively hard to document, because old inventories tend to assign titles casually to paintings and guess offhandedly at attributions; but the losses in Flakturm Friedrichshain are, alas, easier to describe. Four hundred and seventeen paintings disappeared, and forever. There was hope for a while that some of them had merely been stolen, since the depository had been left unguarded day and night; but as none have turned up, they must all be pronounced dead. The roster of losses includes six Veroneses, six Van Dycks, ten Rubenses, two Breughels, three

177 *Famous names attached to pictures make for high prices, so it's not surprising that a lot of questionable Parmigianinos have surfaced across the centuries. This "Portrait of a Young Man as Saint Stephen" used to hang in the Gallery at Dresden, where it was sometimes attributed to Parmigianino, sometimes to Alonso Cano. Though scientific analysis of pigments and canvas might not have established with absolute assurance the name of the artist, it might have narrowed these rather wide alternatives. But all such questions became academic when the painting was incinerated, along with more than a hundred other irreplaceable works, during the closing days of World War II.*

178 *Luca Signorelli's so-called "School of Pan" was one of the many Renaissance paintings immolated in Flakturm Friedrichshain. For years the interpretation of this strange heraldic painting had been the subject of scholarly and critical discussion. Did it perhaps represent the meetings of the Platonic Academy headed by Ficino at one of the Medici villas around Florence? Or was it in some way an allegory of the Medici family them-*

179 *Watercolors, which depend so much on color for outlines as well as emphases, don't reproduce well in black-and-white. But we cannot ignore the disappearance from the Bremen Kunsthalle during World War II of a number of watercolors by Albrecht Dürer. Badly as Bremen was hit by Allied bombing, the loss of these precious items seems to have been due to simple pilferage.*

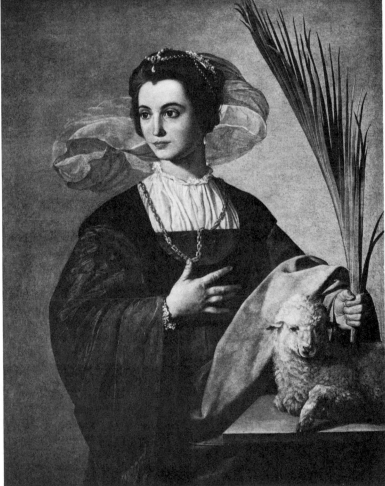

selves? While the picture survived, it was possible to hope for some clarification of these alternatives. But when it is utterly, irrevocably dead, as an object, discussion of it will inevitably languish. By a consequence less logical than emotional, the problems are likely to die with the picture that gave rise to them.

180 *Alonso Cano, "Saint Agnes," a painting incinerated in Flakturm Friedrichshain. It is a particularly polished, almost queenly, patron of chastity that the painter has given us. She is identified by the lamb, whose Latin name (agnus) so nearly puns on hers.*

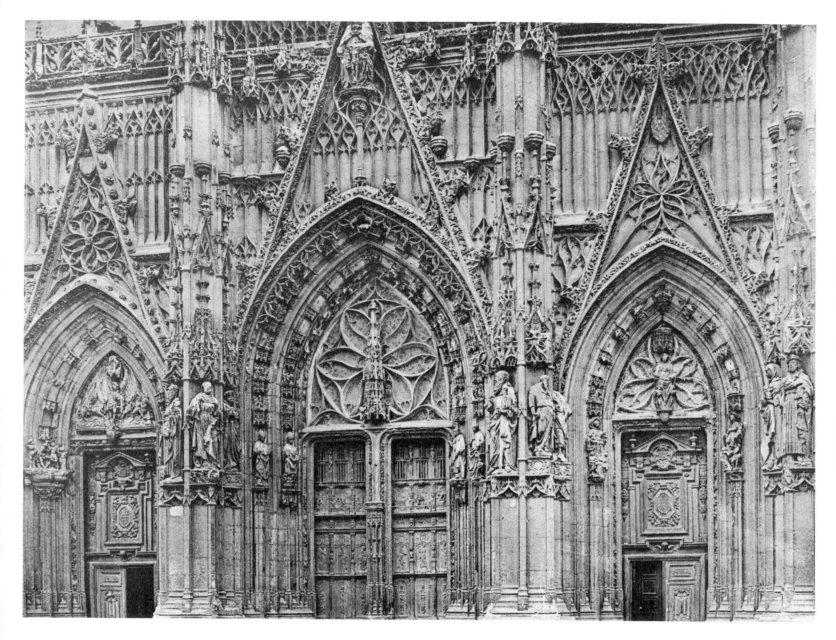

181 *The church of Saint-Vulfran in Abbeville was constructed between 1488 and 1539 and never became as much of a church as it promised to be. But its façade was a classic example of late, elaborate ("flamboyant") Gothic, and behind it there existed a genuine operational church. During World War II the facade was not altogether demolished, but it was badly damaged and the entire church behind it was burned to the bare walls. In town after town the ebb and flow of contending armies pulverized not only the churches, but the museums, the town halls, and the old quarters of the little cities of Normandy.*

Caravaggios, three Ghirlandaios, two Tiepolos, two Tintorettos, plus a Botticelli, a Carpaccio, a Titian, a Zurbarán, a Signorelli—all this over and above a rich collection of bronzes, medals, coins, statues, decorative objects—and 378 other canvases that we don't have space to list by name. The entire collection of the National Museum of Nineteenth-Century Art was also wiped out, along with dozens of smaller collections stored in castles, vaults, and "safe" structures in the vicinity of Berlin.

That we have photographic records of these lost paintings is small consolation for their loss; and there's not even a reasonable lesson to be drawn from the experience. Putting the paintings in the Flakturm was not a bad idea in itself, and a lot of other art objects which had been put in another Flakturm near the Berlin Zoo survived the war perfectly well, though not unscathed by the looting that followed it. What couldn't be predicted was the deliberate callousness or active barbarity of the particular Russian commanders, so different from those at Dresden. Of course, there were contributing circumstances. The northern commanders had been fighting their way through Prussia, a region they particularly loathed and where they took special pains to sack the great Junker estates, gutting and burning and exploding till not one stone was left atop another. The last siege of Berlin was a fight to the death, and when no quarter was being given in the field, it was not

182 When is a building really destroyed? Much depends on the eye of the beholder. The church of Saint-Pierre at Caen was bombed and shelled during World War II; this photograph, showing it in truly dilapidated estate, appeared under the caption "Ruins of Saint-Pierre" in an excellent book published after the war, Lost Treasures of Europe, *ed. Lafarge (Pantheon, 1964). And indeed at first glance the devastation appears complete. But most of the ruins are in the foreground; behind them, the nave is still standing, though with most of the roof gone, and of course the steeple has been demolished. A 1978 resident of Caen minimizes the damage; the steeple was hit, but it has been splendidly restored, and the church is (according to him) almost unharmed.*

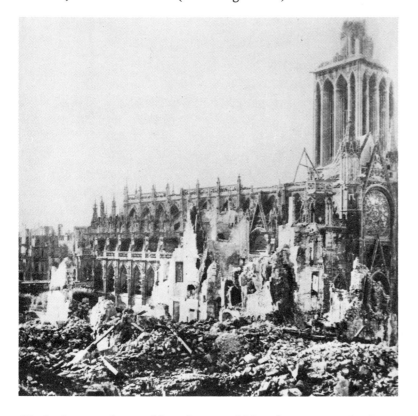

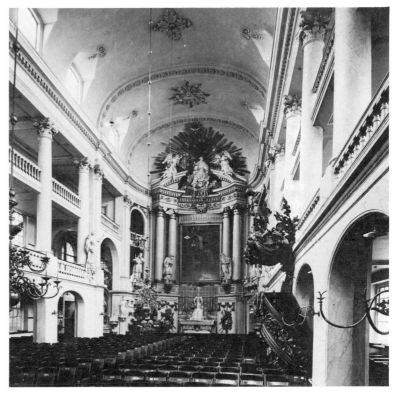

likely that much consideration would be given to art. And as a rule the Russian armies as they moved into Western Europe were not nice or particular in their respect for other people's property. They had no reason to be; German atrocities on the Eastern front were no secret, and the spirit of revenge ran high. In the final holocaust of the Third Reich, art objects were swallowed up far and near, not by policy or intention, perhaps without even any recognition of what they were, but in a blind ecstasy of destruction. A major Caravaggio, "The Incredulity of Thomas," disappeared from Potsdam—not stolen, we may be sure, nor carried off to a house or vault; thieves have nothing to do with a painting of this class, too big to carry off and too well known to be sold or shown anywhere. When such paintings disappear, it is because they have been wantonly destroyed; and against such impulses within the human heart, there is hardly any protection, least of all in times of mass rage and systematic brutality.

Wartime destruction in France was heavily concentrated, as one might expect, in the area of Normandy and across the North; on the whole, France was spared both the mass, indiscriminate bombing that befell Germany and the wholesale savagery that Germany visited on the Eastern front. Even so, we can hardly do more than gesture at the extent of the devastation. Not only were port cities like Cherbourg, Caen, and Le Havre demolished, but there was heavy damage in towns like

183 The church of Saint Rosalie in Rotterdam was not an ancient or historic structure; it was first consecrated in October 1779, and nothing very significant ever happened there. But Rotterdam was never a town of great architectural splendor, and the chaste yet floridly decorated interior of Saint Rosalie made it a rather special little church. In the bombardment of May 1940 it was flattened, along with almost all the rest of Rotterdam's inner city. (Early on in the war, the Nazis thought it important to teach the Allies a lesson in the destructive power of dive-bombing, then a quite novel technique.) Battered, shattered, and burnt out, the cathedral church of Rotterdam, Saint Lawrence, was not quite beyond repair, and it has since been repaired. But Saint Rosalie is gone forever.

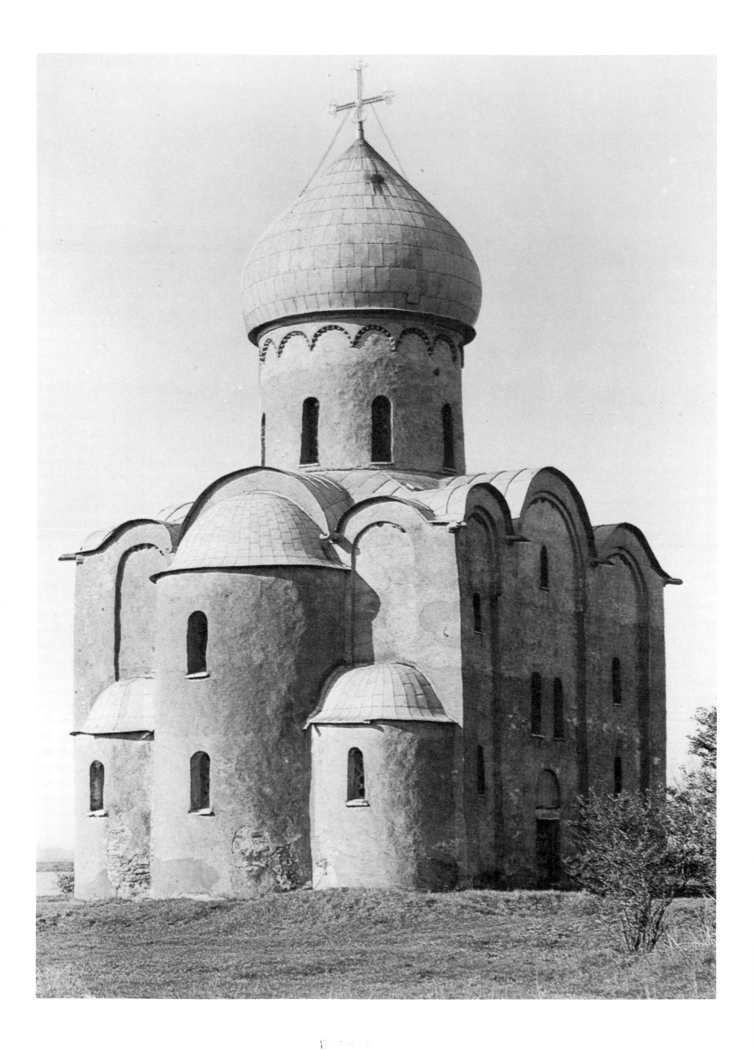

Saint-Lô, Rouen, and Beauvais, where the entire area around the cathedral was battered flat; and the district around Bastogne, Nijmegen, and Arnhem in Belgium and northeastern France was savaged as well. Relatively speaking, France suffered less overall than most of the other major combatants. And yet, when the quantity of destruction is so enormous, the mind tends to deal with it wholesale—one says a church or a district or a city was destroyed without even thinking how much that means in terms of intricately carved choir stalls or altar screens, frescoed walls, painted windows, curious carvings—the work, weary or loving, of skilled craftsmen over the years and centuries, all destroyed by the blind and indiscriminate act of an instant. And the tide of destruction was universal. From the Italian bombings in Ethiopia it washed northward over the great palaces of Peter (at Peterhof) and Catherine (Dyetskoye-Selo) near Leningrad; it reduced to rubble the holy shrine of Pechersk Lavra in Kiev and the amazing New Jerusalem monastery at Istra.

The most barbarous destructive effort of the entire war was that which Hitler unleashed in Eastern Europe; it is also the least documented. We don't know very fully what was in the conquered lands before the Nazi armies came; we know only, and all too well, that nothing was left when they retreated. Hitler's collecting mania made his agents careful of any art objects in the West which might some day be thought worthy of the Führer-museum, or even of the subordinate and provincial museums which would some day have been needed to hold the overflow of German loot. But in Poland, the Balkans, and Russia there was hardly anything worth collecting (from Hitler's point of view), not even very much worth stealing (from the point of view of front-line troops). The Germans despised and feared Slavs of all breeds, considering them only half-human; what they had done in the way of art could, consequently, only be inferior and disgusting. So on the Eastern front, smashing and burning and wholesale devastation were the rule, a rule neatly complemented by the Russian determination to leave nothing behind for the enemy except "scorched earth." On the Western front, nothing worse than theft and confiscation were the order of the day; and sometimes, as an ultimate refinement of Nazi manners, confiscation was even disguised as purchase. But in the East, museums, palaces, churches, shrines, monuments, old estates, anything and everything was ruined, to the limit of human capabilities. We could blacken the very sky, not to speak of intolerable reams of paper, without coming to an end of the destruction accomplished by World War II.

Partly this was because the war ranged so widely across the continents: it wasn't a siege-war, like the First World War, in which ghastly things were done but in a quite limited area. Aerial bombardment, more than anything else, expanded the area of destruction; as the conflict went on, the craft of bomb-carrying and bomb-dropping compressed decades of development into mere months, so that B-29s at the end of the war were carrying forty times as much high explosive for distances ten times greater than the heaviest planes engaged at the war's beginning. Of course the advent of atomic energy raised the whole craft of annihilation to new levels; and in another less spectacular way, so did the steady obliteration of a distinction between soldiers and civilians. War, which used to be a struggle between army and army, became a struggle between one

◄ 184 *Modest in size and not particularly striking in form, the Church of Our Saviour at Nereditsa near Novgorod does not seem such an obviously spectacular catastrophe of World War II as, for instance, the flamboyant New Jerusalem Monastery at Istra. Both were ground to powder by the German war machine. But the little church at Nereditsa was entirely decorated, inside, with frescoes by twelfth-century Novgorodian artists, precious representatives of that early Russian culture which is being resurrected with particular avidity and interest these days. We show it as one instance of the war's devastation out of a thousand in the Novgorod area alone.*

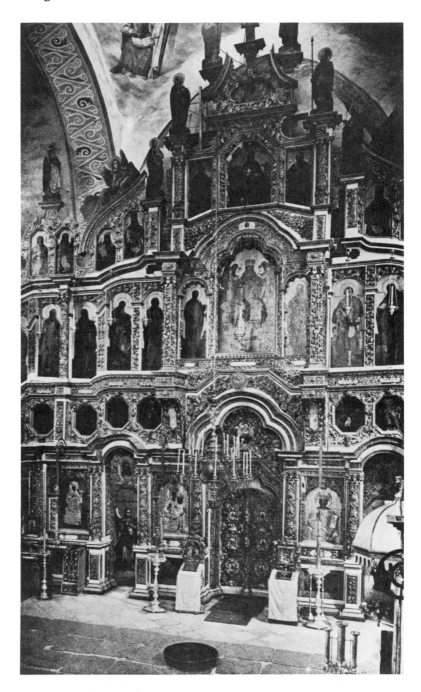

185 *When we show the exteriors of buildings destroyed in warfare, we show a mere outline, an almost abstract form; but each of these buildings was filled with complex decorative work, the full richness of which we must imagine on our own. This picture of the icon-bearing screen in the Cathedral of the Assumption, forming part of the big monastic complex of Pechersk Lavra near Kiev, reminds us of the full dimensions of that building. World War II reduced the entire monastery to unredeemable rubble.*

productive machine and another; such a struggle may produce, among other ironies, a real meeting of minds when both "sides" come to recognize that their common goal is a scorched earth, their only question who shall scorch it.

And yet, and yet—we can't overlook the fact that Paris, Rome, Florence, and Venice were spared; we shouldn't forget that the cathedrals of Chartres and Amiens were twice passed by invading and pursuing armies (German in 1941, Allied in 1944) which scratched not a stone and cracked not a pane of glass. The great Duomo in Milan has been brought into greater danger by the thud and rumble of metropolitan traffic than by bombers or armies. In the main European air war one can't properly say that more than minimal restraint was exercised anywhere, and in many places no restraint was exercised at all. Bombing and strafing by fleets of airplanes ranging across a countryside at four hundred miles an hour and pouring forth napalm, high explosives, and incendiary bullets at the hair-trigger impulse of a nervous, excited boy—this simply can't be a discriminating process. But armies on the ground can apparently be trained to exercise some restraint where cultural treasures are concerned; and if, as we're all bound to feel, the restraint isn't enough, it still seems to be more than commercial entrepreneurs are willing, or can be forced, to exercise in peacetime.

The greatest triumph of cultural forbearance in World War II was surely the decision of the American command to refrain from bombing the Yamato Plain, including the Nara-Kyoto area of Japan. I don't mean to say that this was a difficult decision. Relatively little of Japan's industrial strength lay in that area, and where Japan's industrial strength did lie— along the Tokyo-Osaka axis in particular—the American command neither exercised nor tried to exercise any particular caution against bombing cultural treasures. In the terrible fire-bombings of Tokyo during March 1945, when more than half the buildings in the entire city were burned up, temples and shrines were immolated along with everything else. And of course anything whatever that happened to be in Hiroshima and Nagasaki when those two cities were atom-bombed, was incinerated on the spot. This included the Magoshi art collection at Hiroshima, from which we reproduce a frail little draw-

186 *When an entire city and its population are incinerated in an instant, it is difficult to feel distress that works of art and art collections were atomized as well. Yet, if only as a token of the greater destruction, we reproduce this fragile watercolor of the "Three Laughers" from the Magoshi collection, once in Hiro-* shima. The technique is sumi-e (ink on paper); the spirit of shared, yet secret, glee seems almost a defiant statement against the immensity of that power which annihilated in an instant the picture, the collection, the building housing it, every human habitation, and every scrap of living tissue in the area.

187 *Kano Motonubu, who lived in the sixteenth century, established a line of painters, many of whom adopted his patronymic, even though they lived centuries later. Among the most distinguished of these was Kano Tanyu (1601–1674), much of whose surviving work (some one hundred landscape paintings) was in-cinerated in the bombing of Nagoya Castle. But, by a small piece of good fortune, some of them had been photographed before the war.*

188 *José Maria Sert, "The Triumph of the East," from the decorated Cathedral of Vich, completed after three decades of work, revision, and delay in 1927, put to the torch in 1936, and then in the last years of the artist's fading life, entirely redone. The picture here represents with its towering wall of elephants a vision from a book peculiarly sacred to Sert, Victor Hugo's* La Légende des Siècles.

ing, alight with what Yeats would have called "tragic gaiety." Another loss of catastrophic dimensions, this time to conventional bombs, was Nagoya Castle, with its hundred famous panel paintings by the seventeenth-century landscape artist Kano Tanyu. But in the area of Nara and Kyoto, where it would have been practically impossible to drop a bomb without immolating a cultural treasure, not a bomb was dropped. This was deliberate policy, and represented a real triumph of cultural advisers over military troglodytes, which merits applause quite as much as the opposite experience merits handwringing and lamentations. By contrast with Italy and above all with Germany, Japanese cultural losses during the war were very light. Indeed, not to represent the Japanese too exclusively as victims in this whole infamous business of you-smash-our-treasures-and-we'll-smash-yours, they too were predators when they could be, and probably did as much damage during the struggles over Shanghai and Peking in 1937 as was inflicted on them in the course of the next eight years put together.

While World War II ground up the art of the past as in a gigantic, impersonal machine, two little pendant civil wars on either side of the great conflict serve to remind us that old-fashioned smashing of the past, at once deliberate and passionate, is not yet extinct among us. The Spanish civil war was not quite as destructive of art as it might have been, because the Napoleonic armies and the anticlerical wars of the nineteenth century had already ravaged the country so thoroughly. But as in the French Revolution, so in the Republican experiment of the thirties, popular resentment against an oppressive regime expressed itself primarily against the Church, and that resulted in many losses. As noted above, the monastery of Sigena was burned out, and so was the cathedral at Vich, with the long-delayed, recently-completed decorations by José Maria Sert. Not to put too fine a point on his politics, Sert was a Fascist, but he was also a Catalan; and it was an act characteristic of that dynamic and stubborn people that after the Vich decorations had been burnt, to which he had devoted so much of his life, he dedicated his last few years, not to repainting them, but to painting anew an entire gigantic set of somber, theatrical murals for the cathedral at Vich. They are still to be seen there; but a full comparison with the earlier set, of which we have photographs, remains to be made.

Everyone, at a first mention of the Spanish civil war, thinks of the city of Guernica, blasted by German bombs, and of the Alcázar at Toledo, assailed by the Republicans; but losses that were individually smaller but cumulatively enormous probably amount to more in the end. Spain is the poorer for the damage inflicted by fanatical anticlericals on hundreds of parish churches, for the ruin of the Palacio de Liria (though many of the collections belonging to the Dukes of Alba had been removed to relative safety), for the destruction of the Alcalá de Henares where Cervantes was baptized, for the less spectacular but no less deadly damage that resulted when well-meaning but inexperienced curators stored five precious Grecos from Illescas in the clammy vaults of the Bank of Spain, where mold immediately got at them. Charges of reckless indifference to the survival of the patrimony were made on both sides; and it's as undeniable that churches were gutted and crucifixes axed as it is that bombs were dropped on the Prado and the Palacio Nacional, and rained on the Palacio del Infantado in Guadalajara. Apart from direct damage, there's

189 *When the art historian Osvald Siren made his massive study* The Walls and Gates of Peking *in 1924, he was already deploring damage done to the great middle gate of the south wall, Ch'ien men, which he described as "only a mutilated makeshift for the magnificent old gate composition which formed the main outlet for the Imperial city." The central door of that main gate was exclusively for the use of the emperor, and all other traffic had to be diverted through side streets. But in 1915–1916 the inconveniences of this arrangement became apparent to all, and with the help of a German architect named Rothkegel the structure was radically modified—only to be swept away entirely after the Communist takeover in 1949.*

190 *The outsize Palace of Science and Culture which the Soviets contributed after the war to the rebuilding of Warsaw is a splendid instance of a building erected to the effect, and probably with the purpose, of destroying a city aesthetically. Apart from reminding us of Charles and Emma Bovary's wedding cake, it is as much out of place in the city beside the Vistula as the Flatiron Building would be in the Piazza Signoria, or as the Eiffel Tower would be on the Acropolis.*

always risk when ancient paintings and precious artifacts are carted hundreds of miles, to be stored in improvised workshops or protected warehouses. Though what is lost can never be replaced, though the very subject pales before the human tragedy of this most bestial of civil wars, a full survey of the cultural damage wrought by the Spanish civil war is sorely needed.

The full extent of the destruction wrought by the Sino-Japanese wars of 1937–1945, the Chinese civil wars that followed, and the Cultural Revolution of 1966–1967, is very hard to estimate. Partly this is because records of what used to exist are not very good, but overwhelmingly it is because the present rulers of China will not let anyone see what has happened. From the little that leaks out, however, and from an analogy with what has happened in the arts of literature and music, it seems clear that the amount of devastation has been enormous, all but inconceivable. Monasteries and temples have been torn down or converted into barracks, warehouses, stables; all but a few museums have been closed or converted into shrines of the revolution; the paintings of the Chinese past have been stripped from the walls and replaced by Maoist posters. Not only the walls but the great historic gates of Peking have been ruthlessly torn down to make way for immense asphalt highways along which no traffic moves, beyond the occasional bicycle or donkey cart. When entire artistic traditions—of opera, of literature, of painting, of handicraft—are being wiped out, it seems idle to bewail the loss of individual art works; and indeed, this is impossible, because the regime is incredibly tenacious and persistent in preventing foreigners from seeing anything but the few carefully chosen and arranged sights that are obligatory for them to see. But the Red Guards, who carried so much of the weight of the Cultural Revolution, were clearly hostile, wherever their work can be traced, to remnants of the oppressive, elitist past—which was certainly elitist, certainly oppressive, but not to be changed by smashing up a museum or savaging a temple. Like the Puritans of Cromwell's day or the Communards of 1871, the Red Guards were honest, passionate, blinkered iconoclasts, and the amount of havoc they wreaked on their country's heritage is quite beyond calculation.

A very different, and paradoxical, variety of destruction is that visited on Peking as well as on Warsaw in the shape of a massive, incongruous, ugly piece of masonry planted in the middle of a harmonious artistic complex from the past. The monument to the Heroes of the People interrupts the central perspective from Ch'ien men gate to T'ien men gate, as the Soviet-donated Palace of Science and Culture, outsize and frigid, dominates and oppresses the entire central district of Warsaw where it stands. When the Romans forced their prisoners to pass under the yoke, they did so either in Rome itself or in the field; to erect a public, permanent yoke in the conquered capital was a refinement beyond their conception. An architectural signature can thus be written across the face of a city like a giant cancellation mark. Perhaps it is only appropriate that a hideous era in the world's history should be thus marked at one of its intermissions if not its terminus by pylons so massive, so gross, and so ugly.

191 *So deft are Japanese craftsmen at maintaining old temples in pristine condition by subtly renewing the parts from time to time that one is often in doubt whether it is the same structure or a new one, and when, if ever, it ceased to be one thing and became the other. Kinkakuji Temple in Kyoto is not subject to that intricate questioning; it ceased to be the old temple in 1950 when a crazed monk burnt it down. Yet so skilfully has it been rebuilt in the exact image of the old temple that only experts can distinguish the new structure from the old one. This photograph is of the new temple.*

6/FREAKS AND FAILURES OF SURVIVAL

Quirks of human temperament and accidents of physical circumstance have terrible power to determine the fate of works of art. The temple of Diana at Ephesus which Herostratus burned down simply to immortalize his name does not survive even in representations; what we know from coins (and it's little enough) relates simply to the replacement building. Its predecessor, famed throughout the antique world till it fell victim to the egomaniacal arsonist, is wholly unknown, and indeed remembered only for the perversity that ruined it. Not even the sympathetic imagination of novelist Yukio Mishima (and who could conceivably have been more sympathetic?) can make clear what went on in the mind of the monk Mizoguchi who in 1950 burned Kinkakuji Temple, the famous Golden Temple, in Kyoto—out of envy, self-hatred, adoration, obsession, we are told, whatever the words mean. (In any event, the Japanese, with their usual resourcefulness, built inside five years an exact replica of the fourteenth-century structure.) Again, how could one really get inside the mind of Laszlo Toth, the deranged Hungarian who in May 1972 managed to slip into Saint Peter's with a sledgehammer and attack Michelangelo's Pietà? He was not only beyond the reach of our minds, but even of his own; a coherent explanation of his actions was beyond him, and off he went to where he should have been all along, while the restorers worked despairingly with chips and crumbs and marble paste to recreate a harmony no less delicate than that of a fine violin.

Like assassins of presidents, assassins of art wander among us, unmarked and unregarded, till the moment when it is too late to mark or regard. Our major collections tend to be in big cities where, if the percentage of forlorn nuts is no greater than in the population at large, at least the concentration is higher. And the more we give privileged, semi-sacred position to works of art, the more surely we invite attacks from the unbalanced, whether they be jealous, frustrated, or obsessed. How to protect art works from such people without having pistol-toting guards in every room all the time during visiting hours (as used to be, and may still be, the rule in the Barnes Collection near Philadelphia) is a big problem for museums, but even more of a problem for churches. Already we see more and more pictures going behind glass, with its inevitable, exasperating reflections (the Uffizi in Florence will soon have to be renamed the "Galerie des Glaces"); more and more statues are being moved behind railings, which limit inspection of their three dimensions, and guard systems are multiplying in their elaborateness.

Quite as perilous as malfunctioning people are malfunctioning procedures, ill-considered treatments by custodians, and ill-advised improvements by restorers of art works, or even by the artists themselves. Horyuji Temple in Nara, Japan, was a marvelous structure in its own right; founded in 607 and completed sometime in the seventh century, it was among the oldest wooden structures in the world. It was also the last remaining place where one could gain some impression of the work done by the great T'ang masters of China, among whom Wu Tao-tzu, of whose original work not a single fragment survives, is reputed to have been the greatest. Horyuji Temple, whose wall paintings were directly derived from the now-legendary painting school of ancient

192 *Clevedon Pier was built high and spidery for several local reasons: tides rise and fall by as much as forty-five feet in Bristol Channel, currents are swift, and winds often fierce. The structure was planned to offer minimum resistance to these natural forces. It also made use, for economy's sake, of unusual structural materials: rails torn up from the defunct South Wales Railway were bolted together and formed into segments, shaping the eight hundred-foot spans of the pier. They stood without wavering for a hundred years, till the famous test of 1970. The cost of repairing the structure is estimated now at £75,000, and while fund-raising efforts are under way, no one can predict when, or whether, they will be successful.*

China, survived the war, thanks to the American policy of not bombing the Yamato Plain; but in January 1949 it was utterly destroyed by fire. A team of copyists and restorers was at work within the building; the weather was cold, and one of the workers was using an electric pad as a cushion to keep warm. Either it was left on all night or it was defective, or both; in any event, it short-circuited and burned up the entire building, from which we reproduce the "Paradise of Amida," an undoubted copy of a T'ang original. Fortunately, the blaze did not spread to other structures in the compound; but the building in which it occurred was the most precious of the group, the occasion was the most ridiculous and trivial imaginable, and not even the famous Japanese skill at reproducing lost originals can bring back the wall paintings that are gone.

The damage done by well-intentioned restorers is particularly hard to measure, since it generally eliminates the original against which the new version could be checked. Even today, the number of properly trained restorers and conservationists is minuscule in proportion to the need for them, and the primitive quality of our restoration procedures is shown by the fact that they change radically from week to week, and even more radically from restorer to restorer. Fifty years ago, there was not even a recognized place where one could go to study the craft of restoring; apart from old wives' tales, folk remedies, and random studio shop-talk, trial and error was the only way in which one could pick up the procedures. As for the popular prescriptions that circulated, they were of a quality to make one's hair stand on end. An anonymous volume of 1835, *On the Preservation of Oil Paintings,* recommended that one remove varnish from paintings by rubbing them with sand, dousing them with carbonate of ammonia or nitric acid, or else—these failing—wetting down the surface of the canvas and leaving it outdoors on a frosty night. Even a modern text on restoration includes—though with many cautions and evident misgivings—a recommendation that to remove hard incrustations from the surface of a painting, one should pour alcohol on the surface and set it on fire. Earlier and more conservative suggestions included the application of boiling oil, and—mildest of all alternatives—flooding the surface with linseed oil and leaving the picture under a hot sun. Reading some early texts on the art of restoration (the greater number of them date from the early nineteenth century or later), one feels oneself removed to the world of the alchemists, with urine, sheep's gall, and ashes steeped in aqua regia being freely suggested as cures for a sick painting. Before the chemistry of old paints and varnishes had been thoroughly studied, it was only natural that restoration of paintings had to proceed on a hit-or-miss basis; and even today the craft is full of booby traps, of which one may stand for many. Some late-Renaissance painters, in Venice particularly, used to save time by painting a first tempera version of their picture on canvas, then covering it with a final version in oils, the whole being protected by layers of varnish. But restorers sometimes tried to clean the painting by stripping off the varnish and washing the picture with water—which, though perfectly safe with oils, is fatal to tempera. Thus an entire picture might disintegrate (and we have reports of their doing so) in the course of what looked like a simple cleaning operation. Given this record of disasters, it is natural that the one theme on which all books about restoration most liberally insist is that the worst damage with which restorers must cope is that done by previous restorers.

193 *Writing in the year 847, Chang yen-yüan in his book* Li-tai ming-hua-chi (*The Chronicle of Famous Painters of All Ages*) *laments the loss of many masterpieces from still earlier epochs. One of the great figures he did know was the painter Wu Tao-tzu, of whose intense and concentrated labors many tales were then current, for he had died less than a hundred years before Chang wrote. Today not one scrap of painting by Wu Tao-tzu remains, nor is there so much as a fragment of the entire T'ang-dynasty art school. Only the wall paintings of Horyuji Temple, ancient imitations of the even more ancient Chinese school of painting, remained to bear witness—till they too were incinerated in 1949, as a result of a stupid accident. The central figure of the Buddha gives some remotely reflected sense of the formal yet hypnotic power of that very early school of Chinese wall-painting.*

194 *Mural in the Chiostro dello Scalzo, by Franciabigio, showing the extent of the damage across the bottom of the fresco, caused not only by a series of floods, but by careless handling over the centuries. As a result of the 1967 flood, this mural, even though it was not damaged in the general deluge, has been restored.*

We spoke earlier, in connection with the Roman Forum, of the aesthetic barrenness that often accompanies archaeological excavations, however instructive. Even of recent structures, it's all too frequent that the hand with which we try to raise up the past crushes it irretrievably. Clevedon Pier in Somerset was no great work of art, but an attractive and even audacious Victorian structure of a type that's steadily disappearing nowadays. First opened to the public in 1869, the pier was a gay and gallant piece of structural ironwork, with a pagoda-style café and a set of graceful arches reaching far out into the Severn. It was so attractive a creation that though piers had for years been declining in popularity as vacation at-

a single point of view. The room around which the paintings were hung in an almost unbroken circle was large and round; the paintings represented the 360-degree horizon that would bound one's vision if one stood in a particular spot and surveyed the city in every direction. Being so closely tied to a single exhibition hall, the paintings naturally had nowhere to go when the hall went out of business; "Eidometropolis" is long vanished, but in addition to some fine watercolor sketches for it, we have an etching showing (if only crudely) how the whole arrangement worked. Apart from Girtin's artistic

195 *Géricault, "The Raft of the* Medusa." *The photo was taken some years ago, but shows the painting already darkening as a result of the bitumen undercoating which has continued to strike through, rendering the painting in its present condition almost impenetrably obscure. It is no longer the picture it was; before long, it will hardly be a picture at all, though no doubt it will continue to hang in the gallery and to be known by its name. One could establish quite a list of invisible paintings hanging in the great galleries of Europe, a roster of great and famous names attached to quadrangles of cloudy, all but impenetrable, obscurity.*

227

196 *Because London popular entertainments don't commonly leave detailed records behind them, there has been some debate as to whether the structure that housed Girtin's "Eidometropolis" was circular or horseshoe-shaped. This engraving by Louis Francia shows one open end; and as newspaper accounts of the exhibit make no mention of the buildings and scenery that would be found in that direction, it seems fair to conclude that some parts of the London skyline were omitted. Still, the purpose of the exhibit was clearly to locate the viewer at a specific spot in London and surround him so far as possible with the full dimensions of the cityscape.*

merits, a student of romanticism might find it a highly significant coincidence that such an "invention" should have come along just when the importance of an individual, even idiosyncratic, point of view was being so much emphasized in literature.

It's not uncommon for artists to destroy their own works deliberately, either because they're not satisfied with them or out of revulsion against the very art of painting itself. In recanting his worldly vanities, an artist like Botticelli may be led to destroy some of his completed work, though fortunately not all. But irony or perversity may also lead artists to do work which is deliberately designed *not* to last, not to be portable, salable, or viable outside the exact circumstances of the moment. Some of the Dadaists, who felt that if their work were properly understood, the only proper response would be an uncontrollably violent attack on it by the infuriated public, provided therapeutic hatchets at their exhibits, with which viewers could hack the art to pieces. The original art work was thus destroyed in and through the act of appreciation. Man Ray produced in 1923 an arrangement explicitly titled "Object to Be Destroyed," which rather surprisingly (so strong are our habits of respect for art works) lasted for thirty-five years, until finally a group of German art students took Man Ray's title with appropriate seriousness and smashed it. Man Ray then reproduced it exactly and titled the facsimile "Indestructible Object." The twenty-mile fence to the sea erected near San Francisco during the mid-seventies by "Christo" (Christo Javacheff) had a strict time limit on it; for two weeks it stood, then it was taken down and the materials distributed among the landowners on whose property it had stood. We shall not look upon its like again—probably. But jokers are always with us. More in jest than in earnest, Joan Miró and some of his

friends created in the late sixties a "Vénus maritime," which after being paraded through various French galleries was delivered to its final destination—a particularly deep trough of the Mediterranean off Juan-les-Pins, where it became an instant archaeological relic for the delectation of fishes and scuba divers.

Like festivals and carnivals in general, happenings are a partial formalizing and aestheticizing of the ephemeral; by putting a frame around a piece of life's common stuff, we invite the viewer to reflect how uncommon the whole process is, how remarkable are the things that habit and routine cause us continually to overlook. Such being the intent of the *objet trouvé*, such being its definition of itself as essentially no more than a special act of intention on the part of the viewer, no wonder if it makes itself as minimal as possible. One of the toys that intrigues the modern mind is the self-destroying artifact, the gizmo that automatically blows itself up or wipes itself out. To moralize upon the various attitudes underlying such a mechanical joke would be tedious; but obviously they have significant bearings on modern attitudes toward science, society, and art. If the first two are conceived as self-destroying, why not the last? And if there were peekaboo effects to be achieved by having art works switch themselves off, one wouldn't expect very many of them to survive for posterity's meditation and analysis.

Velázquez destroyed a major equestrian portrait of Philip V because at a public showing of it on the Calle Mayor the popular sentiment was that the horse was out of drawing. Not every painter is so sensitive to public opinion; but a dissatisfied patron can effectively destroy a work he does not like. Around 1840 the Duc de Luynes hired Jean Auguste Dominique Ingres (already famous and successful) to do a new set of decorations for his noble Renaissance seat, the Château de Dampierre. Ingres took his assignment with the utmost seriousness. His theme was to be The Age of Gold and The Age of Iron; he did hundreds of sketches, and at the duke's invitation moved to Dampierre for several summers. But, being a proud and private man, he did not invite his patron to see the first mural, that of the Golden Age, till it was almost completed. Then, what a delusion! the duke, of all things, was a prude, and the amount of nudity in the Golden Age appalled him. What would Mme. la Duchesse say? What sorts of ideas, such as never crossed their little minds before, would now obsess his innocent children? He did not absolutely rip the offending murals from the wall, but the duke's disapproval was very clear. The painting dragged on for a bit, but Ingres gave up on it, and in mutual disgust painter and patron parted company. Whether "The Age of Gold" survives at all is doubtful; for a long time it was covered with tapestries, some old photos of fragments show it in exceedingly bad shape, and by now it is not fit to be seen, though the Renaissance rooms of the château, with their more decorous decorations, can still be visited.

A still more striking instance of moral censorship by an owner involves a painting of Leda done by Correggio and now in the Gemäldegalerie Dahlem, Berlin. Its career was nothing if not eventful; it was sold to Rudolf II in Prague during the early seventeenth century, and there copied by Eugenio Caxes before being stolen by the Swedes and taken to Stockholm. Queen Christina, that broody bluestocking, took it to Rome with her, and from there it passed in 1721 to the collection of the duc d'Orleans, regent of France. He left it to his son Louis, who became "mentally unstable" (as the histories say) after the death of his wife in 1726. He got so upset at the erotic character of the picture that he decapitated Leda, besides slashing the rest of the picture into pieces. Charles Coypel stitched and glued it back together, after a fashion, and repainted the head; then it traveled to Germany, where Napoleon stole it in 1806, though it had to be returned to Germany in 1814. There the head of Leda was repainted "for at least the fourth time," by Schlesinger, and there the painting remains to this day, though to what extent one can still call it a painting by Correggio is moot. So little of it was left after the knifework of the moody, moralistic duke that all the restorations and repaintings since have depended, perforce, on the copy made by Caxes long before the lady's troubles began. Incidentally, the duc d'Orleans also possessed an "Io" by Correggio even more erotic than the "Leda," which he also slashed to ribbons; but though he thought it was the original, it was fortunately only a copy. The copy may thus indirectly have defended the original by serving as a surrogate for it; the time may be coming, before too long, when originals will be too precious to hang in public galleries; their place will be taken by reproductions, and the originals, locked away for safekeeping, will be available only to the inspection of experts.

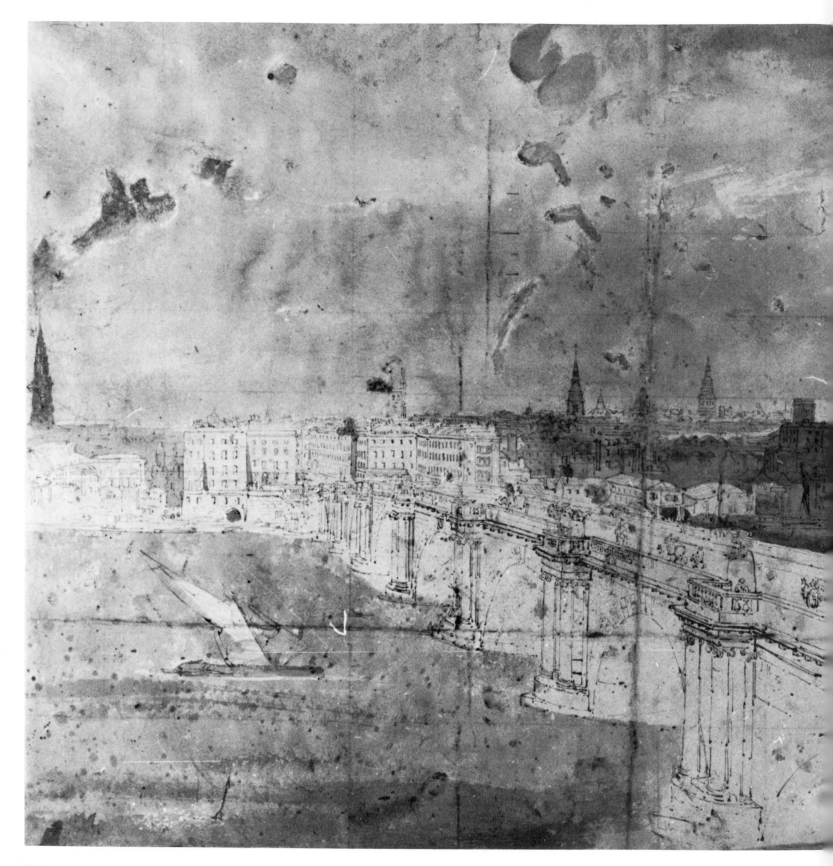

197 *Thomas Girtin, an ink-and-watercolor drawing toward the gigantic horseshoe-shaped panorama of London, "Eidometropolis." In the foreground is Blackfriars Bridge; looming up in the right-hand distance, the dome of Saint Paul's.*

The most famous modern instance of a dissatisfied patron doing away with a distasteful painting involved the murals painted by Diego Rivera for Rockefeller Center in 1933. Rivera was a man very conscious of the publicity value of provocation; already in Mexico one of his murals featuring the slogan "There is no God" had been censored. He arrived at New York in a basic state of low dudgeon because he had expected his associates at Rockefeller Center to be Picasso and Matisse and then found out they would only be Frank Brangwyn and José Maria Sert, whom he considered beneath him. His theme, "Man at the Crossroads," promised a polemical

198 *Man Ray, "Object to Be Destroyed" (or, alternatively, "Indestructible Object"). Close scrutiny distinguishes a metronome and the photograph of an eye. A less provocative title might have been "Duplicatable Object." But of course a less provocative title was not the intention at all.*

approach, a swollen symbolism, a bold and colorful style. That can only have been what the Rockefellers expected, and it was pretty much what they got. So far as specifics went, exception was taken only to the portrait of Lenin in the right-hand portion of the mural, and Rivera himself characterized as "reasonable" the request for its alteration. But he was afraid, he said, that there would be more requests after that—though in fact he offered spontaneously to make a number of important changes on the other side of the painting. Altogether, the quarrel was managed on both sides with an absolute and equal indifference to principles as well as practicalities. The Rocke-

fellers tore out the mural (effectively settling thereby the question, if there had ever been a real question, of whose wall it was); Rivera used the Rockefeller money to do some paintings for a Trotskyite school on Fourteenth Street; and then, later, for the Bellas Artes in Mexico City, he repainted the Rockefeller Center mural more or less as it had been, but with the addition of a few extra anticapitalist caricatures. In the light of events that lay just around the historic corner, it seems a bit self-indulgent for Rivera to call the contretemps at Rockefeller Center a "holocaust," as he does in his autobiography. But the story reminds us how close we still remain even under the guise of liberalism to the destructive iconoclasm of the old puritans.

At first, the New World was much more likely to be described verbally than represented artistically; none of the early explorers or conquistadors thought to bring an artist in their company, and even if they had, it's doubtful that he could have done or kept much work amid the desperate circumstances of those early explorations. One of the rare instances of actual representation occurred when Jacques Le Moyne de Morgues accompanied a French expedition to Florida under René de Laudonnière in 1564; he made forty-two small paintings of the New World. Though only one original has been preserved, all were engraved by Theodore de Buy for publication in a *Brevis narratio* (Frankfurt, 1591). The one surviving original shows that de Buy was a fairly faithful copyist, not of much value if he had been dealing with high art, but perfectly adequate as a reproducer of anthropological documents. What is more dubious is whether Le Moyne and de Buy didn't see Indian life as an assemblage of bald, disparate facts, the significance of which they could represent neither in convincing Indian nor in convincing European terms. When we compare these first efforts with later, nineteenth-century representations of Indians by such a careful, yet romantic observer as George Catlin, we see how much rawer, how much more fragmented, Indian life looked to the first witnesses. Whether Catlin was spreading a nostalgic glow over his Indians, or Le Moyne was insensitive to the social patterns and conventions prevailing among his, the differences are very striking.

What an artist discovers in a subject when he undertakes to represent it depends on prepossessions and limitations so deeply rooted that he may hardly be conscious of them. Medieval representations of Rome make clear that men in those days did not see the city as particularly large or impressive, or if they did, they did not know how to convey that impression. Piranesi could make a single modestly proportioned structure look gigantic, Cyclopean, overwhelming; medieval drawings make even the Colosseum look like a toy. This of course is mostly a matter of manipulating perspective; everyone is aware of how a photographer, by a combination of close-up lenses, enlargements, and croppings, can convert the image of a common grasshopper into a gigantic, ferocious monster. More curious is the situation that results when we get two quite different reports on the identical physical object. Niccolò dell'Abbate did a fine fresco around 1550 for the portico of Palazzo Leoni in Bologna. We know it was a fine picture because Malvasia, who saw it in 1686, said so; but the original has not been visible for more than a century and a half. In 1819 it was completely repainted, apparently in response to gradual but cumulative disintegration; but the process of

199 *This pale sketch in the Musée Ingres at Montauban is a relic of the huge "Age of Gold" mural which so shocked the Duc de Luynes, for whom it was being painted, that he vigorously discouraged M. Ingres from continuing with it. What could have happened to the mind of this French nobleman, who cannot have escaped seeing pictures by Rubens, Fragonard, Boucher, e tutti quanti, who must have known what court life was like under the*

*Grand Monarque, that he should have felt such overwhelming re-
vulsion at the sight of these few capering nudes? The Revolution,
and the bourgeois aristocracy which succeeded to power after the
collapse of the Revolution, obviously have a lot to answer for—
not simply in terms of art destroyed, but in terms of art aborted
in the mind of the maker by puritanical thou-shalt-nots.*

200 *Drawings of medieval Rome, like this one by Taddeo di Bartolo in the Palazzo Pubblico at Siena, or that by Pol de Limbourg in the* Très Riches Heures du Duc de Berry, *often show the city as a perfect circle. This is not because the artists saw it that way, but more likely because of the ancient analogy between* urbem *and* orbem. *More than seventy-five structures have been identified in this picture, some of them, it must be confessed, quite tentatively. Missing altogether from modern Rome are medieval curiosities such as a pyramid known as "The Tomb of Romulus" and another structure so enigmatic in its character that it was known sometimes as "The Emperor's Dinner Table," sometimes as "Nero's Facade," and sometimes as "Maecenas' Tower." Structures like these, with fabulous titles and absurd identifications, were natural candidates for demolition; they may well have been more interesting as relics of the past than some of the structures that have survived.*

decay was not arrested, and more than forty years ago the picture was declared nonexistent—*definitivamente cancellata,* as the Italians eloquently put it. We do have two engravings of it, one by Gaetano Gandolfi (1734–1802), one by Giuseppe Mitelli (1634–1718)—both therefore before the major operation of 1819. The oddity is that they are very different from one another. One has evidently been reversed in the process of engraving, but in addition they are quite differently shaped, and a good many of the details are different. Which is the more accurate? Gandolfi is apparently the preferred version, but in the absence of the original, and without a third report more reliable than these two (for example, a drawing by Niccolò toward the painting), one would have to depend on such imponderables and undemonstrables as a sense of the painter's general style.

Americans, who are determined inventors of new gadgets, are equally determined destroyers of what they have once created, perhaps because so much of what they create is deliberately provisional and ephemeral—gadgety, in a word. Beautiful as they often were, the clipper ships of the China run, the paddle-wheel steamboats of the Mississippi, and the spacious, ornate hotels of Saratoga Springs existed not just in the timeless world of art, but in the competitive, racetrack world of technology. They are now extinct, or all but so; and their loss is the less to be regretted because this sort of loss is universal and uniform. Stagecoaches, triremes, and suits of armor were also at one time, and in about the same measure, works of art; they too are gone, with the technological conditions that produced them, and to wish them back is the idlest form of empty

nostalgia. But the boundary between art and technology is inevitably hazy, and Americans not only carry the technological view into architecture (seeing it as building for a specific and limited function with a specific time span in mind), they also seem to carry it further than most other cultures. Perhaps the Utopianism deeply engrained in American democracy encourages men to think that each generation must and will build its own New Jerusalem. In any event, the fate of ambitious building in America discourages the thought that any building distinguished by splendor or style can long endure on the strength of those qualities alone.

For every building of the Old South destroyed by the War Between the States, ten succumbed to the corrosion of indifference and economic decay. One example may stand for many, and let it be Belle Grove near White Castle, Louisiana. With seventy-five rooms, including a jail, it was built in 1857, fatefully close to war's outbreak, but survived both conflict and reconstruction and was not abandoned for good until 1914. Even then, for nearly forty years it lingered on, a gaunt but still beautiful ghost, till it was destroyed by fire in 1952. Similarly, the Old French Opera House in New Orleans gave its last performance in 1914, and in 1919 it burned. It too was less than a hundred years old and was abandoned for the same reason: it could no longer turn a profit. All across the country, the story is much the same. The princely structures of the patroons and tycoons who built along the shores of the lordly Hudson have suffered decimation like the plantation mansions of the South, and under the same corroding pressure. In an age of many taxes and few servants, aristocratic houses simply

201 *Central panel of "Man at the Crossroads," the Diego Rivera mural destroyed in Rockefeller Center, as repainted by the artist for the Palacio de las Bellas Artes in Mexico City. Assorted Rockefellers revel in the diminished triangle on the left; Lenin on the right makes solemn gestures of fraternal solidarity. The picture displays to the full Rivera's gifts as a caricaturist and (were our picture able to capture its rich tonalities) as a colorist; its popular fame is surely due more to the scandal of its destruction than to its aesthetic qualities.*

are not practical. We retain images of what some of those Hudson castles were like from the painters of the nineteenth century, and perhaps it suffices to have just a few of the breed left as part of our cultural history. But the record of destruction is just as striking when we look at the survival rate of those distinguished architects who have practiced in America.

On any accounting, H. H. Richardson, Louis Sullivan, and Frank Lloyd Wright represent a trio of distinguished American builders, and among their major achievements the survival rate is not impressive. Sullivan's Auditorium Building in Chicago was barbarously truncated in 1950 when sixteen feet were sliced out of the first story to make room for the Congress Street Expressway—eliminated in the operation was a magnificent art-nouveau bar worthy of Diamond Jim Brady. Wright's Midway Garden structure, also in Chicago, was not protected by Wright's name, nor by the fact that Bix Beiderbecke played there; it became a garage, next a car wash, and was then demolished entirely. We might spend more time deploring the losses in that absolutely crucial city in the history of American architecture, were there not already in existence a splendid book documenting the several phases—restaurants, churches, office buildings, and railroad stations, as well as palatial private homes—of *Lost Chicago*.

As for less-pedigreed structures, the impulse to replace them with something cheaper, something more profitable, or for that matter simply to get rid of them and replace them with nothing at all, appears often to be irresistible. To take a single minor instance, for most of the instances are individually minor—it's only collectively that they add up to a wasteland of jerry-built dime stores and squalid parking lots—the so-called Peace Party House was one of the historic structures in Pittsfield, Massachusetts. Apart from its architectural qualities, which were superior if not mind-shattering, it was a structure with many historical associations. In 1952 it was turned over to the wreckers because the land was needed for a new city hall. But as soon as the old building was safely demolished, the need for a new city hall disappeared; the site was asphalted over and made into a parking lot. Along the same lines, when the bureaucrats in Los Angeles discovered that Simon Rodia had built a pair of unusual towers in his slumtown backyard, their response was automatic and immediate. The offending structures must be pulled down because they were unsafe. (One would have thought, from their haste to protect the citizens of Watts, that the safety of that community was an overwhelming concern of the city fathers.) Only after Rodia's structures had proved themselves practically the most substantial buildings in the city were they allowed to remain, and to become sanctified into a "sight." There they will doubtless remain long after the glittering plastic civic center has crumbled into sand, or been torn down in favor of something even more gaudy and pretentious.

202 *Florida Indians preparing to go on the warpath, as painted by Jacques Le Moyne in 1564 and engraved by Theodore de Buy for publication in 1591. It is barely possible that this image, as painted by a man who was seeing Indians for the first time, and*

R.Saturiona

.II.

engraved by a man who had never seen Indians at all, bears
some distant relation to what a camera might have recorded at
the same spot and time. But one wouldn't count on it.

204 *Gaetano Gandolfi's delineation of the Niccolò dell'Abbate* ►
fresco suggests more of the Correggio-like tenderness for which
the original was evidently celebrated; but one need only look at
the two truncated, yet flower-decorated, stumps at the lower left
of the engraving to be lost in speculation as to which version most
accurately represents what must, in either event, have been an en-
chanting original.

203 *Giuseppe Mitelli's early-eighteenth-century engraving of the*
Niccolò dell'Abbate fresco in Palazzo Leoni, Bologna, shows
many striking differences from Gaetano Gandolfi's engraving
made later in the same century. Yet when one accepts the fact
that one engraving is a mirror image, and that Mitelli evidently
did not want to include the doorway arch which is so apparent in
Gandolfi's version, the differences are less striking than they ap-
pear at first glance.

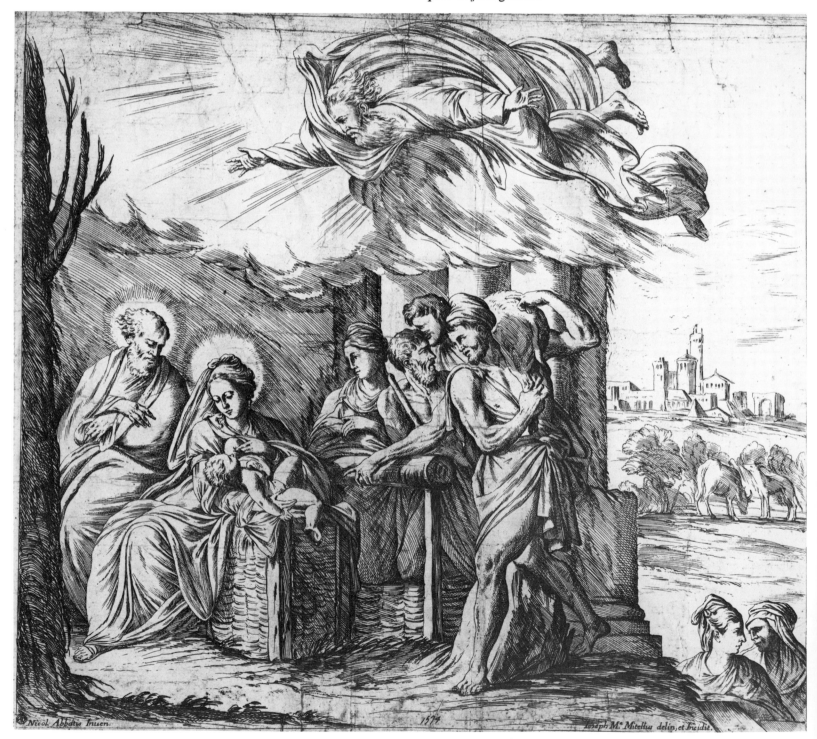

Nicol. Abbatis Inuen. 1574 Ioseph Mª Mitellus delin. et fecidit.

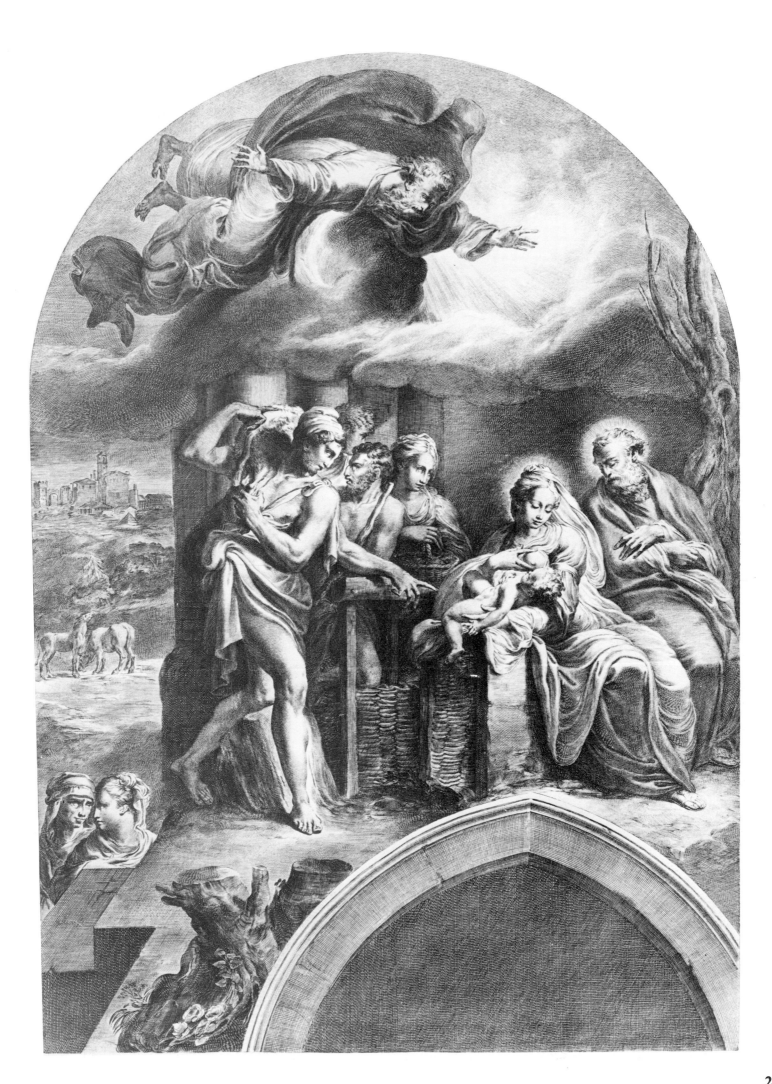

239

There is a perilous bridge across which buildings and art objects must pass, between being offensively old-fashioned and delightfully quaint, or even classic. The Rodia structures made it, so did the Eiffel Tower on which they were partly modeled, but both came close to dropping into the abyss. An American failure of particular poignancy is New South Church in Boston. It was erected in 1814 by Charles Bulfinch, who was either the first professional or the most talented amateur architect in Boston. Among the special features of New South were its special plan for combining a traditional New England steeple with a Greek portico; its original octagonal

205 *The United States Hotel in Saratoga Springs, New York, just after its opening in 1874. With the Grand Union, its arch rival, the United States set a standard for opulent and expensive caravanserais in North America. Of course if it were standing today, its owners would instantly demolish it (or, if they were dishonest, burn it for the insurance); for a thousand reasons, not least of which would be the staffing of such a gigantic establishment, it would be as obsolete in today's world as the dinosaur—which, to a twentieth-century eye, it rather resembles.*

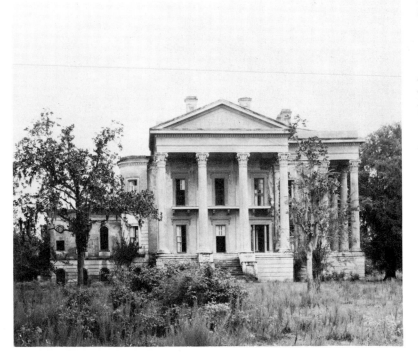

shape; its carefully considered acoustics; and the stonework of its construction, which made it one of the few Boston churches not built of wood. Not only was it an airy and attractive structure by our standards, it was appreciated in its own time; and just fifty years after its erection, a public meeting was held to pay tribute to its merits. The chief speaker on that occasion challenged the whole nation to show a more beautiful, better-designed, more finely appointed church. He was probably right. But just four years later the church was torn down to be replaced by a commercial structure.

206 *Belle Grove near White Castle, Louisiana, originally a plantation-owner's splendid rural seat, had been deserted during the First World War and was moldering away under the encroaching vegetation when this picture was taken. It finally succumbed to accumulated neglect and a climactic fire after the Second World War. But it's a fair question whether the structure wasn't more beautiful in its tatters, as a gaunt white ruinous ghost, than it could ever have been in the days of its pride.*

Martineau raved about it, and other foreign visitors went out of their way to include it on their itineraries too. Nathaniel P. Willis illustrated it in his early and very influential book American Scenery (1840), and painters of the Hudson River school made grandiose, hazy landscapes of the scenery around it—sometimes by actually registering at the hotel, sometimes just by copying the engravings in Willis' book. But fashions change, and for some reason after the 1920s the majestic view no longer looked so majestic. Upkeep of the old hotel became prohibitively expensive, and though for a while it kept going by charging tourists admission fees to wander through the vast rooms and over the grounds, it was finally abandoned and became a derelict. On January 24, 1963, the New York State Department of Conservation took advantage of a massive blizzard, which blanketed the countryside with snow and minimized the risk of a forest fire, to burn up the remaining ruins.

207 *During the middle years of the nineteenth century the Catskill Mountain House high above the Hudson River at Catskill, New York, was one of the major American "sights." Harriet*

208 *One of the high spots of Louis Sullivan's curiously truncated career as a Chicago architect (after his masterpiece, the Carson Pirie Scott building, he never held another major commission) was the Auditorium Building. It still stands, housing Roosevelt University; but when an expressway was built through downtown Chicago, sixteen feet were lopped off one corner of the structure, carrying away a much-admired Long Bar and its art-nouveau decorations.*

209 *The Peace Party House in Pittsfield, Massachusetts, got its odd name in 1783 when it was just a little more than thirty years old; it was the scene of a town party to celebrate the Treaty of Paris, which brought the American Revolution to a triumphant conclusion. Its historic associations were well known when it was bulldozed down for the most trivial of reasons in 1952.*

210 *New South Church, Boston, by Charles Bulfinch. Erected on Church Green at Summer and Bedford Streets in 1814, it was an elegant and quiet structure, and the first Boston church in many years to be constructed of stone. It was built of Chelmsford granite, the blocks dressed (perhaps not quite in the spirit of Christian forgiveness) by convicts being held in a prison that Bulfinch had designed some years earlier.*

211 *Catastrophic as the damage appears in this photograph of Rembrandt's "Jacob's Blessing" after the acid attack of October 1977, several circumstances rendered it less deadly than it might have been—no thanks to the attacker. He had already exhausted most of the contents of his vial on other Rembrandt paintings in the same gallery. "Jacob's Blessing," never having been cleaned, was covered with a goodly layer of varnish coatings and overpaintings, which absorbed the worst of the acid. And the gallery took instant measures to clean off the deadly stuff and turn the picture over to a restorer. As a result, the painting is not altogether lost, and in some respects it may be closer to what Rembrandt painted than it was before the attack. But, like the Florentine flood, the attack was a real disaster with incidental benefits.*

7/CONCLUSION

Hans-Joachim Bohlmann, aged forty, was arrested in Hamburg October 8, 1977, on a charge of throwing acid at paintings in museums. He had done quite a bit of this work, mutilating paintings by Lucas Cranach the Elder, Rembrandt, Rubens, and Paul Klee all in less than a year. The climax of his career came at Kassel when he threw acid on three Rembrandt paintings—a self-portrait, a "Saint Thomas," and the long-famous, highly prized "Jacob's Blessing." Unlike most psychotics who damage museum paintings, he didn't seem particularly obsessed by the subject matter of the pictures he attacked; his acts had no focus beyond the destruction of the pictures themselves. In fact, as if to save everyone trouble, Herr Bohlmann, when caught, brought forth an analysis of his own behavior, so pat and well-rehearsed that it had clearly been a great source of encouragement to him in his labors. The story he gave was that he had been prematurely pensioned off for mental disease, that because of this treatment

(naturally, unfair in his eyes) he tended to accumulate aggression, and felt relieved when destroying something admired by others. That his behavior simply confirmed the original diagnosis he seems not to have thought; nor indeed was there any way for the subtlest student of psychology to predict that the current of his inward feelings would take the turn that (with the perverted help of Doctor Freud's enlightened analyses) it actually did. Herr Bohlmann was but one eccentric, one derailed intelligence, out of a human population that numbers in the millions; but he reduced by three the list of Rembrandt paintings that numbers, now, only in the hundreds. The surviving Vermeers and Caravaggios number only in the dozens; as they are ground down, fewer and fewer, by the corrosive force of humanity—the warped, lonely individual, the roaring public lunatic like Hitler, or the faceless economic automata which plant huge petrochemical works in the very front yard of Venice—it seems inevitable that art will be hidden away, more and more, behind bars and glass and ultimately walls, through which only a few select viewers will be allowed to pass.

212 *"Jacob's Blessing" before the acid attack.*

213 *James Bogardus (1800–1874) is known to history as a machinist, an eccentric mill maker, and a manufacturer of cast-iron houses. The buildings he erected at the corner of Washington and Murray Streets in New York City were easy to assemble and had the special advantage of allowing large parts of the wall fabric to be devoted to windows. Though he had studied in Europe, much of his work is described as "intuitive," i.e., he was an inventor. In its last stages the Bogardus building was a pitiable old derelict, but apart from smashed glass and boarded-up doors on the ground floor, the basic structure was as solid, and could have been as trim, as in the gay little woodcut with which the* London Illustrated News *heralded the structure's erection.*

214 *Cast iron as a building material experienced a real, if brief, boom in the nineteenth century; structures such as Clevedon Pier and the Crystal Palace (figures 192 and 18) exemplified the ingenious and pleasing uses to which the material could be put. It was also appropriate for a factory-warehouse. But architects were perhaps stretching a point when they designed an all-iron church—as they would have done had they tried to make a rustic cottage from the stuff.*

The Bogardus buildings, a set of five associated structures, were put up on Washington Street in downtown Manhattan in 1849. They were historically and aesthetically important in that the facades were made of cast-iron panels bolted together. Because these facades carried no load, they could be made both slender and strong, and could accommodate large windows; because they were precast in modular dimensions, assembly of the building was quick and easy. The Bogardus buildings were the first of their kind, and in many respects a presage of modern building techniques. When they were disassembled in 1971 as obsolete, the panels of the facades were stored in a vacant lot, from which before long most of them were stolen, to be sold for scrap iron. The few remaining ones were then transferred to a building on West Fifty-Second Street where they were placed under lock and key while decisions were being made on where and how they would be used to re-erect, under the auspices of a museum or as part of a community college, a single structure to bear witness of the past. But even the safeguards of a closed and locked building were not sufficient. In 1977 thieves made their way into the storage buildings, obviously with metal-cutting equipment, since the panels were too heavy to carry as units; and they made off with the last remnants of a structure unique in the history of New York architecture. The value of the buildings had long been known; they were officially declared a landmark in 1970, the year before they were torn down(!), and the federal government had allocated $450,000 for their preservation. Architecture students from Columbia University had studied the structures carefully before they were disassembled, thousands of photographs had been taken, samples of the facades had been sent to the Smithsonian. Yet under all these circumstances, the thieves of 1974 had no trouble in making off with four-fifths of the structure, for which they received from a Bronx junk dealer the sum of $63; and the 1977 thieves were so successful that we have no notion how much they got for their haul, but it must have been less.

The second theft of the Bogardus-buildings material was discovered about four months before the arrest of Herr Bohlmann, the acid-thrower. Officially the world was more or less at peace, there were no typhoons or tidal waves, no major earthquakes or catastrophic fires. Yet here a little, there a little, against major masterpieces and minor curiosities from the past the onslaught continued. How many Etruscan tombs or South American archaeological sites were silently robbed in those four months? How often did the wrecker's ball swing against a structure that would be instantly regretted as soon as it was gone? The subject has been expanding even as I've been writing this book, far beyond anyone's ability to document even the additions to a topic which to begin with was immense. The new president of Renault, Inc., dissatisfied with the work being done by Jean Dubuffet to decorate corporate headquarters at Boulogne-Billancourt, fired the artist and proposed to destroy the work already done; the artist sued to prevent demolition, and the case was in litigation during that four-month period. The Boston Museum of Fine Arts announced that its watercolors by Winslow Homer had faded so badly that they would no longer be on public exhibition and might be seen henceforth by private appointment only. Art robberies, great and small, were so many that there is no space to record even a smattering of them. Venice settled, during this

period, by a few fractions of a millimeter; a few thousand more graffiti were scrawled on unattended buildings of the ancient past; a few more pounds of corrosive grit dusted down on the Acropolis and on the stones of Florence. A thousand more bulldozers were born, and a couple of hundred nuclear explosive devices entered the world. A couple of million more buildings, a few worth preserving, most not, sank further into squalor and neglect as urban blight spread like impetigo across the landscape from a thousand itching, festering centers of population. Life, fertile and indiscriminate, and impatient of the old forms, was busy wedging itself into the crevices of timeworn shapes. Inevitably, walls would fall, supports would crumble, canvas would rot, and stones turn to grit. If only half of what the nuclear scientists tell us is true, sixty minutes of all-out warfare will put a period, not only to all the art in the world, but to every creature on the face of the globe more advanced than the plankton of the sea. On these cosmic terms what is happening to the art of the world is no more than a tinpot tragedy, and whether it comes sooner or later, destruction must come inevitably to everything made with the hands of men. A certain sort of sour comfort doubtless derives from these reflections. But in the meanwhile, it is also comforting to see how much can be regained from the past, to sense that not even millennia of destruction have been able to dull in men's minds the luster of certain artistic achievements. Whole museums and entire libraries have been lost, but they only add to the wealth of the lost museum; and as we ruminate on it, and on the magnitude of the human enterprise, which could suffer such inconceivable losses and yet remain so rich and various, so proud even in its record of folly and loss, the old phrase about Rome comes to mind: *Quanta fuit ipsa ruina docet*— How great she was even her ruins bear witness.

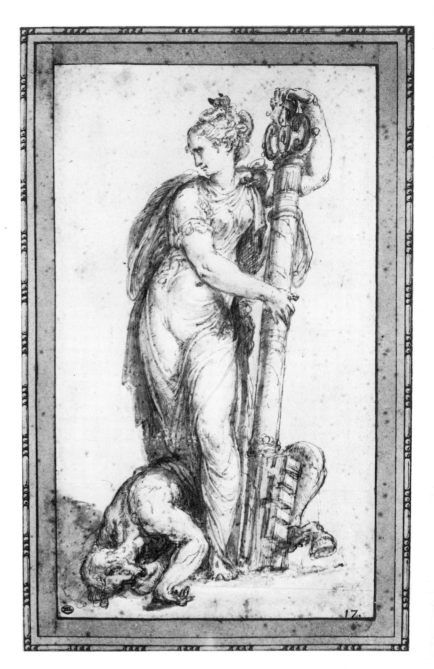

215 *Niccolò dell'Abbate painted around 1550 an allegorical fresco celebrating the elevation of Giovanni Maria del Monto to the papacy as Julius III. The new pope had been Cardinal Legate to Bologna, and his election was cause for jubilation. But the symbolic ingredients which Niccolò combined in his painting on the wall of Palazzo Carbonesi were so erudite that the painting, until its destruction in 1775, was known as the "Hieroglyphic." The figure of Virtue in this much-admired drawing served as a sketch for the finished painting: the lady was one of two holding the massive keys of papal power and crushing underfoot a craven, lustful satyr. The motto was* Dux virtus fortuna comes: *When virtue leads, fortune follows.*

INDEX

(Figures in italics refer to illustrations)

PHOTOGRAPH CREDITS

1. Courtesy Museum of Fine Arts, Boston. Francis Bartlett Donation.

2, 101. Los Angeles County Museum of Art.

3, 36, 129, 138. Reproduced by Courtesy of the Trustees of The British Museum, London.

4, 115, 117, 145, 160, 161, 162, 164, 165, 169, 170, 171, 172, 194. Photo, Alinari.

5, 14, 90. Photo, Giraudon.

6, 84. Kupferstichkabinett, Berlin. Photo, George Anders.

8. National Gallery of Art, Washington, D.C.

9. Photo, A. C. Cooper. Copyright reserved.

10, 20, 93, 103, 105, 137. The Albertina, Vienna.

11. Photo, A. Gombrich, *The Story of Art* (London, 1972) p. 101.

12, 59. National Gallery of Art, London.

13. Ringling Museum of Art, Sarasota, Florida.

15. Collection of H. P. Kraus.

16. National Museum of Ireland, Dublin.

17. Photo, Trinity College Library.

18. *London Illustrated News.* Photo, UCLA.

19. Uffizi Gallery, Florence.

21. Staatliche Museum, Berlin.

22. S. Harrison, *The Arches of Triumph,* "Londinium." Reproduced by permission of The Huntington Library, San Marino, California.

23. Copyright Rubenshuis, Antwerp.

24. A. Hyatt Mayor, *Gio. Battista Piranesi* (H. Bittner & Co., New York, 1952), plate 48.

25. Photo, *Scientific American.*

26. Moyses Hall Museum, Bury St. Edmunds.

27, 28. H. A. Omont, *Athènes au xviie siècle* (Paris, 1898) Photo, UCLA.

29, 45, 63, 189, 202. Photo, UCLA.

30. Julien David Leroy, *Les ruines des plus beaux monuments de la Grèce* (Paris, 1758). Photo, Library of Congress.

31. Bruno Schröder, *Zum Diskobol des Myron* (Strassburg).

32. National Museum, Naples. Photo, University Prints, Boston.

33. Gennadius Library, American School of Classical Studies, Athens.

34. Photo, The Bancroft Library, University of California, Berkeley.

35. F. and J. Riepenhausen, *Gemhalde des Polygnotos in der Lesche 20 Delphi nach der Beschreibung des Pausanias gezeichnet,* Göttingen, 1805. Photo, British Museum, London.

37. The Capitoline Museums, Rome.

38, 41. Etienne Du Pérac. *I vestigii dell'antichita di Roma . . .* (Rome, 1575). Photo, New York Public Library.

39. Giovanni Antonio Dosio . . . *Urbis Romae . . .* (Rome, 1569). Photo, New York Public Library.

40, 60. Charles Huelsen, ed., *Libro di Giuliano di San Gallo* (Torino, 1910). Photo, UCLA.

42. Photo, Civiche Raccolte, Milan.

43. Archivio di Stato, Torino. Photo, Giustino Rampazzi.

44, 94, 98, 99, 203. Gabinetto Nazionale delle Stampe, Rome. Photo, Oscar Savio.

46. From a manuscript of the *World History* of Paulinus in the Biblioteca Marciana, Venice. Photo, Foto Toso Venice.

47, 48. Photo, Peabody Museum of Anthropology and Ethnology, Cambridge, Massachusetts.

49. Photo from F. L. Bruel, *Cluni,* by Photo Service, University of California, Berkeley.

50. Musée Ochier, Cluny. Photo, Pierre Bonzon.

51. Photo, Fogg Museum, Harvard.

52. From the *Heures de Turin* (Bottega d'Erasmo, 1967) with avant-propos by Albert Chatelet. Photo, UCLA.

53. Photo, Bibliothèque Nationale, Paris.

54, 85, 144, 195. Photo, Caisse Nationale des Monuments Historiques. Copyright Arch. Phot. Paris.

55. Photo, Cornell University.

56. Wolfgang Braunfels. *Monasteries of Western Europe.* Photo, UCLA.

57, 58. Photo, Caisse Nationale des Monuments.

61. Photo, Department of Environment, London.

62, 67. Sir William Dugdale. *Monastican Anglicanum.* Photo, UCLA.

64. Photo, Courtauld Institute of Art, London.

65. John Thomas Smith, *The Antiquities of Westminster* (London, 1802). Photo, UCLA.

66. Victoria and Albert Museum, London.

68, 72, 77, 107, 108, 196. Photo, British Museum.

69. John Stuart. *The Sculptured Stones of Scotland* (The Spalding Club, 1859), plate 45. Photo, The Huntington Museum and Art Gallery.

70, 147, 188. Photo, MAS, Barcelona.

71, 200. Photo, Janet Adams.

73. A. Gough. *Sepulchral Monuments in Great Britain,* Vol. II, part 2 (London, 1796). Photo, UCLA.

74. Photo from *The City of Oxford,* Royal Commission of Historical Monuments. Photo, UCLA.

75. T. D. Atkinson and J. W. Clark, *Cambridge Described and Illustrated* (Macmillan, 1897), fig. 21. From an engraving by William Burne after a drawing by T. Hearne. Photo, UCLA.

76. Photo, Dr. David Jackson.

78, 96. Ashmolean Museum, Oxford.

79, 80, 206, 213a. Photo, Library of Congress, Washington, D.C.

81. Museum Boymans–van Beuningen, Rotterdam. Photo, Frequin-Photos.

82, 83. J. A. du Cerceau, *Les plus belles bastimens de la France* (1576). Photo, Cornell.

86. Palazzo Ducale, Mantua.

87. Photo, Royal Collection at Windsor. Copyright reserved.

88, 89, 109. The Wallace Collection, London.

91. Borghese Gallery, Rome. Photo, Alinari.

92. Koninklijk Huisarchief, Den Haag. From the collection of Her Majesty the Queen of the Netherlands.

95, 197. Courtauld Institute of Art, London.

97, 123. Rijksmuseum, Amsterdam.

100. Kunsthistorisches Museum, Vienna.

102. Historical Museum, Bern.

104. The Royal Collection at St. James's Palace. Copyright reserve.

106. The British Museum, London. Photo, Alinari.

110. Foto Biblioteca Vaticana, Rome.

111. From *Raffaello, L'Opera, Le Fonti, La Fortuna* (Instituto Geografico de Agostini, Novara, 1968) II, 469. Photo, UCLA.

112. Photo, Royal Institute of British Architects.

113. Photo, The Museum of Modern Art, New York.

114. Photo, Chicago Historical Society.

116. From Walter J. Friedlander, *Caravaggio Studies* (Princeton University Press, 1955).

118. Photo from *Goya,* No. 88. Photo, UCLA.

119. Museo Nacional de Antropologia y Arqueologia, Lima. Photo, Dr. Hermilio Rosas.

120. Photo, National Gallery, Washington, D.C.

121. National Gallery, Washington, D.C., Widener Collection.

122. Staatsgalerie, Stuttgart.

124. Municipal Archives, Utrecht.

125. Photo, Archivio Fotografico dei Civici Musei, Milan.

126, 127. Kunstmuseum, Basel.

128. Gipsoteca Canovane, Possagno.

130. British Museum Print Room, London.

131–133. From William Dugdale's *History of Saint Paul's* (1716). Photo, UCLA.

134. Photo, Documentation de la Réunion des Musées Nationaux.

135. Collection of the Duke and Duchess of Alba. Photo, A. Wethey. *Titian* (Phaidon, 1971), Vol. II, pl. 151.

136. Museum Boymans–van Beuningen, Rotterdam.

139. Badeslade and Rogue, *Vitruvius Britannicus,* Vol. III (the Benjamin Blom reprint). Photo, University of New Mexico.

140. Courtesy of the County Council of Hereford and Worcester. Photos, H. W. Gwilliam.

141–143. From John Rutter, *Delineations of Fonthill and Its Abbey* (Shaftesbury, 1823). Photo, UCLA.

146. Heliogravure by Eugene Plon, *Benvenuto Cellini* (Paris, 1893), plate XXIX. Photo, UCLA.

148, 150. A. Laborde, *Voyage pittoresque.* Photo, U.C., Berkeley.

149. Staatliche Museum, Berlin. Photo, Jörg P. Anders, Berlin.

151. Blanc, *Histoire des peintreo de toutes les écoles* (Paris, Renouard, 1861–76), Vol. 4, "Ecole espagnole" (1874). Photo, UCLA

152. Woodcut from an undated Guide-Cicerone, *Paris Illustré,* put out by Hachette in the mid-nineteenth century. Photo, UCLA.

153, 155. Collection Roxane Debuisson. Photo, R. Lalance.

154. From Jehan de la Cité's *L'Hotel de Ville de Paris et la Grève à travers les ages* (Paris, Firmin-Didot, c. 1885), fig. 51. Photo, UCLA.

157, 158. Photo, National Monuments Record, London.

159. Caisse Nationale des Monuments Historiques. Arch. Phot. Paris/S.P.A.D.E.M.

163. Photo, Bulloz.

166. Photo, Gabinetto Fotografico, Galleria degli Uffizi, Florence.

167. Photo, courtesy of Gianni Mari, Milan.

168. From Leo Planiscig, *Luca della Robbia* (Florence, 1948). Photo, UCLA.

173. Photo, Stadt Augsburg.

174. From Fritz Löffler, *Das Alte Dresden* (Sachsenverlag Dresden, 1956). Photo, UCLA.

175, 179. Photo, Bildarchiv Foto Marburg.

176, 180. Photo, Bruckmann, Munich.

177. Deutsche Fotothek, Dresden.

178. Formerly in the Kaiser-Friedrich Museum, Berlin. Photo, Gustav Schwarz.

181. Photo, UCLA.

182. From *Lost Treasures of Europe* (Pantheon, 1964) ed. Lafarge, pl. 223.

183. Photo, Gemeentlijke Archiefdienst, Rotterdam.

184. From M. Karger, *Novgorod the Great* (Moscow, 1973). Photo, UCLA.

185. From G. K. Loukomski, *Kiev Ville Sainte de Russia* (Paris, 1929), pl. 34. Photo, UCLA.

186. From *Oriental Art* I (1948), no. 3. Photo, UCLA.

187, 193. Photo, courtesy of Saburo Haraguchi.

190. Photo from F. Isaksson and L. Özkök, *Warszawa* (Bonnier, Stockholm). Photo, UCLA.

191. Photo by NBC Japan, courtesy Saburo Haraguchi.

192. Photo from *Country Life,* September 2, 1971.

198. The Museum of Modern Art, New York.

199. Musée Ingres, Montauban. Photo, Roumagnac.

204. Photo, Civiche Raccolte, Milano.

205. From *Leslie's Weekly,* reproduced on p. 177 of G. Waller, *Saratoga, Saga of an Impious Era* (Prentice-Hall, 1966). Photo, UCLA.

207. From *Picturesque America,* ed. W. C. Bryant (New York, 1874). Photo, UCLA.

208. Photo, Chicago Historical Association.

209, 210. Photo, Society for the Preservation of New England Antiquities.

211, 212. Staatliche Kunstsammlungen, Kassel.

213b. Woodcut from *London Illustrated News.* Photo, UCLA.

214. *London Illustrated News.* Photo, UCLA.

215. Louvre, Paris.